WOMEN
ARTISTS

WORKS FROM THE
NATIONAL MUSEUM OF
WOMEN IN THE ARTS

WOMEN

WORKS FROM THE NATIONAL

NANCY G. HELLER

CONTRIBUTORS:

SUSAN FISHER STERLING

JORDANA POMEROY

BRITTA KONAU

KRYSTYNA WASSERMAN

ARTISTS

MUSEUM OF WOMEN IN THE ARTS

NATIONAL MUSEUM OF WOMEN IN THE ARTS, WASHINGTON, D.C.

IN ASSOCIATION WITH RIZZOLI INTERNATIONAL PUBLICATIONS, INC.

First published in the United States of America in 2000 by Rizzoli International Publications, Inc., 300 Park Avenue South, New York, N.Y. 10010, and the National Museum of Women in the Arts, 1250 New York Avenue, N.W., Washington, D.C. 20005.

Unless otherwise indicated, all texts were written by Nancy G. Heller.

Project Director: Laureen Schipsi
Research Assistant: Corynne A. Hill
Editors: Mary S. Dallao and Susan Q. Graceson
Editorial Assistants: Yasemin Bayraktar, Eileen Binckley, Jennifer Fekete, Amelia Hess, Jeannette Lee, Molly Selway, and Reya Silao

Prepared for publication by Archetype Press, Washington, D.C.
President: Diane Maddex
Editorial Assistant: Carol Kim
Designer: Robert L. Wiser

Printed and bound in Italy

LC 00-101340
ISBN 0-8478-2290-7 Hardcover
ISBN 0-8478-2325-3 Paperback

A Note on the Typography

The display typeface, Trajan, was created by Carol Twombly in 1989. She based her design on the *capitalis monumentalis* letterforms found on the Trajan Column in Rome, a standard against which all Roman capital designs are measured. The text typeface, Minion, was designed by Robert Slimbach in 1989 and was inspired by classic typefaces of the late Renaissance. Minion refers to a typeface size in early printing and means "a beloved servant." The caption typeface, Interstate, was designed by Tobias Frere-Jones in 1993 based on alphabets we read every day as we drive: the signage alphabets of the Federal Highway Administration.

The catalogue is sponsored by **PHILIP MORRIS** COMPANIES INC.

Front Jacket. Alice Bailly: *Self-Portrait* (detail), 1917; oil on canvas, 32 x 23 ½ in. (81.3 x 59.7 cm.); on loan from the Wallace and Wilhelmina Holladay Collection

Back Cover (top left). Frida Kahlo: *Self-Portrait Dedicated to Leon Trotsky* (detail), 1937; oil on Masonite, 30 x 34 in. (76.2 x 61 cm.); gift of the Honorable Clare Boothe Luce

Back Cover (top right). Lavinia Fontana: *Portrait of a Noblewoman* (detail), ca. 1580; oil on canvas, 45 ¼ x 35 ¼ in. (114.9 x 89.5 cm.); gift of Wallace and Wilhelmina Holladay

Back Cover (center left). Elisabeth-Louise Vigée-Lebrun: *Portrait of Princess Belozersky* (detail), 1798; oil on canvas, 31 x 26 ¼ in. (78.7 x 66.7 cm.); gift of Rita M. Cushman in memory of George A. Rentschler

Back Cover (center right). Mary Cassatt: *The Bath* (detail), 1891; soft-ground etching with aquatint and drypoint, 12 ⅜ x 9 ⅝ in. (31.4 x 24.4 cm.); gift of Wallace and Wilhelmina Holladay

Back Cover (bottom left). Lilla Cabot Perry: *Lady with a Bowl of Violets* (detail), ca. 1910; oil on canvas, 40 x 30 in. (101.6 x 76.2 cm.); gift of Wallace and Wilhelmina Holladay

Back Cover (bottom right). Elizabeth Catlett: *Singing Their Songs* (detail), 1992; color lithograph, 23 x 19 in. (58.4 x 48.3 cm.), 12/99; purchased with funds donated in memory of Florence Davis by her family, friends, and the NMWA Women's Committee

Cover Spine. Anna Claypoole Peale: *Nancy Aertsen,* ca. 1820; watercolor on ivory, 3 ½ x 2 ⅞ in. oval (8.9 x 5.6 cm.); gift of Wallace and Wilhelmina Holladay

Pages 20–21. Clara Peeters: *Still Life of Fish and Cat* (detail), n.d.; oil on panel, 13 ½ x 18 ½ in. (34.3 x 47 cm.); gift of Wallace and Wilhelmina Holladay

Pages 38–39. Angelica Kauffman: *The Family of the Earl of Gower* (detail), 1772; oil on canvas, 59 ¼ x 82 in. (150.5 x 208.3 cm.); gift of Wallace and Wilhelmina Holladay

Pages 58–59. Elizabeth Adela Armstrong Forbes: *Will-o'-the-Wisp* (detail) , ca. 1900; oil on canvas, 27 x 44 in. (68.6 x 111.8 cm.); on loan from the Wallace and Wilhelmina Holladay Collection

Pages 76–77. Jennie Augusta Brownscombe: *Love's Young Dream* (detail), 1887; oil on canvas, 21 ¼ x 32 ⅛ in. (54 x 81.6 cm.); gift of Wallace and Wilhelmina Holladay

Pages 112–13. Gabriele Münter: *Breakfast of the Birds* (detail), 1934; oil on board, 18 x 21 ¾ in. (45.7 x 55.3 cm.); gift of Wallace and Wilhelmina Holladay

Pages 136–37. Beatrice Whitney Van Ness: *Summer Sunlight* (detail), ca. 1936; oil on canvas, 39 x 49 in. (99.1 x 124.5 cm.); gift of Wallace and Wilhelmina Holladay

Pages 168–69. Grace Hartigan: *December Second* (detail), 1959; oil on canvas, 48 x 72 in. (121.9 x 182.9 cm.); gift of Mrs. Walter S. Salant

Pages 206–7. Claire Van Vliet: *Dido and Aeneas* (detail), 1989; monoprint on handmade paper, 14 x 7 in. (35.6 x 17.8 cm.) (closed), 100/150; the Janus Press, West Burke, Vermont, and Theodore Press, Bangor, Maine; gift of Lois Pollard Price

This book is warmly dedicated to

Wilhelmina Cole Holladay and Wallace Holladay,

who, by founding the National Museum of Women

in the Arts, set out to transform our understanding

of history to include the creative legacy of women

artists. They have built a museum that, to this day,

sustains and champions the reforms they have so

boldly pursued. Their ceaseless efforts bring immeas-

urable beauty, inspiration, and knowledge to all,

and we are profoundly grateful.

CONTENTS

WOMEN ARTISTS: WORKS FROM

THE PERMANENT COLLECTION

S P O N S O R ' S S T A T E M E N T

In just over a decade, the National Museum of Women in the Arts has become an important institution that is unique in its role of sustaining, presenting, and promoting women artists and providing a home for their work. It also offers us all valuable opportunities to explore the significant role and place of women artists throughout art history.

Philip Morris's partnership with the National Museum of Women in the Arts is part of our commitment to supporting the arts in our communities around the world. For more than forty years, Philip Morris has helped museums and arts centers advance the work of talented and innovative artists, many of whom have been underserved or little recognized by traditional artistic venues.

Our previous support of the museum has included the sponsorship of such exhibitions as *Latin American Women Artists, 1915–1995* and, in its very first year of operation, the funding of the inaugural edition of the permanent collection catalogue. As the museum enters a new decade and century, we are proud to work with it once again on the creation of an updated and revised catalogue to document the museum's permanent collection as it exists today. We hope that this catalogue will give those who visit the museum, and those who may not, a greater understanding and appreciation of women's impact on the history of art.

Thomas J. Collamore
Vice President, Public Affairs
Philip Morris Companies Inc.

FOREWORD

Women artists have always enriched the lives of people around the world. Their contributions, however, have often been forgotten by history. The National Museum of Women in the Arts (NMWA) was founded to increase and sustain the world's awareness and appreciation of women artists of all eras, nationalities, and disciplines. Challenging traditional views of art history, the museum brings to light art by women who have been overlooked for centuries and supports contemporary women artists who might otherwise not receive the attention they deserve.

In its relatively short history, the museum has accomplished much to sustain its mission and continues to build on its accomplishments. Exhibitions of historical and international importance introduce to the public—often for the first time—the creative expression of women artists from the sixteenth century to the present. In addition to the visual arts, the museum showcases the talents of women in other artistic disciplines, including music, film, literature, theater, and dance. Symposia provide forums for groundbreaking scholarship on women in the arts. The permanent collection, which began with five hundred artworks, has grown to more than 2,600, encompassing both traditional and nontraditional media from world cultures.

This book presents eighty-six of the museum's finest paintings, sculptures, prints, drawings, artists' books, and mixed-media pieces. The works are categorized geographically and chronologically and represent the range of styles, nationalities, and periods that constitute the permanent collection. The last chapter is a special section on artists' books, which introduces some of the finest examples of the museum's significant holdings of this recently developed art form.

Wilhelmina Cole Holladay, the founder of the National Museum of Women in the Arts, deserves the utmost gratitude and appreciation for her constant work on behalf of the museum and all of its endeavors. Her vision, intelligence, and dedication inspire the ongoing development of this wonderful and necessary institution. This volume is truly a testament to her achievement.

Sincere thanks go to the people of Philip Morris Companies Inc., who sponsored our first permanent collection catalogue, for choosing once again to be our partner. Without their generosity, this book would not have been possible.

Many individuals are responsible for bringing this project to fruition, and credit is due to each for her expertise and commitment: Nancy G. Heller, for lending her vast knowledge to the writing of this book; Susan Fisher Sterling, Jordana Pomeroy, Britta Konau, and Krystyna Wasserman for their contributions as authors and consultants; Harriet McNamee, for her careful review and guidance; Corynne Hill, for her diligent research efforts; and Laureen Schipsi, for her adept management of this ambitious project.

Finally, no list of acknowledgments would be complete without thanking the members and friends of the National Museum of Women in the Arts. Their tremendous, unwavering support over the years has reinforced the museum's mission and ensured our efforts on behalf of all women in the arts.

On the solid foundation upon which Wilhelmina Cole Holladay envisioned and built this museum, the National Museum of Women in the Arts will continue to work to recognize and celebrate the works of women artists past, present, and future. As the museum's membership and collection continue to grow, the next several years promise new and exciting opportunities to broaden the scope of art history and to help ensure that women artists of today and tomorrow are fully established in this history.

Nancy Risque Rohrbach
Director

ACKNOWLEDGMENTS

In the spring of 1987 a unique institution opened its doors in Washington, D.C., for the first time. Since then the National Museum of Women in the Arts (NMWA) has greatly expanded its facilities, its staff, and its permanent collection of objects made by women artists from all parts of the globe during the past five hundred years. By the start of the twenty-first century the museum and its visitors truly needed a revised catalogue of the permanent collection.

The museum's permanent collection is now so large that only a few highlights could be selected to illustrate and discuss in this volume. The choice was difficult, crafted to give a representative sampling of NMWA's holdings—in various media, from Western Europe and North America, from the late sixteenth century to the present.

Those of us putting together this book faced the inevitable quandaries encountered by anyone attempting to create a chronological survey that would be as efficient as possible for both staff members and museum visitors to use. Many of these questions were purely practical. For example, should an artist whose lifetime spanned two centuries equally be included in the section of this catalogue devoted to the first or the second century? Likewise, how should one categorize an artist whose adult life was divided between two countries? Since there are no definite answers for these questions, we have tried to choose the most logical place for every artist and organized them alphabetically, by their last names, within each chronological-geographical division.

Any project of this scope depends on the contributions of a great many generous individuals from a whole host of fields. Outside experts who gave unstintingly of their knowledge and time include the art historians Joseph Baillio, Bonita Billman, Alan Braddock, Martha M. Evans, Sheila ffolliott, Jennifer Faulds Goldsborough, Frima Fox Hofrichter, Robert S. Mattison, Wendy Wassyng Roworth, Barbara Tannenbaum, and Joyce Zemans. Artists and art professors whose aid was invaluable include Jane Bedno, Diane Burko, Sharon Church, Steven Clay, Walter Hamady, Grace Hartigan, Lila Snow, and Mariana Yampolsky. In addition, the museum curators Margaret Achuleta and Ron Fuchs II, the art experts Kurt Hiller and Isabelle Knafou, the painting conservator Carol Christensen, and the musicians–music historians Robert C. Page and Ralph Pemberton were tremendously helpful, as was scientific expertise provided by Maura C. Flannery. At the University of the Arts, my heartfelt gratitude goes to Liberal Arts

Administrative Assistant Maria Blando, Public Services Librarian Sara J. MacDonald, and Literature-Writing Professor Faith Watson for their assistance with this project. I am also long overdue in acknowledging the enormous debt I owe to a group of exceptional mentors: at Middlebury College—Professors A. Richard Turner and David J. Littlefield; at Rutgers University—Professors Matthew Baigell, Olga Berendsen, and Joan M. Marter; and at the Hirshhorn Museum and Sculpture Garden—Judith K. Zilczer. I was very lucky to have the opportunity to work with these creative, and remarkably generous, individuals.

With the help of a good research assistant, half the work on a given project is already done. In this case, I was fortunate to work with Corynne A. Hill, an art historian with excellent training, great intelligence, fine judgment, boundless patience, and a healthy sense of humor. Without the insightful, yet diplomatic, input of NMWA curators Britta Konau, Harriet McNamee, Jordana Pomeroy, Susan Fisher Sterling, and Krystyna Wasserman, my part of this catalogue would never have seen the light of day. The help of the collections manager Randi Jean Greenberg and the archivist Susan Koutsky was essential, as was the work contributed by the editors Mary Dallao and Susan Graceson. In particular, the publications director Laureen Schipsi deserves my undying thanks, because of her impressive skill and unrivaled flexibility. It goes without saying that the museum's director, Nancy Risque Rohrbach, and its founders, Wilhelmina and Wallace Holladay, literally made possible this catalogue—and the institution it celebrates. I apologize if I have inadvertently left out the names of any other people who contributed to this volume. Moreover, I hereby absolve everyone listed of whatever errors I may have committed in their names or my own.

On a personal note, I would like to express my appreciation to my father, Jules Heller, an artist and author whose own research into the history of women artists—begun a half century ago—first got me interested in this field. I also want to thank my mother, Gloria Heller, whose keen editorial eye and sense of intellectual rigor are a constant source of strength; Carole Regan, for excellent advice and a tremendously helpful sense of perspective; and Robert Gerard and Scooter Regan, who together made it possible for me to enjoy far more of the book-writing process than I otherwise could have done.

Nancy G. Heller

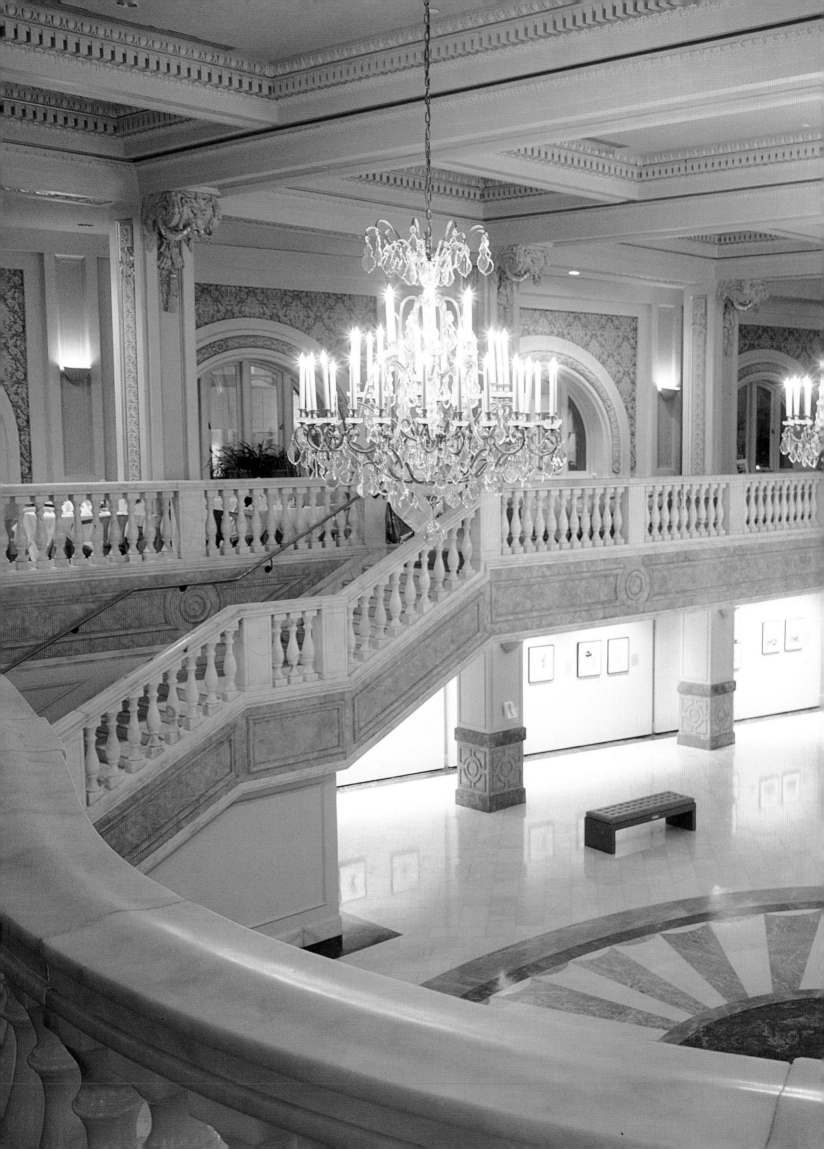

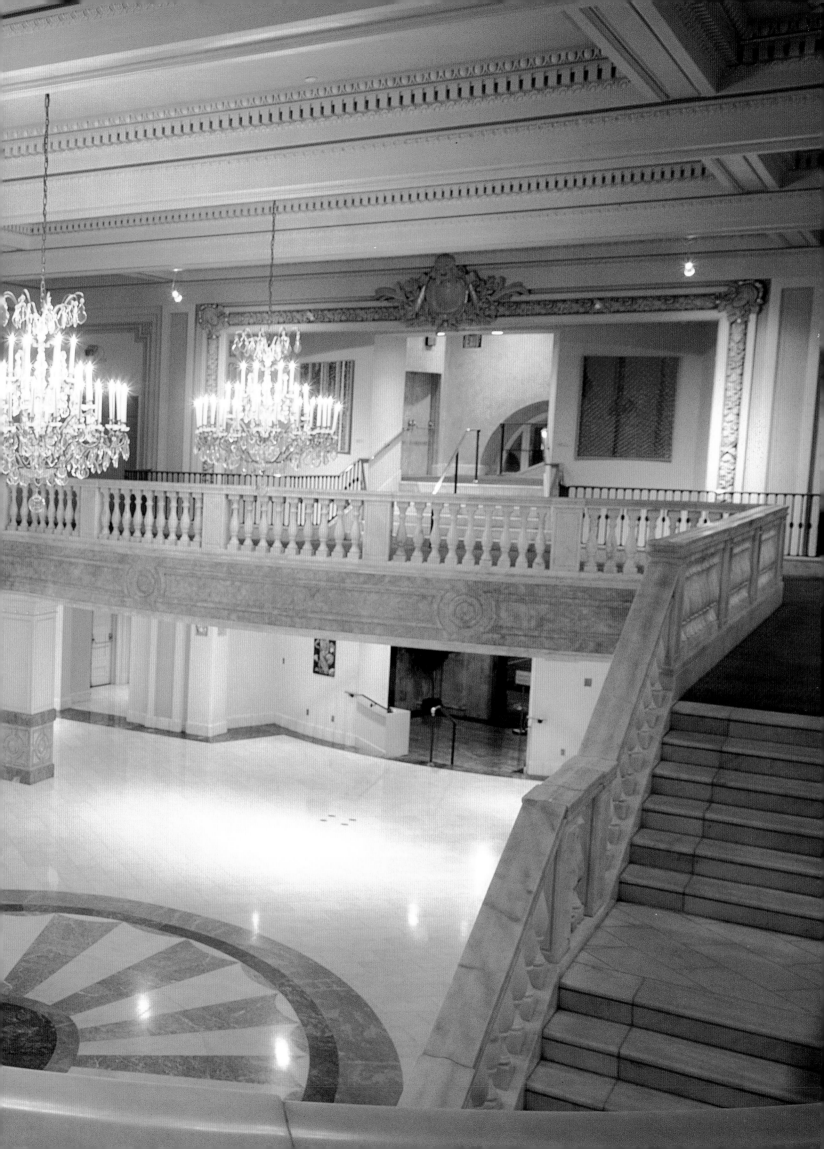

A little over a decade ago, an excellent example of Renaissance Revival architecture in downtown Washington, D.C., underwent an unexpected transformation. Originally designed as a Masonic lodge, for an organization restricted to men, it was renovated to become the National Museum of Women in the Arts (NMWA), the first and only museum devoted entirely to art by women. The adjacent property, formerly an adult movie theater, would also become part of the museum a few years later. It seems fitting that NMWA should occupy space that women had previously been unable, or unlikely, to enter. This development mirrors the emergence of women during the twentieth and twenty-first centuries, as leaders in areas—including the arts—where their contributions had historically been neglected or even prevented. Today, the museum celebrates women's cultural accomplishments over the last five hundred years, unearthing past triumphs and providing a forum for current and future achievements.

If the architectural history of the National Museum of Women in the Arts is unconventional, the story behind the development of its core collection is no less so. It began during a trip to Europe in the 1960s, when Wilhelmina and Wallace Holladay admired several canvases by the seventeenth-century Flemish still-life painter Clara Peeters. On returning home to the United States, they were shocked to discover how difficult it was to find information about Peeters or, indeed, any women artists. At that time very few art dealers, collectors, or scholars were familiar with, or interested in, art by women. In fact, none of the standard art history survey textbooks, which covered the period from Paleolithic times to the late twentieth century, included references to any women artists. Both appalled and intrigued by this state of affairs, the Holladays were inspired to seek out more information about art by women.

As their passion for the project grew, the Holladays also began collecting books and other reference materials about women artists. In 1981 they founded a museum for their

Seventy-five years after a Masonic temple for men was built in Washington, D.C., the National Museum of Women in the Arts acquired the building in 1983 and, four years later, after extensive renovations to the interior, the museum opened its doors to the public. The redesign, including the Great Hall (pages 12–13), garnered many awards, and the building is now listed in the National Register of Historic Places.

IN THE ARTS

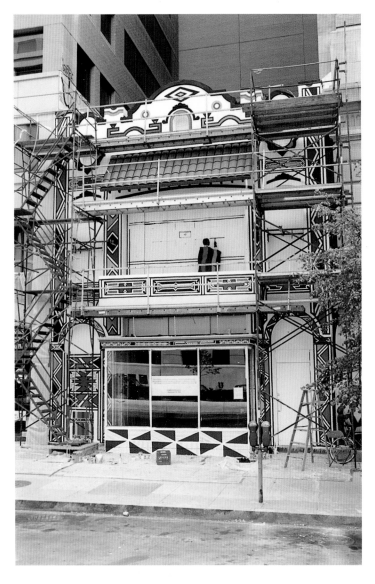

rapidly expanding collection, housed initially in their Washington, D.C., residence. It soon became clear that the collection needed a home of its own, so funds were raised to acquire a separate museum property. Two years later a building was purchased, a wedge-shaped structure at the corner of New York Avenue and Thirteenth Street, Northwest, just two blocks from the White House. Designed in 1908 by Waddy Wood, a prominent Washington architect, the elegant, six-story edifice of Indiana limestone, granite, terra cotta, and gray brick was erected as the Grand Lodge of the Free and Accepted Masons, one of the oldest fraternal organizations in the United States. Unfortunately, by the early 1980s the building had fallen into disrepair. In fact, at the time the museum purchased the property, it was terribly run down and scheduled to be demolished.

After three years of extensive renovation, the National Museum of Women in the Arts opened its doors to the public in the spring of 1987. Since the museum's opening, the surrounding blocks of downtown Washington have prospered, and what was once a collection of dilapidated buildings has become completely rehabilitated.

The museum occupies a spectacular space, comprising more than 73,000 square feet. The building is now in the National Register of Historic Places and has received awards from the American Institute of Architects and the American Society of Interior Designers.

As NMWA emerged as a national presence and the permanent collection expanded, the museum began to outgrow its new home within just a few years. In 1993, when a small adjoining building became available, another fund-raising campaign made it possible for the museum to acquire this much-needed space. The Elisabeth A. Kasser Wing opened in 1997, providing additional facilities that include a gallery designed to display contemporary sculpture.

Since its founding, NMWA has experienced tremendous growth—in its physical space, in its staff, and in the size of its permanent collection. The museum currently owns some 2,600 works of art representing many different media, techniques, and styles, from the sixteenth century to the present. A number of special collections provide rare and rich experiences for both casual viewers and expert researchers. For example, the museum owns a group of painstakingly accurate, and visually lavish, hand-colored engravings of animals, insects, and plants by the seventeenth-century German artist Maria Sibylla Merian. Because Merian was the first person known to depict animals and insects within their natural environments, these prints made important contributions to the fields of science and art. The museum also owns more than one hundred miniatures (small-scale paintings, usually portraits, on ivory or other materials) from the late nineteenth and early twentieth centuries, made by the American artist Eulabee Dix. In addition, going beyond the traditional definition of fine art,

the museum has American Indian pottery made by members of three generations of respected and influential artists from the southwestern United States. It also owns a vast collection of silver objects marked by eighteenth-century English women. The silver collection, and NMWA's 1990 groundbreaking catalogue of these objects, shed light on the critical roles played by women—as successful business owners, designers, and skilled craftspersons—during the 1700s.

According to its mission statement, the National Museum of Women in the Arts was established to "bring recognition to the achievements of women artists of all periods and nationalities by exhibiting, preserving, acquiring, and researching art by women and by educating the public concerning their accomplishments." In keeping with its mission, the museum also presents special exhibitions that contribute to art history and augment the range of works represented within the permanent collection. The women's museum has already presented fifty major exhibitions, including the first shows in the United States of works by several significant European women artists: the sixteenth-century Italian painter Sofonisba Anguissola, the seventeenth-century Portuguese artist Josefa de Óbidos, and the nineteenth-century French sculptor Camille Claudel. Anguissola was one of the earliest European women to achieve international fame through her art; Josefa, a pioneering Iberian painter, produced acclaimed religious pictures, allegories, and still lifes; and Claudel made a noteworthy contribution to modern art, both as an assistant to the distinguished sculptor Auguste Rodin and through her independent work.

Other exhibitions have reflected the museum's commitment to showcasing art created beyond the Western world. A 1994 exhibition showed a diverse group of contemporary paintings and sculptures made by Arab women artists from Abu Dhabi to Tunisia. The museum has also presented shows of art by historic Chinese women, three separate solo exhibitions of art by Japanese women, group exhibitions of avant-garde works by both Korean and Brazilian

women, and a selection of twentieth-century embroidered textiles by women from rural India. Moreover, the National Museum of Women in the Arts has demonstrated its interest in public art. While raising funds for the Kasser Wing, NMWA commissioned the South African artist Esther Mahlangu to paint a mural on a temporary three-story facade. Although only in place for a few months, Mahlangu's powerful patterns and vivid colors—inspired by the traditional art of the Ndebele people—provided museum neighbors and visitors with a brilliant taste of the South African countryside.

In recent years artists have created multidisciplinary works combining elements from both the visual and the performing arts. This phenomenon was clearly, and gloriously,

The National Museum of Women in the Arts purchased the adjoining property in 1993 and built the Elisabeth A. Kasser Wing (right). While awaiting construction, museum officials commissioned the South African artist Esther Mahlangu to paint a mural on a temporary three-story facade (opposite).

demonstrated by the museum's 1992 one-woman show of work by the American performance artist Pat Oleszko. The Michigan native has won many prestigious awards, including the Prix de Rome, for her inventive and often hilarious three-dimensional sewn constructions, inside and around which she sings, dances, and creates unforgettable visual and aural images. Other one-woman exhibitions at NMWA have showcased work by contemporary artists, including the sculptor Judith Shea, painter Hollis Sigler, photographer Carrie Mae Weems, folk artist Nellie Mae Rowe, post-conceptualist Sarah Charlesworth, and installation artist Judy Pfaff.

For those who support women artists but cannot regularly visit Washington, NMWA's network of state committees brings the museum's mission and programs to women artists, members, and friends in both urban and nonurban areas all across the United States. Currently numbering twenty-two, state committees sponsor research on local women artists and organize exhibitions of their work that often travel around the state and to the museum in Washington. State committees further the general public's education about women artists by training volunteers who lecture to young and adult audiences in their communities. In addition, the committees offer internships at local art centers to female college students from their areas.

Because the major goals of the women's museum include research and education, from the very beginning this institution has emphasized the development of a substantive library. What began as the Holladays' personal library has evolved into the museum's Library and Research Center, a unique and invaluable resource. The center contains thirteen thousand books and exhibition catalogues, periodicals, video and audio tapes, posters, the personal papers of several noted artists, and an archive on more than fifteen thousand women artists of all periods and nationalities.

The Library and Research Center houses a collection of nearly six hundred artists' books. These are one-of-a-kind or limited-edition artworks that can take virtually any physical form and may or may not include text. Artists' books have greatly increased in number and since the 1970s have begun to be recognized and collected as fine art. The women's museum organizes and presents important annual exhibitions of artists' books, both examples owned by the museum and others borrowed from outside sources. These exhibitions are popular with museum goers, perhaps because they introduce people to a relatively new and unfamiliar art form.

The museum provides educational programming on its exhibitions and permanent collection. It has also developed some unusual programs that focus specifically on the interests and needs of young audiences. For example, an award-winning literary series brings distinguished female authors to the museum for readings and book signings. These events are combined with creative writing workshops for local high school students, who spend time with the guest authors and then give public readings of their own works. The museum's Role Model Workshops for teens from the Washington, D.C., area enable young people to listen to and talk with successful women in a variety of arts-related professions—from film directing to modern dance, fashion design, and more.

As arts budgets have been cut or eliminated from public elementary schools, the museum has increased its educational outreach. NMWA produces special curricula for teachers, including illustrated booklets, slide packets, study prints, and a CD-ROM about artworks from the permanent collection. NMWA is the only art museum in the country with a formalized connection to the Girl Scouts of the U.S.A. Moreover, in the Education Resource Center young visitors have the chance to learn more about the objects on display throughout the museum, and they can even exhibit their own artworks through special education programs.

The women's museum has cosponsored and hosted symposia on such topics as women and the art of multimedia (web-site design, CD-ROM development, installation art, and

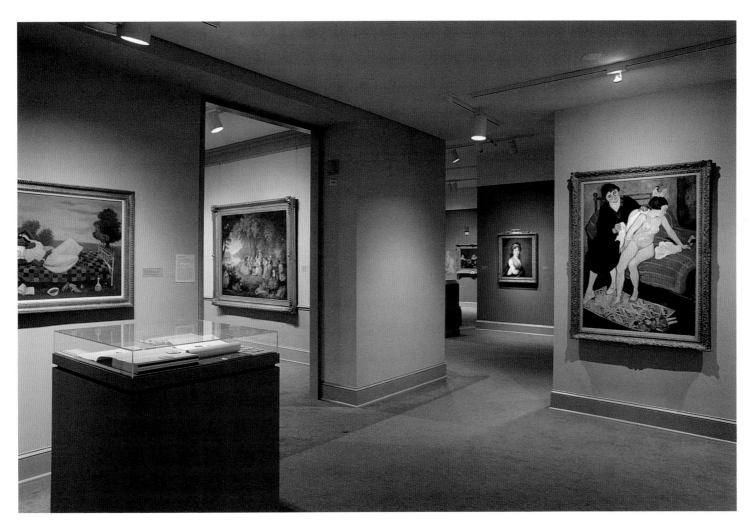

the like), women in the Italian Renaissance, and the achievements of women leaders throughout the Arab world. In 1998 Wendy Wassyng Roworth became the museum's first scholar-in-residence, researching and writing a book about the eighteenth-century Swiss painter Angelica Kauffman.

The museum contributes to the growing body of knowledge about women artists through its publications. These include exhibition catalogues, artists' monographs, and books related to other artistic disciplines. For instance, in 1993 the museum published *Isadora Duncan: The Dances* by Nadia Chilkovsky Nahumck, making available in print for the first time the complete Labanotated scores (with symbols representing every movement) for three hundred dances and dance exercises created by the modern-dance pioneer Isadora Duncan and her protégées—a significant contribution to the field of dance history.

Dance, music, film, literature, and theater are presented at NMWA and often complement the themes of major exhi-

bitions. They also encourage awareness of the extraordinary range of creative accomplishments by women. A regular film series features screenings and discussions of movies written, directed, or produced by women throughout the world. Music—often written by female composers—is presented by women soloists and ensembles.

The National Museum of Women in the Arts is fortunate to have a broad U.S. geographical base—84 percent of the museum's members live outside the Washington, D.C., metropolitan area. More than two hundred thousand people have joined the women's museum during the last thirteen years. Clearly this indicates a passionate commitment on their part to the mission of the museum. It also demonstrates the effectiveness of the efforts of individuals and groups, women and men, young and old, all of whom recognize the need for this institution. Bolstered by the support of these thousands of members and friends, NMWA's future in the twenty-first century promises to be as productive and inspiring as its past.

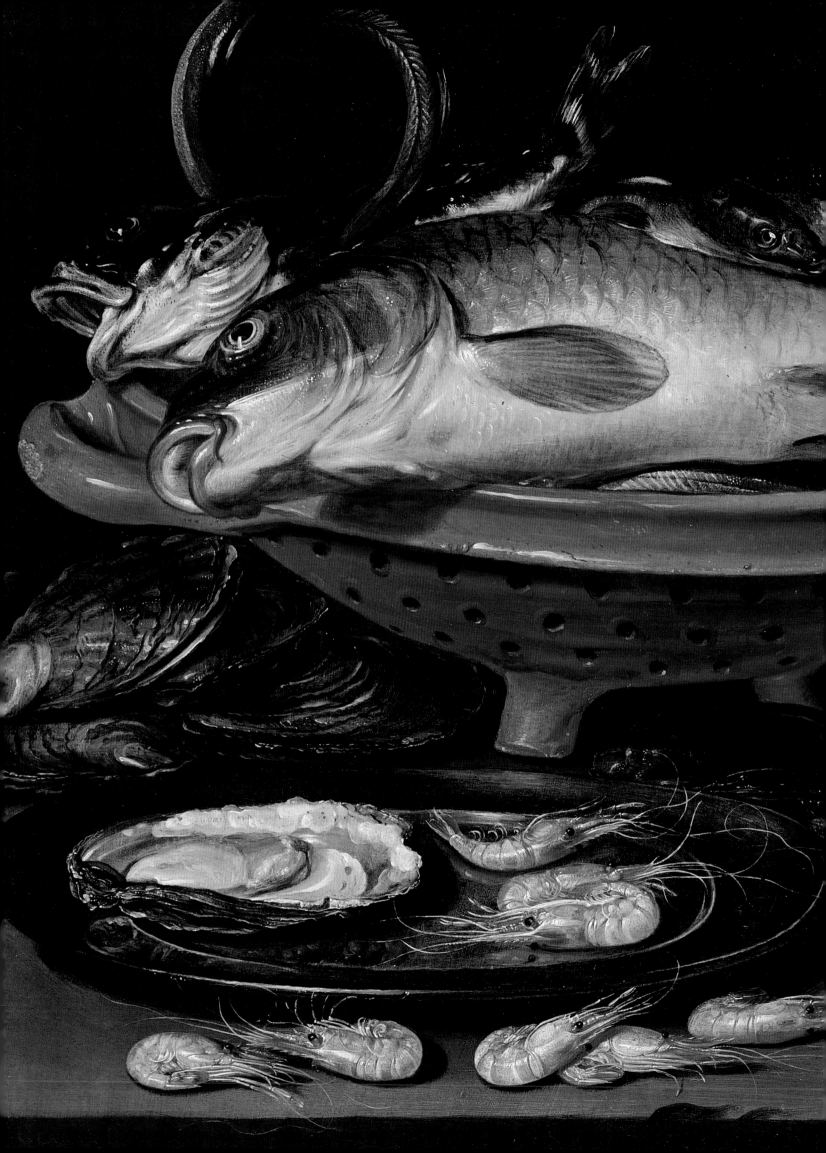

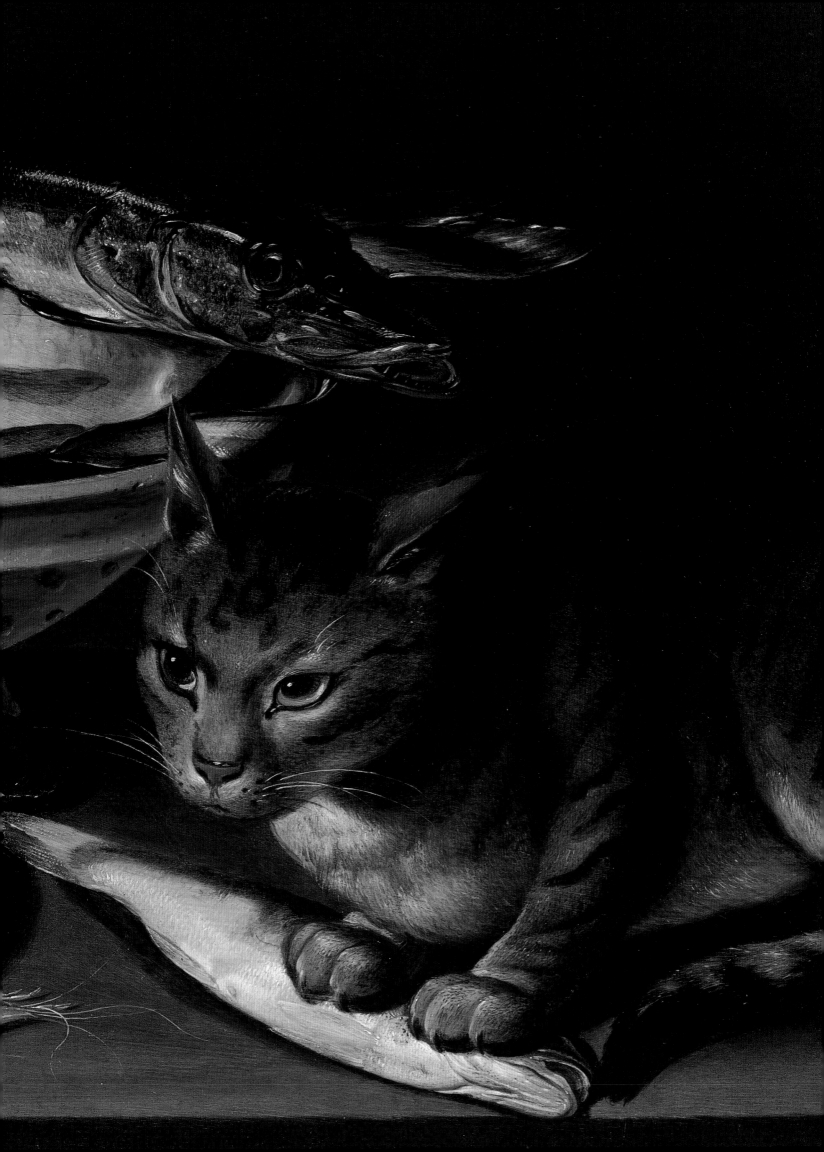

The history of women in the arts from the sixteenth century to the present is a story with a relatively happy ending. Yet there is no denying that the beginnings of this development were modest. During the sixteenth century art played an important role in European aristocratic and ecclesiastical society.

Highly trained painters, printmakers, and sculptors had as their patrons the political, religious, scientific, and intellectual leaders of the day. However, women were generally barred from participating in the most prestigious artistic techniques, such as fresco painting, and from the sophisticated training needed to succeed as professional artists. Only a few middle-class and aristocratic women were educated—at home or in convents. Aside from reading and writing, even the most privileged women acquired only those skills intended to make them more attractive as marriage partners and better able to entertain their relatives and friends. Therefore, women studied poetry, foreign languages, music, dance, and painting—but with no intention of preparing for a career in any of these fields. Women interested in becoming artists were not admitted to art schools; they were not taught the laws of perspective, and they were banned from life classes (where young artists learned anatomy by drawing from the nude model); and their freedom to travel was severely restricted. As a result, the majority of Renaissance women artists were the children—or the spouses—of successful male artists, from whom they acquired the skills and the network of prominent acquaintances needed to establish their own independent careers.

These women worked for both popes and princes, served as the sole sources of financial support for their families, and became role models for European women artists of subsequent centuries.

During the sixteenth and seventeenth centuries, women artists from Northern Europe (Flanders, Holland, Germany, France, England) had some advantages over their female counterparts in the south. In Italy, the Roman Catholic Church was the principal source of artistic commissions—which comprised mainly devotional images involving multiple figures and complex spatial effects. However, the mostly individual, middle-class patrons in the increasingly Protestant north were eager to acquire art based on aspects of their everyday lives. Therefore, in Northern Europe the 1600s marked the emergence of landscapes, still lifes, and genre paintings that functioned independently, rather than serving as backdrops for religious, literary, or other kinds of subject matter. There are no records of seventeenth-century women landscape painters, but women played extremely important roles in the development of the other two forms.

Louise Moillon was one of the earliest and most influential still-life painters in France. Moillon's work reveals intensive training in composition, lighting, color, and depth. These same qualities are evident in still lifes produced by many of her contemporaries of both sexes.

Still-life painting had also become enormously popular with the newly prosperous middle class in Flanders (modern-day Belgium) and Holland, and the seventeenth century is considered the Golden Age of still-life painting. In fact,

EUROPE

still lifes became so important that many Flemish and Dutch Baroque artists made excellent livings by specializing in particular subcategories, such as breakfast pieces, dessert pieces, and flower paintings. Clara Peeters's still life illustrates the use of implied narrative—and a possible moralizing element—within an essentially straightforward depiction of the ingredients for a seafood feast.

Northern enthusiasm for the natural sciences was further encouraged during the seventeenth century by the increased importation by Netherlandish traders of exotic flora and fauna from abroad, a development that may have inspired the German-born Maria Sibylla Merian, whose meticulous illustrations of local and foreign insects and plants (based on her extensive observations in the field) made important contributions to both science and art.

Another innovative type of painting that became especially popular in seventeenth-century Holland was the genre scene—images of ordinary people engaged in everyday pursuits. Judith Leyster was well known in her own time as an expert painter of intimate domestic genre scenes, many of which revolve around music making, a widespread leisure activity for the Dutch middle class.

Given the contributions made to Renaissance art by Italian men, it is not surprising that Italy produced a number of notable women artists as well. Many hailed from Bologna, a city with a long history of progressive attitudes toward women. As a matter of fact, records show that some twenty-three female painters—and at least one sculptor (Properzia de' Rossi)—were active in Bologna during the 1500s and 1600s. Lavinia Fontana, the daughter of a successful painter, Prospero Fontana, made her reputation as a painter of detailed likenesses. Also from Bologna, the prolific Elisabetta Sirani developed an illustrious career as a painter before reaching the age of twenty. Sirani was particularly famous for her religious pictures, a type of art produced by few women of her age.

These exceptional sixteenth- and seventeenth-century women artists from Europe forcefully demonstrated that, even though they had been denied the opportunities that were available to comparably talented men, women were fully capable of becoming successful professional artists. These women also helped pave the way for another group of female artists whose careers made an even greater impact on the international scene during the 1700s.

IT IS A SIN TO BE CONTENT WITH A LITTLE KNOWLEDGE.

—ANNE BAYNARD[1]

LAVINIA FONTANA

ITALIAN, 1552–1614

Like most female artists in late-sixteenth-century Italy, Lavinia Fontana was born and raised in a major art center (Bologna) and was related to a successful male artist (her father, Prospero Fontana). However, she was unusual in that she was commissioned to make not only portraits, which were the typical subject matter for women painters, but also religious and mythological themes, which sometimes included female nudes. Fontana also made great strides in the field of portraiture, for which she was justly famous, both within and beyond Italy. In fact, Fontana is regarded as the first woman in Western Europe to develop a professional career as an artist, working within the same sphere as her male counterparts, outside a court or convent.

At the age of twenty-five Fontana married Gian Paolo Zappi, a fellow painter from a noble family, who acted as his wife's assistant and managed their growing household (the couple had eleven children, only three of whom outlived their mother). For twenty years beginning in the 1580s, Fontana was the portraitist of choice among Bolognese noblewomen. She also painted likenesses of important individuals connected with the University of Bologna.

Because of the popularity of her portraits and a number of prestigious commissions to create large altarpieces, Fontana's fame spread to Rome, where she moved in 1604. There she became a portraitist at the court of Pope Paul V and was the recipient of numerous honors, including a bronze portrait medallion cast in 1611 by the sculptor and architect Felice Antonio Casoni.

PORTRAIT OF A NOBLEWOMAN

ca. 1580, oil on canvas, 45¼ × 35¼ in. (114.9 × 89.5 cm.)
Gift of Wallace and Wilhelmina Holladay

Portrait of a Noblewoman, like most of those painted by Lavinia Fontana, is startling in its attention to detail and in the sumptuousness of the subject's clothing. The contrast between the woman and the picture's plain, dark background is especially strong and ensures that the viewer's attention will be focused on the figure.

The artist depicted every bit of light reflected off the facets of each jewel, the differences in texture among satin, velvet, and lace, and the delicate gold threads of the embroidery. But more than Fontana's technical skill is evident here.

Recent scholarship has established that this painting of an unidentified, very young Bolognese noblewoman is almost certainly her marriage portrait.[1] Studies of account books and family diaries from this period show that the clothes and gems depicted here correspond precisely to the items that made up a typical highborn bride's *corredo* (trousseau). The dowry of a young noblewoman in late-sixteenth-century Bologna comprised a sum of money, plus an assortment of lavish garments and jewels, which established her own inherited wealth and the financial contribution she would bring to her new family.

Red was the color of most Bolognese wedding dresses; the small dog was a common symbol representing marital fidelity. Suspended from the woman's belt is a curious item mentioned in numerous family records of that time. It is the pelt of a marten—a slender, minklike creature—whose head and paws are elaborately decorated with jewels. It serves as an additional adornment and symbol of her wealth.

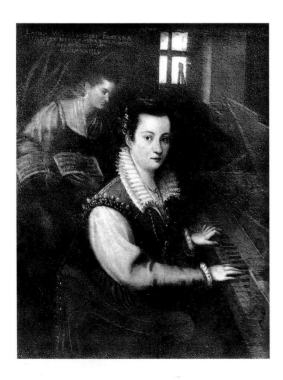

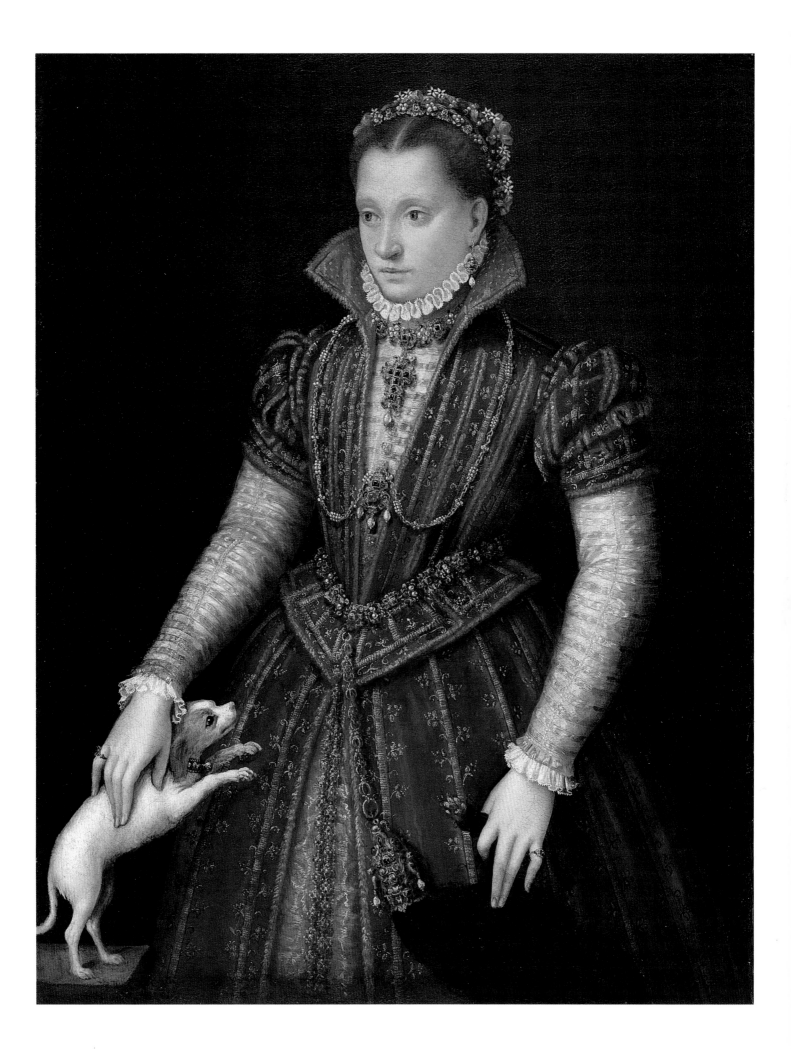

THE CONCERT

ca. 1631–33, oil on canvas, 24 × 34¼ in. (61 × 87 cm.)
On loan from the Wallace and
Wilhelmina Holladay Collection

Along with tavern scenes and intimate domestic genre pieces, Judith Leyster—like her male contemporaries—was fond of musical subjects. In *The Concert* Leyster accurately depicts such elements as the Baroque violin (made without a chin rest and usually supported against the chest), plus the singer's songbook, held open on her lap.[1]

The people depicted here are specific individuals, not generic figures. Based on similar persons in Leyster's other pictures, scholars have tentatively identified the singer as the artist herself, the violinist as her husband, and the lute player as a family friend. The members of the trio, like all musicians, must work together as a unit, "in concert," which has led some writers to theorize that this scene symbolizes the virtue of harmony.

Leyster frequently places her subjects against a plain, monochromatic background, with nothing to distract the viewer from the figures, who are all shown in the midst of various actions (bowing or plucking strings, beating time). The deep angle at which the lute is held adds depth to the composition, and the varied directions in which the musicians are looking offer viewers different points of focus.

JUDITH LEYSTER

DUTCH, 1609–1670

One of only two female members of the painters' guild in her native Haarlem, Judith Leyster was an independent Dutch artist with her own workshop and pupils. As the eighth child of a brewer and cloth-maker, Leyster's career almost ended before it began when her father was forced to declare bankruptcy in 1624. There are no records of her artistic education, but by the time she was eighteen Leyster was already mentioned favorably in a book about culture in Haarlem.

Her work was clearly influenced by the content and style of genre paintings created by the noted Haarlem artists Frans Hals and his brother Dirck. Like them, Leyster had a talent for painting lively scenes of people enjoying themselves in taverns, playing music, and the like. Such subjects were very popular with Holland's newly prosperous middle class, the principal buyers of contemporary Dutch art.[2]

Leyster produced most of her paintings between ca. 1629 and 1635; her artistic output decreased dramatically after her marriage in 1636 to the painter Jan Miense Molenaer. The couple soon moved to Amsterdam and had at least five children. In addition to raising the children, Leyster may have managed the family's business and properties; she probably also assisted with her husband's art. By 1649 the family was back in Haarlem, where Leyster spent the remainder of her life.

Although well known during her lifetime, Leyster and her work were largely forgotten after her death until 1893, when a painting acquired by the Louvre was found to have Leyster's distinctive monogram (her initials entwined with a five-pointed star) hidden under a false signature reading "Frans Hals." This discovery led to renewed research and appreciation of Leyster's oeuvre, which had previously been confused with that of Hals. A 1993 retrospective exhibition of Leyster's paintings and the related research have helped restore this painter to her proper place in art history.[3]

MARIA SIBYLLA MERIAN

GERMAN, 1647–1717

Besides creating visual images of great beauty, Maria Sibylla Merian made observations that revolutionized both botany and zoology. This extraordinary artist-scientist was born in Frankfurt. Her father, Matthäus Merian the Elder, was a Swiss printmaker and publisher who died when she was three. One year later her mother married Jacob Marell, a Flemish flower painter and one of Merian's first teachers.

From early childhood, Merian was interested in drawing the animals and plants she saw around her. In 1670, five years after her marriage to the painter Johann Andreas Graff, the family moved to Nuremberg, where Merian published her first illustrated books. In preparation for a catalogue of European moths, butterflies, and other insects, Merian collected, raised, and observed the living insects, rather than working from preserved specimens, as was the norm.

In 1685 Merian left Nuremberg and her husband, from whom she was later divorced, to live with her two daughters and her widowed mother in the Dutch province of West Friesland. After her mother's death, Merian returned to Amsterdam. Eight years later, at the age of fifty-two, Merian took the astonishing step of embarking—with her younger daughter, but no male companion—on a dangerous, three-month trip to the Dutch colony of Surinam, in South America. Having seen some of the dried specimens of animals and plants that were popular with European collectors, Merian wanted to study them within their natural habitat. She spent the next two years studying and drawing the indigenous flora and fauna. Forced home by malaria, Merian published her most significant book in 1705. The lavishly illustrated *Metamorphosis of the Insects of Surinam* established her international reputation. A second, posthumous, edition was published under the title *Dissertation in Insect Generations and Metamorphosis in Surinam.*

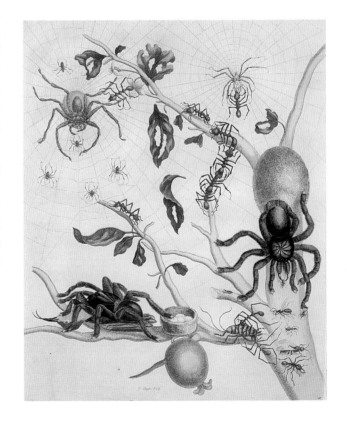

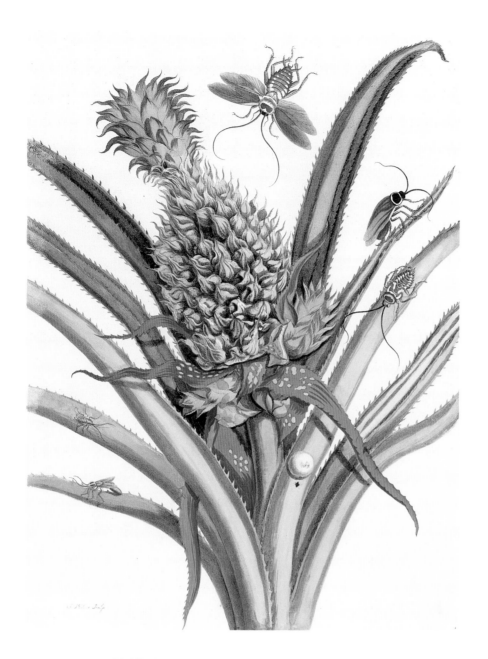

PLATES 18 (SPIDERS, ANTS, AND
HUMMINGBIRDS) AND 9 (PINEAPPLE)
FROM DISSERTATION IN INSECT
GENERATIONS AND METAMORPHOSIS
IN SURINAM

1719, hand-colored engraving on paper
18 × 13¾ in. (45.7 × 34.9 cm.) each
Gift of Wallace and Wilhelmina Holladay

Each of the eighty-two, full-page illustrations in Merian's *Metamorphosis* is a large hand-colored engraving executed after her small-scale watercolors.[1] Merian has combined into a single image the entire life cycle of each animal and plant, arranged with great sensitivity so that every picture is both scientifically useful and aesthetically satisfying. On the facing page is a text written by the artist describing the images of plants and the creatures that feed on them.

The *Pineapple* that begins Merian's book, and which must have seemed particularly exotic to European readers of the day, is set on a diagonal. An additional sense of dynamism is provided by the curving lines of the green leaves and shoots, plus the colorful leaves just under the fruit, which Merian notes look "like red satin decorated with yellow spots." Still more interesting are the insects: two kinds of cockroaches that are attracted to the sweetness of the pineapple.[2]

The plate with *Spiders, Ants, and Hummingbirds* shows a more violent side of nature. Here Merian depicts the large, furry black arachnids she discovered living on guava trees in Surinam. They survived by devouring ants or sucking the blood from hummingbirds. Once again Merian successfully combines valuable scientific information—such as the way ants work together to form a "living bridge" with their bodies—while setting a standard of beauty for future artists to follow.[3]

BOWL OF LEMONS AND ORANGES ON A BOX OF WOOD SHAVINGS AND POMEGRANATES

n.d., oil on panel, 15¾ × 24½ in. (40 × 62.2 cm.)
On loan from the Wallace and
Wilhelmina Holladay Collection

Louise Moillon specialized in painting modest-sized images of fruit. Such tabletop still lifes are seen from above and contrast a few perfect and well-lit specimens against a plain, dark background.[1] The principal focus of Moillon's composition is the bowl of citrus fruit placed in the center of the canvas with a few stray leaves and two pomegranates around its base. The *trompe l'oeil* water drops are standard elements in such still lifes, adding to the naturalism of the scene and showing off the artist's technical skill. Moillon also paints a complex series of shadows, including one cast by the segment of fruit that appears to be hanging over the table's edge. This is another common artistic device that increases the sense of depth.

Contrast—between light and dark areas, round fruit and irregularly shaped branches and leaves, and intact and cut fruit—is a primary compositional element of this painting. In particular, the jagged edge of one pomegranate, ripped open to expose its glistening, deep-red seeds (a traditional symbol of fertility), makes a shocking, almost visceral contrast to the thick, pebbled rinds of the other fruit. Compared to most seventeenth-century Dutch and Flemish still lifes, which feature crowded arrangements of brightly colored and varied objects, Moillon's works seem restrained, even austere. Yet they exude their own kind of rich warmth. Moreover, such deliberately "accidental" touches as the few stray pips from the cut pomegranate soften the composition's symmetry, giving the painting a pleasantly informal feeling.

LOUISE MOILLON

FRENCH, 1610–1696

The Parisian-born painter Louise Moillon played a significant part in a large artistic family. Both her father and stepfather were painters and picture dealers; her maternal grandfather was a goldsmith; and several of her siblings were also artists. Moillon demonstrated marked artistic ability of her own by age ten, and as an adult she became an important pioneer of a new type of French painting— the quiet, contemplative, domestic still life.

Most of Moillon's paintings were executed during the 1630s and the 1670s–80s. The gap in her artistic career is generally attributed to increasing domestic responsibilities after her marriage in 1640.[2]

Because France's Royal Academy (founded in 1648) placed still lifes at the bottom of its rigid hierarchy of subject types, this form never achieved the same level of popularity in that country as it held for a century and a half in the Netherlands. Nevertheless, a group of painters—mainly Protestants, who had fled religious persecution in the southern Netherlands and settled in the Saint-Germain-des-Pres area of Paris—became known for their sober and dignified arrangements of a few meticulously rendered objects in an interior setting. Moillon was a leading member of this group; her work was lavishly praised, and she attracted prominent patrons, including Louis XIII's minister of finance. Modern writers have also been impressed with Moillon's work; a typical source identifies her as "the greatest still-life painter of the French seventeenth century."[3]

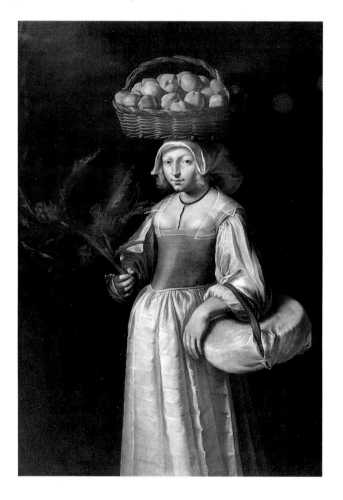

CLARA PEETERS

FLEMISH, 1594–1657

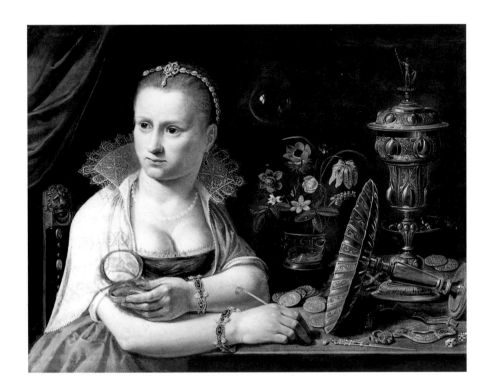

An important pioneer in the field of still-life painting, Clara Peeters is the only Flemish woman known to have specialized in such pictures as early as the first decade of the seventeenth century. While definite details concerning her life are scarce, records indicate that Peeters was baptized in Antwerp in 1594 and married there in 1639. There is no indication that Peeters ever joined the Antwerp painters' guild, but the records for many relevant years are missing.[1]

Peeters's earliest dated oil paintings, from 1607 and 1608, are small-scale, detailed images representing food and beverages. The skill with which this fourteen-year-old artist executed such pictures indicates that she must have been trained by a master painter. Although there is no documentary evidence of her artistic education, scholars believe that Peeters was a student of Osias Beert, a noted still-life painter from Antwerp. By 1612 the eighteen-year-old artist was producing large numbers of painstakingly rendered still lifes, typically displaying a group of valuable objects (elaborately decorated metal goblets, gold coins, exotic flowers) on a narrow ledge, as seen from a low vantage point, against a dark background.

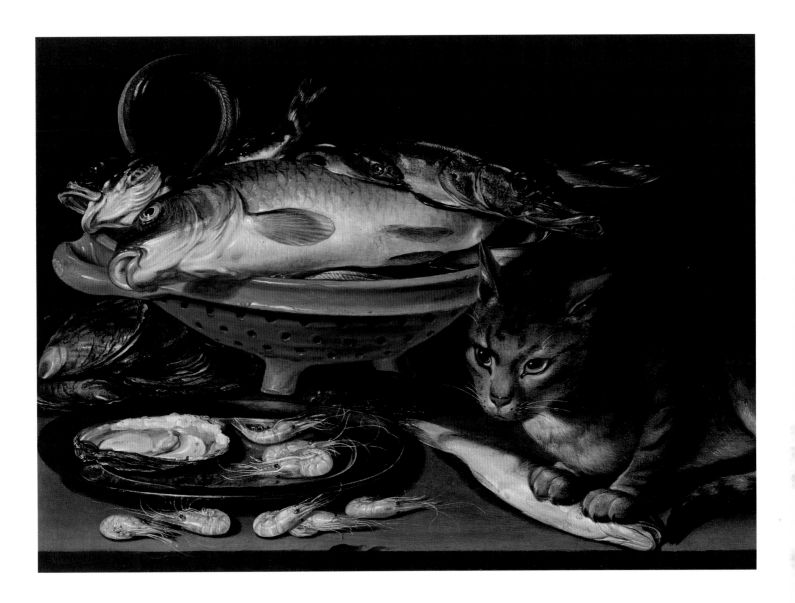

STILL LIFE OF FISH AND CAT

n.d., oil on panel, 13½ × 18½ in. (34.3 × 47 cm.)
Gift of Wallace and Wilhelmina Holladay

Clara Peeters painted several variations on the theme of a live cat with fish and other seafood. This example is typical of her work produced after 1620, featuring simple compositions of relatively humble objects and using a relatively limited palette.[2]

The reddish ceramic colander holds several types of fish, including an eel whose long, slender body forms a prominent loop that adds visual interest to the upper left-hand portion of the painting. Peeters demonstrates great skill in distinguishing among the various textures: slippery fish scales, thickly glazed clay, the cat's fur, and the contrast between the rough shell of the open oyster and the gleaming pewter dish on which it rests. To further show off her technique and to increase the illusion of space within the picture, the artist adds several reflections in the metal salver, plus a number of diagonal elements—notably the small fish on which the cat has firmly planted its front paws and some subtler details, like the two small gouges on the near edge of the wooden table.[3]

Aside from the meticulous descriptions of this array of comestibles, the most arresting element of this piece is the cat—ears pointed back, alert to any potential interloper. Animals from cats to monkeys appear regularly in seventeenth-century Flemish still lifes. However, there may be some symbolism involved here. While fish played an important role in daily life in Northern Europe, cats were not especially well liked because they were considered untrustworthy. Therefore, one writer has suggested that Peeters may have intended for her viewer to play the role of the family cook, catching the mischievous feline just as it is about to snatch its prize.[4]

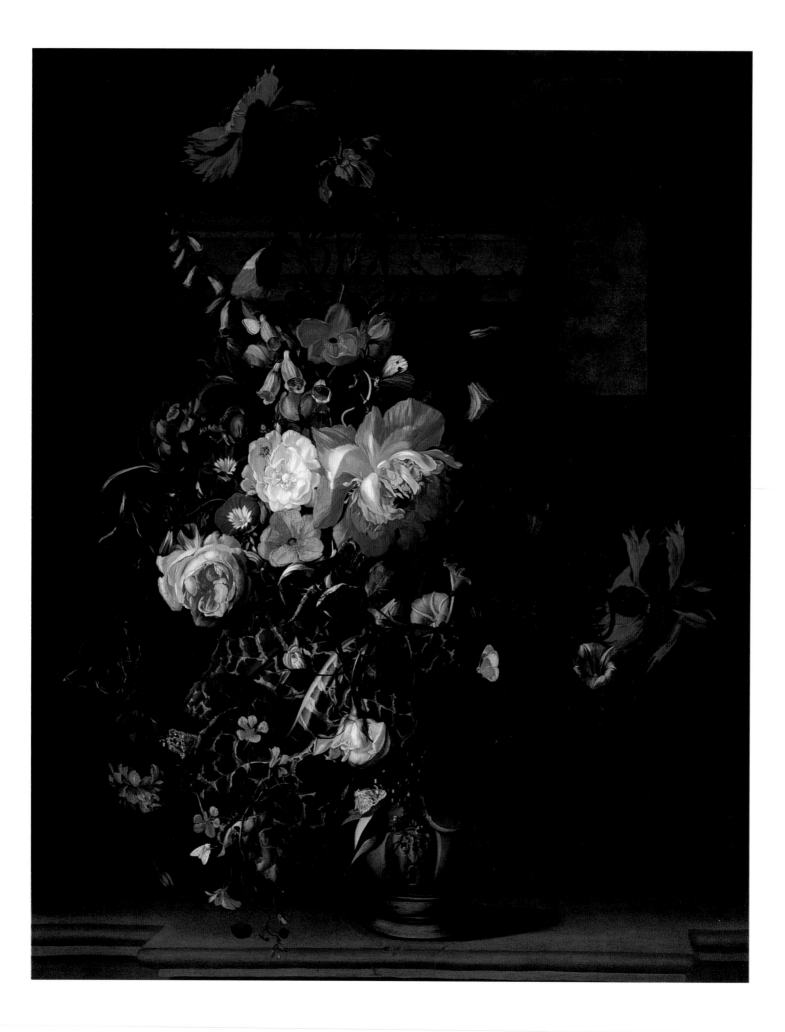

RACHEL RUYSCH

Rachel Ruysch, who has been called the "most celebrated Dutch woman artist of the seventeenth and eighteenth centuries,"[3] was successful for nearly seventy years as a specialist in flower paintings. Born in The Hague, Ruysch moved to Amsterdam with her family when she was three. Her maternal grandfather, Pieter Post, was an important architect and her father, Frederik Ruysch, an eminent scientist from whom she learned how to observe and record nature with great accuracy. In turn, she later taught her father (and her sister, Anna Elisabeth) how to paint.

At fifteen Ruysch was apprenticed to the well-known Dutch flower painter Willem van Aelst. From that point on, she produced various kinds of still lifes, mainly flower pieces and woodland scenes.[4]

In 1701 Ruysch became a member of the painters' guild in The Hague.[5] At that time she began producing large flower pieces for an international circle of patrons. Several years later Ruysch was invited to Düsseldorf to serve as court painter to Johann Wilhelm, the Elector Palatine of Bavaria. She remained there from 1708 until the prince's death in 1716.

After returning to Holland, Ruysch kept painting fruit and flower pictures for a prominent clientele. She remained artistically active, proudly inscribing her age (eighty-three) on a canvas she completed in 1747. Despite the changes in attitude toward flower paintings during the years since her death, Ruysch's reputation has never waned.[6]

ROSES, CONVOLVULUS, POPPIES, AND OTHER FLOWERS IN AN URN ON A STONE LEDGE

ca. 1680s, oil on canvas, 42½ × 33 in. (108 × 84 cm.)
Gift of Wallace and Wilhelmina Holladay

Far more than scientifically accurate descriptions of diverse flora, Rachel Ruysch's flower pieces are exuberant celebrations of color, texture, and form. This dynamic, pyramid-shaped composition derives much of its energy from its asymmetrical arrangement of the blossoms, further accentuated by their wildly curving stems and dramatically spot-lit central section. The dark background reveals a hint of architecture, demonstrating Ruysch's interest in exploring this new trend among flower painters in Amsterdam.[1]

This example is typical of Ruysch's early work made in the late 1680s.[2] Ambitious in scope and large in scale, it stresses variety. Instead of just a few common flowers, Ruysch depicts numerous types, many of which are rare; the blossoms range in hue from delicate shades of lavender to vivid red-orange; their shapes are equally diverse; and some have yet to bloom, while others are past their prime. Ruysch's control of detail is so precise that viewers can virtually count the individual pollen grains inside each open flower. While this painting contains several elements that would also be found in the popular seventeenth-century Dutch picture type known as a *vanitas*, scholars doubt that this was Ruysch's intention. A true *vanitas* painting stresses the brevity of earthly life and the inevitability of death and decay, through such objects as a snuffed-out candle or a worm-eaten fruit. When Ruysch paints insects alighting on the flowers or leaves that are beginning to turn brown, they seem more like a straightforward depiction of reality rather than a moralizing statement on death.

E L I S A B E T T A S I R A N I

ITALIAN, 1638–1665

According to written records when she died at twenty-seven, the Italian artist Elisabetta Sirani had already produced two hundred paintings, drawings, and etchings. An independent painter by nineteen, Sirani ran her family's workshop. When her father became incapacitated by gout, she supported her parents, three siblings, and herself entirely through her art.

Sirani spent her life in Bologna, a city famous for its progressive attitude toward women's rights and for producing successful female artists. Trained by her father, Sirani was encouraged in her career by Count Carlo Cesare Malvasia, a family friend and influential art critic. She quickly became known for her ability to paint beautifully finished canvases so quickly that art lovers visited her studio from far and wide to watch her work. Sirani's portraits, mythological subjects, and especially her images of the Holy Family and the Virgin and Child, gained international fame. Her works were acquired by wealthy, noble, and even royal patrons, including the Grand Duke Cosimo III de Medici.

When Sirani died—suddenly, after experiencing severe stomach pains—her father suspected that she had been poisoned by a jealous maid. The servant was tried for but acquitted of this crime, and an autopsy revealed numerous lacerations in the artist's stomach, presumably evidence of perforated ulcers.

Sirani's funeral was an elaborate affair involving formal orations, special poetry and music, and an enormous catafalque decorated with a life-size sculpture of the deceased. In addition to her substantial oeuvre, Sirani left an important legacy through her teaching. Her pupils included her two sisters, Barbara and Anna Maria, and more than a dozen other young women who became professional painters.

VIRGIN AND CHILD

1663, oil on canvas, 34 × 27½ in. (86.4 × 69.9 cm.)
Gift of Wallace and Wilhelmina Holladay

Elisabetta Sirani's *Virgin and Child* portrays Mary not as a remote queen of heaven but rather as a very real, young Italian mother, wearing the turban favored by Bolognese peasant women, who gazes adoringly at the plump baby wriggling on her lap.[1] There is a great deal of physical contact between the two figures. Mary's long, slender fingers secure the infant's torso as the Christ child playfully leans back into pictorial space to crown her with a garland of roses, which she lowers her head to receive.

Sirani's virtuoso brushwork can be seen clearly in the Virgin's white sleeve, thickly painted to emphasize its rough, homespun texture. There is virtually no ornamentation on Mary's clothing except for the hint of a blue pattern in her headscarf. Indeed, the only other decoration is the gold tassel at the corner of the pillow on which the Christ child is resting. This touch of glitter and the floral garland seem especially noticeable in contrast to Sirani's plain, dark background. The artist has signed and dated this picture, in gold letters, set along the horizontal seam of the pillow.

In her own day Sirani's work was often compared with that of Guido Reni, an extraordinarily popular Italian painter with whom her father had trained. Initially, this identification with a master known for his softly colored, beautiful but sentimental pictures was a definite boon for Sirani's career. By the twentieth century, however, tastes had changed; both Reni's and, by extension, Sirani's work came to be seen as excessively sentimental.

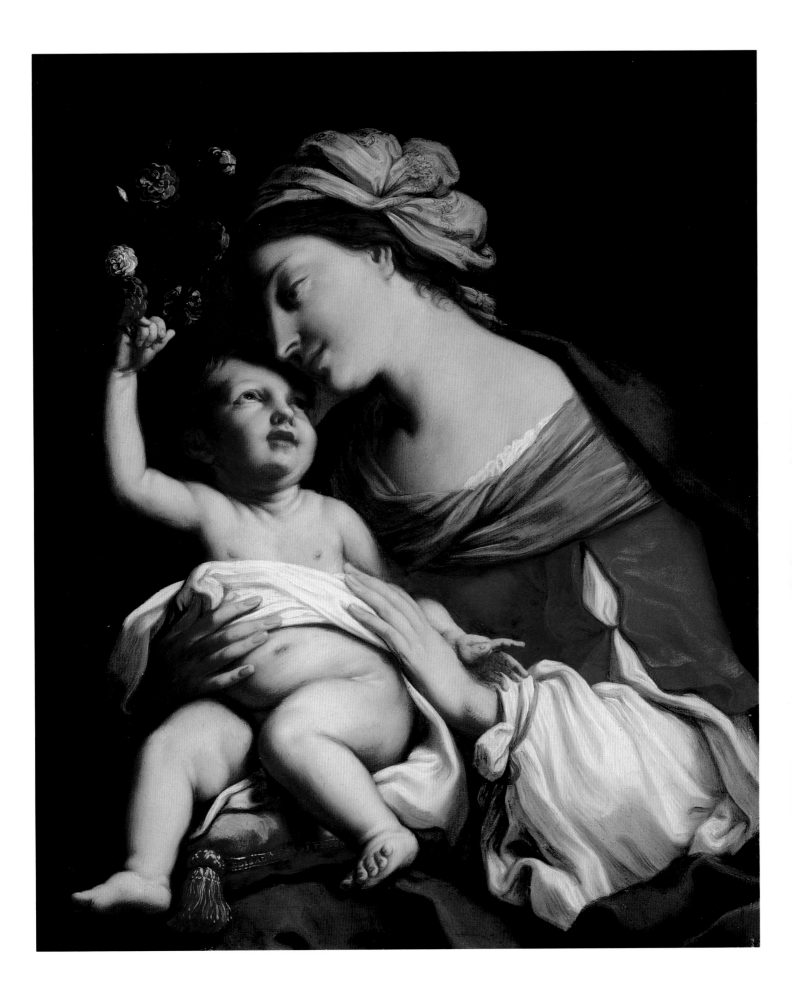

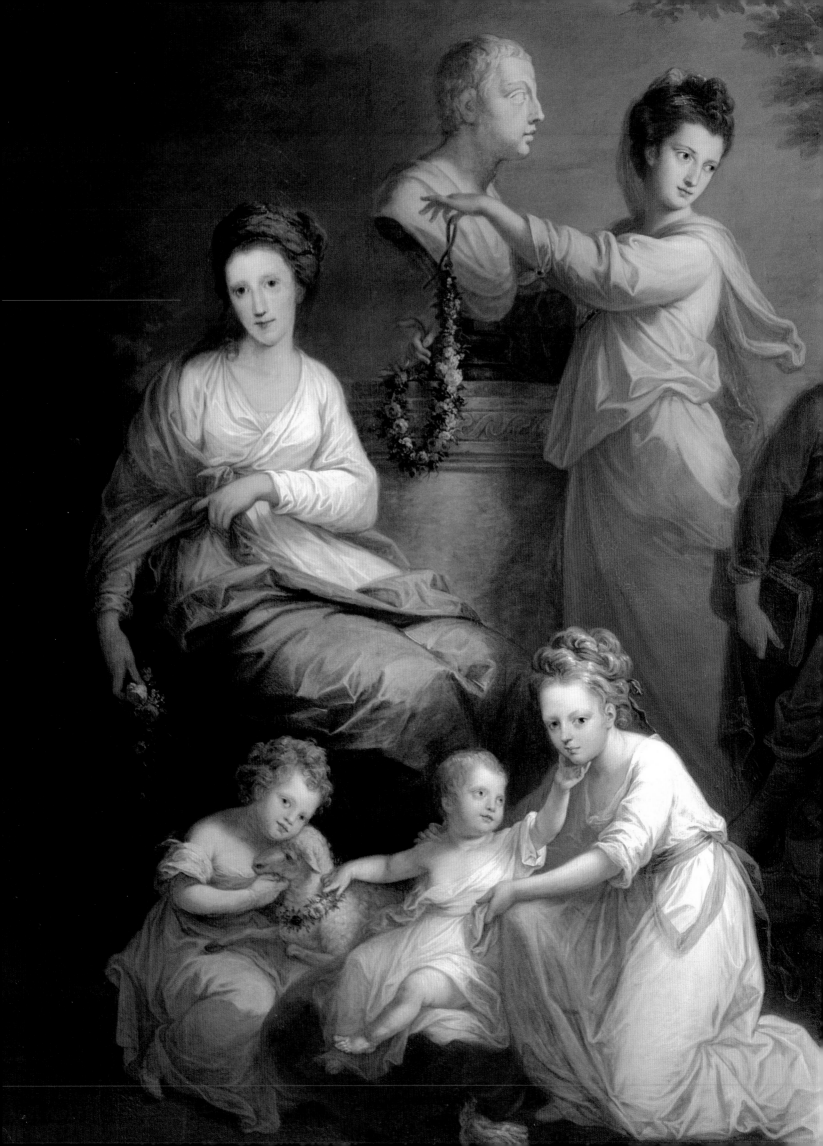

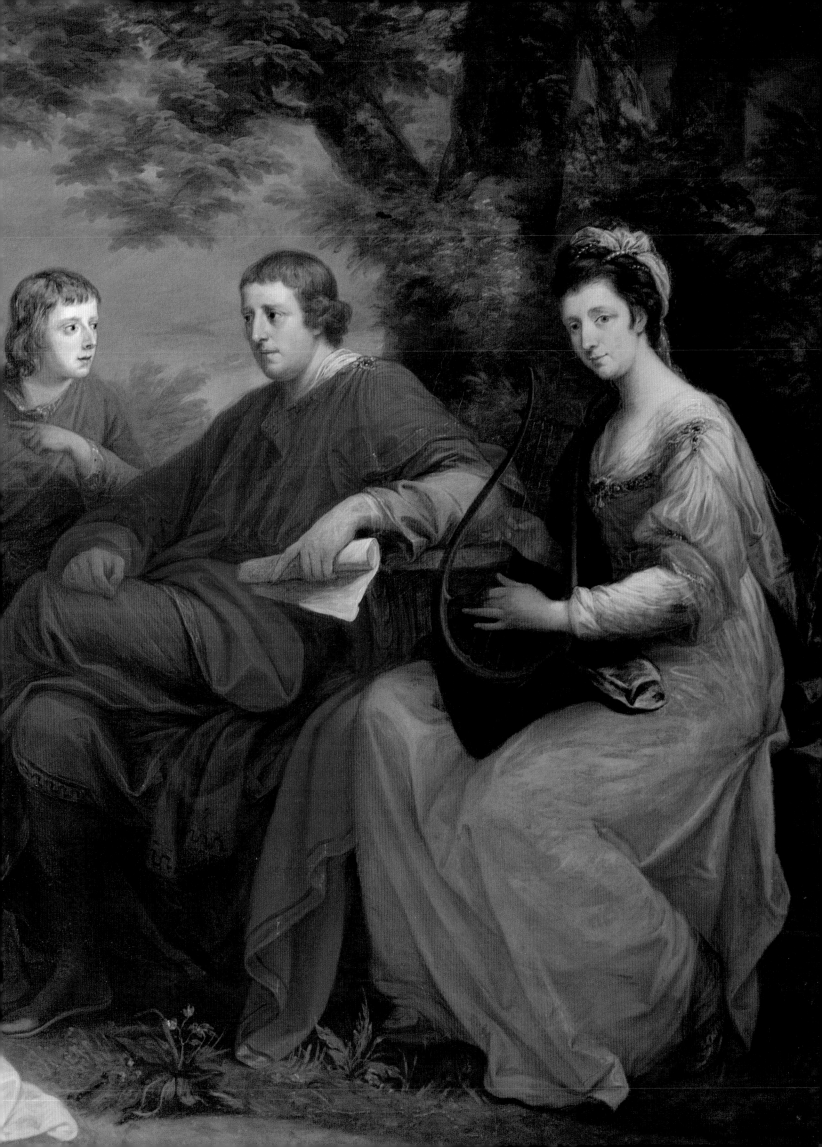

As far as the lives of European women were concerned, the eighteenth century was a period of contradictions. On the surface, women appear to have played prominent roles in many aspects of life during the 1700s, especially in France. This was the age of the *salons*, when socially prominent women held weekly gatherings of France's most important men of letters, arts, and sciences in their well-appointed homes and as a result developed considerable political influence in the outside world. During this period a number of important feminist tracts were published, most notably the *Vindication of the Rights of Woman* (1792) by the British writer and activist Mary Wollstonecraft. In the visual arts, rococo—a style characterized by pastel colors, soft edges, graceful curves, and lavish ornamentation (all traditionally identified as "feminine" traits)—held sway through much of the century.

In retrospect, however, the perceived dominance of women in eighteenth-century Europe was both superficial and impermanent. The influence of the *salonières* was recognized by their male guests, but these otherwise-progressive thinkers of the Enlightenment saw no reason to challenge traditional ideas concerning the inherent inferiority of the female sex when they wrote the books that made them famous;[2] moreover, the *salons* lost most of their cachet after the French Revolution. Well reasoned and impassioned though it was, Wollstonecraft's call for the British government to create a more equitable system for educating women could not compete with the popular theories of Jean-Jacques Rousseau. He argued that since a woman's primary goal was to become a good wife and mother, her education should reflect this fact.[3] Finally, however "feminized" rococo art may seem, most of the artists who produced it were male, women having been systematically denied access to the official schools and exhibition venues that were the standard stepping-stones to professional success in the visual arts.

In the eighteenth century education was still restricted to women from the privileged classes. Even for them, certain fields (notably science and mathematics) were considered inappropriate and thus were accessible only to those well-born few who were persistent and lucky enough to find male experts willing to tutor them.

The situation was not significantly better for women who wanted to become professional artists. By the eighteenth century the major European cities all had their own powerful, state-sponsored academies of art, organized in such a way as to effectively exclude meaningful participation by women. These institutions trained fine artists (painters, sculptors, and architects) in studio practice and theory. The academies also set standards for producing art, put on regular exhibitions, and sponsored competitions.[4]

The centerpiece of an academic education in art—then, as now—was life drawing: drawing from the nude model. Because the model was generally male, it was considered unsuitable for women art students to take life-drawing classes. This restriction effectively prevented all but a few exceptional women from reaching the highest levels of their profession. In addition, women in eighteenth-century France were not allowed to enroll in the Ecole des Beaux-Arts, the rigorous and prestigious government-run School of Fine Arts. They were not eligible to show their work at the Salons, prestigious, government-sponsored exhibitions so called because they were originally held in the *Salon d'Apollon* (Room of Apollo) in the Louvre. Women were also prohibited from competing for the *Prix de Rome*, the most important art prize of the period.

The history of art academy regulations concerning membership for women is long and complicated. Women were generally not admitted to these august bodies at all, or else there were strict quotas placed on their numbers. For example, in 1783 the French Academy decreed that it could have no more than four female members at one time. Even when they were admitted to an academy, women artists enjoyed few of their male compatriots' privileges; female academicians could exhibit in Salons, but they typically could not attend academy meetings or vote.[5]

By the mid-seventeenth century the art academies had adopted a system of hierarchies based on types of subject matter, particularly within the field of painting. Portraits, genre scenes, landscapes, and still-life paintings were considered lower categories because they involved only imitating nature to make a pleasing image. In contrast, the highest form of art was history painting—literally, subjects taken from ancient or modern history, mythology, or literature. History painting was highly valued partly because it was didactic, teaching important moral lessons, and also because it was considered more technically challenging than the other forms. To succeed as a history painter an artist had to have an in-depth knowledge of anatomy and perspective along with the ability to create complex, multifigure compositions. All these skills were normally acquired through life drawing. Because they were barred from such classes, women artists generally specialized in the lesser categories, particularly portraiture and still lifes. The fact that women were unable to enroll in the academies' programs also explains why so many female artists from this period (like those from preceding eras) had fathers, brothers, or husbands who were professional artists and who could give them access to the materials, tools, and training needed to create art.

While it was generally regarded as unnatural for women to become—or even to wish to become—professional visual artists in eighteenth-century Europe, clearly nothing could have been more natural for the women whose works are reproduced in this section. They achieved an extraordinary level of success during their own lifetimes, building international reputations at court and even within the rigid structures of the art academies despite myriad obstacles intended to discourage members of their sex. Moreover, they produced not only portraits but also allegories, genre paintings, and, as seen in one special museum collection, tableware made of silver.

A MAN IS IN GENERAL BETTER
PLEASED WHEN HE HAS A GOOD
DINNER UPON HIS TABLE THAN
WHEN HIS WIFE SPEAKS GREEK.

— SAMUEL JOHNSON [1]

ROSALBA CARRIERA

ITALIAN, 1675–1757

AMERICA

ca. 1730, pastel on paper mounted on canvas
16½ × 13 in. (41.9 × 33 cm.)
Purchased with funds donated by Wallace and
Wilhelmina Holladay

Eighteenth-century Europe recognized four continents: Africa, Asia, Europe, and America (including North and South America, generally depicted as a single land mass).[1] It was common, in illustrations found on the title pages of European atlases published during the seventeenth and eighteenth centuries, to personify the continents, representing each one as a woman identified through details of costume (e.g., a turban for "exotic" Africa) or attribute ("civilized" Europe often holds a scepter). *America* is clearly part of such a set, as indicated by the figure's headband, feathered hair ornament, and quiver of arrows.[2] However, in standard rococo style, Rosalba Carriera has created an image that is fashionable, not ethnologically correct. The headband is made of precious gems, the earrings and hair ornament are obviously European in design, and it is doubtful that the thin, rose-colored strap intended to support both the quiver and the woman's tunic could serve either function.

America's pastel color scheme, soft-edged forms, and flirtatious pink-tinted nipple peeking through her clothes are all typically rococo. What makes this picture unusual is the characteristically informal way in which Carriera has treated her subject. The woman's head is cocked to one side and her expression is quizzical, leading viewers to wonder what she is thinking about. A similar interest in psychological exploration is apparent in many of Carriera's later works. Also noteworthy is the artist's loose, painterly use of the pastels, creating a surface that is at once delicate and lively.

One of the most successful women artists of any era, the Venetian-born Rosalba Carriera spent most of her long life fulfilling commissions for distinguished patrons at courts across eighteenth-century Europe. The daughter of a clerk and a lacemaker, Carriera began her career painting miniatures— mostly portraits and allegorical subjects—which quickly established her reputation within the artistic establishment. Indeed, based on these early works she was accepted into Rome's Academy of St. Luke in 1705. Meanwhile, Carriera was also developing an innovative approach to the medium for which she is best known today: pastels.

At the urging of the prominent French banker and art collector Pierre Crozat, in 1720 Carriera went to Paris, where she spent a triumphant year, visiting important art collections, meeting major French artists, and creating widely celebrated portraits of prominent individuals, including the young Louis XV. Some years later, she spent time working in Modena and Austria, assisted by her sister Giovanna. Carriera's greatest patron was Augustus III of Poland, who sat for her in 1713 and eventually amassed a collection of more than one hundred fifty pastels by the artist, which are currently part of the Dresden Gemäldegalerie.

Although Carriera's last two decades were marred by the emotional and physical traumas of Giovanna's death in 1738 and the loss of her own sight eight years later, her work continued to influence later artists. While pastels had previously been used for making informal drawings and preparatory sketches, Carriera is credited with popularizing their use as a medium for serious portraiture, as can be seen in the work of Georges de la Tour. Her work is also cited as a source of inspiration for the French portraitists Adélaïde Labille-Guiard and Elisabeth-Louise Vigée-Lebrun.

LOUISA COURTAULD

ENGLISH, 1729–1807

The child of a French silk weaver, Louisa Ogier was born in London, where she became one of the most important of the women working in the silver trade. At the age of twenty she married Samuel Courtauld, part of a veritable goldsmithing dynasty.[1] Samuel's father, Augustin Courtauld, had been brought to England as an infant by his Huguenot (French Protestant) family as they fled religious persecution. Interestingly, Augustin was trained by another Huguenot goldsmith: Simon Pantin, whose daughter, Elizabeth Godfrey, also became a prominent goldsmith.

Courtauld and her husband had seven children and, until his death in 1765, they ran a highly successful business. Louisa continued to run the firm on her own. Several years later she took on George Cowles, their senior apprentice, as her business partner. Records show that in 1777 Courtauld's son, Samuel II, replaced Cowles in that capacity. This arrangement lasted three years, at which point they sold the business, Courtauld retired to Essex, and Samuel moved to America.

Courtauld carried on the venerable family tradition of producing high-quality silver. Her continuing success in business was due in part to her ability to change with the times. Courtauld and her husband had made their reputation with silver in the popular French rococo style. However, by the time she began working with Cowles, taste had shifted to the more restrained neoclassical approach, which her firm then produced with equal success.

PAIR OF GEORGE III TEA CADDIES

1766, silver, 7³⁄₈ × 4¹⁄₈ × 4 in. (18.7 × 10.5 × 10.2 cm.) each
Silver collection assembled by Nancy Valentine,
purchased with funds donated by
Mr. and Mrs. Oliver R. Grace and family

Although commonplace today, in the mid-eighteenth century tea was still a rare and valuable commodity in the Western world. The exotic and fashionable hot beverage brewed from tea leaves inspired the creation of a whole host of specially designed containers and utensils, including caddies.[2]

Tea caddies (derived from the Malaysian word *kati*, referring to a unit of measure close to the British pound) are containers used to hold dried tea leaves. They were often made from silver, a material as valuable as the tea itself, and designed as pairs, so that both black and green tea could be offered to guests. For security reasons, tea caddies, and sometimes matching sugar boxes, were typically kept in tea chests, ornate leather-covered cases that could be locked.

Many silver tea caddies from the 1750s are boxlike in form and rococo in style, demonstrating the strong French influence on midcentury English silver. Often they are further decorated with *Chinoiserie* (pseudo-Asian motifs) as a reference to tea's Chinese origin.[3] However, these later examples take the form of vases—a rarer type, more difficult to make. In place of the lavish rococo ornamentation, Courtauld has used just a few decorative elements, mainly drapery swags punctuated by masks, leaving a good deal of smooth, unbroken surface on the bodies of the vessels. The designs on their upper and lower sections—again, restricted to a few narrow bands—are appropriately leaflike. Neoclassical-style tea caddies like these appealed to a change in patrons' taste and remained popular for decades to come.

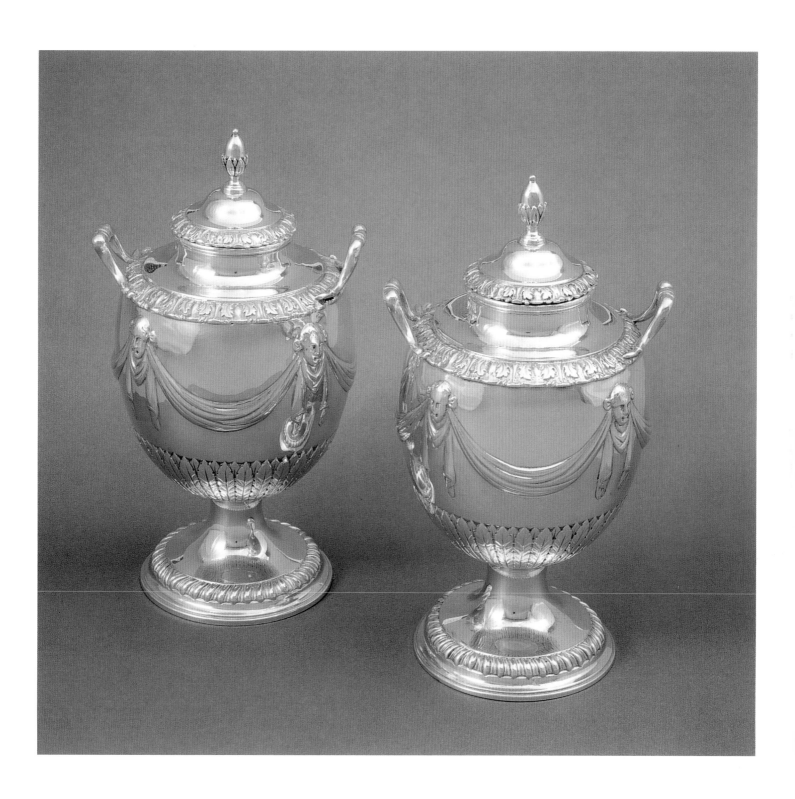

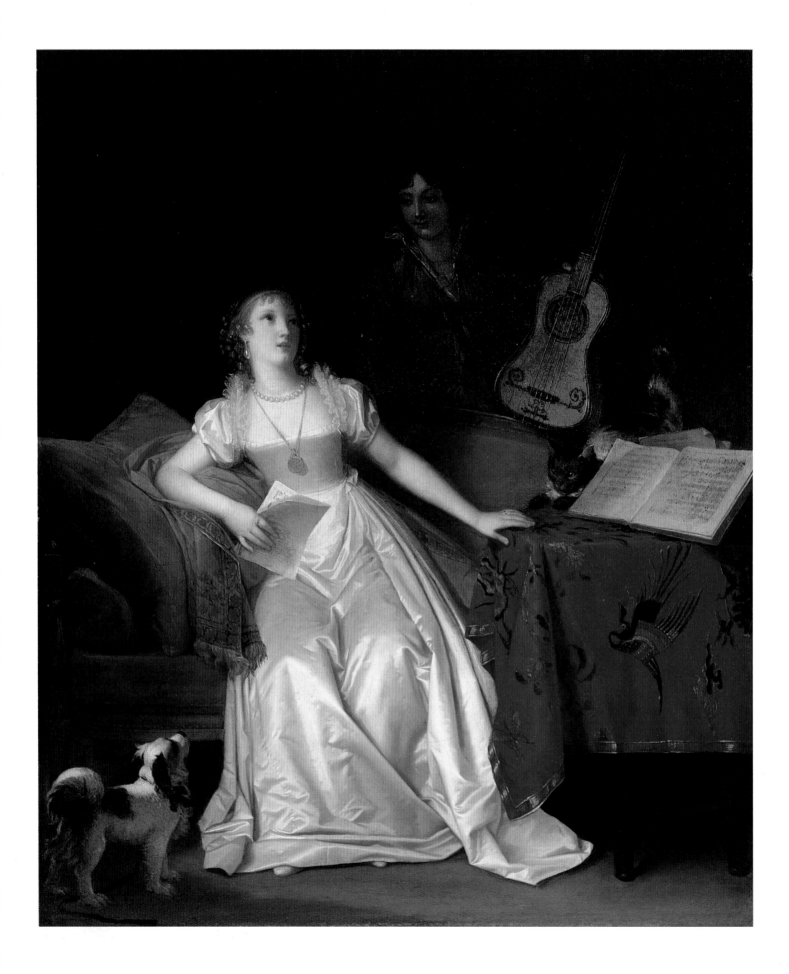

MARGUERITE GÉRARD

FRENCH, 1761–1837

PRELUDE TO A CONCERT

ca. 1810, oil on canvas, 22¼ × 18¾ in. (56.5 × 47.6 cm.)
Gift of Wallace and Wilhelmina Holladay

By the early 1780s Marguerite Gérard was producing numerous paintings of well-to-do women making music—taking instrumental lessons or, as here, rehearsing for an informal concert. On one level, such scenes, inspired by seventeenth-century Dutch models, simply acknowledge the fact that marriageable young ladies of the time were expected to acquire a certain degree of accomplishment in the various social arts, music chief among them. However, recent scholarship has emphasized the traditional link between painted images of music making and physical love. Here, for example, the female singer—clad in the same sumptuous white satin gown worn by many of Gérard's other female subjects—pauses to look up, her expression (and her body language) seeming to signify surprise, perhaps in response to a romantic overture from her male accompanist, standing behind the sofa.[1]

Other erotic overtones may also be symbolized by the contrast between the small dog (a traditional emblem of fidelity) standing alert at the left beside the singer, and the cat (often used to represent sexual promiscuity), eyes bright and tail upraised, apparently ready to pounce from the other side of the painting. Moreover, the guitar has often been compared to the female form. This particular instrument is typical of European guitars from the eighteenth and nineteenth centuries. Smaller than the modern guitar, it has a flat bottom, a decorative rosette set into the sound hole, and only five (versus the now common six) strings.[2]

Although she also produced oil portraits, portrait miniatures, and etchings, Marguerite Gérard is best known for her intimate domestic genre scenes. In the hierarchy of subject types in eighteenth-century France, such paintings ranked higher than portraits or still lifes but considerably lower than history paintings. Yet Gérard, who was something of a rebel (she never married and apparently never demonstrated any interest in joining the Academy), was tremendously successful in her career, which lasted more than forty years. Gérard won three medals for her work, which she exhibited regularly once the Salons were opened to women in the 1790s; her pictures were acquired by such luminaries as Napoleon and King Louis XVII; she also acquired considerable wealth and real estate.

Gérard was born in the Provençal town of Grasse. Her interest in art was shaped by her brother-in-law, the popular rococo painter Jean-Honoré Fragonard, beginning in 1775, when she moved to Paris to live with her sister's family. As part of the Fragonard household, Gérard had considerable financial freedom, along with the opportunity to further her artistic training as her brother-in-law's unofficial apprentice.

By her mid-twenties Gérard had developed her signature style, which featured painstakingly accurate details rendered with subtly blended brush strokes, both traits borrowed from seventeenth-century Dutch genre specialists, notably Gabriel Metsu. Gérard's work is not only technically impressive but also practical: these relatively small-scale, portable canvases were designed to appeal to wealthy collectors who preferred to display in their homes meticulously painted still lifes and genre scenes rather than large history paintings. The numerous engraved versions of Gérard's paintings made them accessible to less affluent art lovers and helped increase her reputation.

ELIZABETH GODFREY

ENGLISH, ACTIVE CA. 1720-1758

Recognized today as "the most outstanding woman goldsmith of her generation,"[1] Elizabeth Godfrey was the daughter of the distinguished silversmith Simon Pantin, in whose London workshop she presumably was trained.

In mid-eighteenth-century London, the term *silversmith* generally referred to the artisan or manufacturer of precious metal objects. *Goldsmith*, on the other hand, encompassed a wide range of individuals, including silversmiths but also master artists who ran their own workshops producing silverware, as well as retailers who sold—but might not be involved in the making of—such objects.[2] Elizabeth Godfrey was successful on many of these levels. One of her trade cards (elaborately engraved versions of today's business cards) bills her as "Goldsmith, Silversmith, and Jeweller, [who] makes and sells all sorts of plates, jewels, and watches, in the newest taste at the most reasonable rates." Known for the high quality and sophisticated style of the silver produced under her name, Godfrey enjoyed the patronage of many members of the nobility, most notably the Duke of Cumberland.

Godfrey married, in succession, two men who were themselves active London silversmiths, and with whom she shared thriving businesses. She wed Abraham Buteux in 1720; he died eleven years later, and Godfrey continued to run the firm alone. She then married Benjamin Godfrey, who had probably been in her employ. After his death in 1741, she continued to head the business for nearly two decades more.

PAIR OF GEORGE II SAUCE BOATS

1750, silver, 6⅛ × 8¼ × 4⅜ in. (15.6 × 21 × 11.1 cm.) each
Gift of Faith Corcoran

Wealthy families in eighteenth-century England regularly sat down to elaborate, multicourse dinners that required numerous silver pieces, from marrow scoops to cake baskets, for proper service and consumption. Jennifer Faulds Goldsborough notes that meat at this time was often preserved by salting or smoking, which rendered it too highly flavored to eat without a variety of neutralizing sauces. Hence the need for sauce boats, produced either in pairs or in larger sets.[3]

This pair of sauce boats is exceptionally elegant. Made in the shape of seashells, each is ornamented with additional marine motifs. The repetition of various curving lines and decorations gives these pieces a sense of fluidity and grace, further emphasized by the intricate, petallike designs on their solid bases—quite a departure from the three-legged supports of most contemporary sauce boats. These qualities demonstrate the strong influence of French rococo style on mid-eighteenth-century English silver and may also owe something to Godfrey's Huguenot (French Protestant) heritage. The importance of these works is shown by the fact that Godfrey includes a virtually identical sauce boat on one of her trade cards. Godfrey's mark here consists of her initials enclosed within a lozenge, the traditional heraldic sign for a widow.

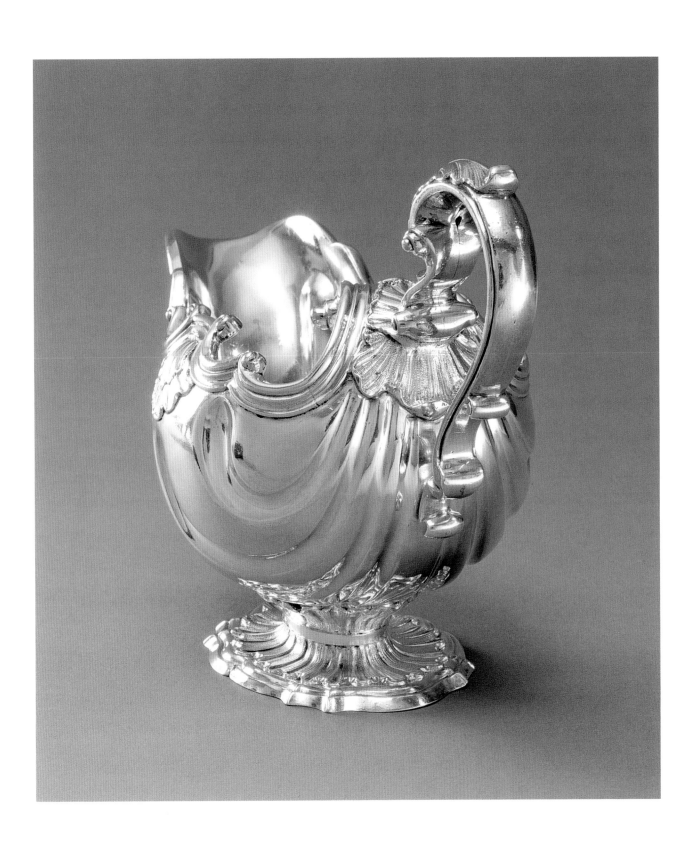

ANGELICA KAUFFMAN

SWISS, 1741–1807

She was a founding member of the British Royal Academy, one of London's most sought-after portraitists, and, by 1787, "the most famous and most successful living painter in Rome."[1] These are just a few of the accomplishments of the Swiss-born artist Angelica Kauffman.

A child prodigy who was producing commissioned portraits in her early teens, Kauffman was trained by her father, the Swiss muralist Johann Joseph Kauffman. During the early 1760s Angelica Kauffman traveled through Switzerland, Austria, and Italy, working as her father's assistant. Thus, she had the rare opportunity for a woman to see and copy many works of ancient and Renaissance masters and to meet leaders of the popular new movement known as neoclassicism.

During a three-year stay in Italy Kauffman made her reputation as a painter of portraits; she also produced history paintings. Recognition of her accomplishments is indicated by her election to Rome's Academy of St. Luke in 1765. In 1766 Kauffman moved to London, where she achieved immediate success as a portraitist. Over the next sixteen years she exhibited regularly at the prestigious Royal Academy and worked for a glittering array of aristocratic and royal patrons. A brief marriage to a man claiming to be the Count of Horn was annulled in 1768. Although this unfortunate experience could easily have derailed her career, Kauffman remained a prolific and highly successful artist.

In 1781 Kauffman married the painter Antonio Zucchi, who succeeded her father as her business manager. One year later the couple settled permanently in Rome, where Kauffman's studio became

a focal point for that city's cultural life. By the time of her death she had achieved such renown that her funeral was directed by the prominent neoclassical sculptor Antonio Canova, who based it on the funeral of the Renaissance master Raphael.

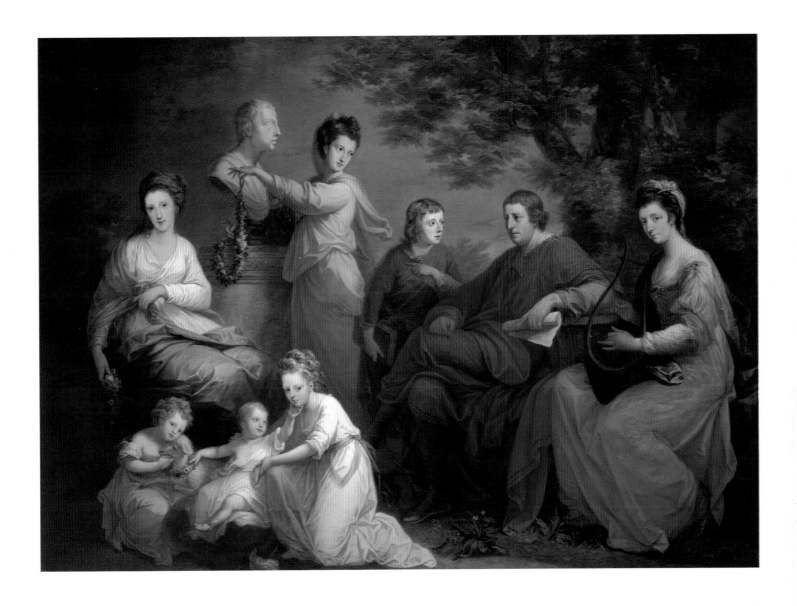

THE FAMILY OF THE EARL OF GOWER

1772, oil on canvas, 59¼ × 82 in. (150.5 × 208.3 cm.)
Gift of Wallace and Wilhelmina Holladay

The Family of the Earl of Gower is an excellent example of Angelica Kauffman's skill in handling complex, multifigure compositions and her tendency to give contemporary scenes a classical tone.

The earl (later, marquess of Stafford)[2] is the patriarch of this clan, gathered in a parklike setting and equipped with all manner of antique-style accoutrements—classically inspired costumes, a lyre, a scroll, floral garlands, a marble bust. The statue may represent the earl, his father, or a figure from antiquity.[3] On the earl's left sits his third wife, Susannah;

on his right is his fourteen-year-old son and heir, George Granville. The woman in a rose-colored tunic is his daughter Caroline. Seated at the base of the bust is Louisa; the three younger daughters are Anne, kneeling in a white dress with a blue sash; the infant Charlotte Sophia; and Georgiana Augusta, who is caressing a lamb (a symbol of innocence).

Kauffman has arranged all the figures here in a typically neoclassical manner: set within a narrow space, close and parallel to the picture plane. Other characteristics of this style are the painting's large size and the fact that the artist has borrowed many of the poses from antique statuary. She has also unified the eight disparate figures through their gestures, which lead the viewer's eye around from one family member to another.

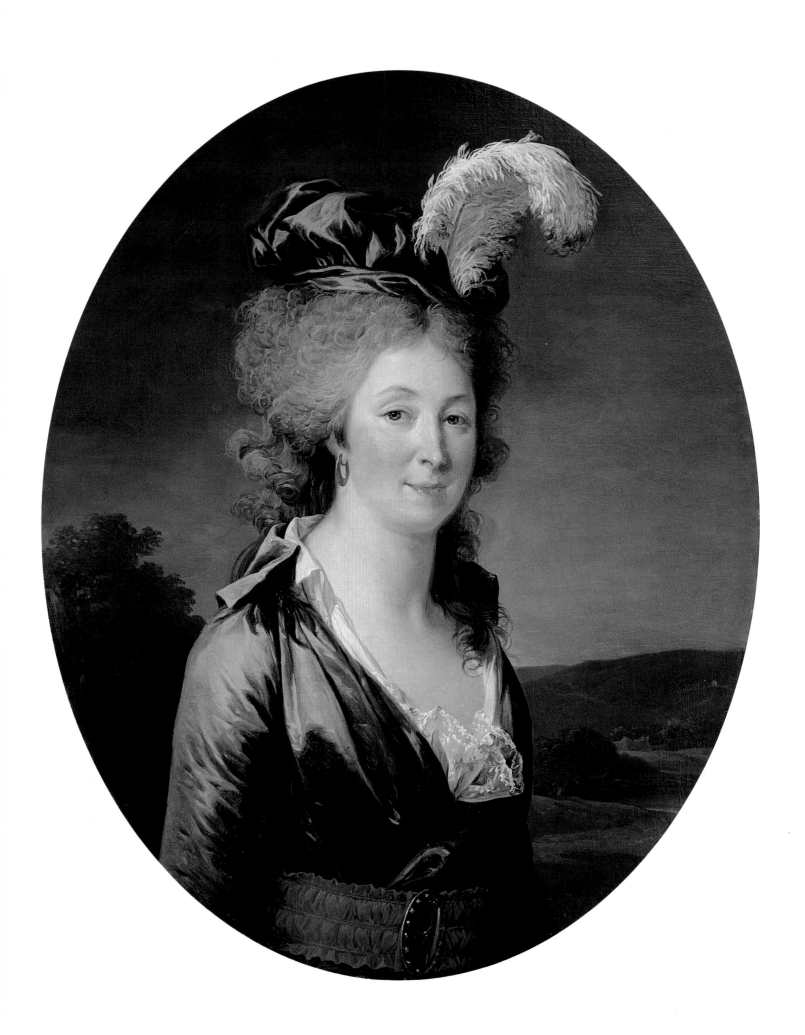

ADÉLAÏDE LABILLE-GUIARD

FRENCH, 1749–1803

PRESUMED PORTRAIT OF THE MARQUISE DE LAFAYETTE

ca. 1790–91, oil on canvas
30¾ × 24¾ in. (78.1 × 62.9 cm.)
On loan from the Wallace and
Wilhelmina Holladay Collection

In her earlier portraits of French nobility, Adélaïde Labille-Guiard had proven herself adept at rendering intricate details of elaborate clothing, furniture, and architecture. In *Presumed Portrait of the Marquise de Lafayette*, however, the artist demonstrates how effective an image she can create using a minimal number of elements. In 1774 Adrienne de Noailles, member of a powerful family of French aristocrats, had married the marquis de Lafayette. This portrait, presumed to depict her, was most likely painted in 1790. By that time the marquise's husband had already become well known in both French and American politics.

Appropriately, Labille-Guiard's sitter wears a simple dress of the type favored by women during the early years of the French Revolution. She wears no ornate jewelry. She is not posed in an elaborate architectural setting, and even the landscape behind the marquise is relatively restrained in keeping with the simplicity of her apparel and her pose. Her somewhat tentative smile emphasizes the sitter's physical attractiveness without unduly flattering her.

Because of her husband's affiliation with the French monarch, the marquise was arrested and imprisoned and narrowly escaped the guillotine (which her mother, sister, and grandmother did not). In 1795 the marquise voluntarily joined her husband in jail, bringing their two daughters with her. The family members were released in 1797 and retired to their home at Château La Grange, near Paris.

Several books have been devoted to the life story of Adrienne de Noailles, marquise de Lafayette, focusing on her remarkable strength of character, bravery, and self-discipline. Through a combination of hard work, political lobbying, and clever business sense, she is credited with having restored the family's fortune and properties seized during the revolution.[1]

The youngest of eight children born to a Parisian haberdasher and his wife, Adélaïde Labille-Guiard was receiving praise for her skillfully crafted portraits by her early twenties. Despite periods of financial distress, an unhappy first marriage (and subsequent divorce), and the inevitable comparisons with her younger, more socially prominent fellow painter Elisabeth-Louise Vigée-Lebrun, this talented and ambitious artist remained dedicated to building a successful career. She worked for numerous royal and aristocratic patrons, won admission to the French Royal Academy in 1783, and was ultimately awarded the title *peintre des mesdames* (painter to the king's aunts), a government pension, and an apartment at the Louvre.

Labille-Guiard worked with several accomplished teachers, learning how to make miniature portraits and work with pastels. She also studied oil painting with François-André Vincent, whom she married in 1800. Labille-Guiard herself became an influential teacher, known for her devotion to her female pupils, many of whom went on to establish their own careers as painters.

A lifelong champion of women's rights, Labille-Guiard worked toward reforming the Academy's policies toward women. Unlike Vigée-Lebrun, she supported the French Revolution and remained in Paris during this tumultuous era, winning new patrons and creating portraits of several deputies of the National Assembly. Although she also produced some history paintings, it was with her carefully crafted portraits that Labille-Guiard made her mark.

MARIANNE LOIR

FRENCH, ACTIVE 1737–1779

The French portrait painter Marianne Loir was born into a family with an impressive artistic pedigree. Although her father, Nicolas Loir, was not an artist, the Loirs had been active Parisian silversmiths since the seventeenth century. Moreover, her brother Alexis Loir III was a highly regarded pastellist and sculptor, also specializing in portraiture, who was based in Paris but who lived and worked as well in England, Russia, and southwestern France.[1]

Unfortunately, little is known about Marianne Loir's life. She was trained by a distinguished French academic painter, Jean-François de Troy, and may have spent some time in Rome. This seems especially likely between the mid-1730s and 1740s, when there is no record of any artistic activity by her in Paris, and when her teacher served as director of the Académie de France in Rome.

Scholars theorize that, like her brother, Marianne Loir may also have lived for a time in the south of France. This theory is based on records of portraits she painted during the 1720s for patrons in Pau and the fact that she was elected to the Academy of Marseilles in 1762. The ten dated portraits that have been securely attributed to her demonstrate that Loir was an extremely skillful painter of her wealthy and generally aristocratic clients. While sacrificing none of the usual eighteenth-century emphasis on details of elaborate clothing, Loir also manages to convey an intriguing sense of her sitters' personalities.

PORTRAIT OF MADAME GEOFFRIN

n.d., oil on canvas, 39½ × 32¼ in. (100.3 × 81.9 cm.)
Gift of Wallace and Wilhelmina Holladay

Marie Thérèse Geoffrin was a particularly famous Parisian *salonière*. On Mondays she held an artistic *salon* attended by such luminaries as the architect Jacques-Germain Soufflot and the painter François Boucher; Wednesdays were reserved for her literary *salon*, where the guest list regularly included Voltaire, Diderot, and Montesquieu.[2]

The ease with which Madame Geoffrin sits (in the standard three-quarter-length pose) and the graceful gesture of her free hand suggest that this woman is indeed perfectly comfortable socializing with the greatest minds of eighteenth-century France. To emphasize further the importance of her sitter, Loir has gone to great pains to convey the sumptuousness of the lady's costume. She carefully picks out each detail of the complicated pattern in her satin dress and in the pearls decorating Madame Geoffrin's hair and fur-trimmed red cloak. The artist seems equally at home with richer, more painterly passages, such as the folds of that cloak, as it falls over the sitter's shoulders and hips. Especially impressive is Loir's treatment of the *salonière*'s delicate striped veil, which cascades down her back. The dark monochrome interior and glimpses of a heavy brocaded chair are standard for this period. What sets this portrait apart from other contemporary examples is Loir's obvious refusal to idealize her subject beyond recognition. Although she is an attractive and thoughtful woman, the soft flesh under Madame Geoffrin's chin hints at the onset of middle age, a detail most fashionable male and female portraitists would undoubtedly have omitted.[3]

ELISABETH-LOUISE VIGÉE-LEBRUN

FRENCH, 1755-1842

PORTRAIT OF PRINCESS BELOZERSKY

1798, oil on canvas, 31 × 26¼ in. (78.7 × 66.7 cm.)
Gift of Rita M. Cushman
in memory of George A. Rentschler

Elisabeth-Louise Vigée-Lebrun was widely known for flattering her sitters, and this canvas is no exception. However attractive Princess Belozersky may actually have been, the artist's decision to paint her with a faint smile on her moist lips, her dark curly hair slightly tousled, and her two-tone shawl (which matches the fringed head wrap) trailing to the side greatly enhances the subject's beauty.

Princess Anne Grigorieva Belosselsky Belozersky was the younger of two daughters of Gregory Vassilievitch Kozitsky, secretary of state to Catherine II.[1] At the time this portrait was executed, during Vigée-Lebrun's St. Petersburg sojourn, the princess was twenty-six years old. A wealthy heiress, six years earlier she had married the prominent diplomat Prince Alexandre Mikhailovitch Belosselsky. The couple had three children and entertained in a home famous for its fashionable décor.

Nevertheless, the artist has chosen to downplay the trappings of her sitter's life, placing the princess before a plain brown background. She wears a simple, long-sleeved, high-waisted dress of the color and type favored by Vigée-Lebrun for both her own wardrobe and the costumes in which she dressed her female subjects. The princess wears very little jewelry, only a pair of gold and amber earrings and a necklace that is faintly visible beneath the diaphanous white scarf covering her throat. According to one scholar, Vigée-Lebrun has wound the princess's shawl around her hands—as though it were a muff—to indicate that she lives in a cold climate.[2]

At the age of fifteen, the Parisian painter Elisabeth-Louise Vigée-Lebrun was earning enough money from her portrait painting to support herself, her widowed mother, and her younger brother. For a decade she was Marie Antoinette's favorite painter; European aristocrats, actors, and writers were also her patrons; and she was elected a member of the art academies in ten cities.

Trained by her father, the portraitist Louis Vigée, she joined Paris's Academy of Saint Luke at nineteen. Two years later she married Jean-Baptiste-Pierre Lebrun, a painter and art dealer who helped her gain valuable access to the art world.[3] Blessed with an ability to please even the most demanding sitters, Vigée-Lebrun soon came to the attention of the French queen, who in 1783 appointed her a member of Paris's powerful Royal Academy.[4] As one of only four female academicians, Vigée-Lebrun enjoyed a high artistic, social, and political profile—too high, once

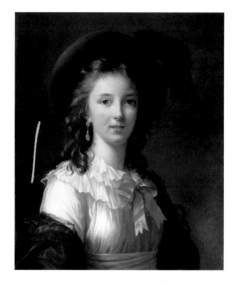

the French Revolution came, forcing her to flee the country with her nine-year-old daughter.

During the next twelve years the artist was commissioned to create portraits of the most celebrated residents of Rome, Vienna, St. Petersburg, Moscow, and Berlin. After brief, highly successful stays in England and Switzerland, Vigée-Lebrun returned to France for good in 1809 and divided the last thirty-three years of her life between her Paris residence, where she held glittering *salons*, and her country house at Louveciennes. Scholars estimate that Vigée-Lebrun produced more than six hundred paintings; her memoirs, originally published in 1835–37, have been translated and reprinted numerous times.[5]

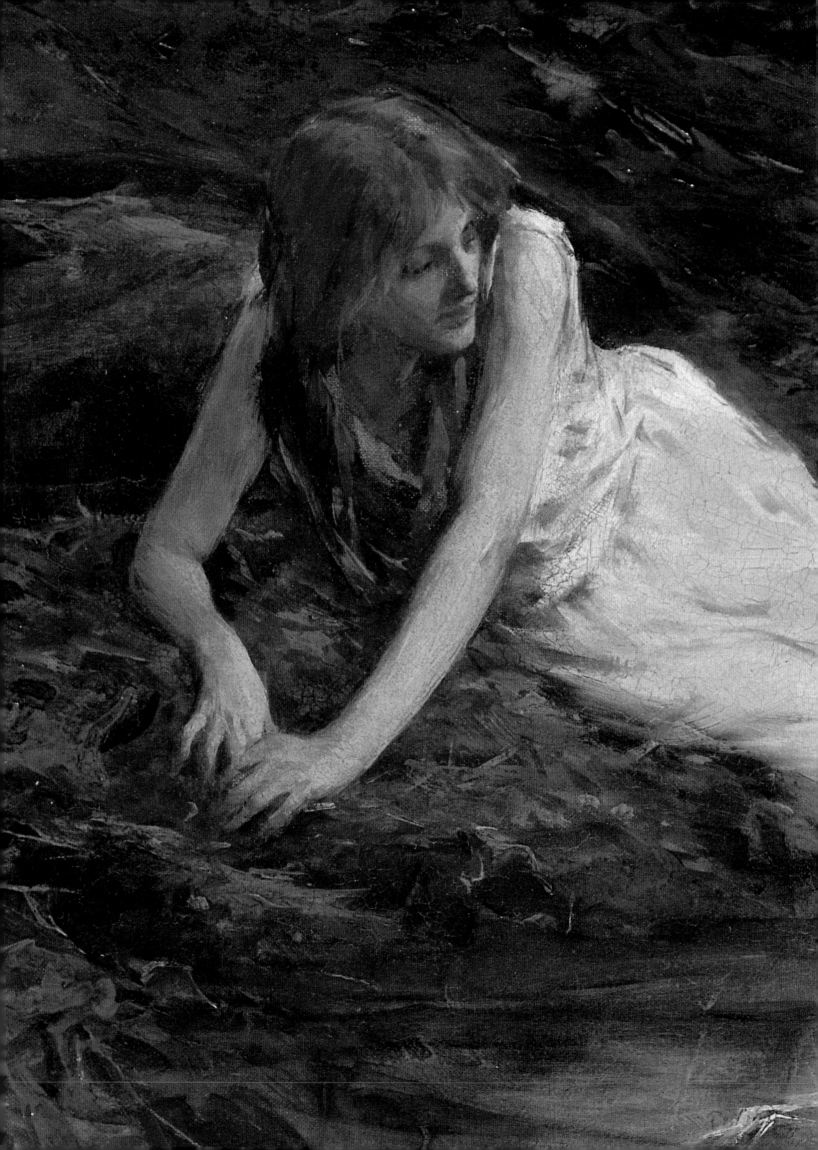

19TH-CENTURY EUROPE

The nineteenth century was regarded as "the greatest period of female social progress in history."[2] A marked increase in industrialization and urbanization, the explosion of the middle class, progressive legislation, new developments in science and medicine, and the growth of the women's rights movement combined to produce an atmosphere that was simultaneously liberating and restrictive for women living in Western Europe and the United States.[3] It comes as no surprise, then, that England and France produced an exceptionally large number of successful women artists during the 1800s.

For middle- and upper-class English women interested in becoming professional artists, the early decades of the nineteenth century offered essentially the same obstacles as earlier eras. Upper-class Victorian women were expected to acquire a limited degree of artistic skill as a hobby or "accomplishment," but their work was seldom taken seriously and it was still difficult for them to receive high-level artistic training.[4] Fortunately, many women artists discovered creative ways to circumvent these obstacles. Moreover, by midcentury the situation had begun to improve. In England, for example, in addition to a number of economic and social reforms—including the Divorce Act of 1857 and the Married Women's Property Act of 1870—educational reform led to the establishment of separate, government-sponsored design schools for women. While these were meant primarily for instruction in the so-called applied arts (subjects useful for middle-class women planning to become teachers or governesses), their curricula also included basic instruction in painting, drawing, and sculpture. This provided a foundation on which women, who had not been allowed to enroll in the more prestigious and rigorous, government-sponsored European art academies, could develop their professional skills, supplementing design school courses with private classes from respected master artists and additional guidance from relatives.[5]

The most significant progress in terms of English women artists occurred during the second half of the century. Women were permitted to study at the schools of the British Royal Academy starting in 1860 (although they could not attend life classes there until 1893), and London's Slade School of Fine Art, which opened its doors in 1871, admitted women from the beginning. Female English artists of the late nineteenth century enjoyed the benefits of a society in which there were more women journalists writing about art and more male journalists willing to deal fairly with art by women. Toward the century's end more owners of prominent galleries handled women's art and more collectors were interested in acquiring it. This was also the era in which the first major public sculptures by women artists were erected in England and their work began to be acquired by important public institutions. While they continued finding success with subjects that had traditionally been considered acceptable for their sex, late Victorian women artists also branched out into a number of esoteric specialties. The most remarkable of these are undoubtedly the enormous battle scenes painted by Elizabeth Butler.

Despite London's importance as a cultural milieu, Paris dominated the fine arts throughout the nineteenth century. Many artists, male and female alike, came from England and other countries to study in Paris. In this highly competitive atmosphere, prestige came largely from an artist's relationship with the official, government-sponsored Ecole des Beaux-Arts—from which women were banned until 1897. Therefore, as in England, nineteenth-century French female artists relied on a combination of private classes and, secondarily, on design school courses for their education. Fortunately, women artists were able to display their work at the important annual exhibition known as the Paris Salon. Also, the enormous increase in public commissions and the new-found enthusiasm for collecting art that were inspired by Napoleon III's desire for visual propaganda opened up new opportunities for women artists.

As in England, the 1860s marked the beginning of

significant progress for French women artists. In 1868 a tremendously influential school, the Académie Julian, began offering classes for both women and men. This school's commitment to training female students is clearly demonstrated by the large number of French and foreign alumnae who had their works selected for display at the Salon.[6] It was also in France that the first international congress on women's rights was held, in 1878. In 1881 a sculptor, Madame Léon Bertaux, founded the Union des Femmes Peintres et Sculpteurs, Paris's first professional organization for women artists; nine years later its members established their own journal, the *Gazette des Femmes*, further increasing their voice within the art community.[7]

During the last three decades of the nineteenth century, French art was created in an unusually broad range of styles, from academic to avant-garde. Many of the newer approaches, such as impressionism—with its emphasis on everyday, domestic subject matter—seemed particularly well suited to female artists. The late 1800s in France were also marked by a proliferation of art dealers sympathetic to the work of women artists, alternative exhibition venues, and the acceptance of female students by other important art schools, notably the Académie Colarossi.

Ironically, relatively little of the painting, sculpture, or other types of visual art produced in Europe by women or men during the nineteenth century reflects the progress that was made in terms of women's lives. Most nineteenth-century European paintings, sculptures, and prints that feature female subjects tend to reinforce the stereotype of the ideal woman. These women are depicted almost exclusively as doting mothers and loyal wives, often portrayed in a decorative and sentimental manner. Despite the widespread belief that sculpture was a field ill suited to the feminine physique and psychology, a significant number of nineteenth-century European women developed successful careers as sculptors.

Although they faced numerous restrictions throughout most of the 1800s, by the century's end European women artists had achieved great success and unprecedented visibility. The seven women discussed in this section are both typical and impressive in that six of them regularly displayed their work at the Paris Salon.[8] Most were also represented in at least one of the major international exhibitions held at the century's end, notably the Exposition Universelle (Paris, 1889) and the World's Columbian Exposition (Chicago, 1893). Given Europe's dominance in the arts, the symbolic importance of having these women's work on view at such influential venues—where they shared space with art made by their American female counterparts—cannot be overestimated.

WOMAN MUST CONFINE HERSELF TO THOSE SUBJECTS WHICH ARE ALLIED TO HER SPHERE ... CHILDREN, ANIMALS, FRUIT, FLOWERS, ETC. BUT WHEN A WOMAN DESIRES TO PAINT LARGE-SIZED PICTURES, SHE IS ... LOST.

— MARIE-ÉLISABETH BOULANGER CAVÉ[1]

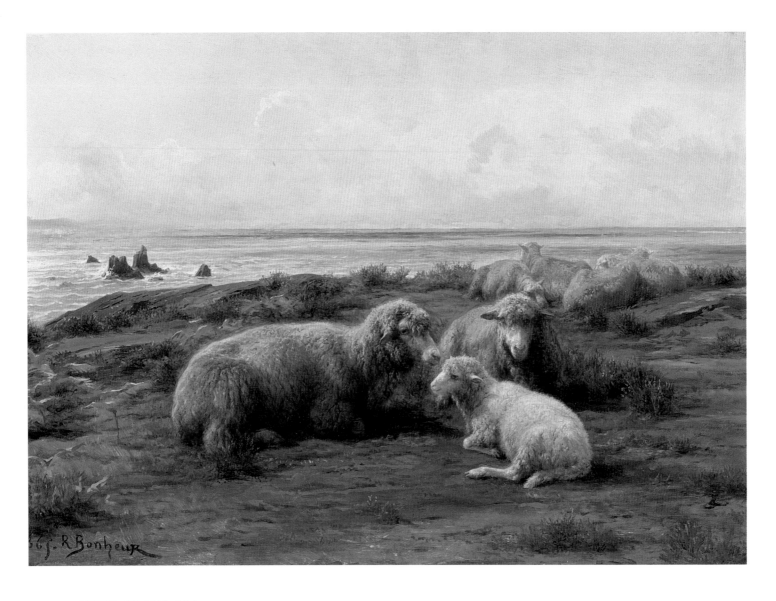

SHEEP BY THE SEA

1865, oil on panel, 12¾ × 18 in. (32.4 × 45.7 cm.)
Gift of Wallace and Wilhelmina Holladay

Sheep by the Sea is based on Rosa Bonheur's travels through the Scottish Highlands in the summer of 1855. In painting this complacent flock of sheep settled in a meadow near a body of water, Bonheur has captured the placidity of the moment. The thickly applied, textured paint conveys the lushness of this verdant landscape at the water's edge. *Sheep by the Sea* demonstrates the artist's commitment to direct observation from nature; the informality of this rustic scene belies the detailed physiognomic studies of animals that Bonheur frequently sketched before executing a work in oil paint.

The empress of France, Eugénie, commissioned *Sheep by the Sea*, although it was exhibited at the Salon of 1867 before it entered the princess's collection. The empress (like her contemporary, Queen Victoria)

also patronized the renowned British artist Sir Edwin Landseer, whose sentimentalized paintings of domestic animals became popular among the upper classes in England and France. Yet, unlike Landseer's animals, which overtly play out and convey human dramas, Bonheur depicted animals within their natural habitat, not subjected to human laws and emotions.

Because many of her works are ostensibly straightforward depictions of the animal kingdom, historically they have invited a wide variety of interpretations. The English writer and artist John Ruskin criticized Bonheur for "shrinking" from the challenge of painting the human face. Others have taken the position that she created paintings of animals as "metaphors for the human predicament." More recent scholarship has asserted that Bonheur found a means of expressing her own personal frustrations with social convention by painting animals free of such constraints, subject to and guided only by the laws of nature.[1]

ROSA BONHEUR

FRENCH, 1822–1899

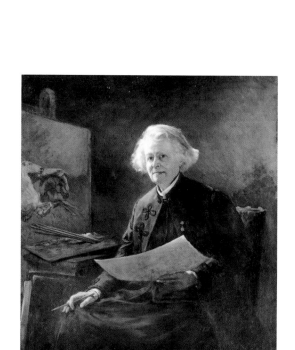

"At one time Rosa Bonheur had a complete menagerie in her home: a lion and lioness, a stag, a wild sheep, a gazelle, horses, etc. One of her pets was a young lion whom she allowed to run about and often romped with.... I was easier in mind when this leonine pet gave up the ghost."[2] So wrote a close friend of Rosa Bonheur in recalling the artist's passion for animals. The artist received special dispensation from the police to wear trousers and a smock to visit butcher shops and slaughterhouses. It was in these gritty locales that she closely studied animal anatomy. Bonheur also wore her hair short, rode astride, smoked cigarettes in public, and achieved a successful career as an *animalier*, demonstrating her independent spirit.

Born in Bordeaux, Rosa Bonheur received her earliest training from her father, Raymond, a minor landscape painter, who encouraged his daughter's interest in depicting animals. In 1829 she moved with her family to Paris, where her mother died four years later. Raymond Bonheur's adherence to the teachings of Henri de Saint-Simon, a rationalist and moralist whose theories questioned traditional gender divisions in labor, created a domestic atmosphere of unqualified support in which Rosa Bonheur thrived.

While unconventional in her ambitions and personal conduct, Bonheur was traditional in her working method. She studied her subjects carefully and produced many preparatory sketches before she applied paint to canvas. The artist and dramatist Henri Cain would later recall that she "was not only an exceedingly intelligent artist, but a very conscientious and hard-working one.... She believed in honesty in art and ever desired to keep very close to nature."[3] Bonheur's reputation grew steadily in the 1840s; she regularly exhibited her animal paintings and sculptures at the Paris Salon from 1841 to 1853. The Salon favored traditional work, and most artists sought to exhibit at the annual shows as it was the primary way for their work to be publicly seen. In 1845 Bonheur won a third prize and in 1848 a gold medal.

Because of this official recognition, the government of the Second Republic awarded Bonheur a commission. The resulting painting, *Plowing in Nivernais* (Musée Nationale du Château de Fontainebleau), exhibited at the Salon of 1849, firmly established the artist's career. She later won international acclaim with her monumental painting *The Horse Fair* (Metropolitan Museum of Art, New York), shown at the Salon of 1853. In 1865 Empress Eugénie visited Bonheur at her studio in the forest of Fontainebleau to award her the cross of the Legion of Honor; after *The Horse Fair* was exhibited in England, Queen Victoria ordered a private viewing of it at Windsor Castle. Bonheur left a legacy as a nineteenth-century woman who achieved a successful career and would serve as a role model for future generations of women artists. —JP

CAMILLE CLAUDEL

FRENCH, 1864–1943

As a young woman, Camille Claudel was recognized for both her artistic talent and her physical beauty; nevertheless, she spent most of her adult life as a recluse. Much attention has been focused on Claudel's relationship with her teacher, mentor, and lover, Auguste Rodin. Her complex personal drama has brought her prominence through scholarly and popular accounts. Yet it was first and foremost her unrivaled ability to convey narrative through marble and bronze that attracted patrons and critical accolades.

Born in Fère-en-Tardenois, Aisne, Claudel moved with her family to Paris around 1881. She studied sculpture at the Académie Colarossi, one of the few art academies in France open to female students. Along with other sculptors, she also shared an independent studio where Alfred Boucher taught. In 1883 Boucher won a Prix de Rome and departed for Italy; he asked Rodin to serve as adviser to Claudel and her colleagues in his stead.

Two years later, Rodin asked Claudel to become a studio assistant. By working as Rodin's apprentice, Claudel had the chance to study the nude figure, an unusual opportunity for a woman in the nineteenth century, but one that gave the artist a profound understanding of anatomical nuances. Claudel modeled hands and feet for Rodin's *Burghers of Calais* and posed for figures in his *Gates of Hell*.

In 1893, because Rodin's work and stature occupied front stage in French culture, Claudel secluded herself in her studio to disassociate herself from him and to try to establish her own reputation.[1] Her love for portraying the human form resulted in certain sculptures that the state and an infuriated press censored as overly sensual and inappropriate for public display. These circumstances may have contributed to the decline of her career and her mental state. In 1913 Claudel was committed to a mental asylum, where she remained until her death thirty years later.

YOUNG GIRL WITH A SHEAF

ca. 1890, bronze, 14⅛ × 7 × 7½ in. (35.9 × 17.8 × 19 cm.)
Gift of Wallace and Wilhelmina Holladay

Young Girl with a Sheaf depicts a seated young woman leaning against a sheaf of wheat. Camille Claudel has emphasized the firmness of her flesh against the foil of a roughly modeled background. The figure's head twists toward the right, while she draws her right arm close to her body and crosses her knees, denying an overt sexuality and instead emphasizing her modesty. Such a pose invites the viewer to regard the sculpture from different angles, while allowing Claudel to capture the tension that underlies this awkward stance.

By specializing in small-scale sculpture, Claudel developed a following of private collectors and produced multiple editions to meet the demand for her work. For example, she produced several versions of *Young Girl with a Sheaf*, including one in terra cotta and a series of twelve cast in bronze (this example is the eighth). Claudel gained renown for exercising direct control over the process of casting her sculptures in bronze—thus emphasizing the technical aspect of the artist's hand—rather than following the traditional workshop system of relinquishing the clay model to specialized technicians.[2] —JP

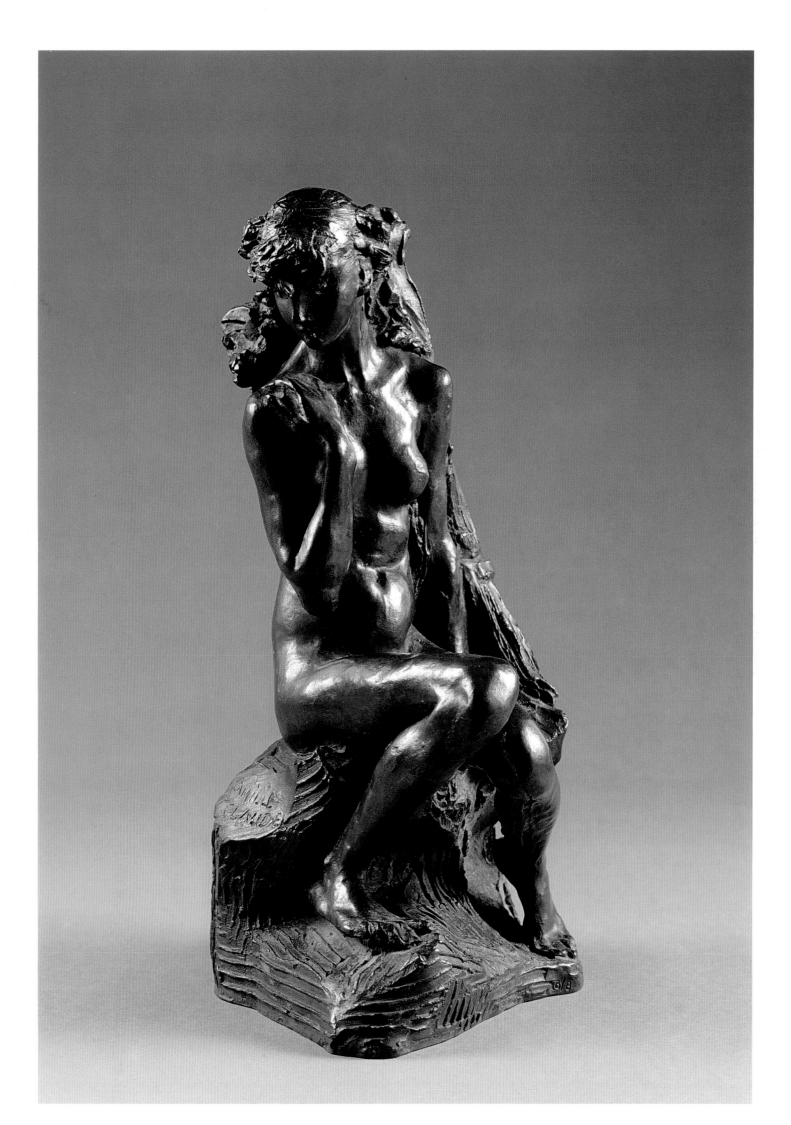

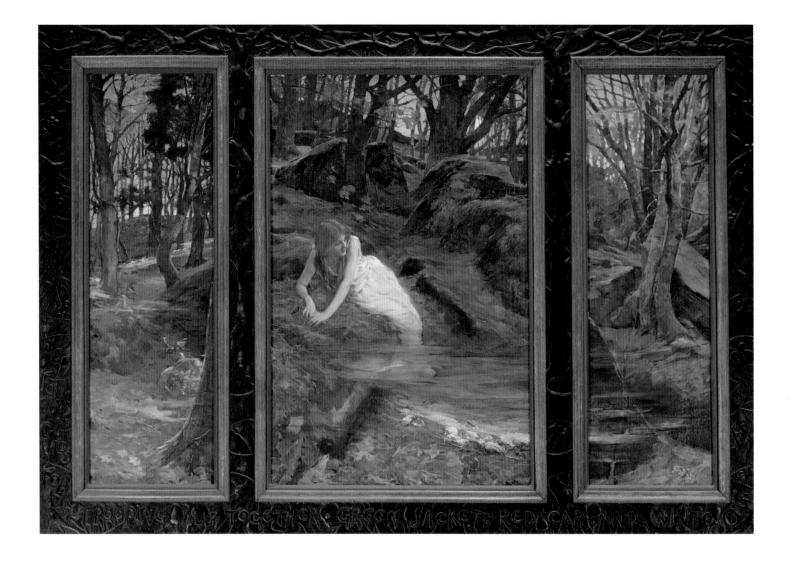

WILL-O'-THE-WISP

ca. 1900, oil on canvas, 27 × 44 in. (68.6 × 111.8 cm.)
On loan from the Wallace and
Wilhelmina Holladay Collection

Based on the richly symbolic poem *The Fairies* by the Irish poet William Allingham, Elizabeth Forbes's *Will-o'-the-Wisp* depicts the story of Bridget, who was stolen by the "wee folk" and brought up to the mountains for seven years. When Bridget returned to her village, she found that her friends were all gone.

Set in autumn with bare trees silhouetted against a moonlit sky, the triptych's dark rocks, swirling mist, and eerie glow in the sky convey a mystical quality to this scene featuring Bridget, the "stolen child . . . dead with sorrow . . . on a bed of flag leaves." In the left panel of the painting, little forest denizens, who in Irish legends often entice young girls with sensory pleasures, troop through the forest.

Will-o'-the-Wisp displays the tenets of the Newlyn Art School in its meticulous portrayal of natural detail. Yet the painting's mythical world shares characteristics with late Pre-Raphaelite works, as does the elaborately hand-wrought oak frame that incorporates sheets of copper embossed with intertwined branches imitating the painted tree limbs. Lines from Allingham's poem inscribed along the sides and bottom of the frame allude to the centuries-old philosophical dialogue between the relative artistic merits of painting versus poetry.

Will-o'-the-Wisp may have been commissioned by a private collector. Its unusual three-panel format suggests that it was created for a specific location, perhaps over a large mantel.

ELIZABETH ADELA ARMSTRONG FORBES

CANADIAN, 1859–1912

Elizabeth Forbes was born in Kingston, in the province of Ontario, Canada. As a young girl, she studied drawing and, at age ten, moved to England with her mother. Around age sixteen, Forbes enrolled at the South Kensington Schools, but her father's death required Forbes and her mother to return to Canada soon after.

Forbes moved to New York City, where she studied at the Art Students League. She continued her art training again in Europe, studying in Munich in 1881, where she discovered that "it was not at all a place in which women stood any chance of developing their artistic powers."[1] In 1882 Forbes and her mother moved to Pont-Aven in Brittany, where she began to experiment with plein-air painting, which would play an important role in her oeuvre for the rest of her life. Moving back to London in 1883, Forbes developed her talent as a printmaker and was elected to the Society of Painter Etchers the same year.

Forbes had established herself as a professional artist by 1885, when she settled in the English town of Newlyn, near Penzance, where she met the painter Stanhope Alexander Forbes, whom she married in 1889. Newlyn, with its picturesque cottages and colorful inhabitants, had been a popular destination for artists (and tourists in general) since the early 1880s. The Forbeses opened the Newlyn Art School in 1899 and based their teachings on the premise that artists should paint from nature. Yet despite being a cofounder of the school, Elizabeth Forbes struggled against the perception that women should not work alone outside unchaperoned.[2] As a result, Forbes turned her attention to painting children, an endeavor at which she excelled but which was also deemed acceptable subject matter for women.

Forbes exhibited at the Royal Academy and the Royal Institute of Painters in Watercolours. She won a gold medal in oil painting in 1893 at the World's Columbian Exposition in Chicago. She also wrote poetry, edited the magazine *The Paperchase*, and wrote and illustrated a children's book, *King Arthur's Wood*, published in 1904. —*JP*

ELIZABETH JANE GARDNER (BOUGUEREAU)

AMERICAN, 1837–1922

Elizabeth Jane Gardner was among the first wave of Americans who sought art training in Paris after the Civil War. Gardner's paintings were accepted into twenty-five of the Paris Salons and at the Exposition Universelle, where she won a bronze medal in 1889.

Born in Exeter, New Hampshire, Gardner received training in the arts typical of well-bred women. Educated at the Lasell Female Seminary in New Hampshire, where she learned "drawing from

outline cards and dabbing water colors or slavishly copying," Gardner decided to join the artistic migration to Paris in 1864 to study contemporary as well as old-master paintings.

While Paris beckoned all artists, women were barred from studying at the prestigious Ecole des Beaux-Arts. Undaunted by such discriminatory practices, Gardner enrolled in private classes. In 1868 she experienced her first success at the Salon, with the judges choosing two of her paintings to hang "in full view among the accepted." Gardner commented that such recognition gave her "a position among foreign artists and raises the value of what I paint," demonstrating her determination not only to be a painter but also to be a competitive artist whose works would fetch a good price.[1] In 1877 she began her tutelage with William-Adolphe Bouguereau, whose love of rich color and portrayals of children as well as mythological and domestic scenes met with wide public acclaim.

Religious, historical, and mythological subject matter dominated Gardner's oeuvre in the early part of her career. She acknowledged that her work was strongly influenced by Bouguereau (to whom she became engaged in 1879 but did not marry until 1896), confiding in her sister Maria that Bouguereau "is ambitious for me as well as I for myself. As it is I can't help working very much like him." As an ambitious painter, she made her own way by producing works in a monumental style and of a subject matter that was most often associated with male artists. As a late-nineteenth-century woman artist engaged to a better-established painter, Gardner also stands out for her stated desire to maintain her freedom to "paint by myself a while longer" to attain independently the success for which she strived.[2]

THE SHEPHERD DAVID

1895, oil on canvas, 60½ × 41⅜ in. (153.7 × 105.1 cm.)
Gift of Wallace and Wilhelmina Holladay

The subject matter of *The Shepherd David* is based on the First Book of Samuel, chapter 17, verse 34, in which David, to prove his worthiness to fight Goliath, recounts to Saul that as a shepherd he would fight wild beasts that threatened his flock. When a lion or bear would steal a lamb, David would intrepidly chase it down and slay it if it turned on him. In *The Shepherd David*, Elizabeth Jane Gardner depicts a young David kneeling victoriously on a dead lion while clutching a lamb in the crook of his right arm. He gesticulates with his left hand as he gazes up toward the heavens, pointing to the source of his strength. Gardner's portrayal of David holding the young creature also alludes to his biblical place as a direct ancestor of Christ, whose sacrificial role is symbolized by the lamb.

The monumental composition and David's pose reflect Gardner's familiarity with old-master paintings and classical sculpture. David's marmoreal skin set against a background of muted blues and earth tones further contributes to this representation as an otherworldly being. The polished surface of the work, which Gardner achieved through the use of a smooth, unbroken brush stroke, conveys the idea that this is a historic moment frozen in time.

Writing to her sister Maria in 1895 about *The Shepherd David*, Gardner boasted that the painting would soon grace a full page in the art dealer Albert Goupil's publication on the best pictures of the year. Gardner also recognized that producing this work was not a "good paying investment," as it might be too "serious for ordinary tastes" and would be better suited for a museum.[3] —JP

EVA GONZALÈS

FRENCH, 1849–1883

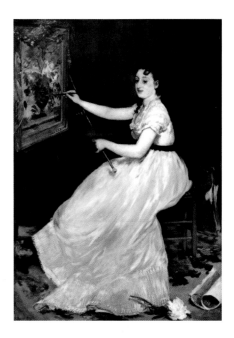

PORTRAIT OF A WOMAN IN WHITE

1873–74, oil on canvas, 39½ × 31 in. (100.3 × 78.7 cm.)
On loan from the Wallace and
Wilhelmina Holladay Collection

Although one of Eva Gonzalès's most formal paintings from this period, *Portrait of a Woman in White* reflects a radical application of paint in broad, unblended strokes. The lack of academic finish, especially visible in the unidentified woman's dress, draws attention to the process of painting and, by association, to the hand of the artist herself. In rejecting a flawless, polished approach in favor of emphasizing the brush stroke, Gonzalès lends a sense of warmth and immediacy to this portrait that conveys the sitter's personality.

Gonzalès has placed the sitter within an intimate setting that in feeling does not match the elegance of her dress. Depicted before a decorative paneled screen and pillows in muted colors, she demurely folds her hands in her lap, holding a pair of gloves. A blue ribbon adorning her square décolleté, a pink flower at her waist, and a green pillow behind the woman provide the only bright accents in this composition of muted tones and luminous whites. Despite the visible, tactile applications of paint, Gonzalès meticulously describes the sitter's dress, defining its lacy flounces and cuffs as well as her feathered hat, which frames her head like an illuminated halo against the somber background.

When Edouard Manet depicted his student Eva Gonzalès, he showed her before an easel in the act of painting. Taking pride in his pupil, Manet encouraged Gonzalès to submit her own work to annual Paris Salons. Manet's strong presence in the Parisian art world and the controversy that surrounded his work overshadowed the efforts of his student, who spent a great deal of her professional life attempting to distinguish herself from her teacher. Nevertheless, with the submission in 1874 of the monumental painting *Une Loge aux Théâtre des Italiens*—a work that was rejected for its "masculine vigor"—Gonzalès demonstrated that she was willing to break traditional gender barriers.[1]

Both Eva and her sister, Jeanne, were supported by their parents in their pursuit of artistic careers, even though their elevated position in society did not encourage professionalism for women. A daughter of Emmanuel Gonzalès, a well-established French novelist and journalist, Eva Gonzalès grew up in Paris surrounded by literary and artistic luminaries. On the advice of the publisher Philippe Jourde, Gonzalès at the age of sixteen began her artistic training under Charles Chaplin, a painter to fashionable society. Around 1869 Gonzalès began studying and working in Manet's studio.

Because of Manet's controversial reputation, Gonzalès listed herself as a student of Chaplin's at her first Salon exhibition in 1870, where she showed *The Little Soldier*. Gonzalès's painting owes a debt to Manet's earlier work, *Fife Player*, but turns his radical two-dimensional figure back into a fully volumetric one. Despite these efforts to distance herself from her teacher, critics immediately homed in on Gonzalès's association with Manet and chastised the young artist for following his unorthodox painting principles. It would not be until the late 1870s, when Gonzalès departed from Manet's Spanish style, with its somber palette and dramatically lit figures, that her work would gain acclaim. Although Gonzalès never exhibited with the impressionists, she emulated their innovative sketchy brush strokes and brilliant palette and shared their interest in the effect of light on color. It was also undoubtedly these qualities that attracted her to the use of pastel, a medium in which she excelled and gained a devoted following.　　*—JP*

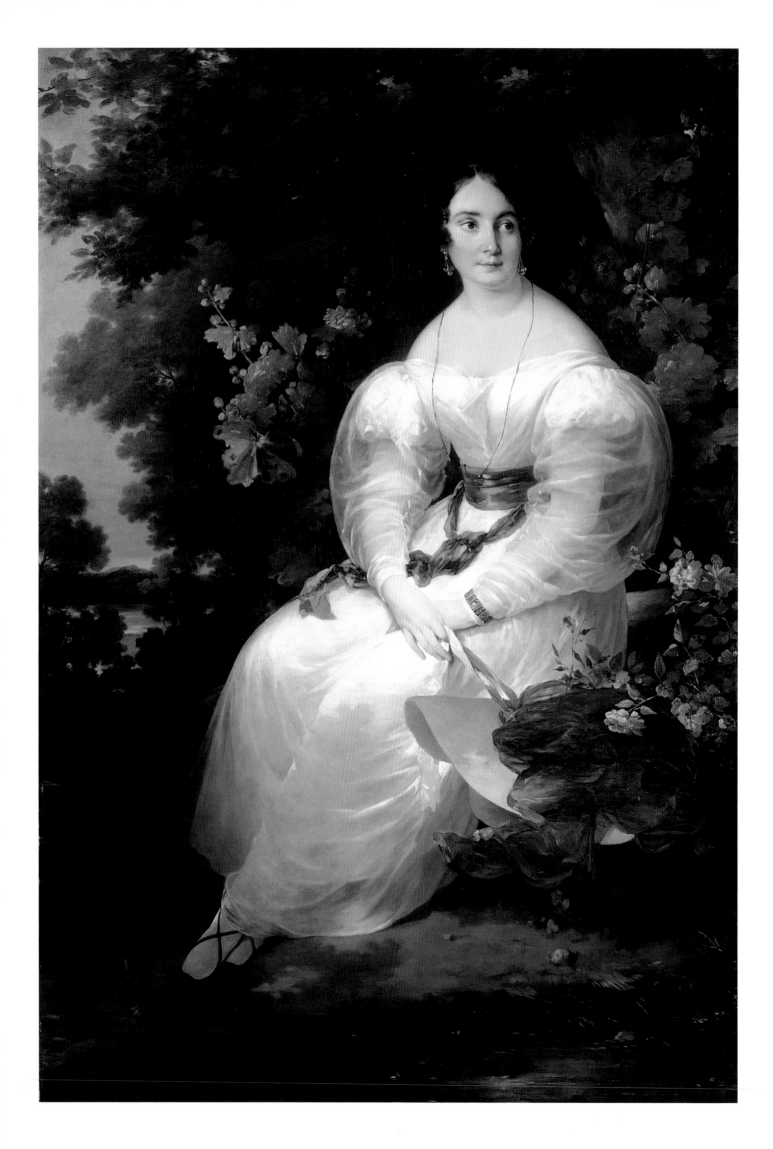

ANTOINETTE-CÉCILE-HORTENSE HAUDEBOURT-LESCOT

FRENCH, 1784–1845

YOUNG WOMAN SEATED IN THE SHADE OF A TREE

ca. 1830, oil on canvas, 67 × 45½ in. (170.2 × 115.6 cm.)
On loan from the Wallace and
Wilhelmina Holladay Collection

In the early nineteenth-century, most women painters specialized in still life, portraiture, and genre painting, the lowest categories of subject matter in the academic hierarchy. Women were barred from studying the nude model, which was considered the prerequisite for painting biblical, mythological, and historical works. Despite these expectations and re-strictions, Haudebourt-Lescot produced large-scale history paintings for which she received adverse criticism. As *Young Woman Seated in the Shade of a Tree* attests, Haudebourt-Lescot welcomed the op-portunity to paint on a large scale.

An unusual size for a portrait, *Young Woman Seated in the Shade of a Tree* must have hung in a principal room of an important house. Draped in a white gauzy gown, with skin as pale as alabaster, the unidentified seated woman presents a striking contrast to the au-tumnal colors of the flowering tree behind her. A body of water provides a distant focal point, while the river in the foreground serves as a barrier between the sitter and the viewer. The thickly impastoed sur-face of the canvas (especially evident in the woman's sleeves and bracelet) and the artist's attention to the rustic surroundings impart a sense of ease to this oth-erwise formidable portrait.

With this painting, Haudebourt-Lescot departs from the traditional posed studio portrait, instead depict-ing the sitter as if she were taking a respite from a stroll in the garden. The woman sits casually on a rock, her feet crossed, and a bonnet hanging by her side. Her gaze to an unseen point in the distance denies the viewer's presence, furthering the illusion that she is alone amidst nature.

Antoinette-Cécile-Hortense Haudebourt-Lescot achieved a degree of recognition in her lifetime that was highly unusual for female artists. Her paintings were so popular that they were copied and dis-seminated in numerous engravings. Although many of the original works no longer exist, the prints testify to her widespread fame and the breadth of her production.

Born in Paris, Haudebourt-Lescot began studying at age seven with the history painter Guillaume Lethière, who in 1807 was appointed director of the Académie de France in Rome. The next year, the budding artist followed her instructor to Italy. She remained there for eight years, observing the popular customs and sketching the col-orful peasant clothing that ap-pears in many of her paintings. Haudebourt-Lescot's depictions of peasants and peasant life re-flected a continental-wide trend to portray an unspoiled past of inno-cence and simplicity at a time when industrialization and urbanization were quickly supplanting the rural agricultural past.

Whereas travel to Italy to study and copy art was considered essen-tial for male artists, Haudebourt-Lescot's sojourn in Italy was highly unusual even for a woman who aspired to professionalism. Unlike other artists, she seems to have been less interested in emulating heroic works of the past. Haudebourt-Lescot has been called the inventor of Italian genre themes that focus on the daily lives of women.[1]

Living in Italy did not impede her ability or desire to establish her-self in the highly competitive Parisian art world. From Rome she sub-mitted eight scenes of Italian life to the 1810 Paris Salon, in which she received a second-class medal. Haudebourt-Lescot was the only female artist François Joseph Heim included in his monumental depiction of Charles X awarding medals to artists for the Salon of 1824.

Returning to Paris in 1816, she married the architect Louis-Pierre Haudebourt in 1820. Over the next three decades—her productivity not hindered by marriage—the artist exhibited more than one hun-dred paintings at the Salons, ranging from works based on popular literature and historical genre scenes to portraits and depictions of domesticity. Haudebourt-Lescot's fame became such that the artist was appointed painter to the duchesse de Berry and she received several commissions from the French government. —JP

BERTHE MORISOT

Berthe Morisot identified herself as an impressionist, the French nineteenth-century group of artists who rebelled against the Salon and the highly refined academic works exhibited there. Associated with Monet, Renoir, Pissarro, and Degas, Morisot was included in seven of the eight impressionist group exhibitions held between 1874 and 1886. Although she associated herself with the renegade group, as a woman painter Morisot often escaped the same unfavorable judgments the other impressionists received. As a matter of course, nineteenth- and twentieth-century critics focused on the "feminine" qualities in her work: intuitiveness, spontaneity, and delicacy. That Morisot herself described the process of painting as a "pitched battle with her canvasses" held no sway in prefeminist literature on the artist.[1]

Born in Bourges, France, to an upper-class household, Morisot and her family moved to Paris in 1848. While educated in the arts like all young women in her social class, Morisot's ability to paint well became evident to her instructor, Joseph-Benoît Guichard, early on in her training. Guichard warned her parents that "in the upper-class milieu ... this will be revolutionary, I might almost say catastrophic," for she possessed such talent that she could turn professional.[2] Morisot's mother supported her daughter's ambitions by allowing her a serious art education. Morisot flourished artistically, copying old-master paintings at the Louvre, studying under the Barbizon painter Camille Corot, and absorbing the tenets of plein-air painting. During the 1860s Morisot developed a close professional relationship with family friend Edouard Manet. In 1864 she began submitting works to the Paris Salon, where she showed regularly throughout the rest of the decade. In 1874 Morisot was invited to exhibit with the Société Anonyme des Artistes-Peintres, Sculpteurs, Graveurs—a landmark event that would become known as the first exhibition of the impressionists. Thereafter, Morisot never again returned to the Salon.

Morisot achieved significant critical recognition during her lifetime. Her work was included in George Petit's International Exhibition as well as in Paul Durand-Ruel's exhibition of impressionist painting in New York, both in 1887. Married to Eugène Manet (brother of Edouard Manet), Morisot had one daughter, Julie, whom she painted frequently and who provided the inspiration for her paintings that document women's lives, including *Jeune femme en toilette de bal* (Musée d'Orsay, Paris).

THE CAGE

1885, oil on canvas, 19⅞ × 15 in. (50.5 × 38.1 cm.)
Gift of Wallace and Wilhelmina Holladay

Painted in 1885, *The Cage* typifies Morisot's mature style. Around 1880 Morisot, Edouard Manet, and Eva Gonzalès began experimenting with painting on unprimed canvas. The texture of the heavy woven fabric affected Morisot's paint application, which became increasingly loose and sketchy. Using a limited palette dominated by brown, white, and green, the artist constructed a still life comprising a birdcage and a bowl of flowers against an ambiguous background of choppily executed strokes of paint. A study of juxtaposed forms and solids against voids, *The Cage* demonstrates Morisot's ability to give a painting the same unstudied appearance as a watercolor.[3] —JP

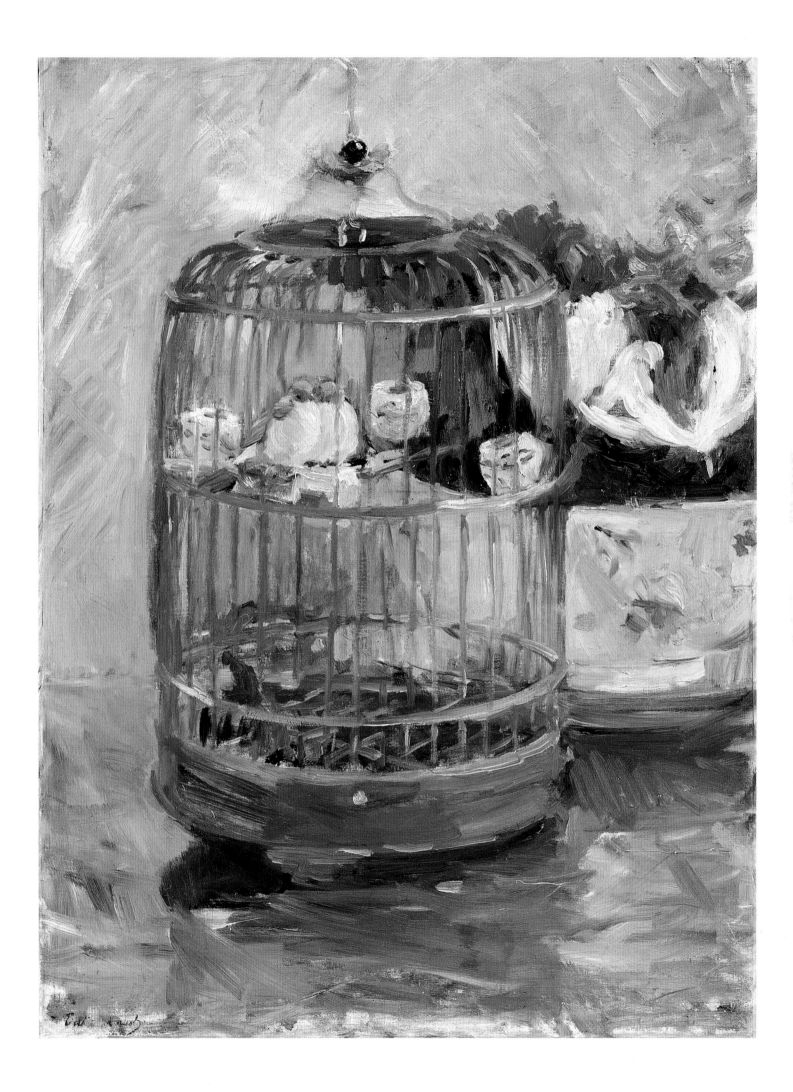

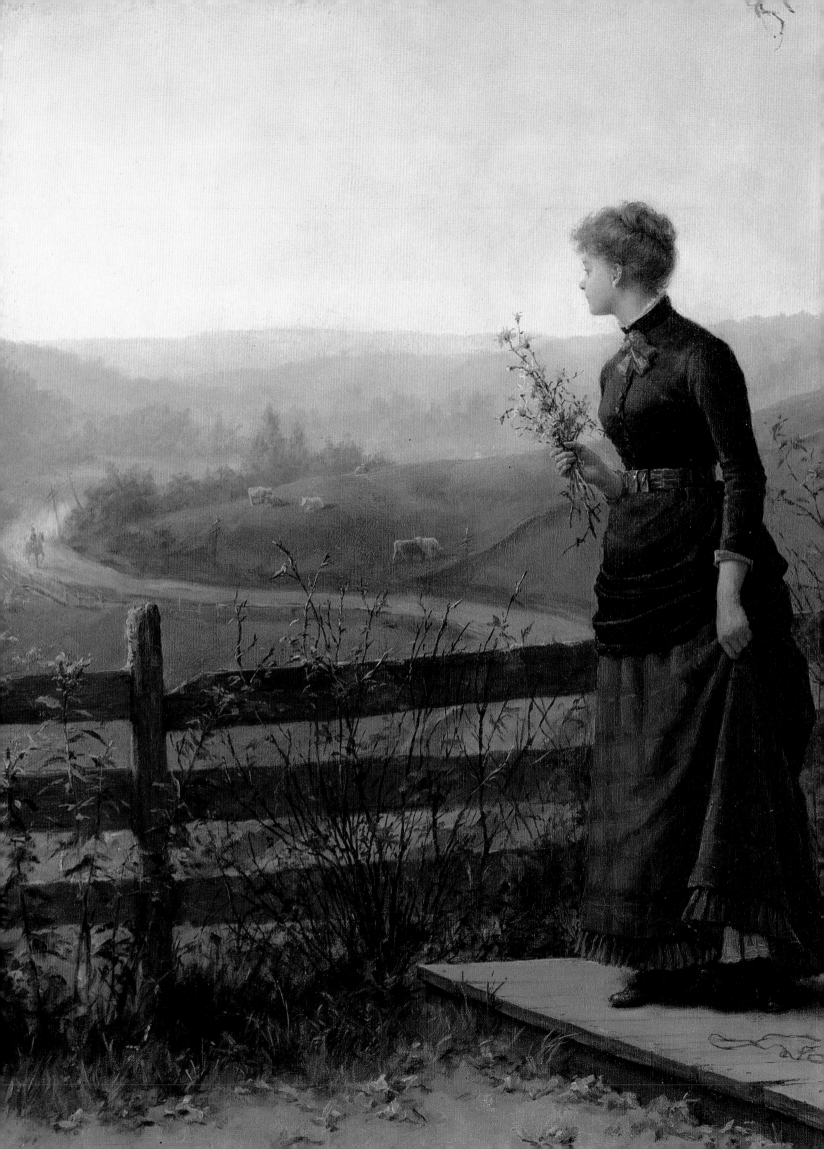

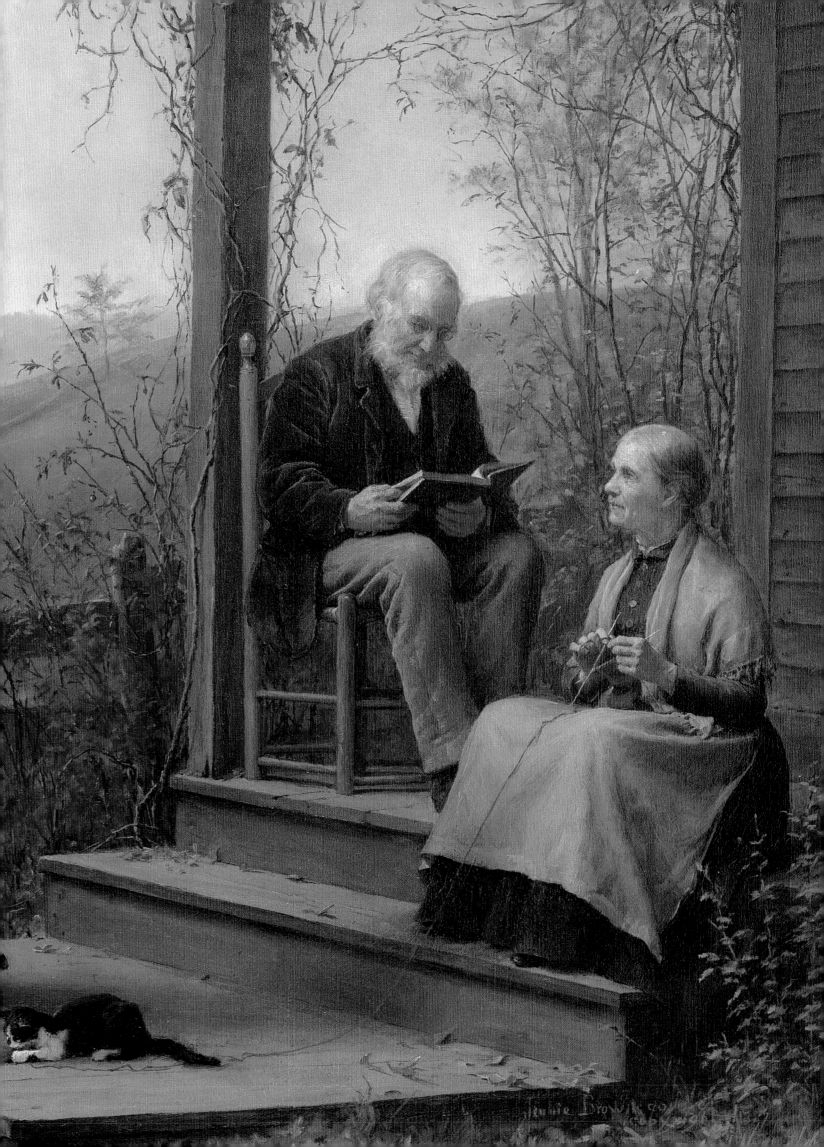

Nineteenth-century women artists were a significant force on the American art scene. In addition to creating noteworthy art and winning prestigious commissions and awards, these women played an important role in founding and supporting many American art institutions and organizations. American women helped establish the Art Students League, the Photo-Secession movement, and the Guild of Boston Artists; they also participated in the first annual exhibitions at the Pennsylvania Academy of the Fine Arts and the American Society of Portrait Miniatures, to name just a few examples. The artists discussed in this chapter also made significant contributions as art writers and teachers, serving as role models for future generations of American women artists. All of this is particularly remarkable, since they themselves had so few role models from whom they could draw inspiration.

Thus far, all of the discussions in this catalogue have concerned art made by women from Western Europe. While professional female artists were active in the New World before 1800, they were few in number and produced comparatively little work that survives.[2] However, this situation changed dramatically during the nineteenth century, when there was a large increase in the number of American women artists, working with a wider variety of materials, techniques, subjects, and styles than ever before. The works discussed here represent that broad range of approaches. While portraits and figure studies retained their widespread popularity, women artists also dealt with religious and landscape subjects, genre scenes, and still lifes.

Like their male counterparts, nineteenth-century American women artists were at a disadvantage compared to contemporary Europeans. As a relatively young nation, the United States was still building its cultural infrastructure. Through most of the nineteenth century America had few art schools, public art museums, galleries, and art-related publications. The number of American art patrons was limited, and those wealthy individuals who did purchase art generally sought out the more prestigious work of Europeans.

During this period most American women artists received their training at a handful of pioneering institutions: at the Art Institute of Chicago, the Pennsylvania Academy of the Fine Arts in Philadelphia, the National Academy of Design or the Art Students League in New York City, or the School of the Museum of Fine Arts or the Massachusetts College of Art, both in Boston. Many art students, especially women, also took private classes with established artists. To further their education and more firmly establish their artistic credentials, it was also common for American artists who could afford it to spend time studying abroad—in Rome or, toward the latter part of the century, Paris. As in the past, foreign travel remained considerably more difficult for women. Yet American women artists did enroll at the popular and well-regarded private Parisian art schools, especially the Académie Colarossi and the Académie Julian. There women could work with the same respected masters under whom male artists studied—although records indicate that female students frequently paid higher fees for fewer advantages.[3]

Because domestic obligations continued to fall primarily on the shoulders of wives and mothers rather than husbands and fathers, some nineteenth-century American women artists chose to remain unmarried in order to concentrate on their work.[4] A remarkable number of nineteenth-century American women artists lived unusually long lives. Thirteen of the sixteen artists included in this section survived into their eighties; only one died before fifty (of typhoid fever), and another lived to be sixty-eight.[5] These women produced an extraordinary variety of works. During the 1800s portraiture was still a particularly accessible, and acceptable, option for female artists. Given the growing demand for portraits of well-to-do Americans, this was a lucrative field. Like male artists, nineteenth-century American women artists produced both painstakingly rendered, detailed likenesses and broadly brushed canvases strongly influenced by

impressionism, which emphasized vibrant color and light. At the same time, there was a revival of interest in the demanding technique of portrait miniatures.

While sentimental genre scenes were becoming popular in Victorian England, a vogue for similar subjects swept through America. The late nineteenth century was also a golden age for American still life, with numerous painters specializing in illusionistic arrangements of humble household objects.

The etching process had been popular among European printmakers since the seventeenth century, but it became widespread in the United States only during the 1800s. The illustrated examples clearly demonstrate the broad range of effects available through this sophisticated technique.

Despite the considerable strides made by American women painters and printmakers during the nineteenth century, it was still unusual for women to seek careers in sculpture.[6] Working in clay, plaster, marble, or bronze was regarded as unsuitably messy; it also required more physical strength than a woman was presumed to possess. More significantly, there was concern that a woman would not be able to command the respect of the male workers with whom she would have to collaborate on large sculptural projects. In addition, until the very end of the nineteenth century women still did not have the opportunity to study and work from the nude model—a serious restriction, given that virtually all sculptural commissions focused on the human form.

Nevertheless, a significant number of American women did manage to develop long-standing, successful careers making art in three dimensions. During the nineteenth century American women sculptors produced everything from small-scale decorative figures and portrait busts to monumental allegorical statues and ornate fountains. This fact is all the more impressive when one considers that there were no important male sculptors working in America before the 1820s.

Photography, as we know it today, was invented in 1839 and quickly became an extremely popular medium. In America, photography was considered an excellent "hobby" for women because the process could be done at home, without formal training.[7] The invention of the dry-plate technique in 1867 made photography more widely accessible, and by the late 1880s cameras had become considerably less expensive and easier to carry. Kodak aimed the advertising campaign for its new "automatic" camera at middle-class women, for whom photography offered a practical way to earn a living. In fact, a significant number of American women developed important careers as photographers during the late nineteenth century.

THE CHIEF OBSTACLE TO
A WOMAN'S SUCCESS IS THAT
SHE CAN NEVER HAVE A WIFE.
JUST REFLECT WHAT A WIFE
DOES FOR AN ARTIST.

—ANNA MASSEY LEA MERRITT [1]

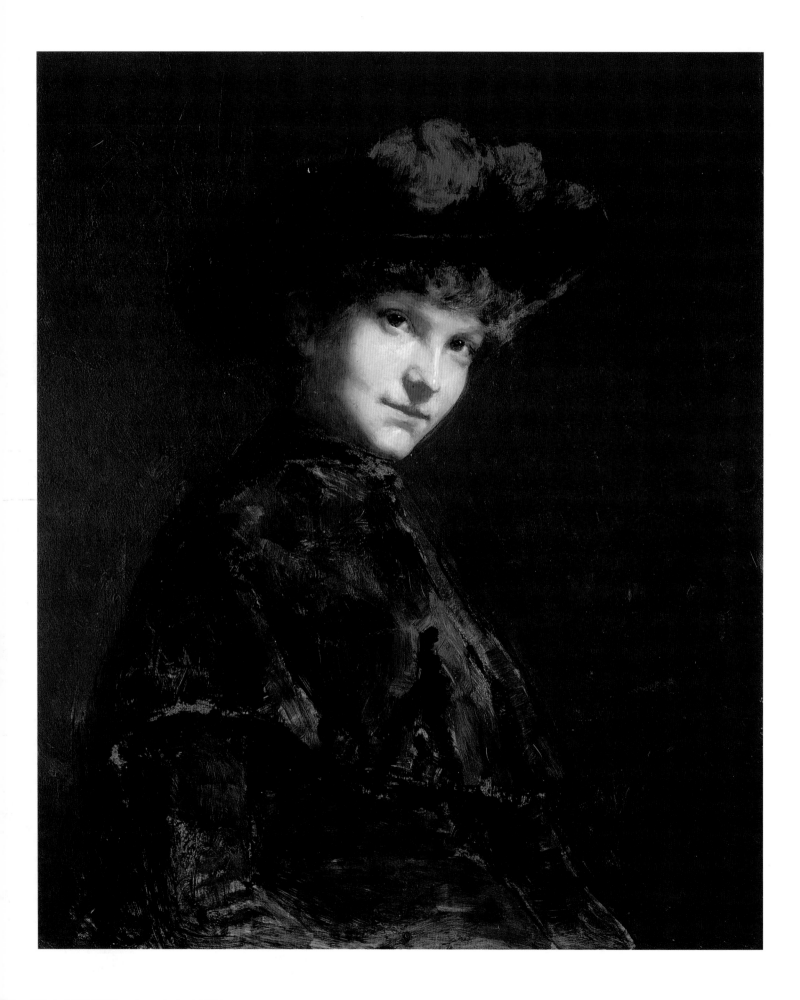

CECILIA BEAUX

AMERICAN, 1855–1942

ETHEL PAGE (MRS. JAMES LARGE)

1884, oil on canvas, 30 × 25⅛ in. (76.2 × 63.8 cm.)
Gift of Wallace and Wilhelmina Holladay

Although Cecilia Beaux captured the likenesses of many cultural and political leaders, many of her most powerful portraits are of her relatives and friends. Ethel Page came from a distinguished Philadelphia family that traced its lineage to Roger Williams, the founder and governor of Rhode Island. Page met the artist in 1876; this is the first of many portraits of her by Beaux.

Typical of Beaux's early style, this picture features a brightly lit face set against a dark, unarticulated background with thick brush strokes—for example, in the woman's fur cape—and one note of color: the large red bow on Page's hat. The rich, dark tone of the picture, the sense that it captures a single moment in time, and the emphasis on the subject's personality all demonstrate the influence of major Philadelphia portraitists, notably Thomas Eakins, with whom Beaux never studied but whose work she certainly knew.

Beaux presents her subject in a flattering, yet honest, way—stressing Page's sharp nose, curly bangs, alert gaze, and the jaunty angle at which she holds her head. Without introducing additional details of Page's costume or surroundings, Beaux depicts an attractive, intelligent young woman.

In 1933 First Lady Eleanor Roosevelt presented Cecilia Beaux with the Chi Omega fraternity's gold medal, for "the American woman who had made the greatest contribution to the culture of the world."[1] At seventy-eight, Beaux had enjoyed an international reputation as a distinguished painter of portraits for well over four decades.

Beaux was born to Cecilia Kent Leavitt, a teacher, and Jean Adolphe Beaux, a silk manufacturer from France. When her mother died twelve days after her birth, Beaux's father returned to France, leaving Cecilia and her older sister, Aimée, to be raised by relatives. Fortunately, Cecilia's early interest in art was encouraged at home and school; she studied with several local painters beginning in 1871.

By the age of eighteen Beaux was earning her living through commercial art. During the following decade she made lithographs and painted on china while studying at the Pennsylvania Academy of the Fine Arts and taking private classes from several noted Philadelphia painters. She completed her first medal-winning portrait in 1884, and in 1888, after rejecting several marriage proposals, Beaux decided to devote herself to a career as a portraitist. That same year she went to Europe, where she spent nineteen months studying at the Académie Colarossi, the Académie Julian, and an art colony on the Brittany coast. Back in Philadelphia, Beaux soon became a sought-after painter of prominent writers, politicians, and other artists. For many years, she taught at the Pennsylvania Academy, a practice she continued after moving to New York City in 1898.

Beaux's pictures were widely exhibited in the United States, Paris, and London. Her work was favorably compared with that of John Singer Sargent and Thomas Sully, and the summer house she built in Gloucester, Massachusetts, became a popular stopping point for her increasingly distinguished clientele. Her reputation hit its peak during the 1930s, when she received several major awards, had two retrospective exhibitions, and published her autobiography.[2]

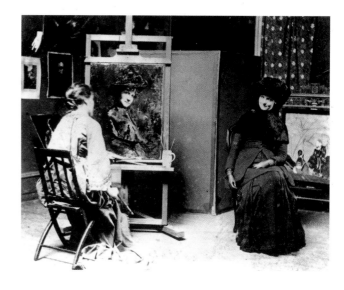

JENNIE AUGUSTA BROWNSCOMBE

AMERICAN, 1850–1936

She has been called "a kind of Norman Rockwell of her era."[1] In fact, the skillful drawing, attention to detail, and nostalgic moods of her paintings make the comparison between Jennie Augusta Brownscombe and the popular American illustrator seem quite apt.

Brownscombe's early life sounds like the story behind one of her own pictures. Born in a log cabin in rural northeastern Pennsylvania, she was the only child of William Brownscombe, an English-born farmer, and Elvira Kennedy, a direct descendant of a Mayflower passenger, who encouraged her young daughter to write poetry and draw. Brownscombe won her first awards as a high school student, exhibiting her work at the Wayne County Fair. When her father died in 1868, Brownscombe began supporting herself through teaching, creating book and magazine illustrations, and selling the rights to reproduce her watercolor and oil paintings as inexpensive prints, Christmas cards, and calendars. More than one hundred of Brownscombe's works were distributed this way, spreading her images into homes throughout the nation.

A prize-winning student at the Cooper Institute School of Design for Women and the National Academy of Design, both in New York City, Brownscombe in 1875 became a founding member of the Art Students League, where she later served on the faculty. Her oil paintings met with immediate success, as both her subjects (sentimental genre pictures and scenes from colonial American history) and her style appealed to prevailing Victorian tastes. Brownscombe studied art in France in 1882, spent the winters of 1886 through 1895 in Rome, and exhibited her pictures there and in London, New York, Chicago, and Philadelphia. She continued working until virtually the end of her long life, completing her final large oil painting at the age of eighty-one after recovering from a stroke.

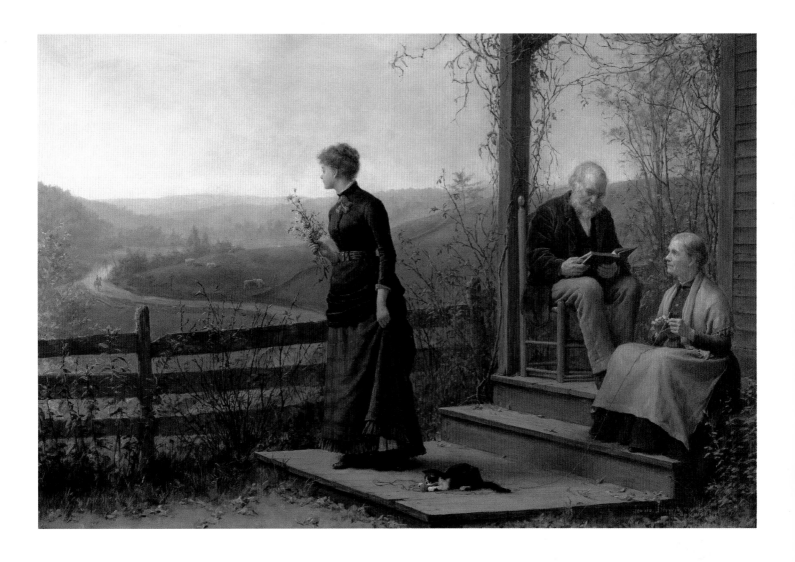

LOVE'S YOUNG DREAM

1887, oil on canvas, 21¼ × 32⅛ in. (54 × 81.6 cm.)
Gift of Wallace and Wilhelmina Holladay

One of Jennie Augusta Brownscombe's most popular paintings, *Love's Young Dream* celebrates life in a traditional, close-knit rural family.[2] Brownscombe's ability to create a wealth of believable details adds to the strength of her narrative. A young woman stands on the middle step of her humble home, halfway between the interior (domestic) sphere where she has been living and the outside world she hopes to enter soon. She gazes longingly toward the road, where a man on horseback, presumably her romantic interest, approaches. Meanwhile, the gray-haired woman (pre-sumably her mother) glances up from her knitting, her bemused expression registering fondness and concern and perhaps a warm memory of her own first love, while her partner busies himself with his book. Fallen leaves scattered about the yard identify the season as autumn, in an idyllic setting where cattle graze peace-fully in the middle distance.

Compositionally, Brownscombe contrasts the right-hand side of the picture, where all three figures have been placed, with the left, where an unencum-bered view of the landscape stretches back to the mist-shrouded hills. The predominant color scheme (black, browns, and grays) is relieved by a few well-placed spots of bright color, while the kitten adds a note of playfulness.

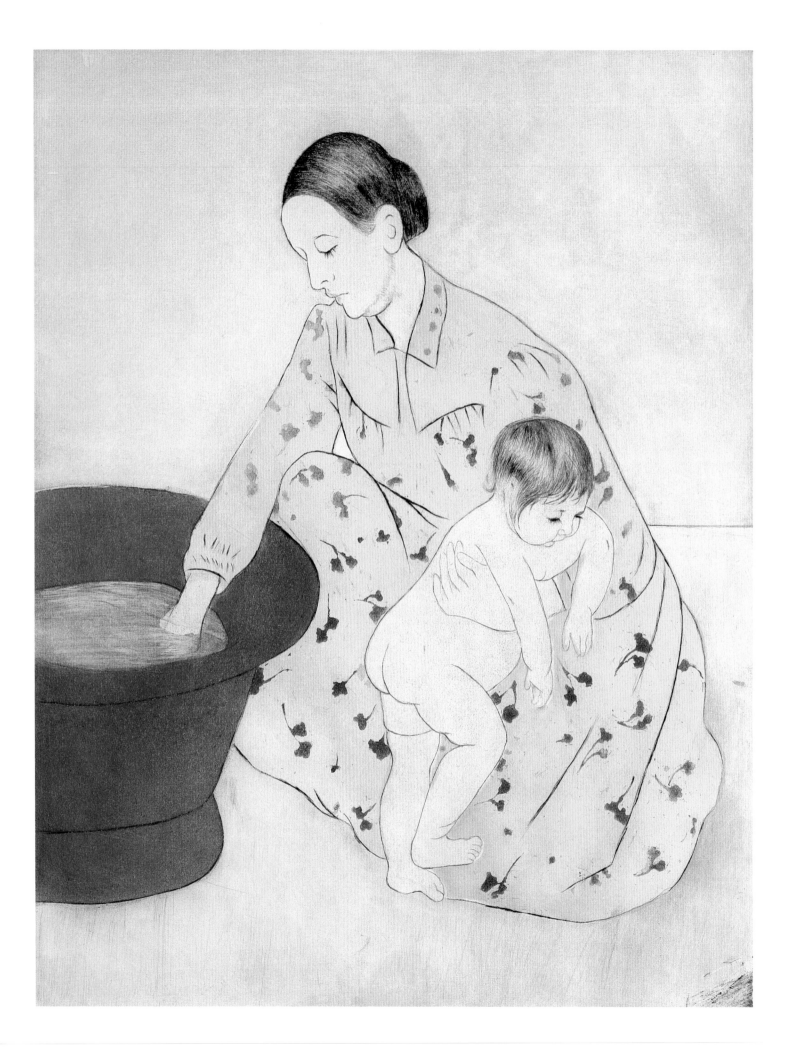

MARY CASSATT

AMERICAN, 1844–1926

THE BATH

1891, soft-ground etching with aquatint and drypoint
12³⁄₈ × 9⁵⁄₈ in. (31.4 × 24.4 cm.)
Gift of Wallace and Wilhelmina Holladay

In 1890 the Ecole des Beaux-Arts held a large-scale exhibition of Japanese prints that strengthened Mary Cassatt's interest in printmaking. These works had become increasingly popular in Paris, but this was the first time so many Japanese prints had been gathered in one place at one time in France. The exhibition had a profound effect on the artist and inspired her to create a series of ten color aquatints. *The Bath* is the first print in the series and derives from a long series of related works of mothers and children.

Japanese art influenced not only Cassatt's choice of subject matter but also her technique and composition. Women bathing children is a theme commonly found in Japanese woodblock prints, and Cassatt has depicted a woman and child who are neither clearly European nor Asian. Clad in a light yellow dress with a delicate leaf print, the mother kneels down at a blue tub of water. She submerges her right hand in the water while, in her left arm, she holds her chubby baby upright. Cassatt renders the figures and tub as two-dimensional shapes, almost completely eliminating the traditional shading and tonal variations that create the illusion of depth in Western art.

Cassatt produced *The Bath* in seventeen editions; the National Museum of Women in the Arts owns a final impression. To create *The Bath*, Cassatt used one plate for the tonal area and another for drypoint lines. Cassatt applied color by hand to each of the plates, which were then successively impressed on paper. The procedure was complex and labor intensive, requiring a day of preparation just to ink and reprint the plates for each of the impressions.

Mary Cassatt grew up in an upper-middle-class household in western Pennsylvania. Cassatt's training as a painter began in 1861, when she enrolled in the Pennsylvania Academy of the Fine Arts. In 1865 she took her first trip to Europe, where she would remain for the next four years, traveling and studying in Paris, Rome, and Madrid. In 1868 her painting *A Mandolin Player* became Cassatt's first work to be accepted by the Paris Salon.

Edgar Degas saw Cassatt's work at the Salon, and in 1877 he asked her to join the impressionists. Having experienced a number of rejections from subsequent Salon exhibitions and other significant juried shows, Cassatt readily accepted Degas's invitation. "At last, I could work with absolute independence without considering the opinion of a jury," she told her biographer, Achille Segard. "I had already recognized who were my true masters. I admired Manet, Courbet, and Degas. I hated conventional art—I began to live."[1]

Cassatt's painting style and subject matter changed greatly because of her association with the impressionists. She abandoned colorful costume genre depictions in favor of scenes from contemporary life. In 1879 Degas, the etcher Félix Bracquemond, and Camille Pissarro were preparing work for a new print journal *Le jour et la nuit*. Cassatt's subsequent involvement in this project would indelibly influence her oeuvre by whetting her appetite for the graphic medium. The journal was never published, but the artists' efforts to experiment with graphic techniques were very important to Cassatt's development as a printmaker. The majority of these early works were soft-ground etchings with aquatint, a process that echoed Cassatt's experience as a painter. Throughout the latter half of the 1880s, Cassatt produced drypoints of members of her family, and in 1889 at the *Exposition de Peintres-Graveurs* at the Durand-Ruel gallery, she submitted both a drypoint and an etching.

Although an expatriate from 1874 on, Cassatt is recognized as one of the foremost American painters and printmakers of the nineteenth century. An exceptionally prolific printmaker, she produced more than 220 prints during the course of her career. Cassatt's failing eyesight prevented her from working for the last fifteen years of her life. —JP

E U L A B E E D I X

AMERICAN, 1878–1961

First introduced to the portrait miniature at age seventeen, Eulabee Dix from the 1890s through the 1930s became instrumental in the revival of this centuries-old art form in the United States and England.

She was born in Greenfield, Illinois, but financial setbacks forced her family to move several times during Dix's youth. Her early interest in art was stimulated by the year she spent studying oil painting and life drawing at the St. Louis School of Fine Art, where she won several awards. In 1895 the Dixes settled in Grand Rapids, Michigan. Four years later, Dix moved to New York City to become a professional artist.

In New York, Dix studied at the Art Students League, took private classes with the noted miniature painter Isaac A. Josephi, and exhibited with the newly established American Society of Miniature Painters. Between 1902 and 1909 Dix got to know many important artists and had numerous prominent sitters, including the actresses Ellen Terry and Ethel Barrymore and the photographer Gertrude Käsebier.[1]

Dix's first trip to Europe in 1904 led to an important one-person show of her work in London two years later. She won a medal at the 1927 Paris Salon and also displayed her work at important venues in the United States and Portugal. Dix received glowing reviews and was a popular lecturer.

In 1910 Dix married the New York lawyer Alfred Becker, with whom she had two children; the couple divorced fifteen years later. When miniatures again went out of fashion in the late 1930s, Dix adapted by painting large oil portraits and a popular series of floral

still lifes. At the age of seventy-eight, perhaps attracted by the low cost of living, Dix moved to Lisbon, Portugal, where a retrospective of her art was held at the Museu Nacional de Arte Antiga in 1958.

86 19TH-CENTURY NORTH AMERICA

ME

1899, watercolor on ivory, 2½ × 2⅛ in. oval (6.4 × 5.4 cm.)
Gift of Mrs. Philip Dix Becker and family

This self-portrait miniature is an excellent example of Eulabee Dix's extraordinary control of watercolor on ivory—a demanding technique developed by Rosalba Carriera in the eighteenth century. After being soaked, cut, and flattened, a thin slice of ivory is abraded to make the paint stick to its surface; the artist must be careful not to shatter the ivory. Measuring just a few inches in diameter, Dix's miniatures required painstaking effort: a typical portrait took four to five sittings, after which she worked from mem-

ory for as many as eight additional hours at a time.[2]

Throughout her life Dix was excited about "the magic of getting a likeness." In fact, this self-portrait seems remarkably close to Dix's written description of herself: "I was five-foot-six, my neck so long one wondered where my sloping shoulders began. A large mouth, nose that seemed too big to me when I looked in the glass. My reddish brown hair tumbled into order without much care."[3] *Me* also resembles contemporary photographs of the artist,[4] in which she wears a similar outfit and hairstyle. A close-up view of the miniature reveals the myriad tiny dots of pigment with which Dix has created the face, in contrast to the broader, looser areas of color in her scarf.

ELLEN DAY HALE

AMERICAN, 1855–1940

JUNE

ca. 1893, oil on canvas, 24 × 18⅛ in. (61 × 46 cm.)
Gift of Wallace and Wilhelmina Holladay

Although Ellen Day Hale also produced numerous landscapes and large religious murals, she specialized in impressionist-style figure studies such as *June*.[1] Like the seventeenth-century Dutch masters whose work she admired, Hale excelled at depicting solitary females in light-filled interiors, absorbed in domestic pursuits.

Here the artist emphasizes the sitter's concentration on her sewing, as she ignores the dazzling landscape beyond the window. Despite Hale's extremely loose brushwork—for example, in the thick areas of white paint behind the sitter's head—we can clearly see the woman's thimble and the quick movements of her needle, glinting in the sunlight.

This canvas was presumably painted in Santa Barbara, California, where Hale lived in 1892–93. The dark back of the chair is contrasted with the bright light that floods in and picks out a few strands of the woman's upswept hair. Hale has taken liberties with the checkered pattern on the woman's dress, flattening it out in certain sections, allowing the right shoulder to appear to dissolve into the light, and adding the unexpected, humanizing touch of a missing button, of which the seamstress seems ironically unaware.[2]

The peripatetic painter and printmaker Ellen Day Hale lived on both coasts of the United States, spent time in Western Europe, and visited the Middle East. She was born in Worcester, Massachusetts, the only daughter of the noted orator and author Edward Everett Hale and Emily Baldwin Perkins. Hale's great-great-uncle was the Revolutionary War patriot Nathan Hale; her great-aunt Harriet Beecher Stowe wrote *Uncle Tom's Cabin;* her brother Philip and his wife, Lilian Westcott Hale, were both professional painters, as was her aunt Susan Hale, a well-known art lecturer who was also Ellen's first drawing teacher.

Hale also found a number of female role models among her painter friends, most notably Helen Knowlton, with whom she studied from 1874 to 1877, and Gabrielle de Veaux Clements, from whom she learned the technique of etching. Hale never married but helped raise her seven younger brothers and then, because her mother had become an invalid, acted as hostess for her father when he served as chaplain to the U.S. Senate in Washington, D.C., between 1904 and his death in 1909.

Hale studied art in Boston with William Morris Hunt, a Paris-trained painter who encouraged his pupils to work in Europe. She also took classes at the Pennsylvania Academy of the Fine Arts but was more influenced by her experiences in France at the Académie Colarossi and, especially, the Académie Julian, where she was a pupil in 1882 and again in 1885. Hale began exhibiting her work in 1878 at the Boston Art Club; her pictures were also displayed at the Royal Academy in London, the Paris Salon, and at important venues in Philadelphia and Chicago. Hale supplemented her income by teaching but did not settle down in one place until she was nearly fifty. She continued painting well into her eighties.

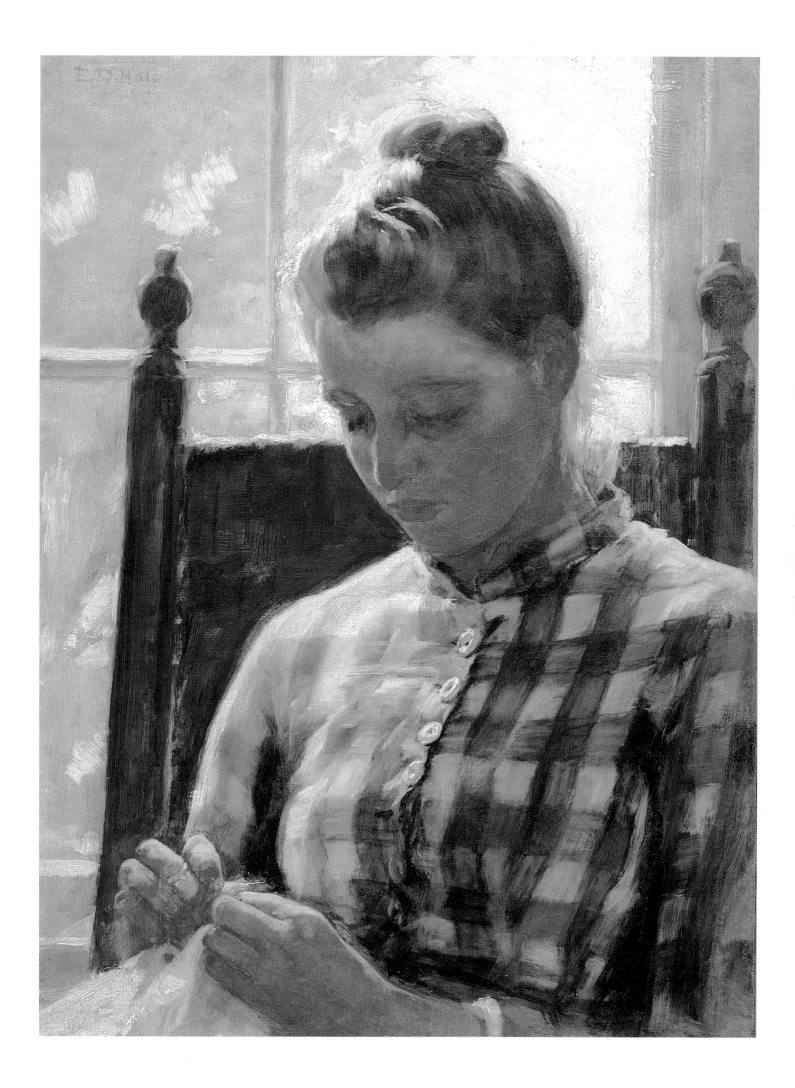

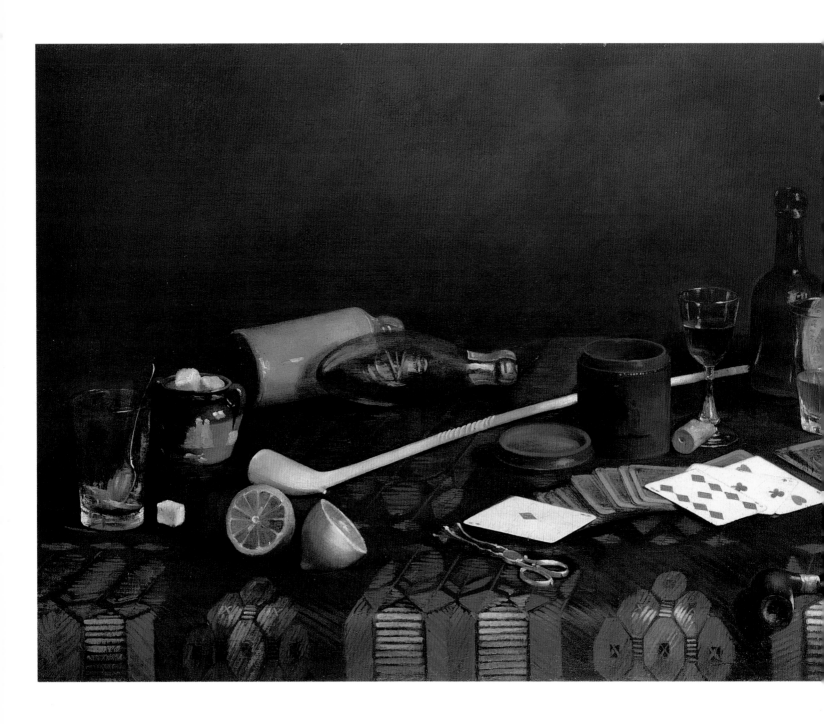

A GENTLEMAN'S TABLE

after 1890, oil on canvas, 18 × 32 in. (45.7 × 81.3 cm.)
On loan from the Wallace and
Wilhelmina Holladay Collection

Claude Raguet Hirst's work is clearly based on the tradition of seventeenth-century Dutch tabletop still lifes and on nineteenth-century American variations on this theme. Like its old-master counterparts, this painting depicts a group of humble objects placed against a plain, dark wall. Hirst likewise shares an interest in creating the illusion of volume and space, as can be seen in the subtle overlapping of the playing cards and the convincingly three-dimensional tablecloth with the bowl of a dark pipe cantilevered out over its edge.

CLAUDE RAGUET HIRST

AMERICAN, 1855–1942

Originally named Claudine, Claude Raguet Hirst adopted a masculine signature to avoid gender-based prejudice from art juries. Born and raised in Cincinnati, Ohio, Hirst spent four years at that city's McMicken School of Design beginning in 1874. Eight years later she moved to New York City, where she studied privately with the painters Agnes D. Abbott, George Smillie, and Charles Curran.

Hirst first specialized in painting floral still lifes, especially roses; she exhibited these pictures at the National Academy of Design from 1882 through 1886. However, a major change occurred in her work in 1890, when Hirst suddenly switched to painting pipes, tobacco, steel-rimmed spectacles, and other traditionally masculine still-life props. According to Hirst, she began depicting these items because William C. Fitler, an American landscape painter who shared her studio while his own was being constructed, was very disorderly, always leaving his meerschaum pipe and related paraphernalia scattered about.[1] Hirst found herself admiring the aesthetic qualities of the pipe—particularly its color, which she compared to aged ivory—and began painting it, along with a selection of her own books. The artist recalled that her first attempt in this vein sold immediately, so Hirst thereafter concentrated on similar images. Hirst's change in artistic direction also coincided with the return to New York, after six years in Europe, of the well-known American *trompe l'oeil* still-life painter William Michael Harnett. Harnett rented the studio next to Hirst's, on East Fourteenth Street, and many scholars have suggested that the two artists knew each other.

Although Hirst enjoyed critical acclaim during the 1920s and is considered Harnett's only important female follower, by the time of her death her approach to painting had long been out of style.

The assortment of still-life objects depicted in *A Gentleman's Table* (wine and liquor bottles and glasses, a corkscrew, two pipes, a box of matches, and the cards) suggests an environment frequented by men.[2] More objects are found here than in most of Hirst's still lifes; in fact, the table is rather crowded. Because of its luminous color and long, slender line, the clay pipe attracts attention,[3] drawing the viewer's eyes across the entire canvas on a diagonal path, from left to right; the row of cards spread out below it parallels this movement.

Perhaps the most endearing aspect of Hirst's piece is its seemingly informal composition. Although it was, in fact, carefully calculated, this canvas appears to be an unstudied, candid look at an evening's entertainment.[4]

GERTRUDE KÄSEBIER

AMERICAN, 1852–1934

In the early twentieth century Gertrude Käsebier was regarded as "one of the finest photographers in the world."[1] Remarkably, this successful artist, who eventually produced some 100,000 negatives, first used a camera in her late thirties.

Gertrude Stanton was born to a Quaker family in Des Moines, Iowa. When she was very young her family moved to Colorado, where her father became a silver miner. After her 1873 marriage to a shellac importer named Eduard Käsebier, she lived in Brooklyn, New York.

Although she had long been interested in art, it was only when her three children entered high school that Käsebier began formal training. Initially, she planned to be a painter. But after five years at the Pratt Institute, Käsebier switched to photography, approaching this new medium with characteristic energy and thoroughness. In 1894 she took classes in Paris, then apprenticed herself to a German photographic chemist; back in Brooklyn, Käsebier worked for a portrait photographer to learn about business. Finally, in 1897, she opened her own Fifth Avenue portrait studio, achieving immediate success: attracting wealthy clients, exhibiting her work regularly, and receiving enthusiastic reviews. In addition to portraits, Käsebier produced photographic landscapes and evocative figure studies. She was also an important pioneer in the movement known as pictorialism, which emphasized the artistic as opposed to the purely documentary aspects of photography. In 1902 she was a founder—along with the noted American photographer Alfred Stieglitz—of the Photo-Secession, an organization that promoted pictorialism.

Käsebier was otherwise active within Stieglitz's circle: her work was featured in the inaugural issue of his ground-breaking periodical *Camera Work*, and she had an important exhibition at 291, Stieglitz's radical New York gallery. With the help of one of her daughters, Käsebier (whose husband had died in 1910) continued to run her portrait studio until 1927; she had a major retrospective exhibition of her work at the Brooklyn Museum two years later.

THE MANGER

ca. 1899, platinum print, 7⅝ × 5½ in. (19.4 × 14 cm.)
Gift of the Holladay Foundation

One of Gertrude Käsebier's favorite photographs, and also one of the most popular images she ever made, is *The Manger* (also known as *Ideal Motherhood*), a typical example of her approach to pictorialism. Rather than a straightforward depiction of a woman holding an infant, here the artist has employed subtle tones (a characteristic of the platinum print) and blurred details to create a romantic, soft-focus image that merely suggests the subject, without revealing any details. In fact, several writers point out that no baby was under the pile of drapery on the adult model's lap.

With her head bowed and held forward in the shadows, the mother's facial features are completely obscured; we see only her hands and a hint of her profile. The woman's gauzy dress and long veil, plus the strikingly simple setting—a whitewashed stable in Newport, Rhode Island, where Käsebier frequently vacationed—evoke both a specifically Christian theme and a more general reference to the dignity and emotions of motherhood.

In 1899 this photograph was sold for a record price of $100; it was also reproduced in the first issue of *Camera Work* (January 1903).

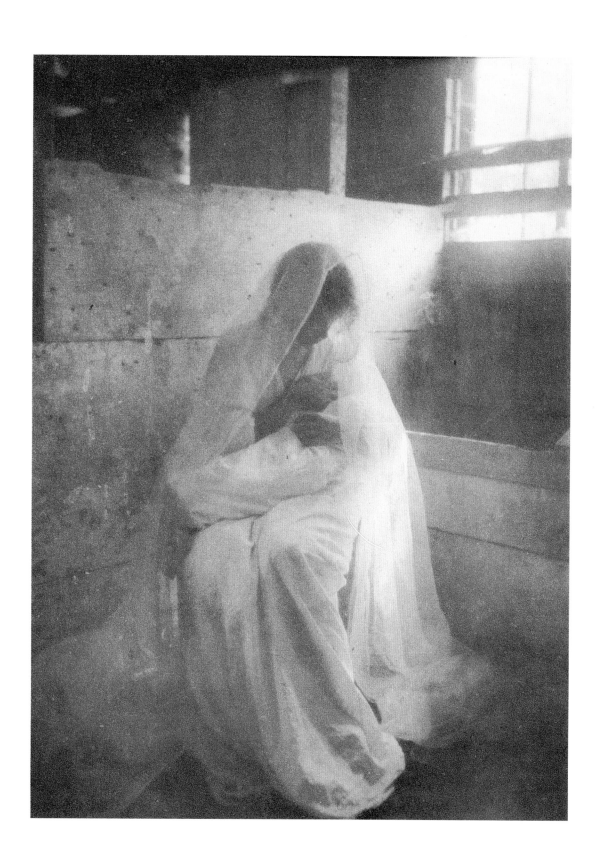

EVELYN BEATRICE LONGMAN

AMERICAN, 1874–1954

PEGGY
(PORTRAIT OF MARGARET FRENCH)

1912, bronze, 27½ × 12 × 10½ in. (69.9 × 30.5 × 26.7 cm.)
Gift of Wallace and Wilhelmina Holladay

Although she achieved fame for her formal public monuments, Evelyn Beatrice Longman was also a master of lively, small-scale portrait sculptures like this bust-length bronze work, displayed on its original marble-and-metal base. Because of the young woman's ecstatic expression and the grapes entwined in her hair, the dramatic sculpture has sometimes been identified as *Head of a Bacchante*, referring to a female worshiper of the ancient Roman god of wine. However, it is actually a depiction of Daniel Chester French's only child, Margaret French, who later established her own career as a sculptor.[1]

To make this portrait, Longman required twenty sittings between January and March 1912 in her New York studio. Yet it is obvious that, in addition to the likeness of the young woman, Longman was interested in evoking her subject's personality, high energy, and infectious sense of fun. She does this by emphasizing the twenty-three-year-old's tousled curls, broad smile, and sparkling eyes. The vigorously worked surface of the bronze head is well matched with the variegated colors and swirling patterns in the rectangle of marble that supports it. *Peggy* was first exhibited at the National Academy of Design in the same year it was made. The following year it was illustrated on the cover of *The World Magazine*.[2]

From the age of thirty, Evelyn Beatrice Longman was widely known as a creator of important public sculpture; she was equally comfortable making enormous allegorical figures and intimate portrait busts. Yet her background seemed unlikely to lead to such a successful career in this highly competitive field.[3] Born in a log cabin near Winchester, Ohio, Longman was one of six children. When she was fourteen, her father, a musician turned farmer, encountered severe financial difficulties, so Longman quit school to take a job in a Chicago warehouse. Inspired by evening classes that she took at the Art Institute of Chicago, Longman saved her money for six years so she could study art full time, first at Olivet College in southern Michigan and then back at the Art Institute. In Chicago she proved sufficiently adept at her studies to be able to complete the four-year sculpture program in half that time, impressing the noted artist Lorado Taft so much that he made her his assistant. She also taught there, while improving her technique in working with both marble and bronze.

In 1902 Longman became the only female assistant ever hired by Daniel Chester French, creator of some of America's most important public monuments. Three years later she established her own studio in New York City and proceeded to win several major competitions for monumental statuary, bronze doors, and, in 1916, a 20,000-pound, twenty-foot-high gilded bronze statue, *The Genius of Electricity* or *The Spirit of Communication*, that was placed atop New York's American Telephone and Telegraph (AT&T) building. Longman also collaborated on varied projects with a number of important architects, most notably Henry Bacon, the architect of the Lincoln Memorial in Washington, D.C., for which Longman produced the ornamental sculptures.

ANNA MASSEY LEA MERRITT

AMERICAN, 1844–1930

A versatile artist and writer, Anna Massey Lea Merritt was born in Philadelphia to an affluent Quaker family. Her father, Joseph Lea Jr., owned cotton manufacturing and printing factories, and three of her five younger sisters also developed careers in the visual and performing arts.

As a young girl, Lea attended politically progressive schools and studied classics, languages, mathematics, and music with private tutors. Initially, she taught herself to paint, but later she studied anatomy at the Women's Medical College in Philadelphia and, after moving to Europe with her family in 1865, she took art lessons with various masters in Italy, Germany, and France.

At the start of the Franco-Prussian War, Lea settled in London, where her teacher—the British painter and picture restorer Henry Merritt—also became her mentor and, in April 1877, her husband. Unfortunately, he died just three months after their wedding. As a memorial, Anna taught herself to etch and produced a book of Henry Merritt's art criticism and fiction, illustrated with twenty-three of her prints. A prolific author in her own right, Anna also wrote and illustrated two books about Hurstbourne Tarrant, the English village to which she moved in 1891 and where she spent the remaining four decades of her life. In addition, she published articles about mural painting, gardening, and the obstacles facing women artists.[1]

Merritt executed several major mural commissions, as well as portraits and easel paintings on literary and religious subjects. A member of London's Royal Society of Painters and Etchers, Merritt exhibited her work regularly at the Pennsylvania Academy of the Fine Arts, the Royal Academy in London, and the Paris Salon. Her paintings and prints were also displayed at a number of prestigious venues, including the 1876 Centennial Exhibition in Philadelphia, the 1889 Exposition Universelle in Paris, and the 1893 World's Columbian Exposition in Chicago.

ST. CECILIA

1887, etching on paper, 24⅝ × 14 in. (62.5 × 35.6 cm.)
Gift of Rona Schneider

The strongest influence on Anna Massey Lea Merritt's work was the art of the Pre-Raphaelite Brotherhood, especially William Holman Hunt, whose paintings had impressed Merritt as a child and whom she got to know personally while living in England. Merritt's etching of *St. Cecilia* reflects Hunt's influence in its meticulous attention to detail. Several other elements—including the saint's youthful beauty and her crown of flowers—are traditional ways of representing Cecilia. Because she is the patron saint of music, Cecilia is depicted here next to a pipe organ, holding in one hand a scroll that presumably contains a musical score, as she sleeps with her head propped up on the other. According to legend, St. Cecilia was protected by an angel; hence, the angelic faces hovering in the upper left margin of the etching.

Widely praised for her technical mastery as a printmaker, Merritt here conveys an amazingly rich range of tones and textures. She provides a strong sense of depth through the use of such devices as the elaborately patterned floor. Merritt also has a thorough command of human anatomy, as demonstrated by the way that the folds of Cecilia's garment fall about her body.

Anna Lea Merritt

MARY NIMMO MORAN

AMERICAN, 1842-1899

Considered "the most prominent of the [American] women etchers in the late nineteenth century,"[1] Mary Nimmo Moran produced a large number of prints that were widely celebrated for their boldness and originality.

In 1847 the artist and her brother emigrated to the United States from their native Scotland with their widowed father, a weaver named Archibald Nimmo. The family settled in Crescentville, Pennsylvania, where their next-door neighbors, English immigrants named Moran, introduced Mary to their son Thomas, a well-known artist. At eighteen Mary began to study drawing and painting with Moran; two years later they were married and moved to Philadelphia. The couple soon had two daughters and a son, and in 1872 they relocated to Newark, New Jersey.

While Thomas achieved great success with his oil renditions of the western United States, Mary concentrated on painting the landscape near their home. Although she sometimes traveled with her husband—to the West, Florida, and Europe—during the early years of their marriage Mary was too busy taking care of three young children, managing the household, and assisting her husband with his commissions to do much painting. She came into her own as an artist in 1879, when Thomas introduced her to the technique of etching. Working in this medium Mary achieved immediate success: she was elected

to membership in the Society of Painter-Etchers of New York; she became the only woman among the sixty-five original Fellows of London's Royal Society of Painter-Etchers; her prints won several awards and were collected by such prominent individuals as the English critic John Ruskin. Rather than being overshadowed by her famous spouse, on many occasions when both husband and wife exhibited etchings in the same show, it was Mary's work that was singled out for special praise.

In 1884 the Morans built a new home on Long Island, the surrounding area of which became the subject of many of Mary's most successful etchings. She died in 1899 of typhoid fever, after nursing their daughter Ruth through a bout with the same disease.

THE HAUNT OF THE MUSKRAT, EAST HAMPTON

1884, etching, brown ink on cream parchment
4½ × 11¼ in. (11.4 × 28.6 cm.)
Purchased with funds donated by the Ott family
in honor of Louise S. Ott

The Haunt of the Muskrat, East Hampton is one of many scenes by Mary Nimmo Moran that depict the area around her home in the village of East Hampton, New York. Known today as a mecca for artists, by the 1880s East Hampton was already a magnet for Manhattan-based painters, sculptors, and printmakers who enjoyed spending their summers amid the potato fields, salt ponds, and windmills of this light-infused, still-undeveloped landscape. This etching demonstrates the qualities that made Moran's work popular with so many viewers. Using a horizontal format with unconventional proportions, she creates a powerful, pleasing contrast between areas of dark, dense foliage and barely artic-ulated water. The vigorous, energetic line for which she was known is evident throughout this scene. Also clear is her intimate knowledge of the subject and her familiarity with seventeenth-century Dutch landscapes. This particular print has long held great appeal for specialists in the field; the year after it was completed, it was reproduced as the frontispiece for an important book about the history and technique of etching.[2]

NANCY AERTSEN

ca. 1820, watercolor on ivory
3½ × 2⅞ in. oval (8.9 × 5.6 cm.)
Gift of Wallace and Wilhelmina Holladay

This is a typical example of the portrait miniatures for which Anna Claypoole Peale was well known. It is made with watercolor on ivory, a highly demanding technique that had been developed by Rosalba Carriera during the previous century and that was still relatively new in America. The small scale of the painting shows off Peale's ability to create precise details; this is especially evident in the highlights on the sitter's tight, dark brown ringlets. Other passages reveal the artist's versatility—for example, in de-

picting the mass of soft curls that emphasizes the woman's unusually long, slender neck.

Nancy Aertsen was the second of eight children born in Charleston, South Carolina, to Esther Parry and Guillaem Aertsen. Four years after her father's death in 1806, Aertsen and her family resettled in Philadelphia.[1] What engages the viewer here is Aertsen's distinctive face, with its tentative, yet warm smile and expressive eyes. She is modestly attired, in a white dress covered by a red, paisley-bordered shawl, and wears no jewelry. The plain background encourages viewers to focus on the figure. Aertsen's status is further accentuated by the luxuriant, navy blue curtain—shot through with hints of gold thread—which has been pulled aside at the left.

ANNA CLAYPOOLE PEALE

AMERICAN, 1791–1878

As a member of America's first artistic dynasty, Anna Claypoole Peale played a critically important role in the burgeoning cultural life of early-nineteenth-century Philadelphia. Her uncle, Charles Willson Peale, was a noted painter and scientist; her father, James Peale, was a successful painter; and many of her siblings and cousins—both female and male—were also professional artists.

Peale was born in Philadelphia, where she spent most of her adult life, although she also lived and worked in Washington, D.C., Baltimore, Boston, and New York City. Trained by her father, Peale sold her first two paintings when she was only fourteen.[2] While she also produced still lifes, landscapes, and full-size oil portraits, from the age of twenty-three Peale specialized in portrait miniatures, for which there was a lucrative market. She quickly became popular with a succession of prominent sitters, including two American presidents, an ambassador, and several U.S. senators, plus major writers and scientists.

Founded in Philadelphia in 1805, the Pennsylvania Academy of the Fine Arts began holding its prestigious annual exhibitions five years later. Peale had work in this inaugural exhibition and continued showing there regularly. In 1824 she and her sister Sarah Miriam became the first women to be elected members of the Pennsylvania Academy. Anna married the Reverend William Staughton in 1829; he died just three months later. In 1841 she wed General William Duncan; they spent nearly a quarter century together until his death in 1864. In addition to her own busy career, the prolific Anna Claypoole Peale also trained another miniaturist, her niece, Mary Jane Simes.

SARAH MIRIAM PEALE

AMERICAN, 1800–1885

The youngest daughter of the American painter James Peale, Sarah Miriam Peale was "the leading portrait painter in Baltimore and St. Louis" during the mid-nineteenth century.[1] As part of a large and artistically talented family, this Philadelphia native was initially trained by her father. In 1818 she spent three months studying with her cousin, the noted painter Rembrandt Peale; his influence and inspiration, plus that of her uncle, Charles Willson Peale, were important for her early work.

After experimenting with still lifes and miniatures, Peale exhibited her first full-size portrait at the Pennsylvania Academy of the Fine Arts in 1818. Six years later she and her sister Anna Claypoole Peale, a miniaturist, became the first two female members of the Academy, an enormously influential Philadelphia institution.

Peale never married, preferring to devote her energies to her career. Her oil portraits quickly became sought after by diplomats, congressmen, and other eminent individuals who visited her studios—first in Baltimore and later in St. Louis. Records show that Peale received many more portrait commissions than such celebrated male painters of the day as Thomas Sully and John Vanderlyn.[2] Beginning in 1859, Peale went back to painting still lifes, for which she won numerous awards. She spent the last seven years of her life in Philadelphia, where she lived with her sisters Anna Claypoole and Margaretta Angelica.

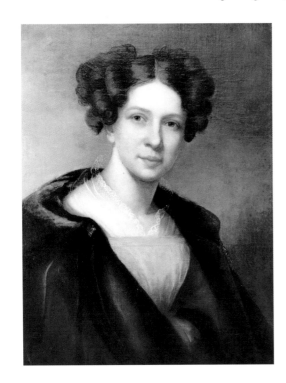

SUSAN AVERY AND ISAAC AVERY

1821, oil on canvas

35¼ × 27½ in. (89.5 × 69.9 cm.) each

Museum Purchase: The Lois Pollard Price Acquisition Fund

This pair of pendant portraits (painted as a set, typically of husband and wife) illustrates the skill of Sarah Miriam Peale. In what are probably their wedding portraits,[3] both figures are depicted in a pose made popular by French neoclassical painters such as Jacques-Louis David and adopted by Rembrandt Peale by 1810.[4] The Averys both have stiff, formal postures, sitting with their bodies turned slightly to one side and their gazes directed toward the viewer. Their neoclassical-style chairs and rich attire are indications of their elevated socioeconomic status. Particularly noteworthy in this regard is Susan's jewelry—earrings and a heart-shaped pendant—plus the large tortoise-shell comb worn at the back of her head and complemented by a pair of

smaller combs that hold back the dark curls framing her face. Research suggests that Isaac Avery was probably a manufacturer of such combs, which were expensive luxury items of the time, as were cashmere shawls of the kind seen draped around Susan Avery's left arm.

Peale's affinity for painting details is further demonstrated in the highlights on Isaac's stick pin, watch chain, and the double row of gold buttons on his jacket—the second button from the top, on the viewer's right, is actually painted as though it were twisted at an angle, to make it catch the light. Even more remarkable than Peale's ability to convey such decorative elements is the balance she achieves between this kind of specificity and the broad, plain background in both paintings. Most important, through her depiction of the Averys' postures and facial expressions, Peale has created a visually and emotionally satisfying image of this proud and prosperous Philadelphia couple.

LILLA CABOT PERRY

AMERICAN, 1848–1933

LADY WITH A BOWL OF VIOLETS

ca. 1910, oil on canvas, 40¼ × 30 in. (102.2 × 76.2 cm.)
Gift of Wallace and Wilhelmina Holladay

Lady with a Bowl of Violets combines Lilla Cabot Perry's love of light-infused impressionist colors and bravura brushwork, plus her familiarity with Japanese aesthetics and her affinity for portraying young women within domestic interiors. Painted after the family's return from Tokyo, this canvas features a Japanese color woodblock print behind the sitter's head on one side and a simple floral arrangement on the other.[1] Both print and flowers are cropped dramatically, in a manner reminiscent of traditional Japanese art; the curious and daring compositional emptiness of the left side of the picture derives from the same source.

Although the sitter's head is rendered in a relatively realistic manner, the rest of the canvas exhibits the loose, painterly brushwork favored by Perry and other impressionists. She manages to suggest the texture of the young woman's skin and the heavy white lace trim on her gown with just a few broad strokes of pigment. Even more radical are the vibrant orange highlights representing reflected light from the fireplace. As intriguing as Perry's technique and composition may be, the most affecting aspect of this painting is the mysterious, slightly melancholy expression on the young woman's face.

As a member of a distinguished Boston family who received her first formal art training at age thirty-six, Lilla Cabot Perry was unlikely to become a professional painter, let alone a devotee of the French movement known as impressionism. Yet she did precisely that, developing a solid reputation during her lifetime as a painter and a poet, helping to promote impressionist art in the United States and Japan.

In 1874 Lilla Cabot married Thomas Sargeant Perry, a university professor of eighteenth-century English literature, with whom she had three daughters. The family traveled widely, living in Paris from 1887 to 1889, where Lilla studied painting at two well-known schools—the Académie Colarossi and the Académie Julian; she also trained in Munich and copied old-master paintings in Italy, England, and Spain. It was in 1889, when she was forty-one years old, that Perry saw her first impressionist painting (a work by Monet) in a Paris gallery. The experience literally changed her life; Perry sought out the artist and became his close friend. For nine summers the Perrys rented a house at Giverny, near Monet's, and while he never took pupils, he often advised Perry on her art.[2]

For three years, between 1898 and 1901, the family resided in Japan, where Thomas Perry taught at Tokyo's Keiogijiku University. This gave Lilla a rare opportunity to study the sources of impressionism—notably Japanese fabrics and prints—in depth. There she produced some eighty paintings; she continued to be prolific throughout her life.

Back home, Perry worked in Boston during the year and on a New Hampshire farm during the summers. To supplement her husband's income, she painted portraits and impressionistic landscapes. Perry exhibited her work at the Paris Salon and the World's Columbian Exposition in Chicago (1893) and won medals for her paintings at important exhibitions in Boston, St. Louis, and San Francisco. She was active in numerous arts organizations and published four well-received volumes of verse.

LILLY MARTIN SPENCER

AMERICAN, 1822–1902

In 1830 the eight-year-old Angélique Marie Martin (known as Lilly) was brought to the United States from her native England. Her mother and father, a politically progressive couple of French extraction, raised their daughter in the small town of Marietta, Ohio. When her artistic abilities and ambitions outstripped the cultural resources available there, her father took her to Cincinnati, where she studied with the portrait painter John Insco Williams.

At twenty-two, Lilly Martin married Benjamin Rush Spencer. They made their home first in New York City, then in Newark, New Jersey, and then moved into a large house in Highland, New York, across the Hudson River from Poughkeepsie. The Spencers had thirteen children, seven of whom survived to adulthood; Lilly was the family's principal breadwinner, while Benjamin managed their growing household. In the late 1840s and 1850s, the artist became popular in Europe and America for her still-life and portrait paintings, and especially for her humorous domestic genre scenes.[1]

Spencer exhibited her paintings at the National Academy of Design and was represented at the Women's Pavilion of the Philadelphia Centennial Exhibition in 1876. She also produced work for a number of prominent patrons. However, much of Spencer's fame resulted from the widespread sale of inexpensive engraved copies of her oil paintings.

THE ARTIST AND HER FAMILY AT A FOURTH OF JULY PICNIC

ca. 1864, oil on canvas, 49½ × 63 in. (125.7 × 160 cm.)
Given in memory of Muriel Gucker Hahn
by her loving husband, William Frederick Hahn Jr.

Lilly Martin Spencer's *The Artist and Her Family at a Fourth of July Picnic* depicts an idyllic scene in which well-dressed, middle-class Americans have gathered to celebrate their country's independence by eating, drinking, and entertaining one another. Sprawled on the ground at the center of the picture is the painter's husband, whose weight has apparently snapped the tree swing. While most of the assembled crowd seem amused by his fall, a child attempts to help him up, while the artist herself rushes in, her arms outstretched. Meanwhile, several revelers, and even the family dog, seem oblivious to Benjamin's mishap.

On one level, this painting is exactly what it seems to be: a charming genre scene that pokes fun at human foibles. Seen from an art-historical perspective, the painting is rather erudite, making references to several rococo masterpieces (notably Antoine Watteau's *Embarcation for Cythera* of 1717 and Jean-Honoré Fragonard's *The Swing* of 1766), while Benjamin's pose recalls the ancient Roman sculpture known as *The Dying Gaul*.

Even more intriguing is the suggestion by recent scholars that Spencer's painting is also an allegorical comment on the state of the nation.[2] Executed by the child of abolitionist parents during the Civil War (shortly after the Emancipation Proclamation was issued), this canvas has been interpreted as a cautionary vision of postwar America. Benjamin's undignified pose and the general merriment that greets his accident indicate a lack of respect for traditional authority figures. The black male servant, distractedly pouring a glass of wine onto a white woman's dress; his female counterpart, who looks away from the baby in her charge; the boy shooting a pistol into the air; and the young woman modeling the soldier's cap can all be interpreted as symbols of societal upheaval.

BESSIE POTTER VONNOH

AMERICAN, 1872–1955

Bessie Potter Vonnoh enjoyed a long and successful career at a time when it was still unusual for an American woman to make sculpture. A native of St. Louis, Potter suffered a series of baffling illnesses that kept her partially paralyzed from the ages of two through ten.[1] She recovered but remained physically small, reaching a height of just four feet, eight inches.

Potter was raised in Chicago, where her family had moved in 1874. She so enjoyed the clay-modeling classes at school that, by fourteen, she had decided to become a sculptor. As a teenager she studied at the Art Institute of Chicago under Lorado Taft, a noted, Paris-trained, American sculptor who later employed Potter as one of his assistants

making sculpture for the World's Columbian Exposition of 1893. This experience enabled the twenty-two-year-old Potter to open her own Chicago studio, where she began modeling small, delicately tinted plaster portraits of her friends. These proved so popular that Potter was able to take her first trip to Europe in 1895, during which she met Auguste Rodin, who was to become an important influence.

On her return to Chicago the following year, Potter achieved fame with *Young Mother*, a tabletop-size image of a woman cradling her infant. This work received enthusiastic reviews and became one of Potter's most sought-after sculptures. As the artist's reputation continued to grow, she also received several commissions for monumental public art.

In 1899 Potter married the painter Robert Vonnoh and moved with him to New York City, where they resided until his death in 1933. Her career continued to prosper. She received many medals, had important one-woman exhibitions, and in the 1920s, expanded her oeuvre to include large sculptural fountains and decorative garden figures.[2]

THE FAN

1910, silvered bronze
11⅜ × 4¼ × 4 in. (28.9 × 10.8 × 10.2 cm.)
Gift of Wallace and Wilhelmina Holladay

Called "an impressionist in plaster"[3] because of the momentary poses and rich textures of her works, Bessie Potter Vonnoh made her reputation largely through small, graceful figures like this one.[4] Virtually every aspect of *The Fan*'s composition emphasizes movement. The woman's torso sways to the right, causing her draperies to cascade over one side of the base, revealing the tip of her shoe on the other. This fluid motion is continued in the feathered fan, held at an angle against her hip, and in the reflexive gesture with which the woman holds the top of her gown closed with one hand. From 1903 on, Vonnoh dressed her women in generalized, flowing robes related to ancient Greek tunics, rather than the clumsy and unflattering fashions of the day.[5] This change also reflects Vonnoh's interest both in contemporary dance garb, specifically the unstructured, Greek-inspired costumes worn by the American modern dancer Isadora Duncan, and in the dress reform movement in the United States, which was attempting to liberate women from the unhealthful effects of the corset.

One of the most intriguing aspects of this sculpture is its extreme contrast between the carefully delineated textures of the draperies and fan and the woman's blurred, virtually featureless face. The addition of gleaming silver to the darker bronze further emphasizes this contrast.

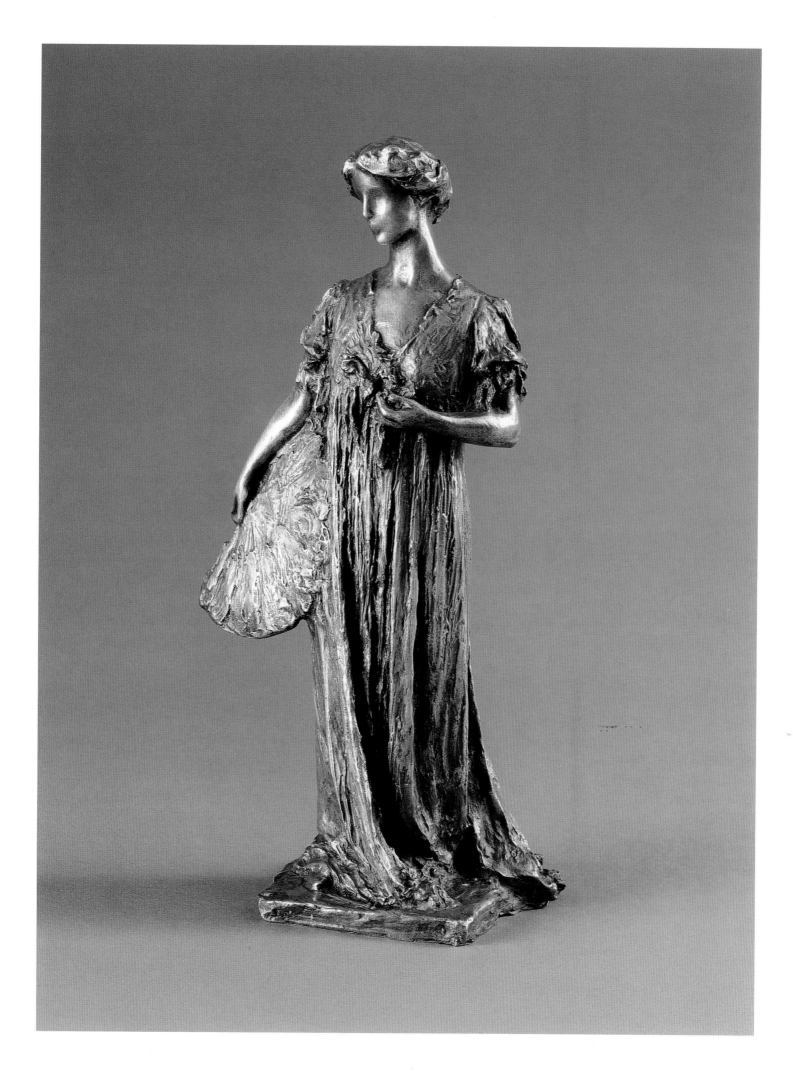

EVA WATSON-SCHÜTZE

AMERICAN, 1867–1935

THE ROSE

1905, gum-bichromate print, 13⅜ × 5 in. (34 × 12.7 cm.)
Gift of Wallace and Wilhelmina Holladay

The Rose demonstrates Eva Watson-Schütze's affinity for creating strong silhouettes. Here she has posed the young woman against a plain studio backdrop, thereby emphasizing the irregular outline of her dress, accentuated at the shoulders by the broad sweep of its heavily embroidered panels. The woman's placement in the center of the composition, facing straight toward the camera, adds to the feeling of flatness and further stresses the outline of her body against the backcloth, which is itself flat.

Watson-Schütze has chosen an unusual format for this photograph: a tall, narrow, vertically oriented rectangle, which the figure nearly fills. Virtually every element in this composition adds to its sense of verticality. One such aspect is the way the embroidered panels narrow to a point as they descend toward her hem. In addition, the woman holds a fully opened rose, the stem of which is so long it reaches from her throat to her knees, forming a slender dark line that echoes her slim proportions and her dark hair, which is parted in the center. The broad satin ribbon near the hem of the dress provides one of the few horizontal lines in the picture, paralleling the division between light and dark sections of the backdrop; its shiny texture is complemented by the gleam of the pearl ornament framing the subject's head. Clearly visible in the upper left corner of the image is Watson-Schütze's monogram, a device favored by many contemporary photographers who signed their work.

Like many late-nineteenth-century photographers, Eva Watson-Schütze originally intended to become a painter. Born Eva Lawrence Watson, the native of Jersey City, New Jersey, spent six years studying at the Pennsylvania Academy of the Fine Arts, primarily with Thomas Eakins. By her late twenties, however, Watson had developed a passion for photography. Between 1894 and 1896 she shared a studio space with another Academy alumna, and the following year she opened her own Philadelphia portrait studio. Within four years Watson had established a significant reputation as a professional photographer—exhibiting her works in the prestigious Philadelphia Salon and in group shows that traveled to London and Paris; writing articles on photography for several periodicals; and being labeled one of the "Foremost Women Photographers of America."[1]

Watson married the German-born lawyer Martin Schütze in 1901 and moved to Chicago. There, Watson-Schütze's career continued to prosper: in 1902 she was elected to membership in the Linked Ring, an important London-based organization that promoted pictorialism (emphasizing the artistic as opposed to the purely documentary aspects of photography); the next year she was a founding member of the Photo-Secession; and in 1905 she had her work exhibited at Alfred Stieglitz's influential New York gallery, 291.

Watson-Schütze established a new studio in Chicago and soon attracted a large and appreciative clientele for her romantic, yet powerfully composed portraits and figure studies. Beginning in 1902, she and her husband spent their summers in Woodstock, New York. Eventually, Watson-Schütze lived there six months out of the year, working on photography and painting.

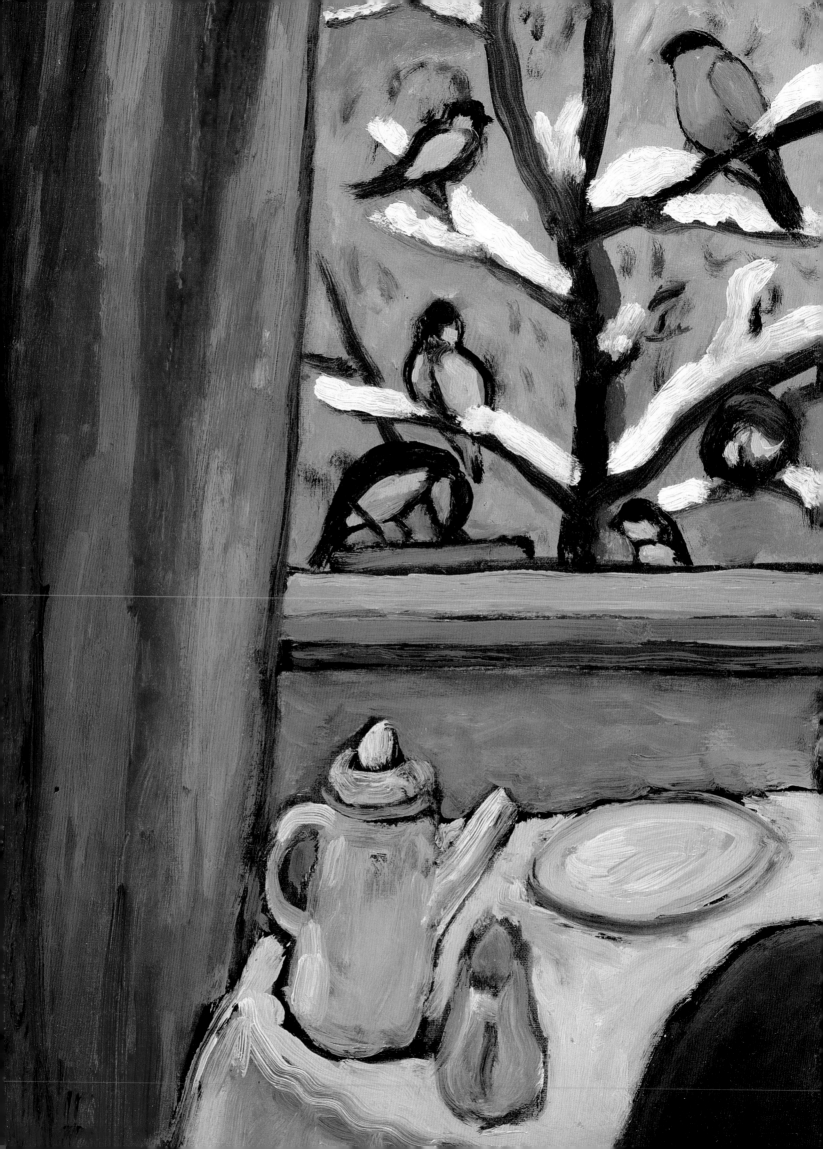

20TH-CENTURY EUROPE

In 1913 the French writer Charles Péguy commented: "The world has changed less since the time of Jesus Christ than it has in the last thirty years."[2] This astonishing statement reflects the unprecedented rate of transformation that occurred in virtually every aspect of life during the period immediately before and after the start of the twentieth century.

Industrialization drastically changed the Western world. Daily life had been permanently altered by the introduction of the electric light, the telegraph, the airplane, and urban skyscrapers. At the same time, intellectuals had to deal with the profoundly exciting and equally unsettling questions raised by Sigmund Freud, Albert Einstein, Marie Curie, and other pioneering scientists, philosophers, and mathematicians, not to mention the effects of serious economic crises and World War I.

Similarly, many startling changes took place within the arts. In the early years of the new century, the revolutionary music of Igor Stravinsky and the choreography of such ballet and modern-dance pioneers as Vaslav Nijinsky and Mary Wigman permanently affected the way people thought about the performing arts. The visual arts experienced parallel changes with the birth of three influential avant-garde movements (fauvism, expressionism, and cubism) in less than ten years. The pace of such change continued throughout the 1900s.

For European women artists, the twentieth century was a period of increased opportunities and new challenges. In many ways the artists discussed in this section embodied the modern ideal of the New Woman. This independent, strong-minded individual ignored traditional ideas about appropriate behavior and appearance, bobbing her hair, wearing practical clothing, and smoking cigarettes in public. Europe's modern females were just as rebellious in terms of their art. Some academies remained closed to them at the turn of the century, but many women found success through unconventional career paths. The most extreme example of this phenomenon is Suzanne Valadon, who managed to become a celebrated painter despite being raised in poverty with no formal education. Twentieth-century European women were also instrumental in founding and sustaining radical artists' movements, political organizations, and periodicals. Moreover, for the first time, significant numbers of women artists specialized in such unusual subjects as monumental nudes.

Earlier sections of this book concentrated on women from particular countries, especially Italy, France, and England, but some of the most important contributions to European art of the early 1900s were made by women from Germany, Switzerland, and prerevolutionary Russia. Nevertheless, Paris remained the principal cultural center of Europe; thus, while only one of the ten artists represented in this section was born in France, six spent the majority of their adult lives there.

The personal profile of the twentieth-century European woman artist was significantly different from that of her predecessors. Most professional female artists from earlier centuries had fathers or husbands who were artists. However, none of the women discussed here had the advantage of an artist father. Valadon never knew her father, and the fathers of Laserstein, Taeuber-Arp, and Vieira da Silva died when their daughters were just two years old. The remaining women in this section grew up with fathers who had jobs so far removed from art (factory worker, surveyor) that they could not provide much practical assistance in terms of their daughters' careers. Likewise, of the women in this section who chose to marry, only half wed other artists.[3] Balancing motherhood with a career remained difficult throughout the twentieth century. Less than half of this group had children, yet Hepworth managed to achieve international celebrity as a sculptor along with raising four children—including a set of triplets.

Unquestionably, the most significant phenomenon that took place in the visual arts during this period was the development of pure abstraction (also called nonobjective or nonrepresentational art). Such art is not specifically based on anything from the real world; rather, it is an arrangement of colors and forms, organized in purely aes-

thetic terms. While radical European artists had been moving toward abstraction since the late 1800s, it was during the early twentieth century that fauve, expressionist, and especially cubist artists made possible the final break with traditional representation. Alice Bailly's *Self-Portrait* provides an excellent example of a cubist-inspired work in which the underlying subject, while still recognizable, is highly stylized. On the other hand, Vieira da Silva's painting is so far removed from its source that it is difficult to identify, and the works shown here by Hepworth and Taeuber-Arp have no counterparts in the real world. At the same time a good deal of twentieth-century art made by women and men retains an obvious connection with reality, although significant liberties have been taken. The works of Kollwitz, Laserstein, Münter, and Valadon fall into this category.

Twentieth-century European culture was also marked by an increasing interest in the so-called decorative arts. For centuries, a clear distinction had been drawn between the fine arts of painting, sculpture, and printmaking and the less prestigious, "minor" or decorative arts—such as embroidery, weaving and similar fiber arts, ceramics, stained glass, and other various types of design. The textile arts, in particular, had long been associated with women and were,

therefore, considered less important than easel painting.

This situation changed with the art of women such as Sonia Terk Delaunay, who challenged the traditional distinction between artist and designer by creating both abstract paintings and abstract sculptures and radically innovative costumes and sets for Sergei Diaghilev's Ballets Russes and other avant-garde performing-arts troupes.[4]

Europe's new women of the twentieth century broke through most of the remaining barriers to art education for females. They went to Paris, where they became leaders among the art pioneers. There, despite continuing pressures to conform to a particular lifestyle or aesthetic system, twentieth-century European women artists conquered the challenge of representing the nude figure, while simultaneously championing the artist's right to create images that had no subject at all.

In addition, these women helped raise the status of artists working in theatrical and other design areas. By the mid-twentieth century, women artists in Europe had gone much further than Lavinia Fontana and her sixteenth-century colleagues could ever have imagined. As we shall see in the following sections, a similar process was going on among women artists from North America.

I HONOR EVERY WOMAN WHO HAS STRENGTH ENOUGH TO STEP OUT OF THE BEATEN PATH WHEN SHE FEELS THAT HER WALK LIES IN ANOTHER, STRENGTH ENOUGH TO STAND UP AND BE LAUGHED AT, IF NECESSARY.

— HARRIET HOSMER[1]

ALICE BAILLY

SWISS, 1872–1938

Alice Bailly was one of Switzerland's most radical painters in the early decades of the twentieth century. Bailly was born in Geneva, where she attended separate women's classes at the Ecole des Beaux-Arts. She also studied in Munich. By 1906 Bailly had settled in Paris, the center of avant-garde culture; there she became friends with a number of modernist painters, including Juan Gris, Francis Picabia, and Marie Laurencin. Bailly was in Paris exhibiting her early wood engravings, when the radical style known as fauvism first came to the fore. She was inspired by that style's bold use of intense colors, dark outlines, and emphatically unrealistic anatomy and space. In 1908 her new paintings hung at the Salon d'Automne alongside the art of the principal fauve painters.

At the age of thirty-nine, Bailly developed her own variation on an even more radical kind of art: cubism.[1] In 1912 her work was chosen to represent Switzerland in a traveling exhibition seen in Russia, England, and Spain. When World War I broke out, Bailly returned to Switzerland, where she invented "wool paintings," mixed-media works in which short strands of colored yarn imitated brush strokes. She made approximately fifty wool paintings between 1913 and 1922 and received an award for them when they were displayed in Paris in 1925.

Bailly was briefly active in the dada phenomenon. She then moved to Lausanne in 1923 and stayed there the rest of her life, continuing to exhibit regularly and promote the cause of modern art. In 1936 Bailly accepted a commission to paint eight large murals for the foyer of the Theatre of Lausanne. This monumental task led to exhaustion, which presumably made Bailly more susceptible to the tuberculosis that claimed her two years later. Her will directed that the proceeds from the sale of her art be used for a trust fund to help young Swiss artists.[2]

SELF-PORTRAIT

1917, oil on canvas, 32 × 23½ in. (81.3 × 59.7 cm.)
On loan from the Wallace and
Wilhelmina Holladay Collection

Alice Bailly's *Self-Portrait* of 1917 clearly demonstrates the influence of fauve, cubist, and Italian futurist art. Despite the standard three-quarter-length pose, this painting is a curious mixture of recognizable and unclear elements. The artist's hands, while stylized, elongated, and rubbery looking, are nonetheless easy to distinguish, as is the paint brush held in one hand and the palette, covered with dabs of bright color and held parallel to the picture plane, in the other. However, the area behind the figure—sections of gray, blue, and red-orange, sometimes overlaid with diagonal slashes—is ambiguous.

Although strong, dark outlines define Bailly's shoulders and breasts, there is no sense of her torso. The strangest part is the figure's face. Framed by Bailly's bobbed hair and signature wire-rimmed eyeglasses, one side of the face appears to have been painted out. The unexplained absence of one eye and half the mouth is profoundly unsettling. This effect represents neither cubist fragmentation of forms nor the futurist obsession with movement that fascinated Bailly from the 1910s. Instead, it appears to reflect a dissociation of the artist from her own image—in short, a kind of identity crisis.

STUDY FOR PORTUGAL

ca. 1937, gouache on paper, 14¼ × 37 in. (36.2 × 94 cm.)
Gift of Wallace and Wilhelmina Holladay

Portugal is the title of one of the two enormous murals—both now lost—that Sonia Terk Delaunay made for the Railroad Pavilion, one of a pair of temporary buildings devoted to honoring recent advances in transportation at the Paris World's Fair of 1937.[1] Planned to fit in with the scheme of the building—which had been designed to look like a real train station, complete with ticket booth, café, and magazine stand—Delaunay's painting comprised four large segments, the impact of which can only be imagined today through black-and-white photographs and this preparatory sketch.

This painting reveals Delaunay's typical emphasis on forms constructed entirely from vivid colors, rather than from lines. Although everything is highly stylized, it is clear that she has depicted peasant women and men, an ox cart, houses, several boats, and—in the background of all four sections—an aqueduct, the arches of which seem to get lower and lower as the imaginary train carrying the viewer moves from left to right.

The title of the work, and some of its imagery, presumably derive from the artist's memories of the years she spent in Spain and Portugal during World War I. Its repeated, interlocking shapes and surprising splashes of color reflect not only orphism but also the rapid pace of the many changes that occurred in modern art and life during the first decades of the twentieth century.

SONIA TERK DELAUNAY

RUSSIAN, 1885–1979

An extraordinarily prolific and innovative artist, Sonia Terk Delaunay produced easel paintings; public murals; theatrical, graphic, fashion, and interior designs; and designs for playing cards, ceramics, mosaics, and stained glass during her long career.

She was born Sarah Stern (nicknamed Sonia) in Ukraine, where her father was a factory worker. At five, Sonia went to live with a wealthy uncle in St. Petersburg and took his surname, Terk. Sonia Terk studied art in Karlsruhe, Germany, and also, beginning in 1905, in Paris, where she spent most of the rest of her life. In 1910 she married the French painter Robert Delaunay, with whom she had a son.

Both Delaunays are associated with orphism (also called simultaneism), an offshoot of cubism that they developed jointly in 1911. Like cubism, the Delaunays' approach to art is abstract, yet based on the real world. Unlike the mainly monochrome cubist works by Picasso and Braque, orphism consists of bright hues and bold, repeating patterns, based in part on the Russian folk art Sonia Delaunay had known as a young girl. In 1918 she designed her first set of costumes for Sergei Diaghilev's famous Ballets Russes. Thereafter, while Robert concentrated on painting, Sonia Delaunay created costumes and sets for various theatrical organizations. She also designed "total environments," including, for example, the interior of a Paris clothing boutique, plus the dresses, accessories, and furs sold there.

From the 1950s on, Delaunay received numerous awards for her work. In 1964 she became the first living female artist to have a retrospective exhibition at the Louvre, and in 1975 she was named an officer of the French Legion of Honor.

Alex. Exter

RUSSIAN, 1882–1949

COSTUME DESIGN
FOR LES EQUIVOQUES D'AMOUR

ca. 1933, gouache and pencil on paper
22³⁄₈ × 17¹⁄₈ in. (56.8 × 43.5 cm.)
Gift of Wallace and Wilhelmina Holladay

This is one of the costumes that Alexandra Exter designed for a male character in *Les Equivoques d'Amour* (*The Ambiguities of Love*), written by her friend the French playwright Francis de Miomandre. With its asymmetrical arrangement of unusually bright colors and unexpected forms, the design looks more like one of Exter's abstract paintings than a traditional theatrical costume. She developed this approach to such projects through Leon Bakst, a prominent Russian designer who believed that stage sets and costumes should be more than mere decoration. Rather, Bakst thought that they should interact with the performers, playing their own dynamic roles in the overall production.

In this example, Exter contrasts one part of the costume with another. The collar is long and tapering on one side, short and notched on the other; the pneumatic chartreuse sleeve seems unrelated to its mate, which features a broad blue pointed cuff and a dramatic lightning-bolt motif; even the elaborate fabric belt, gathered and knotted on one hip, turns into a voluminous, multicolored train that would undoubtedly create an eye-catching effect as the actor moved about the stage. Indeed, motion is tremendously important in all of Exter's designs; that fact is emphasized here by the actor's pose: turning slightly toward stage left, with his hand raised in a rhetorical gesture.

Although she was also a painter and book illustrator, the Ukrainian native Alexandra Exter's principal contribution to twentieth-century culture was as "a pioneering artist of modern theatrical design."[1] Born Alexandra Alexandrovna Grigorovich, she attended the Kiev Art Institute from 1901 to 1907. One year after completing her studies she married Nikolai Exter.

As a member of Russia's prerevolutionary artistic avant-garde, Alexandra Exter was close to other progressive artists, writers, and composers; she traveled frequently within Russia and also spent considerable time in Western Europe, especially Paris, where she began exhibiting her work in 1912. She opened her own studio in Kiev, where a number of noted artists, including Pavel Tchelitchew, were pupils. In 1916, at a time when nonobjective art was still extremely rare, Exter created her first totally abstract paintings. In the same year she began designing sets and costumes for a Moscow play. Her revolutionary designs won critical acclaim, and her theatrical career was launched.

For the next several decades Exter produced innovative and influential stage designs for plays, ballets, and experimental films. However, like many radical artists whose work did not fit in with Soviet ideology, Exter eventually left the country, settling permanently in Paris in 1924. There she remained an important influence through her exhibitions, her stage work, and her teaching at Fernand Léger's Académie d'Art Moderne. Exter continued experimenting and sometimes incorporated modern industrial materials such as celluloid and sheet metal into her futuristic designs. In 1925 she created a set of "epidermic" costumes for a ballet in which the dancers' bodies were painted, rather than dressed, with colorful shapes and patterns.[2]

BARBARA HEPWORTH

When Barbara Hepworth died, the *New York Times* ran both a formal obituary and an "Appreciation," thus indicating the broad recognition she had received during her lifetime.[1] The former called Hepworth "one of the world's foremost sculptors," while the latter praised her as a noted carver, "whose place in the annals of modern sculpture seems secure."

Born in the north of England, Hepworth discovered her passion for art as a young child and, in 1920, entered Leeds School of Art. Two years later she was admitted to the Royal College of Art in London, from which she was graduated in 1924. While on a postgraduate fellowship in Italy, Hepworth worked with master stonecarvers and met the British sculptor John Skeaping, whom she later married. Back in London, Hepworth was one of a small group of pioneering sculptors committed to exploring abstraction. She had her first solo exhibition in 1928 and, by the early 1930s, had developed her mature style: a sensuous kind of organic abstraction, sometimes incorporating strings, wires, colored paint, or holes piercing the sculpted form.

In 1931 Hepworth and Skeaping divorced; two years later she married the English avant-garde painter Ben Nicholson, with whom she lived and worked for the next two decades. During the 1950s Hepworth's reputation grew exponentially: she was represented in the Venice Biennale and won a first prize at the Biennial exhibition in São Paulo; she also had her first major retrospective exhibition and was made a Commander of the Order of the British Empire (she was awarded the rank of Dame in 1965).

MERRYN

1962, alabaster, 13 × 11½ × 8¼ in. (33 × 29.2 × 21 cm.)
Gift of Wallace and Wilhelmina Holladay

Merryn reveals Barbara Hepworth's preference for what is known as "direct carving." In art school, English sculptors were trained to model clay or plaster versions of their pieces and then turn them over to professional stonecarvers for completion. For Hepworth, however, an intimate, tactile relationship with her material was an essential part of the creative process. She avoided power tools and even polished her stone pieces herself.

Created three decades after Hepworth developed her signature style, *Merryn* still embodies many of these characteristic elements. Most obviously, *Merryn* is an organic abstraction made of simple, rounded shapes that nevertheless have a great sensual and emotional appeal. Like many of Hepworth's stone pieces, this one is pierced, creating a series of irregular, mysterious shadows that change as the viewer walks around the sculpture. Although *Merryn* is monochrome, it is carved from translucent alabaster, which reveals subtle internal irregularities and seems to change color, depending on the light.

Throughout her career, Hepworth stressed the influence that geography—specifically, the rugged Yorkshire countryside in which she grew up, and the Cornish coast, where she lived as an adult—had on her sculpture. So, while the vertical orientation of this work implies that it was inspired by the human body, placed on its side it could easily call to mind the curves and hollows of an English landscape. The title of this sculpture presumably refers—as do many of Hepworth's works—to an actual place, in this case, the village of St. Merryn, on the north coast of Cornwall, approximately eighty miles east of her home in St. Ives.

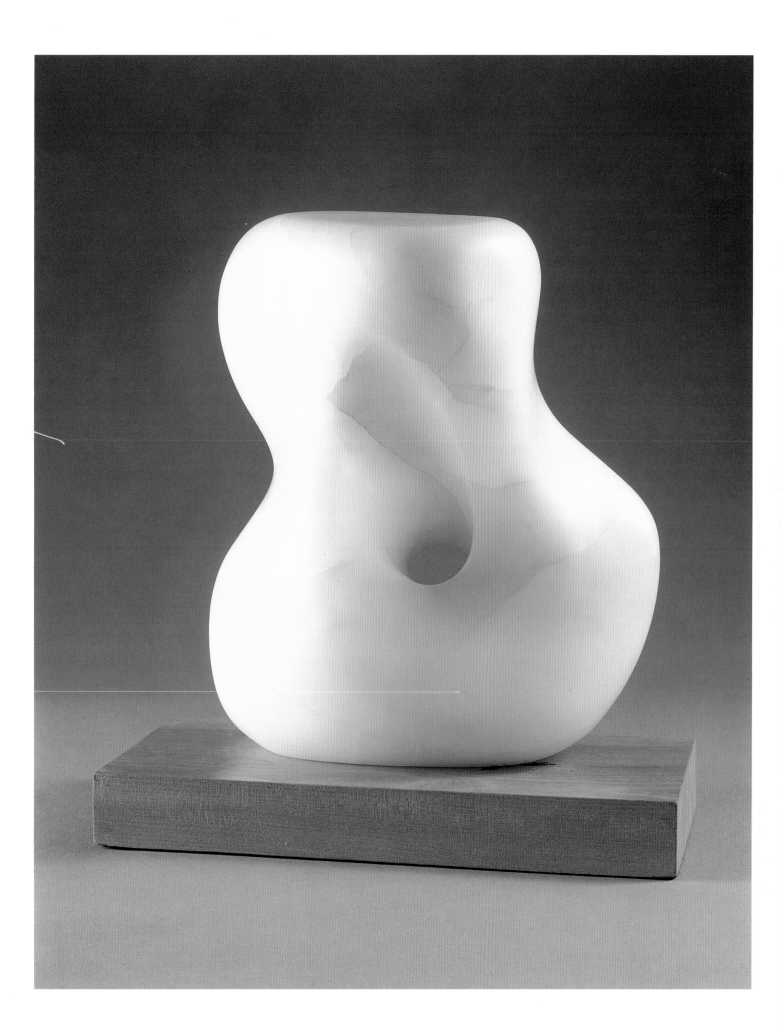

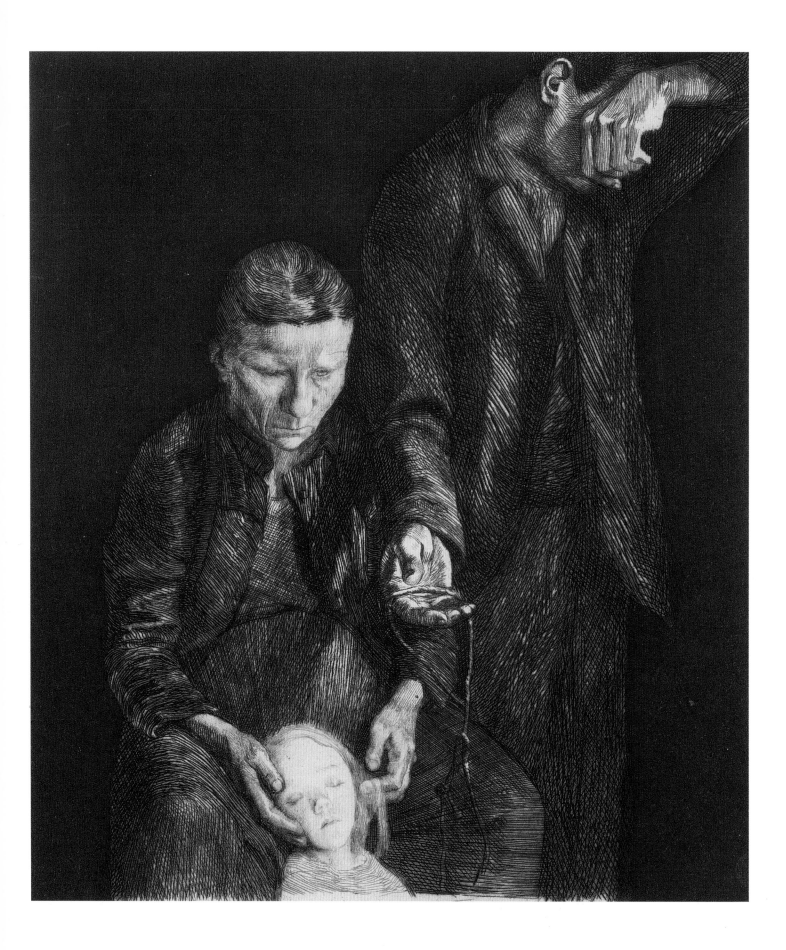

KÄTHE KOLLWITZ

GERMAN, 1867–1945

A lifelong commitment to championing the rights of underprivileged people and an extraordinary ability to express human suffering in artistic terms characterize the work of Käthe Kollwitz. As part of a politically progressive, middle-class family in Königsberg (now Kaliningrad, Russia), Käthe Schmidt was encouraged to develop her skills in painting and drawing. By age fourteen she was taking private classes with local artists, since the Königsberg Academy barred female pupils. She later studied in Munich and Berlin.

In 1891 Schmidt married the physician Karl Kollwitz and later had two sons. The family settled in a working-class neighborhood of Berlin, where her models and her husband's patients were the urban poor. Intrigued by both the narrative potential and the democratic qualities of the graphic arts, which could be produced in inexpensive editions, Kollwitz decided to become a printmaker.[2]

For the next fifty years she produced dramatic, emotion-filled etchings, woodcuts, and litho-graphs—generally in black and white but sometimes in-cluding touches of color. Al-though Kollwitz's wrenching subjects and virtuoso technique soon made her work popular throughout Germany and the Western world, they also gener-ated controversy. In 1897, for example, Kaiser Wilhelm pre-vented Kollwitz from receiving a gold medal at the Berlin Salon because of the "subversive" nature of her subject matter. Kollwitz also encountered diffi-

culties during the Nazi era. In 1933 she was forced to resign her posi-tion as the first female professor appointed to the Prussian Academy (in 1919); soon thereafter she was forbidden to exhibit her art.

During her final years Kollwitz produced bronze and stone sculp-ture, embodying the same types of subjects and aesthetic values as her work in two dimensions. Much of her art was destroyed in a Berlin air raid in 1943; later that year, Kollwitz was evacuated to Dresden, where she died at seventy-eight.

THE DOWNTRODDEN

1900, etching on paper, 12⅛ × 9¾ in. (30.8 × 24.8 cm.)
Gift of Wallace and Wilhelmina Holladay

The Downtrodden was originally conceived as the left-hand section of a triptych that Käthe Kollwitz had created several years before. Inspired by an 1893 pro-duction of Gerhart Hauptmann's play concerning the brutal repression of a workers' revolt, Kollwitz spent the next five years laboring over a six-part cycle of prints called *The Weavers' Rebellion*. The series was to have ended with this triptych, the form and content of which clearly allude to the traditional Italian Renaissance al-tarpiece, with a central, Christ-like figure laid out on a slab and mourned by two allegorical female figures. Kollwitz later rejected these religious references, re-working the portrait of a grieving proletarian family as an independent image.

Kollwitz further strengthens the emotional power of this etching by contrasting its rich, dark, unarticu-lated background with the careful cross-hatching in the parents' clothing and the startlingly pale face of the dead child. As is typical of her work, here the artist pro-vides just enough details—including the dramatic ges-ture of the father's left hand and the mother's stolid facial expression—to tell a story that, although it is rooted in nineteenth-century Silesia, still has reso-nance for working-class families the world over.[1]

LOTTE LASERSTEIN

GERMAN, 1898–1993

At the age of five, Lotte Laserstein told a friend that she had decided to become a painter and to remain unmarried. She honored both pledges for the remaining ninety years of her life, becoming a successful artist specializing in monumental female nudes and evocative portraits.[1]

After her father's death in 1902, Laserstein and her family moved from Prussia to Danzig; ten years later, they settled in Berlin. There, having received her initial art training in a school run by one of her aunts, Laserstein became one of the few female students at the prestigious Berlin Academy of Fine Arts, where she was enrolled from 1919 through 1925. Working with Erich Wolfsfeld, Laserstein became an accomplished realist painter, winning the Academy's gold medal for her work. She soon had her own pupils, and her first one-person exhibition at a Berlin gallery in 1930 garnered critical praise. Meanwhile, to supplement her income Laserstein took various jobs making decorative art and, most significantly, illustrating an anatomy text.

Despite her increasing success, the rise of Nazism in Germany began to affect Laserstein's life. Because her paternal grandfather had been Jewish, Laserstein's mother's apartment and many of her valuables were confiscated by the state; it became difficult for Laserstein to find artists' materials, and in 1935 she was forced to close her studio. Fortunately, some years earlier a friend had introduced her to several Swedish art dealers who expressed an interest in handling her work. Therefore, in 1937 Laserstein moved to Stockholm, where she remained for the rest of her life, becoming a member of the Swedish Academy of Arts and developing a reputation as a popular and respected portraitist. Her sister eventually joined Laserstein in Sweden, but their mother died in a concentration camp.

TRAUTE WASHING

ca. 1930, oil on panel, 39¼ × 25⅝ in. (99.7 × 65.1 cm.)
Gift of the Board of Directors

Lotte Laserstein met Traute Rose during the 1920s. A gifted athlete, Rose became the artist's tennis coach and, later, her favorite model, capable of holding difficult poses for an extended period of time. The two women remained close friends, even after Rose married and Laserstein moved to Scandinavia.

This painting[2] is typical of the straightforward, sober, and unflattering style known as German realism.[3] Although it features the life-size nude figure of a woman at her toilette—a venerable theme throughout Western and Asian art—*Traute Washing* exhibits none of the sensuality or grace generally associated with this subject, particularly as painted by male artists. Instead, Laserstein gives viewers her impression of the *neue Frau* (new woman): physically powerful and independent, clearly a real person rather than a goddess. Rose's connection with the world of the 1930s is evident from such touches as her blunt-cut, chin-length hair, several lank strands of which hang on one side of her face. She is also tied to reality by the well-worn bedroom slippers and dramatically cropped water basin at the lower edge of the canvas.

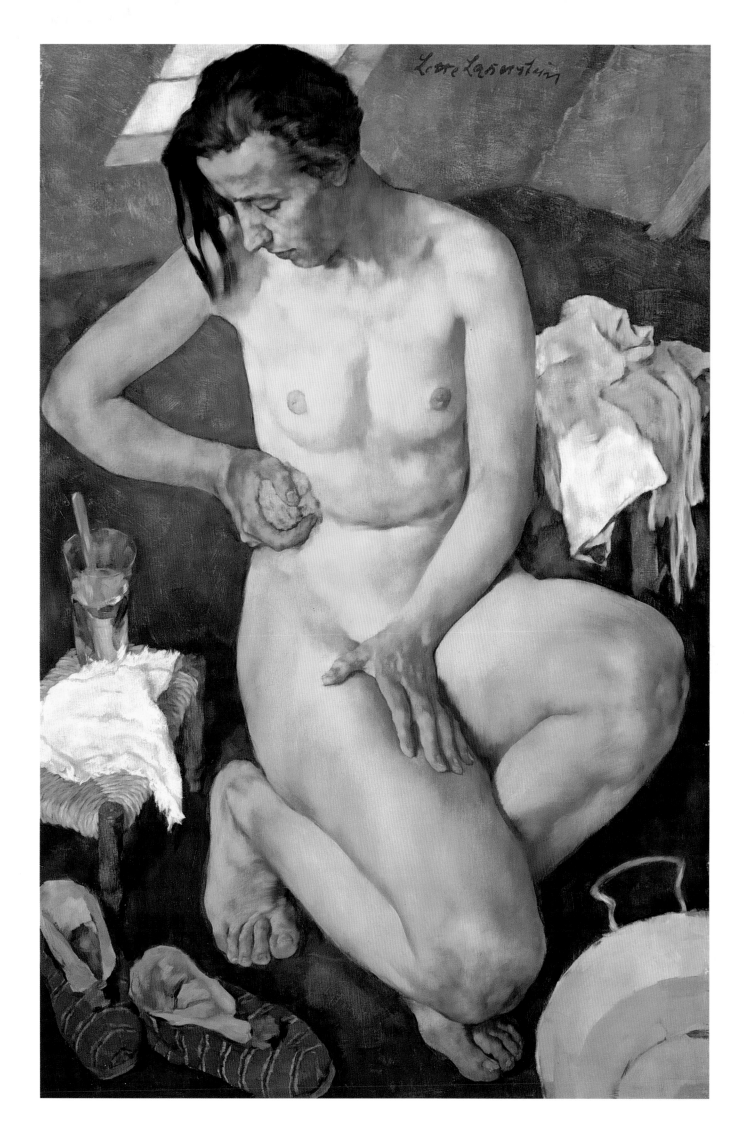

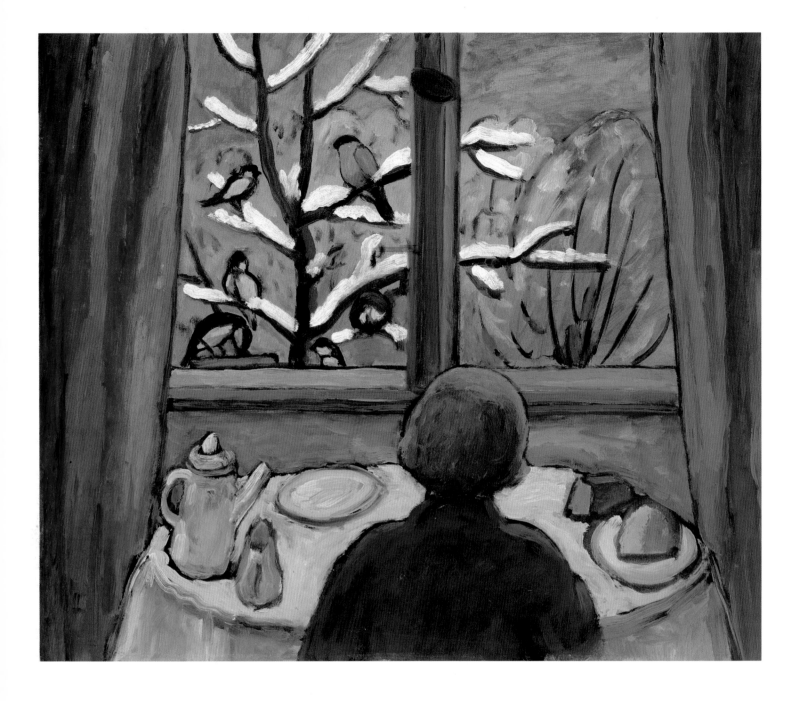

BREAKFAST OF THE BIRDS

1934, oil on board, 18 × 21¾ in. (45.7 × 55.3 cm.)
Gift of Wallace and Wilhelmina Holladay

In *Breakfast of the Birds*, Gabriele Münter takes a surprising viewpoint: depicting from behind a woman seated at her dining room table. The woman—sometimes identified as the artist herself—looks out the window onto a wintry landscape, where a group of titmice and a robin are perched on the snow-covered limbs of a tree.[1]

This painting demonstrates the signature elements of Münter's style: broad, thick, quickly applied brush strokes; heavy, dark outlines; the ambiguous use of perspective (as in the tilted tabletop, which clearly reveals everything on it but which does not conform to the angles from which the other elements of the picture are being viewed); and the lack of modeling, which makes the empty plate, for example, seem two-dimensional.

Münter frequently painted images of women in domestic interiors. Here the figure, sporting a decidedly modern haircut, seems to ignore her modest meal in favor of birdwatching. While critical interpretations vary, many scholars view this as a painting that stresses the contrast between indoor and outdoor spaces, emphasizing the woman's solitude and her physical and emotional isolation.

GABRIELE MÜNTER

GERMAN, 1877–1962

Despite being raised in a family and a country that discouraged women from developing a career in art, Gabriele Münter became a founding member of one of the most influential early-twentieth-century modernist movements: German expressionism.

Born in Berlin to upper-middle-class Protestant parents, Münter began drawing as a child. Because women were not allowed to enroll in the official German academies, she received private lessons and attended classes at the local Women Artists' School. Dissatisfied with its curriculum, Münter began attending Munich's progressive new Phalanx School, where she studied sculpture and woodcut techniques as well as painting. In 1902 Münter began a twelve-year professional and personal relationship with the Phalanx School's director, the Russian painter Wassily Kandinsky. Together they traveled through Europe and North Africa and in 1908 visited and fell in love with the picturesque village of Murnau in the lake district of southern Bavaria. Münter later bought a house there, where she spent much of her life. The following year, Münter helped establish the Munich-based avant-garde group Neue Künstlervereinigung (New Artists' Association), and in 1911 she, Kandinsky, and several other artists left that group to form Der Blaue Reiter (the Blue Rider), an important expressionist organization.

During World War I, Münter and Kandinsky went to neutral Switzerland, but, as a Russian national, Kandinsky was considered an enemy alien, so he returned to Moscow in 1914. Shortly thereafter, Kandinsky obtained a divorce from his first wife and, instead of marrying Münter, in 1916 he wed Nina Andreyevskaya, whom he had met in Russia. Münter never saw him again.

After a period of relative artistic inactivity, Münter, who by then was back in Germany, returned to painting seriously in the late 1920s. Despite the limitations imposed on her as a radical artist working during the Nazi era, Münter continued producing landscapes, portraits, still lifes, and interior scenes in a vividly colored, highly stylized manner similar to the one she had developed early in her career.[2]

S O P H I E T A E U B E R - A R P

SWISS, 1889–1943

One of the most radical artists of the early twentieth century, Sophie Taeuber-Arp was born in Davos, Switzerland. She left home at eighteen to study textile design in Germany and remained there a half-dozen years, during which time she was inspired by the innovative experiments of the German expressionists.

By 1915 Taeuber was producing paintings that were totally abstract—or, as she preferred to call them (since they were not abstracted from something else), "concrete." That same year she moved back to Switzerland and met the French sculptor, painter, and poet Jean Arp, whom she later married and with whom she collaborated on many artistic projects. Between 1916 and 1919, Taeuber-Arp was active in Zurich's dada group, dancing in its antiestablishment "performances." Dance was an integral part of Taeuber-Arp's life; she studied with the modern-dance pioneer Rudolf von Laban and became close friends with his assistant, Mary Wigman. Constantly exploring different media and techniques, Taeuber-Arp also produced innovative theatrical designs, embroideries, weavings, and sculptures.

After World War I, many of Taeuber-Arp's friends and colleagues moved to Paris, the headquarters of the European avant-garde. However, financial considerations forced her to remain in Zurich, where she had been a professor of textile design at the School of Applied Arts since 1916. An important commission to design the interior of Strasbourg's Café de l'Aubette gave Taeuber-Arp the wherewithal to move to Meudon, near Paris, in 1928.[1] This marked the beginning of the most productive period in the artist's life. She joined a number of artists' organizations, edited and wrote for radical publications, and exhibited her work throughout Europe. Taeuber-Arp and her husband fled to southern France when the Nazis invaded Paris. In late 1942 they returned to Zurich, where she died the following year.

COMPOSITION OF CIRCLES
AND SEMICIRCLES

1935, gouache on paper, 10 × 13½ in. (25.4 × 34.3 cm.)
Gift of Wallace and Wilhelmina Holladay

Composition of Circles and Semicircles exemplifies
the type of nonobjective painting Sophie Taeuber-Arp
began to create around 1930. A deceptively simple-
looking arrangement of blue, white, and red forms on
a black background framed by white, this piece has
actually been carefully worked out so that its flat,
hard-edged, geometric shapes seem visually bal-
anced. At the same time, the varying levels of in-
tensity among the colors used, and the unexpected
placement of whole, versus half circles, gives the

painting a strong sense of implied movement—which
many scholars believe has its source in the artist's
extensive choreographic experience.

Taeuber-Arp's visual art has a serene beauty that
requires no theoretical, political, or spiritual justifi-
cation. This painting demonstrates the direction in
which Taeuber-Arp moved after completing an earlier
series of related works that are composed exclusively
of rectilinear forms. She also produced polychrome
wood reliefs dealing with the same aesthetic issues. As
a young artist Taeuber-Arp was influenced by the work
of such painters as Paul Klee and Wassily Kandinsky.
In turn, the elegance and spareness of her art influ-
enced several of her contemporaries, most notably
her husband, Jean Arp, and Sonia Terk Delaunay.

SUZANNE VALADON

FRENCH, 1865–1938

THE ABANDONED DOLL

1921, oil on canvas, 51 × 32 in. (129.5 × 81.3 cm.)
Gift of Wallace and Wilhelmina Holladay

Suzanne Valadon was always best known for her powerful, unconventional, and sometimes controversial figure paintings that included many female nudes. *The Abandoned Doll* is one of two double portraits the artist created of Marie Cola and her daughter Gilberte, who was Valadon's niece.[1]

This painting exhibits all the characteristics of Valadon's mature work: brightly colored forms defined by heavy, dark outlines; strange, somewhat awkward poses; and deliberately simplified, distorted anatomy and space. These traits are also found in the work of post-impressionist painters like Paul Gauguin and fauve pioneers such as Henri Matisse, but Valadon denied being affected by their work and avoided all attempts to label her painting style.

In addition to its unusual aesthetic elements, this painting also has a strong psychological dimension: as the mother dries her daughter's back after a bath, the girl turns away to study her own image in a hand mirror. Meanwhile, her doll lies on the floor, symbolizing the adolescent's transition into adulthood.

Although her body is obviously maturing, Gilberte still has a child's large pink bow in her hair, identical to the one worn by the doll.[2] Avoiding the voyeuristic aspect of so many female nudes painted by men, Valadon gives viewers a compassionate glimpse of an intimate moment in a young girl's life.

Transforming herself from an artist's model into a successful artist, and rising from the hardscrabble existence of a poor, barely educated street child to a wealthy lifestyle with homes in Paris and the French countryside, Suzanne Valadon led a truly remarkable life.

The child of an unmarried domestic worker, Marie-Clémentine Valadon (she later changed her given name to Suzanne) grew up in the bohemian quarter of Paris called Montmartre. There Valadon supported herself from the age of ten with a series of odd jobs: waitress, nanny, and circus performer. A fall from a trapeze persuaded her to leave the circus. From 1880 to 1893, Valadon worked as a model for several of the most important painters of her day, including Pierre-Auguste Renoir and Henri de Toulouse-Lautrec. These masters, plus Edgar Degas—for whom she did not model but who became a close friend and mentor—had an enormous impact on Valadon's life and art. Although she could not afford formal classes, Valadon learned readily from the painters around her. Degas also helped, teaching her drawing and etching techniques.

It was not until 1909, at the age of forty-four, that Valadon began painting full time. By then, her personal life had become complex: in 1883 she had a son out of wedlock (Maurice Utrillo, who also became a painter); in 1896 she married a wealthy older man, whom she divorced several years later; and in 1909 she started living with another man, André Utter, who became her second husband.[3] With her first one-person show in 1911, Valadon attracted critical acclaim and numerous patrons. She continued to exhibit regularly, reaching the peak of her fame in the 1920s, and had four major retrospective exhibitions during her lifetime.

MARIA ELENA VIEIRA DA SILVA

PORTUGUESE, 1908–1992

"When I paint a landscape or a seascape, I'm not very sure it's a landscape or a seascape. It's a thought form rather than a realistic form."[1] Thus did Maria Elena Vieira da Silva explain her approach to her art, which is almost always completely abstract.

Although she was generally regarded as Portugal's greatest contemporary artist,[2] Vieira da Silva spent six decades of her life in France, where she became a naturalized citizen in 1956. Born in Lisbon, Vieira da Silva began seriously studying drawing and painting at that city's Academia de Belas-Artes when she was only eleven. At sixteen, she expanded her artistic interests to include the study of sculpture. Three years later she moved to Paris. There Vieira da Silva studied painting with Fernand Léger, sculpture with Antoine Bourdelle, and engraving with Stanley William Hayter, all acknowledged masters in their fields. She also created textile designs.

In 1930 Vieira da Silva was exhibiting her paintings in the French capital; that same year she married the Hungarian painter Arpad Szenes. Aside from a brief sojourn back in Lisbon and a period spent in Brazil during World War II, Vieira da Silva continued to reside in Paris for the rest of her life.

By the late 1950s Vieira da Silva had become internationally known for her dense and complex compositions, influenced by the art of Paul Cézanne and the fragmented forms, spatial ambiguities, and restricted palette of cubism. She exhibited her work widely, winning a prize for painting at the Biennial in São Paulo in 1961. Vieira da Silva was the first woman to receive the French government's Grand Prix National des Arts in 1966; she also won many other awards and honors, including being named a Chevalier of the Legion of Honor in 1979.

THE TOWN

1955, oil on canvas, 39½ × 31¾ in. (100.3 × 80.6 cm.)
Gift of Wallace and Wilhelmina Holladay

Virtually the entire surface of Maria Elena Vieira da Silva's canvas *The Town* is covered with tiny, repeated squares and cubes or vertical lines. While these forms clearly suggest the rectilinear and vertically oriented architecture of the modern city, they also create a dynamic and richly textured, abstract surface that is visually exciting in its own right.

The cool colors (muted brown, gray, blue, beige, yellow, and white) are set off by a few touches of brilliant orange. Meanwhile, the overall design is anchored in place by a grid of black lines. One of the most interesting aspects of Vieira da Silva's painting is the way in which its constituent parts, especially the colored squares and cubes, seem to shift back and forth within the implied pictorial space. They sometimes seem to shimmer, calling to mind the blinking lights and fast-moving traffic of an urban environment.

Vieira da Silva started each work without any image in mind. Rather, she simply began laying down a few lines, which in turn suggested what she should do next. Although she worked intensely, almost obsessively, Vieira da Silva seldom completed more than ten paintings per year, presumably because of the slow, careful way in which she wove together myriad, carefully balanced colors and forms.

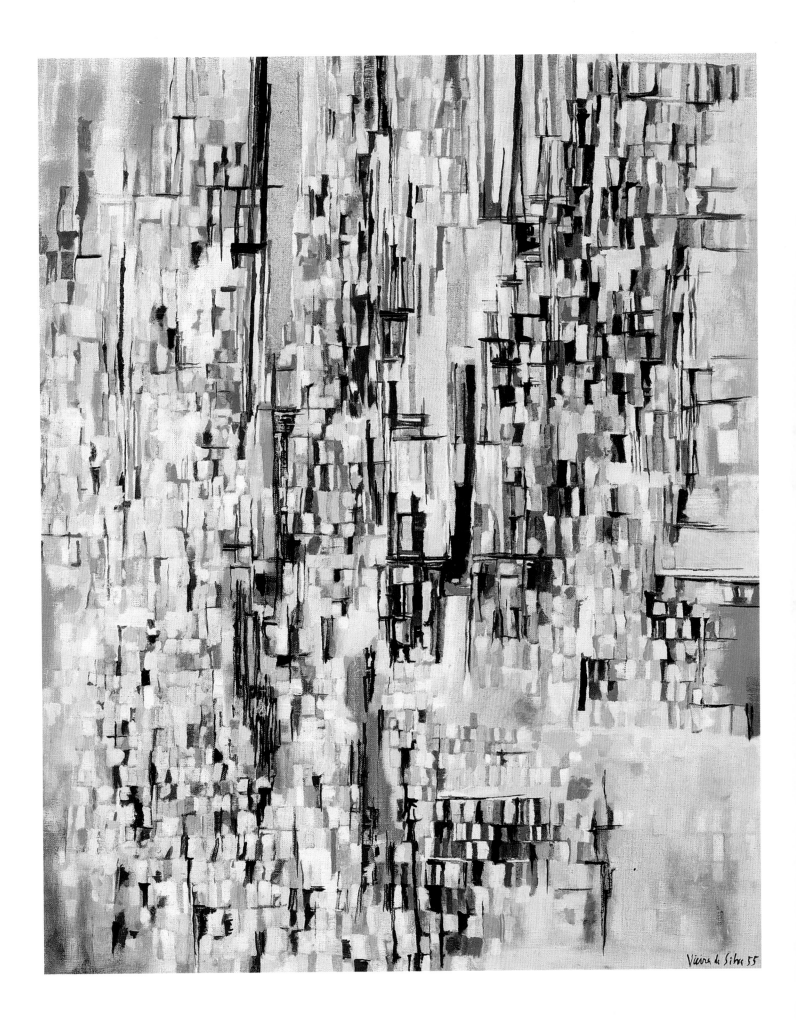

Artists in North America, like their European counterparts, were affected by the fast-paced, stimulating and unsettling changes that occurred in virtually every aspect of life during the early twentieth century. Women played major roles in all of the important artistic developments of this period, including the exploration of abstraction, the revival of relief printmaking, and the tremendous growth of photography.

Nevertheless, a significant number of obstacles remained to be overcome. By 1900 most of the important art schools in North America had opened their doors to women, although several were remarkably slow to make life drawing and anatomy classes coeducational.[2] Likewise, women were able to join the most prestigious arts organizations, but only in very small numbers and with limited membership privileges.[3] Denied full admission to the center of the art world's power structure, women helped establish and maintain alternative organizations such as New York's Art Students League, founded in 1875, a politically progressive institution that enjoyed tremendous influence throughout the first half of the twentieth century. A group of wealthy artists and art patrons, including Katherine Dreier and Gertrude Vanderbilt Whitney, ran private salons. Based on eighteenth-century European models, these ready-made communities were extremely important for the careers of women artists. Women also made significant contributions through political action groups like American Abstract Artists. In 1913 women composed more than one-sixth of the artists represented in the ground-breaking Armory Show. Throughout the 1930s, they were extremely active. Forty-one percent of the Works Progress Administration artists and a number of its most important administrators were also women.

At the same time, however, artists of both sexes in the United States still had to deal with the relative paucity of venues in which to display their work. The Art Institute of Chicago, the Museum of Fine Arts, Boston, and New York's Metropolitan Museum of Art had all been established during the 1870s and 1880s, but their permanent collections concentrated on the works of male Europeans from previous centuries. By 1940 there were significantly more opportunities to see contemporary art, at least in New York City, where the Museum of Modern Art opened in 1929 and the Guggenheim Museum in 1937. Again, however, these institutions collected and exhibited art that was almost exclusively European and almost entirely created by men. Ironically, it was nearly impossible for living American artists to have their work displayed in their own country, except at a few radical galleries, the most influential of which was Alfred Stieglitz's 291, named after its address on Fifth Avenue. Stieglitz showed the work of both men and women—most notably Georgia O'Keeffe; he also displayed objects such as African tribal sculpture and children's drawings, which few people classified as art.

The major avant-garde art movements from the first part of the twentieth century developed in Europe. For this reason, and because of their rich cultural histories, European cities continued to attract American artists throughout the early 1900s. France was a particularly popular destination for American painters, many of whom were strongly influenced by impressionist and fauve styles. Like their French counterparts, modern American artists were also inspired by Japanese color woodblock prints. Grace Albee began making prints and first gained recognition when she and her family lived in France, while Bertha Lum was one of the first Western artists who went directly to the source, spending much of her life in Asia working with various printmaking techniques.

The obstacles Lois Mailou Jones and Elizabeth Catlett had to overcome had as much to do with race as with gender,

AMERICA

nationality, or artistic style. Raised in segregated America, these African American women found it easier to work outside their native countries—Jones in France and Haiti, Catlett in Mexico, where she settled permanently in 1946. Both enriched their art with elements borrowed from their adopted cultures.

Also remarkable are the lives and careers of María Montoya Martínez and Lucy Martin Lewis. Although they were from two different pueblos, these women shared an ancient tradition—Indian women had been making pottery for more than two thousand years. They also shared the numerous challenges facing any members of a marginalized ethnic group. Yet each woman developed a distinctive type of pottery that quickly became valued both within and outside her tribe.

While Lewis and Martínez traced their artistic roots back many generations, another group of important North American women artists made great strides working with an art form that was less than a century old. Although it had existed since the late 1830s, photography was widely recognized as a fine art only in the 1900s. The work of the four women photographers discussed in this section demonstrates several ways in which this process was used during the early twentieth century. Working for *Harper's Bazaar*, Louise Dahl-Wolfe helped change fashion photography. However, like Berenice Abbott, she preferred taking psychologically probing celebrity portraits. During

her fifty-year career Barbara Morgan created some of the most memorable photographs of motion ever made—especially the work of America's modern-dance pioneers. Growing up during the 1910s, Lola Alvarez Bravo had to overcome traditional attitudes toward the proper role of women in Mexican society.[4] She did so and became a respected professional photographer, known for her riveting images of everyday life in Mexico.[5]

Traditional Mexican culture also forms the basis for the art of Frida Kahlo. Known today as much for her tragic life as for her paintings, Kahlo created surreal self-portraits that depicted her personal reality. Badly injured at eighteen, Kahlo had to overcome many obstacles simply to survive. Yet her intelligence, imagination, and commitment to contemporary politics and her own cultural roots enabled Kahlo to create art that still fascinates viewers a half century after her death. Although she was born a world away from Kahlo, Alice Neel also drew on her own harrowing experiences to paint powerful, and startlingly frank, portraits of herself and others.

During the first half of the twentieth century, the North American women artists discussed in the following pages managed to overcome a whole host of personal and professional challenges to become successful working in a wide range of media and styles. Their efforts and triumphs set the stage for an unprecedented flowering of art made by women in the decades after World War II.

IF I DIDN'T START PAINTING, I WOULD HAVE RAISED CHICKENS.

—ANNA MARY ROBERTSON ("GRANDMA") MOSES[1]

BERENICE ABBOTT

AMERICAN, 1898–1991

"I didn't decide to be a photographer; I just happened to fall into it," Berenice Abbott once recalled.[1] In 1917 Abbott went from her hometown of Springfield, Ohio, to Columbia University, intending to study journalism. Disappointed by her courses, Abbott soon switched to sculpture, which she studied in New York, Berlin, and Paris. It was only in Paris in 1923, when the avant-garde American expatriate Man Ray was looking for a darkroom assistant, that Abbott discovered her love and natural ability for working with the camera. She began taking portrait photographs and in 1926 opened her own studio. Abbott had the first of many one-woman exhibitions that same year.

During the 1920s Abbott became "the semiofficial portraitist of the intelligentsia" in Paris and New York.[2] Her straightforward, detailed, powerful images of such luminaries as James Joyce, André Gide, and Peggy Guggenheim made her famous. In the 1930s, Abbott continued her portrait work while completing a ten-year project commissioned by the Works Progress Administration: documenting the changing landscape of New York City.

Remarkably prolific, Abbott produced numerous books and several other ambitious series, notably images demonstrating various physical laws of nature and a photo essay on U.S. Route 1. When she began her career, photography was not considered a serious art form and women were not regarded as serious artists. Berenice Abbott overcame these and many other obstacles during her illustrious sixty-year career. She also invented new photographic equipment and techniques, received several honorary doctorates, and was the subject of many retrospective exhibitions. Abbott died at age ninety-three in rural Maine, where she had been living since 1965.

EVA LE GALLIENNE

ca. 1927, vintage silver print, 3½ × 4½ in. (8.9 × 11.4 cm.)
Gift of Wallace and Wilhelmina Holladay

Berenice Abbott was staunchly committed to the documentary approach to photography. Unlike pictorialists, who often used soft-focus and other painterly techniques to flatter and romanticize their subjects, Abbott preferred to show her subjects as they actually appeared, together with something of their character. Thus, her portrait of the American actress and director Eva Le Gallienne reveals the underlying intensity of her personality rather than focusing exclusively on her physical beauty.

Le Gallienne's awkward, radically asymmetrical pose makes the composition dynamic. The appropriately theatrical contrasts between the darkness that dominates the photograph and Le Gallienne's spotlit face and hands have the same effect. There are other strong contrasts here, between the sensual texture of her velvet gown and the lush embroidery at her neckline and cuffs, and between the tight focus on every stitch of that embroidery, as opposed to the blurred vase in the background. Other unexpected touches include Le Gallienne's commanding gaze—directed away from the camera—and her somewhat wild-looking hair.

This portrait was made soon after the London-born actress, with a half-dozen years' worth of Broadway success to her credit, founded the Civic Repertory Theatre, an organization charged with making classic foreign plays available to American audiences at a modest price.

MANHATTAN BACKWASH

1938, wood engraving on Japanese paper
6½ × 8½ in. (16.5 × 21.6 cm.)
Gift of P. Frederick Albee

To make works such as *Manhattan Backwash*, Grace Albee first sketched her subject carefully in pencil on the spot. Next she taped her drawing to the end of a block of Chinese boxwood and traced its major outlines onto the wood. She then cut away all the areas she wanted to keep white and put ink onto those sections that remained standing, in relief, above the cutaway portions. Albee printed each impression of every print by hand, using a burnisher to ensure that the ink was distributed evenly.

Because she worked with the end grain of the wood, Albee's images are small. Their size required her to be careful and precise in order to create the intricate shapes and rich, varied textures that characterize her prints. This technique allows for no corrections, and the use of black ink on white paper strengthens the contrasts—for example, between the tree limbs and the sky.

This engraving shows two of Albee's favorite themes: the effects of human habitation on the natural landscape and the passage of time. Rather than welcoming, the dilapidated Victorian house, with its blank windows and disintegrating fence, seems sad or even ominous. The oddly placed horizon line and the long series of stone steps make the house seem still further removed from the viewer's own world.

GRACE ALBEE

AMERICAN, 1890–1985

For more than fifty years, Grace Albee worked in the demanding technique of wood engraving, producing images that one reviewer described as "superlatively controlled [and] meticulously observed. Few artists have understood this medium so well."[1] Born on a Rhode Island farm, Grace Thurston Arnold started drawing at three. She studied at the Rhode Island School of Design from 1910 to 1912, and the next year she married the mural painter Percy F. Albee, with whom she had five sons. The family moved to Paris in 1928.

Long regarded as simply a technique for reproducing oil paintings, wood engraving as a fine art enjoyed a revival during the early twentieth century. As a child Albee had become fascinated with the engraved illustrations in her grandfather's books; as an adult, she made this medium her specialty.

During her five years in France, Albee developed a lifelong interest in depicting the urban and rural landscapes around her. Albee's works were exhibited at several Paris Salons and received positive reviews; she had her first one-woman exhibition in France in 1932. The following year the Albees moved back to the United States, settling in New York City, where Albee's detailed, evocative prints continued to be praised for their technical mastery. In 1937 the family bought a summer house in rural Bucks County, Pennsylvania. This region provided the material for much of Albee's subsequent work. By the 1940s her reputation was well established; the first article on Albee's work was published in 1946, the same year she was elected to full membership in the National Academy of Design.

Albee won numerous awards and honors; the Brooklyn Museum held a major retrospective of her prints in 1976; and she was still working actively well into her nineties.

LOLA ALVAREZ BRAVO

MEXICAN, 1907–1993

A native of Lagos de Moreno, a small city in Jalisco on Mexico's Pacific coast, Dolores (Lola) Martínez Vianda grew up to be one of that country's first professional women photographers. Her parents moved to Mexico City when she was very young. Orphaned at eight, she was raised by relatives and in 1925 married the young Mexican photographer Manuel Alvarez Bravo, who had been her friend and neighbor for many years. The newlyweds spent a year in Oaxaca, in central Mexico, where Lola assisted her husband in the darkroom and began taking her own pictures. The couple's son, Manuelito, was born in 1927; he also became a professional photographer. Lola and Manuel came to know many of the most important Mexican artists of the day, including the painters José Clemente Orozco, Rufino Tamayo, Diego Rivera, and Frida Kahlo.

In 1934 Alvarez Bravo's marriage came to an end; the couple separated and were divorced fifteen years later. Meanwhile, inspired by such photographers as Edward Weston and Tina Modotti, Lola established a successful independent career. For the next fifty years, Alvarez Bravo photographed a wide variety of subjects, making documentary images of daily life in Mexico's villages and city streets and portraits of great leaders from various countries. She also experimented with photomontage.

Alvarez Bravo's first one-woman exhibition was held at Mexico City's Palace of Fine Arts in 1944; numerous solo and group shows followed. From 1951 through 1958, she directed her own Mexico City art gallery, where in 1953 Frida Kahlo had her only one-woman exhibition in her native country during her lifetime. In addition, Alvarez Bravo taught photography at the prestigious Academia de San Carlos in the Mexican capital. A major retrospective of her work was held in Mexico City in 1992, although the artist had stopped making new work three years earlier because of failing eyesight.

DE GENERACION EN GENERACION (FROM GENERATION TO GENERATION)

ca. 1950, gelatin silver print, 9 × 6⅛ in. (22.9 × 15.6 cm.) Gift of the artist

This black-and-white photograph is typical of Lola Alvarez Bravo's work in that it combines a strong sense of Mexican nationalist pride with universal human emotions and an emphasis on abstract form. While the photograph itself is unposed, its composition has been carefully planned, creating a sense of mystery because of the mother's unseen face; the child's startled gaze, focused directly at the camera; and the cropped forms of other people on either side.

The woman's hairstyle—an unbound single braid that appears to be unraveling, plus a comb—and this particular type of wraparound skirt come from the town of Hueyapan in a mountainous area of south-central Mexico called Morelos.[1] Like Frida Kahlo, Alvarez Bravo celebrated the traditional costumes and customs of her country's varied regions. At the same time, the artist has captured a casual, yet elegant asymmetry—with the child peeking over her mother's left shoulder and the mother's earring gleaming on the right.

Adding to the visual interest of this photograph are the irregular puddles of light falling onto the mother's back and the contrast between the delicately embroidered borders of the neckline and sleeves of the little girl's shirt with the unadorned fabric worn by the adults in the picture.

ELIZABETH CATLETT

AMERICAN, B. 1915

SINGING THEIR SONGS

1992, from For My People
Color lithograph on paper
15¾ × 13¾ in. (40 × 35 cm.), 12/99
Purchased with funds donated in memory
of Florence Davis by her family, friends, and
the NMWA Women's Committee

Strength and dignity characterize the art of Elizabeth Catlett. As a young woman she studied—but quickly rejected—abstraction, believing that recognizable imagery was needed to make her work accessible to viewers. *Singing Their Songs* is part of a series of prints Catlett created to illustrate an important poem by the award-winning African American author Margaret Walker. Each of the four figures in this print offers a different view of the heroic quality and the physical beauty of African Americans. The first stanza of Walker's poem refers to black people "everywhere/singing their slave songs repeatedly"; it also describes people kneeling in prayer. Catlett has literally illustrated both actions, catching figures with their lips parted, in the middle of a sung or spoken phrase, thus adding a strong sense of dynamism to the print. The artist's use of numerous textures and patterns, as well as bold colors, further emphasizes the visual power of this work.

For sixty years, Elizabeth Catlett has been producing politically powerful art in both the United States and her adopted country of Mexico. Catlett was raised in Washington, D.C., the granddaughter of former slaves. Her father died six months before she was born, and her mother held several jobs to raise the three children. Refused admission to Carnegie Institute of Technology because of her race, Catlett enrolled at Howard University, where she studied painting and design, the latter with Lois Mailou Jones. She was graduated with honors in 1937, never to forget that first college experience, which radicalized the young artist. She has spent a lifetime creating images that champion poor and working people of all colors.

Catlett was the first person to earn an M.F.A. degree from the University of Iowa, in 1940. Her painting teacher, Grant Wood, encouraged students to make art about what they knew best and to experiment with different media. This inspired Catlett to create lithographs, linoleum cuts, and sculpture in wood, stone, clay, and bronze, all based on African American and later Mexican life. She established her reputation when she won first prize for sculpture at an important exhibition in 1941, but she also developed a career as an educator, teaching at Dillard University in New Orleans and at institutions in several other states.

In 1946 a grant from the Rosenwald Foundation enabled Catlett to move to Mexico City with her husband, the printmaker Charles White. There she joined the Taller de Gráfica Popular, an influential group of printmakers. At the Taller Catlett met the Mexican artist Francisco Mora, whom she married after divorcing White, and with whom she had three sons. Catlett taught at the National School of Fine Arts in Mexico City from 1958 until her retirement in 1976. Meanwhile, she produced realistic and highly stylized figures in two and three dimensions. Her work ranges from tender maternal images to confrontational symbols of the Black Power movement, plus portraits of Martin Luther King Jr. and the writer Phyllis Wheatley.

During the past forty years Catlett has had more than fifty solo shows of her sculptures and prints, including important retrospectives in 1993 and 1999. In her mid-eighties, Catlett continues to make art while dividing her time between New York City and Cuernavaca.[1]

COLETTE

1951, gelatin silver print, 10⅞ × 13⅛ in. (27.6 × 33.3 cm.)
Gift of Helen Comming Ziegler

Although best known for her fashion work of the 1940s, Louise Dahl-Wolfe always preferred taking photographic portraits, which allowed her more flexibility. This is one of a series of portraits Dahl-Wolfe took for *Harper's Bazaar* of distinguished writers—also including W. H. Auden, Dylan Thomas, and Eudora Welty—whose fiction the magazine published.

Colette (born Sidonie Gabrielle Colette) was one of France's best loved and most respected novelists. While the writer was seventy-eight years old and in poor health when this photograph was taken, Dahl-Wolfe clearly conveys Colette's lively intelligence, charm, and sense of style. Reclining in bed with a

manuscript propped up on her knees, the author of *Gigi* still manages to look both elegant and dignified. Colette wears a fashionably tailored suit, and her right pinkie is raised as though in the middle of a tea party. Dahl-Wolfe creates an intimate ambience by photographing Colette in her Paris apartment, with a glimpse of the city visible beyond the balcony. The composition is dynamic because of the strong diagonal of the writer's torso, the curve of the background curtain, and the impression that Colette has just turned away from her work for a moment to acknowledge our presence in the room.

Famed as a perfectionist, Dahl-Wolfe always developed her own photographs. Her technical control is evident in the dramatic contrasts between black, white, and shades of gray and in the rich variety of textures that make this photograph so visually satisfying.

LOUISE DAHL-WOLFE

AMERICAN, 1895–1989

As a staff photographer for *Harper's Bazaar* from 1936 through 1958, Louise Dahl-Wolfe introduced a witty, relaxed, and natural aspect to fashion photography and, in the process, helped "define the post-war look of American women."[1] She also made memorable portrait photographs of leading figures from politics and the arts, "discovered" a teenage Lauren Bacall,[2] and was a pioneer in the technique of color photography.

Born in San Francisco, Louise Dahl spent six years at her native city's Institute of Art studying painting, figure drawing, anatomy, and design. Inspired by the work of a friend, Dahl began experimenting with a camera at twenty-six. By 1929 she had established herself as a professional photographer and married the American sculptor Meyer (Mike) Wolfe, who often constructed the backgrounds for her photo shoots.

In 1933 the couple moved to New York, where Dahl-Wolfe was a freelance photographer. She accepted the position at *Harper's* because of her respect for the magazine's editor, Carmel Snow, and the fashion editor, Diana Vreeland, and also because they offered her considerable creative freedom. Using her extensive knowledge of art history, Dahl-Wolfe created surprising, often humorous, juxtapositions of her human models with famous paintings and sculptures. Fashion assignments led her to locations around the world and to unexpected parts of New York City, such as the elephant house at the Bronx Zoo.

Dahl-Wolfe's work was shown in important touring exhibitions, and she had several retrospectives. In 1989 Dahl-Wolfe received an honorary doctorate from Moore College of Art in Philadelphia, the first women's art college in the United States; her work is often cited as a significant influence on later photographers, notably Richard Avedon.

LOIS MAILOU JONES

AMERICAN, 1905–1998

In a career lasting more than seventy years, Lois Mailou Jones overcame racial and gender prejudices to become a successful painter and designer whose influence as a teacher extended far beyond her native country.

Jones was raised in Boston by working-class parents who emphasized the importance of education and hard work. After graduating with honors from Boston's School of the Museum of Fine Arts, Jones designed textiles for several New York City firms. She left in 1928 to take a teaching position at Palmer Memorial Institute in Sedalia, North Carolina. At Palmer, Jones founded the art department, coached basketball, taught folk dancing, and played the piano for Sunday services. Two years later she moved to Washington, D.C., to establish a career in painting. For more than forty years, between 1930 and 1977, Jones won widespread recognition for her art while teaching full time at Howard University, where she trained several generations of African American artists.

Jones was strongly affected by a sabbatical year she spent in Paris, 1937–38. After so much time in a segregated society, she felt exhilarated to be living in a country where her race seemed irrelevant. Equally important was her introduction to African tribal art, which was enormously popular in Parisian galleries. At home, Jones began incorporating African motifs into her canvases. After her 1953 marriage to the Haitian graphic designer Louis Vergniaud Pierre-Noël, Jones became intrigued by the bright colors and bold patterns of the Haitian art she saw on annual trips to her husband's home.

In 1970 Jones was commissioned by the United States Information Agency to serve as a cultural ambassador to Africa. She gave lectures, interviewed local artists, and visited museums in eleven countries. This experience led to a further exploration of African subjects in Jones's work, especially in the paintings executed between 1971 and 1989, which one writer has called "her most original contributions to American art."[1]

ESQUISSE (SKETCH) FOR ODE TO KINSHASA

1972, acrylic on paper, 11 × 8 in. (27.9 × 20.3 cm.)

ODE TO KINSHASA

1972, mixed media on canvas, 48 × 36 in. (121.9 × 91.4 cm.)
Gift of the artist

Ode to Kinshasa is named for the capital of Congo (formerly Zaire), a central African republic that Lois Mailou Jones had visited two years earlier. Unlike much of Jones's previous art, this example is neither academic nor impressionistic in style and has no overt political content. Jones's sketch reveals that she had already decided on the abstract composition and color scheme for the finished work. She made only minor adjustments yet created two distinct moods in the works through her treatment of the painted edges.

The fresh, loose, and unstudied quality of the sketch is replaced in the painting by strong geometric patterns and unexpectedly varied textures achieved through collage. Touches of shiny gold foil and creamy Japanese rice paper are pasted on amid the painted forms. This surface richness lends additional visual interest to Jones's mysterious, shieldlike form.

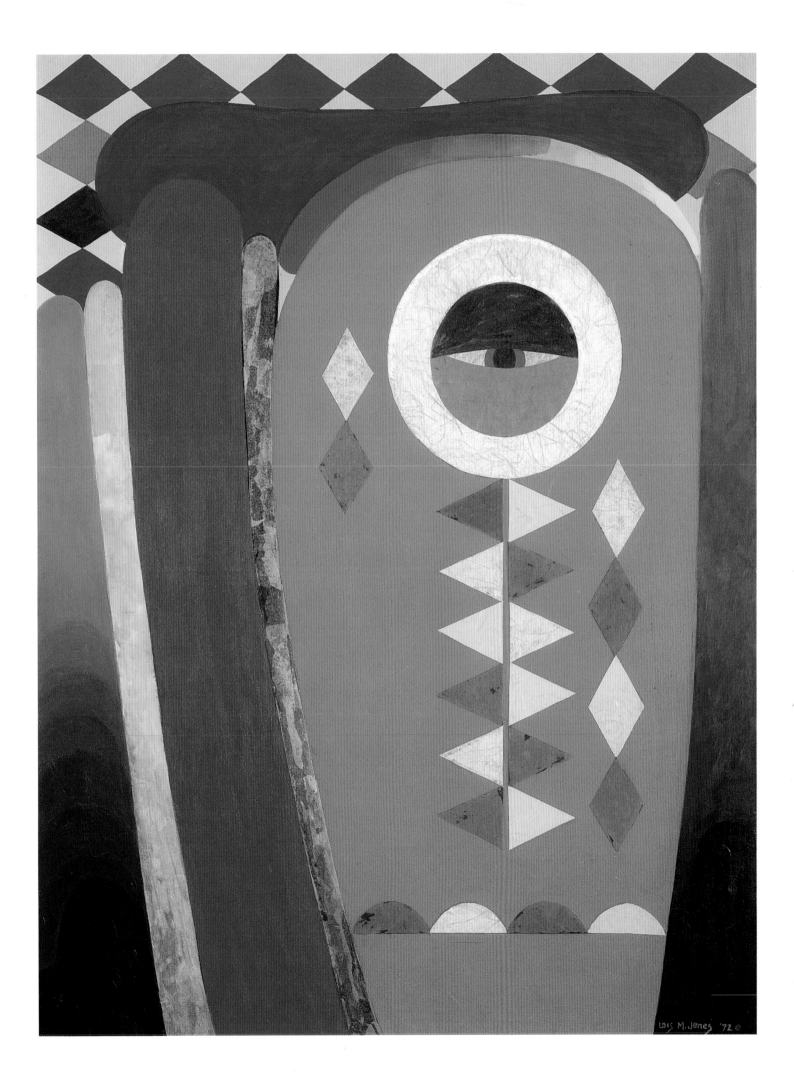

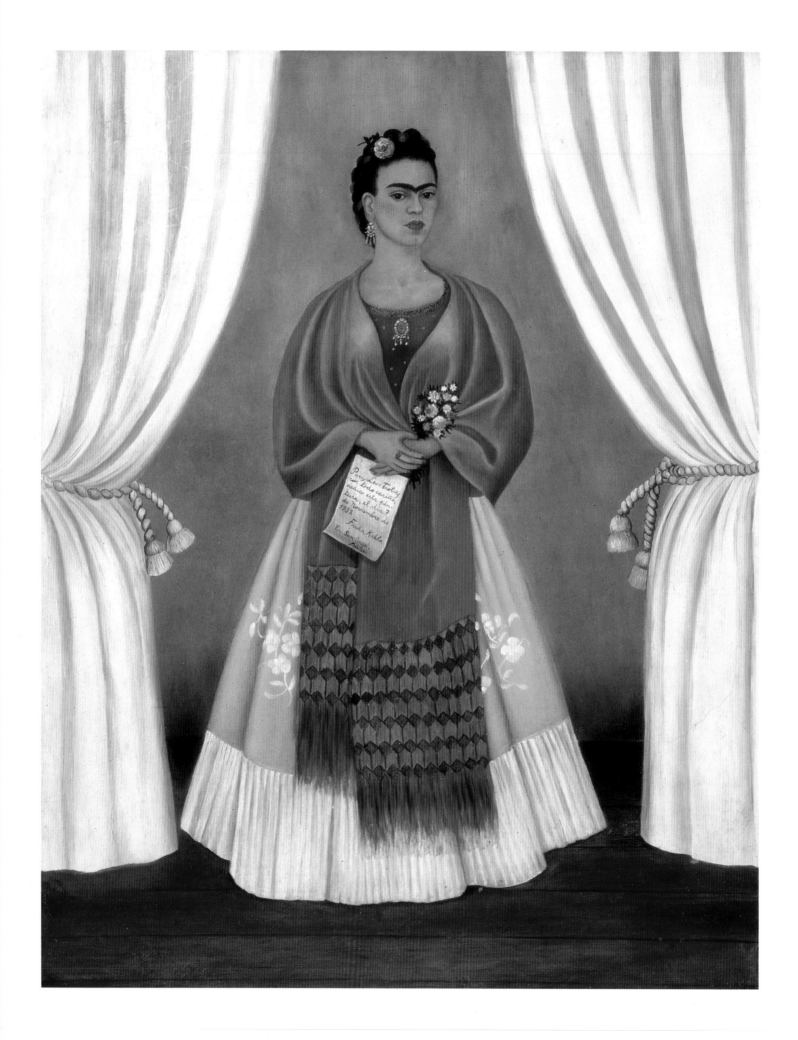

FRIDA KAHLO

MEXICAN, 1907–1954

SELF-PORTRAIT
DEDICATED TO LEON TROTSKY

1937, oil on Masonite, 30 × 24 in. (76.2 × 61 cm.)
Gift of the Honorable Clare Boothe Luce

This self-portrait shows the same Frida Kahlo seen in numerous photographs: intense, with broad, expressive eyebrows and a fondness for traditional Mexican garb. However, it omits the overt symbolism and sometimes-harrowing depictions of her medical history featured in many other self-portraits.

Instead, the artist displays herself standing on a stagelike wooden floor between curtains dramatically tied back with heavy cords. Kahlo's hair is braided and adorned with flowers; she wears a long embroidered dress, a *rebozo* (Mexican shawl), and gold jewelry, calling attention to her carefully manicured hands, which hold a small bouquet and a sheet of paper. The fact that her feet are hidden makes Kahlo appear to float, and the overall composition recalls *retablos*, the small Mexican religious images painted on tin that Kahlo avidly collected. The paper, with its inscription, signature, and date, is a surprisingly old-fashioned touch. In it, Kahlo dedicates the self-portrait to Leon Trotsky, "with all [her] love."[1] Kahlo presented this painting to the Russian revolutionary leader as a gift, presumably a memento of the brief love affair they had shortly after his arrival in Mexico.[2]

From 1926 until her death, the Mexican painter Frida Kahlo created striking, often shocking, images that reflected her turbulent life. Kahlo was the third of four daughters born to a Hungarian-Jewish father and a mother of Spanish and Mexican Indian descent, in the Mexico City suburb of Coyoacán.[3]

She did not originally plan to become an artist. A polio survivor, at fifteen Kahlo entered the premedical program at the prestigious National Preparatory School in Mexico City. However, this training ended three years later when Kahlo was gravely hurt in a bus accident. She spent more than a year in bed, recovering from multiple fractures of her back, collarbone, and ribs, as well as a shattered pelvis and shoulder and foot injuries. Despite more than thirty subsequent operations, Kahlo spent the rest of her life in constant pain, finally succumbing to related complications at the age of forty-seven.

During her convalescence Kahlo had begun to paint with oils. Her pictures, mostly self-portraits and still lifes, were deliberately naive, filled with the bright colors and flattened forms of the Mexican folk art she had always loved.[4] At twenty-one, Kahlo met and fell in love with the famous Mexican muralist Diego Rivera, whose approach to art and political activism complemented her own. Although he was twenty years her senior, they were married in 1929; this stormy, passionate relationship survived marital infidelities, the pressures of Rivera's career, a divorce and remarriage, and Kahlo's deteriorating health.[5] The couple traveled to the United States and France, where Kahlo encountered luminaries from the worlds of art and politics; she had her first one-woman exhibition at the Julien Levy Gallery in New York City in 1938. Kahlo enjoyed considerable international success during the 1940s, but her reputation soared posthumously, beginning in the 1980s with the publication of numerous books about her work by feminist art historians and others.[6] In the last two decades an explosion of Kahlo-inspired films, plays, calendars, and jewelry has transformed the artist into a veritable cult figure.

LUCY MARTIN LEWIS

AMERICAN INDIAN, CA. 1890–1992

One of the so-called matriarchs of American Indian pottery, Lucy Martin Lewis had a life quite different from María Martínez's.[1] She was born and raised on Sky City mesa, a land formation five hundred feet off the ground in Acoma Pueblo, west of Albuquerque, New Mexico. Since there were no schools on the mesa, Lewis received no formal education. Instead she worked at home, sewing, preparing food, and making pots—the latter, a skill she acquired as a young child by watching her great-aunt.

"Nobody famous ever came to Acoma," she said.[2] Therefore, Lewis was never helped—or interfered with—by archaeologists, museum curators, collectors, or tourists. Moreover, she did not travel to pow-wows or fairs; the farthest Lewis generally ventured was to the nearest town, twenty miles away, where she occasionally sold her pottery.

Lewis married and had nine children. Her remarkable energy enabled her to do the household chores, help her husband with the farming, and also make pots. While many American Indian potters worked collaboratively, Lewis—who had insisted that all her children attend school, requiring them to leave home—worked alone.[3] Her art first became well known outside the pueblo in 1950, when Lewis received a blue ribbon for her pottery at the first competition she ever entered. At forty-eight, she suddenly began winning awards—from the American Crafts Council, the College Art Association, the state of New Mexico. Lewis's art was championed by Edgar Lee Hewett of the Museum of New Mexico and exhibited in a New York City gallery; in 1986 Lewis was honored by the Honolulu Academy of Fine Arts.

JAR

1983, earthenware with slip, 9½ × 12 in. (24.1 × 30.5 cm.)
Gift of Wallace and Wilhelmina Holladay

This jar is typical of the black-and-white pottery for which Lucy Martin Lewis was famous. She developed this approach, with slender black lines decorating a white clay body, based on the eleventh-century Mimbres style of pottery native to the area. Lewis was familiar with this style because tiny shards of such pots covered much of the ground on the reservation.

Acoma potters generally work with a special, kaolin type of clay—dug from a secret site that is considered sacred. This clay turns white when fired but is harder to work and more fragile than other local clays.

The basic process of making this pot was the same as the one used at San Ildefonso, where María Montoya Martínez worked. Potters build up coils of clay, smooth, polish, and then fire their vessels. However, in this case the outside of the pot was covered with white slip, after which Lewis painted the complex network of lines, using a yucca-frond brush and black pigment. She worked freehand, with no preparatory drawings, planning the brush strokes in her mind and then applying them quickly.

This jar has an especially pleasing quality because of the repeated geometric pattern (an eight-pointed star), combined with the slight irregularities within each line. Although the outside of the jar is smooth, it has a dramatic, overall visual texture, set off handsomely by the thin slice of white at the base and a solid black stripe running around its lip.

AMERICAN, 1879–1954

In the spring of 1922, an American printmaker arrived in Yokohama, Japan, with her two young daughters, ten steamer trunks, twenty-eight suitcases, and no hotel room. When no accommodations materialized, Bertha Lum simply took her children back to the ship on which they had arrived and sailed on to China. This same single-mindedness enabled Lum to develop a successful career, blending Eastern and Western cultures despite considerable linguistic, financial, and gender-related obstacles.

Bertha Boynton Bull was born in Tipton, Iowa. She attended the Art Institute of Chicago School from 1895 to 1896 and again from 1901 to 1902, taking courses in figure drawing and design; she also studied illustration and stained-glass technique.

Like many other Westerners, by the late 1890s Bull had become fascinated by Japanese color woodcuts. Her interest was so strong that she and Bert F. Lum, a corporate lawyer from Minneapolis whom she married in 1903, took their honeymoon in Japan, where she sought out tools, artists, and information about traditional printmaking practices. The couple's children were born in 1908 and 1911, and the family moved to California in 1917. Bertha Lum eventually divorced her husband. She and her children took extended trips to Japan and China.

Although Lum's art features both the subject matter and the flattened-out, decorative quality of traditional Asian prints, it has its own distinctive style and was immediately popular with critics and collectors both East and West. In 1912 Lum was the only foreign artist to show her woodcuts at Tokyo's Tenth Annual Art Exhibition. She was the first American woman artist to have her work acquired by the British Museum and was one of four silver medal–winners at the prestigious Panama-Pacific International Exposition of 1915.

Lum wrote and illustrated two books of her own and created the illustrations for books and articles by both of her daughters. She returned to Peking after World War II but, because of failing health, moved five years later to her younger daughter's home in Genoa, Italy, where she died at the age of seventy-five.[2]

THROUGH THE WEST GATE

1924, hand-colored woodcut on paper
14¼ × 9⅛ in. (35.9 × 23.2 cm.)
Museum Purchase: The Lois Pollard Price Acquisition Fund

Bertha Lum made *Through the West Gate* toward the end of a two-year stay in Peking. In this work she employs a variation on the standard Asian method of creating color prints by using several blocks of wood. After cutting away the areas of each block that she did not want to appear in the final print, Lum individually hand colored every block, so that each print is slightly different.[1]

What presumably appealed to early Western viewers about such prints was Lum's ability to create believable depth. Here the principal archway frames a view of an elaborate piece of traditional architecture. Through its arches appear faraway trees and sky, becoming less distinct as they recede into the distance. As a deliberate contrast to these touches of naturalism, Lum has created an almost abstract pattern of pools of light on the foreground stones and graceful, Art Nouveau–like swirling patterns of incense.

MARÍA MONTOYA MARTÍNEZ

AMERICAN INDIAN, CA. 1880–1980

Probably the most famous American Indian artist of the twentieth century, the potter María Martínez spent all of her ninety-nine years in the place where she was born: San Ildefonso Pueblo in northern New Mexico, about twenty miles from Santa Fe.[1] Pottery making had been an important part of her culture for more than two thousand years, and many Martínez family members—including María's four sisters, her husband, two sons, a daughter-in-law, and several cousins—were also involved in producing pots.[2]

Martínez learned to make pottery in the traditional way, by watching her aunt and grandmother at work. By age thirteen, she was already celebrated within the tribe for her creative skills. In 1904 she married Julian Martínez, a noted American Indian painter. Together they revived an ancient local process for making the all-black pottery (rather than the all-red, or polychrome, ware that had been common for generations) for which they became well known. Julian also painted the designs on many of his wife's pots.[3]

Thanks to a book published about her work and the efforts to exhibit and sell her pots by Edgar Lee Hewett, director of the Museum of New Mexico, by the mid-1920s María Martínez's blackware had become extremely popular outside the pueblo. Martínez was encouraged to sign her pots, which were beginning to be regarded as works of art rather than household or ritual vessels.[4] Soon collectors, scholars, and busloads of tourists began visiting San Ildefonso to meet her and buy her pots. Although she had not had any formal schooling, Martínez was awarded two honorary doctorates, had her portrait made by the noted American sculptor Malvina Hoffman, and in 1978 was offered a major exhibition by the Smithsonian Institution's Renwick Gallery. Her enormous success enabled Martínez to support her family; it also made it easier for other artists to earn their livings by making pottery. Having inspired five generations of artists, today she is considered one of the matriarchs of American Indian pottery.

JAR

1939, blackware, 11⅛ × 13 in. (28.3 × 33 cm.)
Gift of Wallace and Wilhelmina Holladay

María Montoya Martínez made this black-on-black jar in the traditional way, gathering and mixing local clay with volcanic ash (also found on the pueblo), then building up the basic form with coils of clay that she scraped and smoothed with a gourd tool. Once it had dried and hardened, the clay was polished with a small stone. Julian Martínez used yucca-frond brushes to paint the designs on with slip (liquid clay), producing a matte surface that makes a subtle, sensuous contrast with the highly polished areas. Then the pot was fired in a hand-built kiln using wood and dried manure for fuel, cutting off the supply of oxygen halfway through the process, so that the pot would turn black from the carbon smoke.

It is precisely that contrast, between glassy and flat black surfaces, plus the unusual silhouette of the vessel, that makes this pot so visually exciting. The painted designs, while abstract, nevertheless suggest certain natural forms and relate harmoniously to the proportions and overall style of the jar.

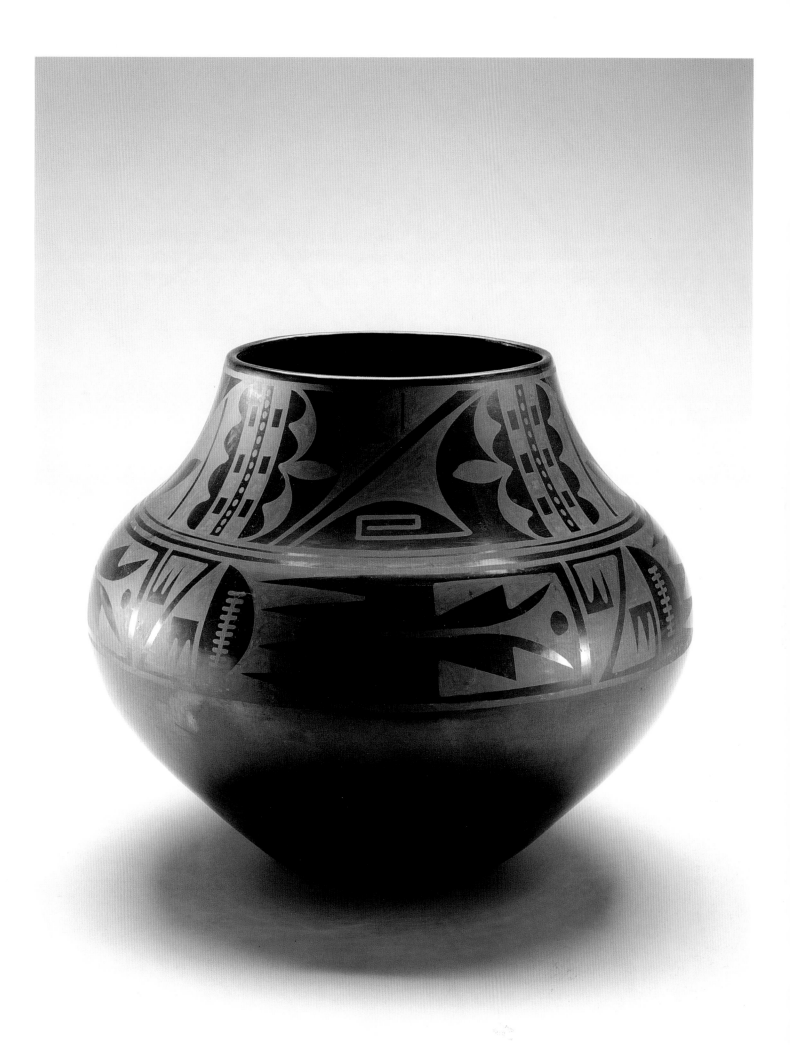

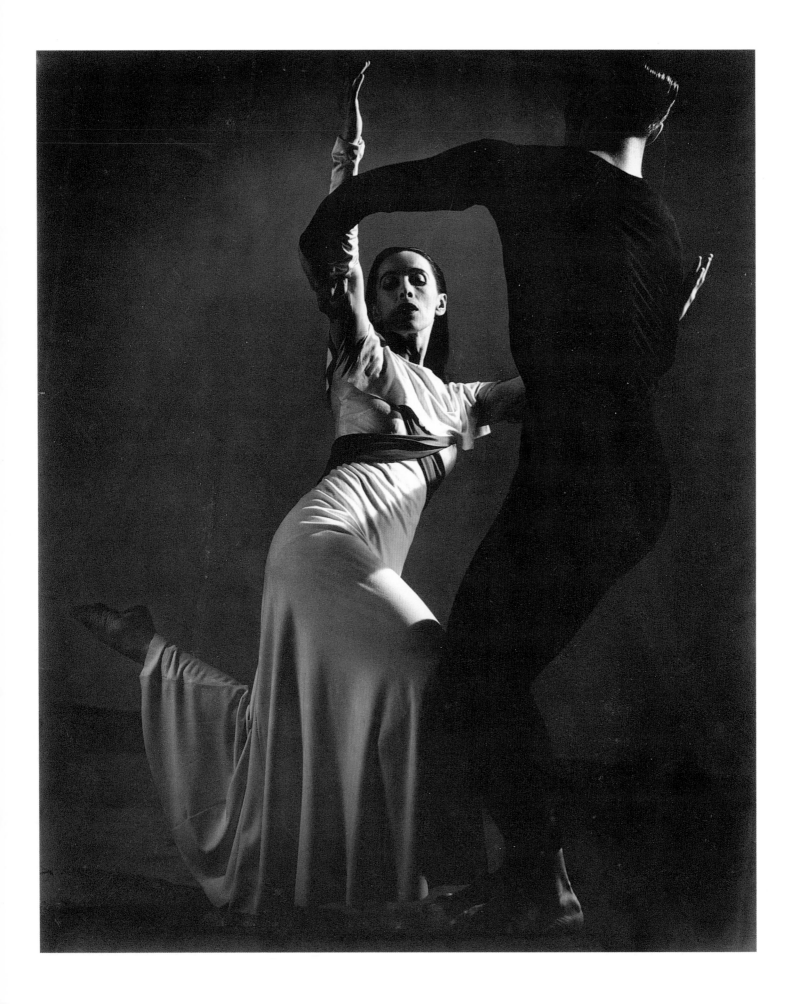

MARTHA GRAHAM AND
ERICK HAWKINS, "LOVE DUET"

1939, from American Document
Gelatin silver print, 13 × 10½ in. (33 × 26.7 cm.)
Gift of Roslyn Wyckoff Rusinow in honor of her uncle
and aunt, Louis Britwitz and Eleanor LeMaire

Barbara Morgan's images of Martha Graham are among her most celebrated and memorable photographs. Both artists were fascinated by American Indian ritual dances, and both believed that Western theatrical dance—like photography—could communicate on more than a purely aesthetic level. As Morgan said, "Dance was just a means through which one could express the emotions of the soul."[1]

This photograph shows Graham and Erick Hawkins in the "Love Duet" from her 1938 composition *American Document*. This was Graham's first male-female duet and her first popular success (including a sold-out concert at New York's Carnegie Hall). The piece is a dance drama, in which a narrator and a group of dancers summarize highlights from American history. The "Puritan Episode," from which this duet comes, is a study of sexual repression, where the speaker recites lines from the sermons of the Puritan minister Jonathan Edwards, alternating with sensuous verses from the Old Testament's "Song of Solomon." The tension inherent in the contrast between these two literary sources is mirrored in Graham's intense choreography, dramatic lighting, the black-versus-white costuming, and the dancers' poses, with Hawkins's face hidden from the camera. This work demonstrates Graham's characteristic rebellion against the artificiality of ballet, instead stressing real problems experienced by actual people in contemporary America.

Morgan required extensive preparations to capture this split-second image. She studied numerous rehearsals and performances of *American Document* to identify its key gestures. Then she invited the dancers into her studio, set up the lights, tried a few test shots, and took the pictures using her Speed Graphic 4 × 5, a small camera that allowed her to move as Graham did.[2]

Since dance is, by definition, motion, it seems an unlikely subject for the photographer's lens. Yet Barbara Morgan's fifty-year career began with her stunning photographs of America's modern-dance pioneers.

Barbara Brooks Johnson was born in Buffalo, Kansas, but raised in southern California. Having decided at age five to be a painter, she studied art at the University of California at Los Angeles, and later taught there for five years. In 1925 she married Willard D. Morgan, a prominent photojournalist, who encouraged her to explore making art with a camera. In fact, after the birth of their second son in 1935, Barbara Morgan devoted her professional life to photography. By then the family was living in New York City, the focal point of avant-garde dance in the United States. Inspired by one of Martha Graham's performances, Morgan determined to create an entire book of photographs of Graham's troupe. The book was published in 1941, a landmark in both women's careers.[3]

In addition to their extraordinary power and beauty, these photographs, displayed in traveling exhibitions, introduced many people across the United States and abroad to modern dance, then a relatively unknown art form.[4] At her home in Scarsdale, New York, where she moved in 1941 and where she spent the rest of her life, Morgan continued taking photographs of dancers, children, and other subjects; she experimented with pictures of light sources in motion, published several more books, and received numerous grants and honors.

ALICE NEEL

AMERICAN, 1900–1984

T.B. HARLEM

1940, oil on canvas, 30 × 30 in. (76.2 × 76.2 cm.)
Gift of Wallace and Wilhelmina Holladay

The subject of this painting is Carlos Negrón, the brother of Alice Neel's lover, José Santiago. He was twenty-four years old at the time and had come to live in New York's Spanish Harlem from his native Puerto Rico two years earlier.[1] Tuberculosis runs rampant in poor, overcrowded urban neighborhoods, and in 1940 the available treatments were few and drastic. The bandage on Negrón's chest covers the wound where surgeons removed eleven ribs in an attempt to drain fluid.[2]

Like the German expressionist painters whom she admired, Neel has deliberately distorted the figure, elongating Negrón's neck and arms and using heavy, dark outlines to emphasize and flatten the forms. The sick man's face expresses both suffering and a kind of sensuality, while his pose and the gesture of his right hand call to mind traditional images of the martyred Christ.[3]

Although it is certainly empathetic, Neel's painting is not sentimental. Like so many of her portraits of neighbors from this period, it makes a political point about the underclass without sacrificing the subject's individuality.

"All experience you can have is good for you. Unless you get killed by it, and then you've gone too far."[4] So said Alice Neel, who endured an extraordinarily difficult life to become one of the century's most powerful portrait painters.

Raised in rural Pennsylvania, Neel turned her back on middle-class society by becoming a professional artist, an ardent political activist, and a resident of a poor urban neighborhood. She was graduated from the Philadelphia School of Design for Women (now Moore College of Art) in 1925 and fell in love with the Cuban painter Carlos Enríquez. They married and moved to Havana, where their daughter Santillana was born. In 1927 the family settled in New York City and Neel's life began to fall apart. First, Santillana died of diphtheria; then Enríquez suddenly moved to Paris, taking their second daughter with him. In 1930–31 Neel suffered a nervous breakdown, attempted suicide, and was hospitalized for six months. Soon after her release, Neel began living with a drug-addicted man who slashed sixty of her paintings. Two subsequent relationships—with the Puerto Rican guitarist José Santiago and the Russian-born filmmaker Sam Brody, by each of whom Neel had a son—were also volatile.

Neel's unconventional life parallels the approach she took toward portraiture. Her images—whether of Nobel laureates, art world celebrities, relatives, or neighbors—are unfailingly, often disconcertingly, honest. It is hard to imagine any other painter creating such confrontational male nudes or such a startling self-portrait, wearing nothing but her eyeglasses, at the age of eighty-one. Even when Neel's sitters are clothed, they seem naked given the artist's uncanny ability to reveal their personalities.

Because Neel never adjusted her painting style to fit prevailing art world fashions, her early work received limited attention. During the last decades of her life, however, Neel achieved great success. Her many honors included the National Women's Caucus for Art outstanding achievement award, which President Jimmy Carter presented to her in 1979.

GEORGIA O'KEEFFE

AMERICAN, 1887–1986

The subject of several plays, with a museum devoted to her work and one of her paintings reproduced on a postage stamp, Georgia O'Keeffe is the most famous American woman artist and an important pioneering modernist.[1]

Although mostly associated with the desert Southwest, O'Keeffe was born near Sun Prairie, Wisconsin. Having decided to become an artist at age nine, she was trained at the School of the Art Institute of Chicago and New York's Art Students League. O'Keeffe supported herself as a freelance commercial artist for two years and then, from 1911 through 1918, taught at schools in Virginia, South Carolina, and Texas. During summer vacations, O'Keeffe took additional classes at the University of Virginia and Columbia University Teacher's College, where she was strongly influenced by the theories of Arthur Wesley Dow, who stressed the importance of developing one's personal style by paring forms down to their essences. In 1915 O'Keeffe destroyed her earlier work, finding it derivative, and embarked on a series of spare, elegant, and extremely radical charcoal drawings and watercolors that led directly to experiments with total abstraction.

Thanks largely to the support of the New York photographer, editor, and art dealer Alfred Stieglitz, O'Keeffe moved to Manhattan in 1918 and established a successful career as a professional artist. Stieglitz featured her work in more than twenty one-woman shows. O'Keeffe attracted widespread critical attention for her huge paintings of flowers and sun-bleached animal bones. In 1924 O'Keeffe married Stieglitz. They lived in New York until his death twenty-two years later. It was only in 1949, at the age of sixty-two, that O'Keeffe finally felt free to settle in New Mexico, which she had visited alone many times previously.

O'Keeffe's reputation increased exponentially thereafter. She won numerous awards, including medals from two U.S. presidents and ten honorary doctorates. By the time of her death, O'Keeffe had become a living legend.

ALLIGATOR PEARS IN A BASKET

1923, charcoal on paper, 24⅞ × 18⅞ in. (63.2 × 47.9 cm.)
Gift of Wallace and Wilhelmina Holladay

If she had died before painting a single bone or flower, Georgia O'Keeffe would still have a significant place in American art history because of works such as this drawing. Although the still life is one of the oldest subjects in Western art, here O'Keeffe has drastically modernized it by simplifying the forms of both the avocados and their container.

By eliminating color and most details, as well as any reference to the physical location of the basket, O'Keeffe forces viewers to concentrate on the drawing's composition. The rounded shapes of the avocados are echoed by the irregular curves of the basket, while this repetition is further enhanced by the stark contrast of dark, velvety charcoal against untouched paper. This also allows the white background areas above and below the avocados to appear solid. Subtle variations in texture distinguish the parts of this composition as the weave of the paper shows through in lighter areas. Although *Alligator Pears* is part of a series of still lifes O'Keeffe produced during the early 1920s, it bears a close relationship to the paintings of black river rocks she made a half century later.

SUMMER SUNLIGHT

ca. 1936, oil on canvas, 39 × 49 in. (99.1 × 124.5 cm.)
Gift of Wallace and Wilhelmina Holladay

Although she also produced commissioned portraits, still lifes, and interiors, Beatrice Whitney Van Ness was recognized primarily for her brightly colored outdoor scenes featuring friends and family members. *Summer Sunlight*, a typical example, was painted during a summer sojourn in Maine. It depicts the artist's older daughter (wearing a broad-brimmed hat), her nephew, Winthrop Stearns (with his back to us), and Barbara Allen, a neighbor.

However, as indicated by the title, the true subject of this painting is light itself and the artist's fascination with the colors it brings out in flesh, fabrics, and landscape. The continuing influence of impressionism

can be seen in the broad brushwork and bright palette, along with the momentary nature of Allen's gesture as she proffers a banana, the unusual cropping (so that Stearns's right arm and one whole side of the standing figure are cut off), and the dramatic way the sunlight glances off Allen's beach robe. The strong diagonal created by the vivid orange umbrella adds dynamism to the scene, as does Stearns's hair, tousled by the sea breeze.

Many painted beach scenes are purely hedonistic, reveling in the sensual pleasures of sunlight, sand, and exposed skin; others, such as those painted by Winslow Homer, can be darkly dramatic. Some scholarship has placed *Summer Sunlight* in a third category of beach pictures that emphasize the sense of psychological isolation within each of the figures, despite their physical proximity.[1]

BEATRICE WHITNEY VAN NESS

AMERICAN, 1888–1981

An award-winning painter who developed a highly successful personal variation on impressionism, Beatrice Whitney Van Ness was also an authority on art education, an author, and an influential teacher for nearly forty years.

Beatrice Whitney was born and raised in the Boston suburbs.[2] From age seventeen through twenty-five, she was a student at the School of the Museum of Fine Arts, Boston, where her principal professors were the American impressionists Edmund Tarbell, Frank Benson, and Philip Hale. From them—and from Charles S. Woodbury, a noted New England painter with whom she studied during the mid-1920s—she learned to depict the effects of bright sunlight.

In 1915 she married Carl Norwood Van Ness and shortly thereafter had two daughters. The family settled in Brookline, Massachusetts, and spent summers at Bartlett's Harbor in North Haven, Maine, an idyllic island retreat. There she made oil and watercolor sketches outdoors, shipping them back to Brookline, where she would complete them.

Teaching was an important part of Van Ness's life. She was appointed to her first post at the School of the Museum of Fine Arts while still a student there, a clear indication of the high regard in which she was held. Between 1921 and 1949, Van Ness founded, directed, and taught in the innovative art department at the Beaver Country Day School in Chestnut Hill, a suburb of Boston. Van Ness also taught at five other local schools, wrote numerous articles on art education, and served on several prestigious educational commissions.

In addition to five one-woman exhibitions held during her lifetime, Van Ness also participated in major international expositions and won numerous prizes. She kept painting until the age of ninety-one.

The United States came into its own as a center of cutting-edge culture at the midpoint of the twentieth century. As the widespread devastation caused by World War II permanently altered the fabric of Western society, it also redirected the focus of the international art community—from Paris to New York City. One tangible record of this shift was the publication of a 635-page book surveying the history of American art, itself based on an eight-part television series.[2] Another was the exhibition mounted by New York's Whitney Museum of American Art, which included so many works created between 1900 and 2000 that it had to be split into two separate exhibitions.[3] The very fact that such ambitious projects could attract widespread public interest indicates the powerful emergence of American art.

The recognition of art made specifically by women in North America also reached unprecedented heights during the late twentieth century. The rise of the women's movement along with related publications, legislation, the establishment of university women's studies departments, the growing prominence of feminist art-historical scholarship, ground-breaking exhibitions,[4] and the opening of the National Museum of Women in the Arts all made it increasingly difficult to ignore the considerable achievements of women artists. As they had done earlier in the century, women made important contributions to virtually all the major artistic movements that emerged between 1950 and 2000. However, the lives of the seventeen artists profiled in this section also demonstrate that North American women had not yet achieved equality with their male counterparts.

The United States first became known as a cultural power through abstract expressionism, a movement characterized by enormous, highly stylized canvases covered with thick brush strokes capable of conveying strong emotions.

Abstract expressionism came to be associated with male artists—notably Jackson Pollock, whose macho persona seemed antithetical to women. Yet there were many female pioneers within the New York School, most notably Lee Krasner, who made abstract expressionist–style paintings before the term was coined. Nevertheless, and despite the progress women had made during the 1930s, the predominantly male American art establishment of the 1940s and 1950s systematically barred the participation of women in important exhibitions and organizations. This attitude was strongly influenced by discriminatory laws and also by the stereotype of married women as devoted, full-time housewives and mothers, an image fueled by print advertisements and, above all, television. As recent scholars have pointed out,[5] even such talented, ambitious, and strong-minded women as Krasner found it impossible to avoid societal expectations regarding traditional women's roles. Moreover, as the wife of Jackson Pollock, Krasner was inevitably perceived as an ancillary figure; her art did not receive a fair evaluation until the last decades of her life.

Beginning in the 1960s, many American artists distanced themselves from what they perceived as the emotional excesses and increasingly formulaic nature of abstract expressionist painting. Whether appropriating elements of American popular culture (in pop art) or exploring the cooler type of abstraction known as minimalism, this younger generation largely rejected the work of the so-called New York School. At the same time, political activism was on the rise, sparked by such factors as escalating American involvement in the Vietnam War and increasing demands for civil rights, especially by African Americans and women.[6] In the art world, too, there was a new militancy—protesting the unequal representation of women in major schools, exhibitions, and publications.

AMERICA

The political demonstrations of the 1960s led to a proliferation of public activities intended to focus national and international attention on the enormous contributions being made—and too often neglected—by women in all walks of life. The American women's movement gained tremendous strength during the 1970s and greatly increased both the visibility and the power of American women artists. This was accomplished partly through the formation of influential new organizations and publications,[7] as well as the prominent roles played by women in such innovative areas as performance and installation art, the Pattern and Decoration movement, and through consciousness-raising works such as Judy Chicago's *The Dinner Party* (1975–79).

Writers have identified a backlash in the position of American women artists during the 1980s.[8] In part because of the growing strength of political conservatism, large segments of the art world regressed drastically. Suddenly, prominent New York dealers openly refused to handle the work of women artists—citing a lack of enthusiasm for such work among collectors—and the percentage of women represented in important exhibitions actually declined. Indeed, the discovery that the Museum of Modern Art's 1984 *International Survey of Recent Painting and Sculpture* included work by 165 artists, only fourteen of whom were women, led directly to the establishment of the Guerrilla Girls. This anonymous group of activists, always appearing costumed as gorillas, systematically gathers and distributes—through leaflets, posters, books, and theatrical events—statistics demonstrating the unequal treatment of women artists in America.[9]

Yet the situation during the 1980s was not entirely bleak and, during the fifteen years since demonstrators picketed the Museum of Modern Art, real progress can again be discerned. By the turn of the twenty-first century North American women artists had made tremendous strides—appearing on the covers of national magazines, winning more awards and participating in more prestigious exhibitions than ever before, commanding higher prices for their work, and receiving greater attention from major critics. The best-known North American women artists of the twentieth century now have museums devoted to their art.[10] However, significant obstacles remain, and it is still too easy for hard-won gains to be reversed.[11] Continued vigilance will be required—by concerned artists, teachers, critics, editors, curators, dealers, and art lovers—to keep women artists in the public eye and to document their achievements. Ultimately, that will be the only way to ensure that women artists will receive, and retain, their rightful place in art history.

THE FUNCTION OF ART IS TO DO
MORE THAN TELL IT LIKE IT IS—
IT'S TO IMAGINE WHAT IS POSSIBLE.

— BELL HOOKS [1]

LOUISE BOURGEOIS

AMERICAN, B. FRANCE 1911

Her first one-woman exhibitions were of paintings, and she has long been celebrated as a sculptor; however, between 1939 and 1949, and then again from 1973 to the present, Louise Bourgeois has also produced more than one hundred and fifty prints. They address the same political and aesthetic issues as her works in other media.

Bourgeois was born in Paris and started helping as a child in the family's tapestry-restoration workshop. After graduating from the Sorbonne with a degree in mathematics, she entered the Ecole des Beaux-Arts in 1936. Quickly determining that the venerable school was too conservative for her taste, Bourgeois spent three years studying privately with various artists. At twenty-seven, she married the American art historian Robert Goldwater and moved with him to New York City, where she lives today.[1]

During her first decade in New York, Bourgeois experimented with drawings, paintings, and prints, while taking classes at the Art Students League and raising three sons. She met art-world luminaries, including important surrealist and abstract expressionist artists; by the 1950s she had begun concentrating on making sculpture.

Bourgeois's art explores opposite qualities: light/dark, rough/smooth, male/female; it refers to strong emotions, often tied to sexuality. Bourgeois says she creates art to externalize, examine, and thus control her own emotions.[2] Unpleasant thoughts—especially ones about her father, who had a ten-year affair with the family's English nanny—become bearable and pleasant thoughts easier to re-experience when embodied by her work.

Although she had been showing her art for many decades, Bourgeois's oeuvre first received widespread recognition after her 1982 retrospective at the Museum of Modern Art. Since then, her sculptures—made of wood, bronze, plaster, latex, marble, and glass—have been displayed throughout Europe and the United States, and a catalogue raisonné of her prints has reawakened interest in Bourgeois's two-dimensional work.[3] The artist was chosen to represent the United States at the Venice Biennale of 1993.

UNTITLED

1996, lithograph, woodcut on paper, with hand coloring
21½ × 96 in. (54.6 × 243.8 cm.)
Museum Purchase: Members' Acquisition Fund

It took three years for Louise Bourgeois to complete this mural-size, three-color print.[4] Because the artist has colored certain areas by hand, each impression of the print (produced in an edition of forty) is slightly different from the rest.

Untitled seems to depict a confrontation between two rival groups of spiral forms, massed together at either end of Bourgeois's composition, with a pair of forms isolated in the center, one looming over a much smaller version of itself. These mysterious spirals could be interpreted as anything from stylized seashells, candies, or insect larvae to phalluses. Likewise, the mood they evoke can range from amusing or mysterious to menacing. Bourgeois, who typically provides more than one "explanation" of her images, has described these spirals as maggots (recalling the swarms of insects that invaded their family workshop during the summer), as well as harbingers of hope for the future.[5]

Symbolism aside, the composition is particularly powerful because of the contrasts Bourgeois has created between the heavily textured spirals, which seem to exist within three-dimensional space, and the flat, monochromatic, electric blue background.

PETAH COYNE

AMERICAN, B. 1953

UNTITLED #781

1994, wax, plastic, and cloth over metal and wire
armature, 62 × 35 × 44 in. (157.48 × 88.9 × 111.76 cm.)
Promised gift of Steven Scott, Baltimore, Md.

Petah Coyne started working with wax in 1992. *Untitled #781* belongs to a series of suggestive sculptures that she covered with as many as 150 layers of white, lightly colored, or black wax. They have been described as resembling frosted cakes, chandeliers, wedding dresses, elaborate hats, or other feminine paraphernalia. *Untitled #781* has an underlying wire structure formed to resemble a dress, to which satin ribbons have been attached, over which layers of pink and white wax has been dripped and poured. The upper part of the sculpture includes several small candle stumps with burnt wicks. The large-link chain that suspends the piece from the ceiling is covered by a white satin sheath.

Coyne has stated that these wax sculptures relate to her memories of what she thought it would be like to become a woman.[1] Thinking then that it "would be incredibly beautiful," the reality of adulthood makes her now remember those fanciful expectations as beautiful. *Untitled #781* indeed reminds one of a frilly and fantastic petticoat, shaped to reflect the female figure and evoking associations of festivities. For all its seeming innocence, though, the pink underlayer seductively suggests sexual expectations as well. Although the wax is fragile, it in fact hides the strong structure underneath. "They look fragile, but they're not," says Coyne in describing the sculptures. "Like women, they're really tough inside."[2]

Unlike many contemporary artists who focus on social or media-related issues, Petah Coyne imbues her work with a magical quality to evoke intensely personal associations. Her sculptures convey an inherent tension between vulnerability and aggression, innocence and seduction, beauty and decadence, and, ultimately, life and death. Coyne's work seems Victorian in its combination of an overloaded refinement with a distinctly decadent and morbid undercurrent.

Coyne was born in Oklahoma City, but the family moved repeatedly before settling in Dayton, Ohio, when Coyne was twelve. While in high school, she took art courses at the University of Dayton, and then went on to Kent State University and was graduated from the Art Academy of Cincinnati. Besides creating the sculptural installations for which she is best known, Coyne also works in photography.

Coyne changes materials every few years to approach the creative process from a fresh angle. The inspiration for each change often derives from one of her many travels abroad. So far, materials have included dead fish, mud, sticks, black sand, old car parts, wax, satin ribbons, artificial flowers and birds, birdcages, and, most recently, taxidermy animals, Madonna statues, and horsehair. Coyne's creations are extremely labor intensive, and their multiple layers of materials relate to the passage of time it took to complete the work, as well as time in the form of memory—the artist's personal memories and ones these objects evoke in us. She has been influenced by the sculpture of Eva Hesse and Louise Bourgeois. *—BK*

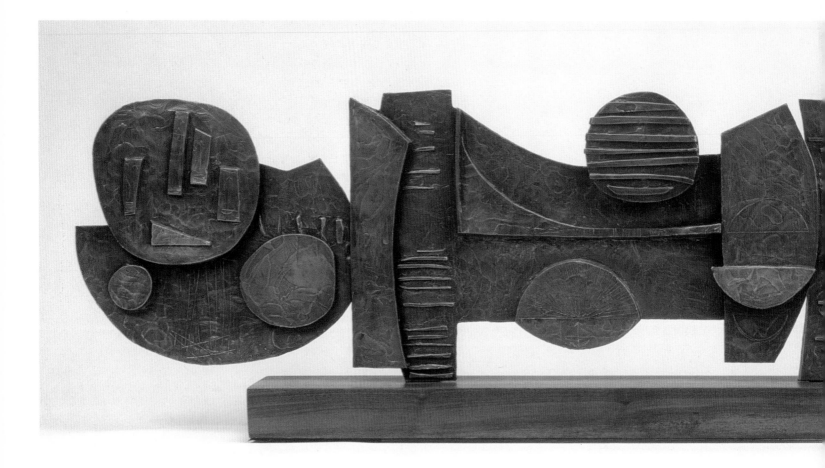

LOOKING NORTH F

1964, bronze, 17 7/8 × 64 × 2 in. (45.7 × 163.8 × 7.6 cm.)
Gift of the artist

While it is essentially abstract, *Looking North F* is based on the view from Dorothy Dehner's studio window at 41 Union Square in New York City.[1] Like most of her sculptures, this bronze bas-relief emphasizes contours over mass. It is both flat and thin; seen from the side it looks like an irregular, vertical metal line.

Dehner made this sculpture using the lost wax technique, in which a mold is placed around shapes she fashioned out of wax. When the wax is heated, it melts and runs through holes that have been punched in the mold; it is then replaced by molten bronze. This process produces a unique solid bronze artwork, as the mold must be destroyed to retrieve the cast.

The numerous small shapes that make up this sculpture recall urban buildings, the sun, and a sense of the movement and sounds endemic to a busy downtown neighborhood. However, it could also suggest a more rural sort of landscape or even a stylized animal. The deliberate irregularity of Dehner's disks, ovals, and rectangles, their asymmetrically applied textures and rich, golden-coppery color give the sculpture a surprisingly warm, organic feeling.

DOROTHY DEHNER

AMERICAN, 1901–1994

She began making sculpture at fifty-four, and just two years later Dorothy Dehner had her first one-woman exhibition at New York's Willard Gallery. Throughout the next four decades, Dehner was an award-winning sculptor, producing abstract works in various media.

The Cleveland native had originally intended to be an actress. Following the death of her parents, in 1918 Dehner moved to California, where she took classes at the Pasadena Playhouse and majored in drama at the University of California at Los Angeles. In 1922 she resettled in New York City and three years later switched her sights to a career in visual art.[2] For several years Dehner studied painting at the Art Students League, getting to know emerging American modernists, including the sculptor David Smith, whom she married in 1927.

While living in Brooklyn and then, from 1940 to 1950, on a farm at Bolton Landing in upstate New York, Dehner limited her artistic production to drawings and paintings, participating in only a few group shows. Her work at this point was figurative, alternating idyllic representations of her daily life on the farm with devastating, demonic images that reflected the deteriorating state of her marriage. After she and Smith separated in 1950 (they divorced two years later), Dehner was more active professionally, studying printmaking at Stanley Hayter's Atelier 17 and becoming known for her work in three dimensions. Initially Dehner made cast-bronze sculpture; in the mid-1970s she started working with wood, and during the early 1980s she produced enormous pieces in Cor-ten steel. The recipient of numerous art prizes and an honorary doctorate, Dehner had major retrospectives of her work at the Jewish Museum in New York (1965), City University of New York (1991), Katonah Museum of Art (1993), and Cleveland Museum of Art (1995).

HELEN FRANKENTHALER

AMERICAN, B. 1928

The American painter Helen Frankenthaler is a second-generation abstract expressionist widely considered "the country's most prominent living female artist."[1] A New York City native, Frankenthaler was graduated from the Dalton School, where she studied with the Mexican painter Rufino Tamayo. After earning her B.A. degree at Bennington College in Vermont, she moved back to New York. In 1950 Frankenthaler encountered the influential art critic Clement Greenberg, through whom she met the major figures in New York's avant-garde art world. Inspired by an exhibition of paintings by Jackson Pollock, Frankenthaler began the experiments that culminated in her stain paintings: large-scale abstractions with thin washes of pigment, reminiscent of watercolors. This technique inspired the color field painters and earned impressive reviews for Frankenthaler from 1953 on.

For many years Frankenthaler executed stained canvases that seem nonrepresentational, but which are actually based on real or imaginary landscapes. During the summers, she worked in Provincetown, Massachusetts, and in the mid-1970s she bought a second home and studio in Connecticut. In addition to her two-dimensional work, Frankenthaler produced welded steel sculptures; she has also explored ceramics, prints, and illustrated books, and in 1985 she designed the sets and costumes for a production by England's Royal Ballet. She has taught at New York University, Harvard, Princeton, and Yale and has had numerous one-woman exhibitions of her work, including important retrospectives at the Whitney Museum of American Art in 1969 and New York's Museum of Modern Art in 1989. Frankenthaler has won many awards and has been the subject of a documentary film.

SPIRITUALIST

1973, acrylic on canvas, 72 × 60 in. (182.9 × 152.4 cm.)
Gift of Wallace and Wilhelmina Holladay

Helen Frankenthaler makes stain paintings by pouring thinned pigment onto unstretched canvas rolled out on her studio floor. Because the canvas has not been sealed in the usual way, the paint soaks down into the fibers, literally staining the fabric. Like the art of Lee Krasner, Jackson Pollock, and other first-generation abstract expressionists, Frankenthaler's paintings are large and strongly affected by chance, as the colors flow into whatever shapes they choose, with the artist making only minimal additions with her brush or fingers. However, Frankenthaler uses a lighter palette, makes only a few large forms, and trades the emotional intensity of her predecessors for a calmer, often lyrical set of soft-edged, floating forms.

In the early 1970s Frankenthaler's work became more abstract. She also started including short, curving black lines as visual accents again—she had not done this since 1963. One scholar attributes this new phase to several factors in Frankenthaler's life, including her move to a second New York studio, the appearance of the first major book devoted to her work, and the end of her first marriage.[2] Despite these potentially unsettling events, *Spiritualist* conveys a mood of serenity, created through such formal means as the dynamic balancing of the left-hand field of luscious pink against the central orange form in the center and the brownish purple form on the right.

SELF-PORTRAIT
IN KIMONO WITH BRIAN, NYC, 1983

From The Ballad of Sexual Dependency
Cibachrome, 27 × 34¾ in. (68.6 × 88.3 cm.)
Promised gift of Steven Scott, Baltimore, Md.,
in Honor of the Tenth Anniversary
of the National Museum of Women in the Arts

Nan Goldin's creation of *The Ballad of Sexual Dependency* centers on her perception of the irrevocable differences between men and women and the struggle between autonomy and dependency. As she writes, *Ballad* "begins and ends with this premise, from the first series of couples including the Duke and Duchess of Windsor—the epitome of the romantic ideal—crumbling in a Coney Island wax museum to the picture of skeletons together in an eternal embrace after having been vaporized. In between I'm trying to figure out what makes coupling so difficult.... The friction between fantasies and the realities of relationships can lead to alienation or violence."[1]

The Ballad of Sexual Dependency was first exhibited at the Mudd Club in New York in 1979, incorporating forty-five minutes of slowly cross-fading photographs with sad love songs past and present.[2] Filled with images of the bohemian subcultures of Boston, Provincetown, and New York, it records the people who have moved in and out of Goldin's life. (Later editions included photographs from London and Berlin as well.) Abjection is a key concept in these works, but it is not without pathos and a real sense of identification. Remarkably direct in its expression of love, sex, and repression, *Ballad* has been called by Goldin "a diary I let people read."[3]

Self-Portrait in Kimono with Brian, NYC, 1983 captures the estrangement that Golden feels is often the result of intimate relations. When she decided to publish her photographs from *The Ballad of Sexual Dependency* as a book in 1986, this photograph became its cover image—a frank, unglamorized rendering of Goldin's own experience of love's loss and loneliness.

NAN GOLDIN

AMERICAN, B. 1953

Nan Goldin's photographic gift lies in the telling of her story. Assuming the mantle of the engaged documentarian, she has spent the past two decades photographing herself and an extended family of friends coping with the modern mythology of romance.

Born in Washington, D.C., in the Eisenhower Fifties, Goldin grew up in Silver Spring, Maryland. The youngest of four children in a middle-class family, she was especially close to her sister Barbara, who committed suicide when Goldin was eleven years old. Rebellious like Barbara before her, Goldin left home by the age of fourteen, and by nineteen she had found a new family of like-minded friends in Boston.

In analyzing her turn to photography at this time, she said, "I began taking pictures because of my sister's suicide. I'd lost her. And I became obsessed with never losing the memory of anyone ever again."[4] Unschooled in photography, Goldin decided to attend classes at the School of the Museum of Fine Arts, where she became friendly with the artists Mark Morrisroe and David Armstrong (several years later, this group would become known as the Boston School).

By the time she had completed her degree, she had already begun work on what would eventually become *The Ballad of Sexual Dependency*—a slide show of friends that captured the essence of Provincetown's gay scene in the late 1970s. Over the years the work's slide track has evolved to include more than seven hundred images arranged by subject, accompanied by a music soundtrack and a point of view. With its rhythm of cross-fading images, it functions more like a documentary film than a slide show. Its roots, however, lie in the family slide shows of vacations and other happy scenes practiced in so many middle-class U.S. households in the 1960s and 1970s, even if Goldin's Zeitgeist is anathema to that time and culture.

From Boston, Goldin moved to New York in 1978 and immersed herself in the downtown art and punk scene in its heyday. Goldin has since produced related series and books, including *The Other Side* (1993), *A Double Life* (1994), with David Armstrong, and *Ten Years After* (1998).[5] In 1996 Goldin's art was the subject of a major retrospective, *I'll Be Your Mirror,* at the Whitney Museum of American Art. —SFS

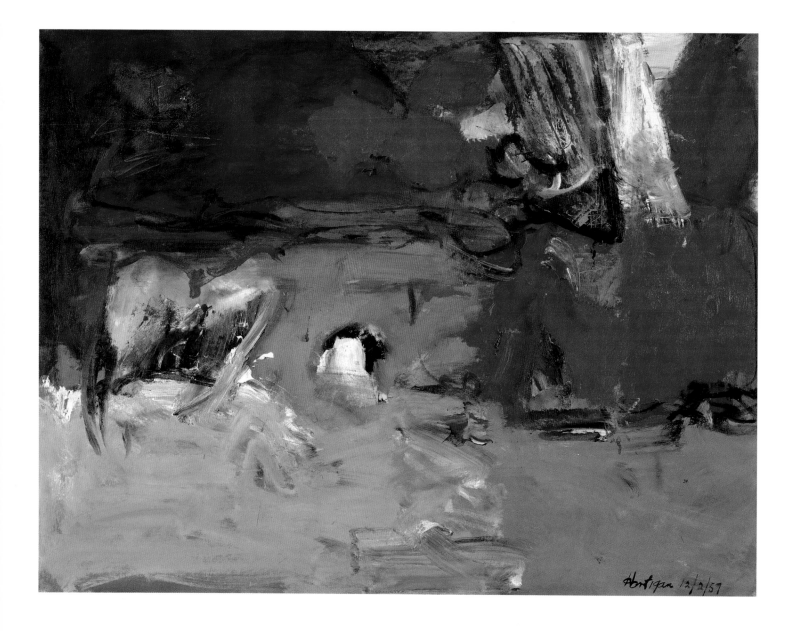

DECEMBER SECOND

1959, oil on canvas, 48 × 72 in. (121.9 × 182.9 cm.)
Gift of Mrs. Walter S. Salant

"My art was always about something," Grace Harti-gan has said,[1] explaining that even paintings that seem nonrepresentational refer to her feelings about a place or a poem. *December Second* is clearly abstract; its title refers to the date when the painting was executed, visible—along with the artist's signature—in the lower right corner of the canvas. Nevertheless, the picture suggests various associations—a landscape, a still life, a figure—to different viewers.[2]

On a formalist level, this is a dynamic, motion-filled composition in which dramatic strokes of black, white, purple, and green contrast with large areas of vivid, visceral red, set above a ground plane con-structed of several shades of gray. Like most of Har-tigan's work, this piece was painted quickly, giving it a sense of freshness and fluidity.

The year in which she executed this canvas was an important one for the artist: her career was at a high point; she had recently made her first trip to Europe; and that autumn she had fallen in love. Presumably the unsettled, intense quality of this painting re-flects Hartigan's emotions during this time of per-sonal and professional change.

GRACE HARTIGAN

AMERICAN, B. 1922

In 1950, just five years after moving to Manhattan, Grace Hartigan was participating in a major exhibition curated by Clement Greenberg and Meyer Schapiro, two of the most influential figures in the New York art world;[3] the following year she had the first of many one-woman exhibitions. Born to a middle-class family in Newark, New Jersey, Hartigan married at nineteen. Her son was born in 1942, the same year her husband was drafted; the couple divorced in 1947.

During World War II, Hartigan worked as a mechanical draftsperson in an airplane factory. A coworker introduced her to the art of Henri Matisse, sparking her decision to dedicate herself to painting. Between 1942 and 1947, Hartigan studied with the local artist Isaac Lane Muse, moving to New York just as abstract expressionism was beginning to dominate the avant-garde scene. Hartigan met Jackson Pollock, Lee Krasner, and other seminal figures from this group, whose interest in creating large canvases covered with abstract, emotion-filled marks paralleled her own.

By the late 1950s Hartigan had become widely known. She was featured in *Life* and *Newsweek* magazines and was the only woman among seventeen artists chosen to participate in the Museum of Modern Art's prestigious exhibition *The New American Painting*, which traveled to eight European countries from 1958 to 1959. As with other abstract expressionists, interest in Hartigan's work waned during the 1960s and 1970s, but her art has enjoyed renewed popularity over the past two decades.

Since 1960 Hartigan has lived in Baltimore, far removed from the excitement—and the pressures—of the New York scene. Seven years after settling there she began teaching at the Maryland Institute College of Art, where she continues to direct the Graduate Program in Painting. Retrospectives of Hartigan's work have been held at American University in Washington, D.C. (1987), the Fort Wayne (Indiana) Museum of Art (1981), and New York's Kouros Gallery (1989).

EVA HESSE

AMERICAN, B. GERMANY, 1936–1970

Eva Hesse was one of the most original and influential sculptors of the 1960s in the United States. Born to an Orthodox Jewish family in Hamburg, Germany, she fled Nazi Germany with her family and came to the United States when she was three. Hesse studied at Pratt Institute, the Art Students League, Cooper Union, and the Yale School of Art and Architecture. Her notebooks mention repeated abandonments: her parents' divorce, her mother's suicide, and Hesse's separation from her husband. Throughout her life she battled mental and physical instability. Hesse died of a brain tumor in 1970.

Together with a group of like-minded artists, including Robert Morris, Jackie Winsor, and Lynda Benglis, Hesse modified the rational geometry and identical repetition of 1960s minimalism to what came to be known as post-minimalism, while retaining certain elements of minimalism. Like minimalist sculpture that relates to its surrounding space, many of her works engage more than one gallery surface. However, where minimalist work emphasizes its relationship to the viewer's space, Hesse refocused that relationship on the viewer's body itself and imbued it with erotic undercurrents. She also introduced an organic sensibility and element of chance to post-minimalist sculpture, and much of her work retains an intentional ugliness to create a sense of imperfection that opposes minimalism's flawlessness.

Hesse's work has been described as combining opposing forces, such as feminine/masculine principles, hardness/softness, and freedom/confinement. These coexisting incompatibilities give her work a feeling of internal absurdity, humor, animation, and humanness that result in an emotional and psychological intensity that sets her work apart from that of other post-minimalists.

Part of Hesse's originality lies in her use of unexpected materials, such as rubber, cord, translucent fiberglass, and latex. She also used techniques traditionally associated with "feminine" occupations, such as wrapping, winding, and threading. Hesse's work has continued to influence other artists to this day. Her allusions to body parts, sexuality, and a feminine element have made her work particularly meaningful to many female sculptors, including Petah Coyne, Rona Pondick, and Kiki Smith.

STUDY FOR SCULPTURE

1967, Sculp-Metal, cord, Elmer's glue, acrylic paint, and varnish on Masonite
10 × 10 × 1 in. (25.4 × 25.4 × 2.54 cm.)
Gift of Wallace and Wilhelmina Holladay

The relief *Study for Sculpture* consists of an impastoed surface on which a 9 × 9 grid of eighty-one short cords is laid out. These cords are visibly knotted at the relief surface and at their ends. The entire sculpture is painted in opaque, matte gray, which unifies it but makes the cords' shadows seem eerily alive.

Study for Sculpture is one of several works that extend a formal vocabulary introduced by Hesse in 1965 and with which she experimented over two years. As a study, it tests an idea for further use in another context. *Study for Sculpture*, and other works like it, lead up to the relief *Constant* (1967). On a heavily impastoed surface, this work has a 19 × 19-inch grid of short, knotted rubber tubes.[1]

However, *Study for Sculpture* is also an independent and fully developed work in its own right. Light and shadow are important in many of Hesse's works, as is the use of gravity as a shaping force. The minimalist grid in combination with the organic and random quality of the hanging cords reflects her interest in the tension between order and disorder. —BK

THE SPRINGS

1964, oil on canvas, 43 × 66 in. (109.2 × 167.6 cm.)
Gift of Wallace and Wilhelmina Holladay

"Painting, for me, when it really 'happens,' is as miraculous as any natural phenomenon—as, say, a lettuce leaf."[1] Although she consistently refused to "explain" the meanings of her works, Lee Krasner often indicated that even her most abstract paintings had ties to nature.

Like many of her pieces, *The Springs* is partly autobiographical. Its title refers to the village near East Hampton, on Long Island, where she and Jackson Pollock moved in 1945 and where she remained until settling in Manhattan two decades later. Stylistically, this is an example of gestural abstract expressionism: a large canvas, entirely covered with thick paint applied quickly in curving marks. Although it does not describe anything in particular, its rich texture, the various shades of green and white, and implied motion suggest grass and wind. In many parts of the painting "accidental" drips and splatters were left visible to emphasize the "automatic," unplanned way the pigments were applied.

Krasner painted *The Springs* soon after completing a group of dark abstractions called the *Night Journeys* and immediately after a series of personal traumas (surgery for a brain aneurysm, followed by a fall in which she broke her wrist, and then a second serious illness). Once Krasner had recovered, she began a new, very different series of paintings, much lighter in both palette and mood. As a result, many writers have interpreted *The Springs* as a symbol of rebirth and renewal.

LEE KRASNER

AMERICAN, 1908—1984

One of the most radical painters in the first generation of abstract expressionists, Lee Krasner devoted six decades of her life to making art. As a teenager, the Brooklyn native commuted into Manhattan to attend Washington Irving High School, an all-female institution where she majored in studio art. After graduating in 1926, Krasner continued her studies at the Women's Art School of Cooper Union, the Art Students League, the National Academy of Design, and City College of New York. Krasner also took classes with the avant-garde painter Hans Hofmann, who encouraged her to explore pure abstraction. A series of jobs in the Public Works of Art Project's Mural Division gave her valuable experience working on a large scale. During the 1930s Krasner was an active member of such organizations as the Artists Union and American Abstract Artists. Her commitment to political activism continued throughout her life.

For eleven years Krasner was married to Jackson Pollock, the most famous, and most controversial, abstract expressionist painter. Inevitably, his career and his colorful lifestyle overshadowed her reputation, even though Krasner was producing pioneering, totally abstract, painterly canvases at least two years before Pollock developed his signature drip-painting technique.

While continuing to promote Pollock's art, Krasner kept discovering new approaches to her own paintings and collages. She had her first solo exhibition at New York's prestigious Betty Parsons Gallery in 1951 and her first major retrospective in 1965 at the Whitechapel Gallery in London. During the early 1970s Krasner's contribution to abstract expressionism began to be reevaluated. The last decade of her life was marked by numerous honors, awards, publications, and exhibitions.

MELISSA MILLER

AMERICAN, B. 1951

In 1986, on the occasion of Melissa Miller's first major solo exhibition at the Albright-Knox Gallery, one critic aptly commented, "Miller is an animal painter. The very term has a nineteenth-century ring to it, calling forth images of exotic lands, unruffled pastoral life, ... a nostalgia for a lost harmonious world in which animals and nature were in precarious but fruitful balance."[1] In a very direct way, this description dovetails with Miller's artistic intentions at least as well as the trendsetting labels, such as new image painting and neo-expressionism, which were used to identify her work at the time. While both these movements have come and gone, Melissa Miller continues to develop highly subjective narratives in her art that bring to mind the work of Eugene Delacroix, Vincent Van Gogh, and Emily Carr, as well as allegories and animalia that date to sixteenth-century Dutch art.

Miller was born in Houston, Texas, and has lived most of her life in the hill country just outside Austin or at her family's ranch in Flatonia, Texas. A 1974 graduate of the University of New Mexico, she spent a single summer on the East Coast at the Yale University Summer School of Music and Art. There, under the tutelage of Gabriel Laderman, she made her first decisive move away from abstract expressionism toward landscape painting. Returning to Austin after a half year of traveling around the country, she began teaching herself how to paint in a figurative style. Spending much of her time alone on her family's ranch, she began to draw her images from the surrounding territory, and "one day in 1977, she let a few cows and chickens wander into a painting."[2]

As Miller described it, her new work "started out as portraits of animals that were at the ranch or that I owned. ... I really enjoyed the moment of recognition, of seeing some animal I knew evolve on the canvas."[3] In searching for subject matter with a deeper emotional draw, she began to weave narrative into her paintings through dream images, childhood memories, and other phantasmagoria with metaphorical overtones. Moreover, once she had gained confidence in her painting style, she began to look beyond her own backyard, incorporating animals from the wider world that held deep cultural significance—from bears, tigers, and coyotes to swans, owls, and monkeys, among many others.

BROKEN WING

1986, oil on linen, 58 × 66⅛ in. (147.3 × 168 cm.)
Partial gift of Laura Lee and Jack Blanton
Museum Purchase: The Lois Pollard Price Acquisition Fund

In the beginning of her career, most of Miller's paintings consisted of lively, high-colored expressions of animals in their natural habitats. By the mid-1980s, however, her works took on a fantasy life that deepened their sense of purpose and emotional impact. As the artist has written: "Since 1985, there has been a shift in my paintings from an external observation of the human condition to an internal dialogue about the psyche. ... Though individual animals are still the main protagonists in my paintings, they now interact with humanoids, angels, demons and spirits. In all the paintings, symbols and characters are carefully considered. I often use western cultural symbols of angels and devils to personify good and evil."[4]

Nowhere is this more evident than in her painting entitled *Broken Wing*. Drawn from imagery associated with Dutch fantasists such as Albrecht Altdorfer, the Brueghels, and Hieronymus Bosch, Miller paints a scene in which the fate of a white swan is sealed by its threatening surroundings. A powerful image of death triumphant, the figure of a lascivious-looking demon holds the majestic bird in its grip, while a host of hobgoblins emerges from a nearby wood to close in for the kill. Like a saint in swan's clothing, the central figure arches its neck to the sky with both wings outspread in what appears to be a final trumpeted call across a desolate marsh. Whether it is read as a deeply personal statement by the artist or carries with it a larger social message about our fate in this world, Miller's *Broken Wing* reveals a sense of beauty in utmost peril. —SFS

JOAN MITCHELL

AMERICAN, 1926–1992

SALE NEIGE (DIRTY SNOW)

1980, oil on canvas, 86¼ × 70⅞ in. (219.1 × 180 cm.)
Gift of the artist

Sale Neige (Dirty Snow) is typical of Joan Mitchell's lyrical, yet mysterious paintings from the early 1980s. Like most of her pictures, it is larger than human scale, so the abstracted landscape—or, rather, Mitchell's memories of and feelings for the landscape—literally becomes the viewer's environment.

Thick layers of pigment contrast with parts along the edges of the canvas where there is no paint at all. Mitchell creates a nervous rhythm through myriad crisscrossing brush strokes. As a result, the top two-thirds of the canvas—a complex mass of gray, pink, blue, lavender, and white—seems to be melting down onto the more vividly colored lower third. Mitchell's title encourages onlookers to perceive the composition in this way. It also relates the painting to several of the artist's most vivid early memories: of gazing at frozen Lake Michigan from the windows of her parents' apartment; falling through the ice in a childhood sledding accident; and being a champion figure skater in high school. Mitchell associates the cold, a common theme in her art, with silence and loneliness, and although many writers have referred to the joyous quality of her abstractions, scholars have also noted the influence of Mitchell's preoccupation with death and abandonment.[1] *Sale Neige* was painted shortly after Mitchell's companion, the Canadian painter Jean-Pierre Riopelle, ended their twenty-four-year relationship. This may explain the stress on the dark section at the bottom of the canvas, but the light green areas could just as easily refer to the coming of spring.

Although it seems spontaneous, with numerous drips of paint amid the thick brush marks, this painting is actually the product of careful consideration, preparatory drawings, and many months of work.

One of the most important members of abstract expressionism's second generation, Joan Mitchell executed large paintings full of energy and tension. Instead of pure abstraction, however, Mitchell concentrated on highly stylized representations of landscapes.

Mitchell was born in Chicago, where she began taking art classes in second grade. Influenced by her mother's work as coeditor of *Poetry* magazine and the authors who came to visit, including T. S. Eliot and Dylan Thomas, Mitchell first considered a career in writing, studying English literature at Smith College. Soon after, she decided to become a professional painter instead and received her B.F.A. and M.F.A. degrees from the School of the Art Institute of Chicago.

In 1950 Mitchell moved to New York and began exhibiting her work to considerable acclaim at a time when abstract expressionism was the principal avant-garde painting style. Despite her growing success as a member of the so-called New York School, the artist began spending time in France, where she had gone in 1948 on a yearlong scholarship.

After nine years in Paris, Mitchell moved to a country house in Vétheuil in 1968. She continued making large, multipart canvases, had several major retrospectives of her work, and received three honorary doctorates. In 1982 Mitchell became the first American woman to have a solo exhibition at the Musée d'Art Moderne de la Ville de Paris.

LOUISE NEVELSON

AMERICAN, B. RUSSIA, 1900–1988

Although she earned no steady income from her sculpture until she was in her sixties, by the time of her death Louise Nevelson was considered "one of the world's best-known artists."[1] As a child, Leah Berliawsky left Russia with her family to settle in Rockland, Maine. At six she played with scraps from her father's lumberyard; by ten she had decided to become a professional sculptor. In 1920 she married Charles Nevelson, a wealthy ship owner, and moved to New York City, where she spent the next decade studying painting at the Art Students League and pursuing her interest in the performing arts.[2]

After a brief period spent living and studying in Europe, Nevelson resettled permanently in New York in 1932 and began concentrating on visual art. As early as 1936 her work was singled out by critics as noteworthy, and her first one-woman show was held in 1941.[3] Nevelson moved from her early carved sculpture to her signature style in the late 1950s. She began scavenging bits of discarded wood from neighborhood streets, filling boxes with these found objects. She painted both the boxes and the objects black and constructed abstract compositions within each box, stacking them to form sculptural walls and environments through which spectators could walk. A 1958 exhibition of Nevelson's all-black environments caused a sensation.[4] However, it was with her room-size, all-white environment, *Dawn's Wedding Feast*, exhibited in *Sixteen Americans*, a prestigious group show at the Museum of Modern Art in 1958–59, that Nevelson was "first recognized as a major artist."[5]

Nevelson's reputation soared during the 1960s, when she represented the United States at the Venice Biennale and had her first important retrospective at the Whitney Museum of American Art. In subsequent years Nevelson received six honorary doctorates and continued to exhibit her work regularly in Europe and the United States.

WHITE COLUMN

1959, painted wood
92½ × 11½ × 10 in. (235 × 29.2 × 25.4 cm.)
Gift of an anonymous donor

White Column is made up of two separate segments that were originally part of Louise Nevelson's ground-breaking installation *Dawn's Wedding Feast.* The original installation consisted of numerous all-white, assembled wooden forms, including *Wedding Chest, Wedding Pillow, Wedding Cake,* and seven tall columns. Each part of this sculpture was the bottom half of a different column, but because no single buyer purchased Nevelson's whole environment, the pieces were dispersed among various collections or incorporated by the artist into later works. Nevelson first arranged this column in its present configuration for her second Whitney Museum retrospective of 1980.

Viewed in isolation, this single, nine-foot-tall column has a powerful impact. Its apparently simple silhouette is actually made up of myriad small shapes, skillfully arranged so that their forms, plus the shadows they cast, create a rich, endlessly fascinating surface. Some pieces of wood reveal their origins as decorative finials from furniture, and instead of being removed several nails have been hammered over to one side. Nevelson has used her remarkable compositional sense, together with a thick coat of white paint, to transform these disparate parts into a unified visual whole that, although it is abstract, reminds viewers variously of a human figure, a skyscraper, a totem pole, or a mechanical puzzle.

DOROTHEA ROCKBURNE

CANADIAN, B. 1934

SHEBA

1980, gesso, oil, Conté crayon, and glue on linen

74 × 59½ in. (188 × 151.1 cm.)

Gift of Wallace and Wilhelmina Holladay

Sheba is part of Dorothea Rockburne's "Egyptian" series—shallow reliefs based on ancient wall paintings. As in most of the artist's work, the title is simply a point of reference. Rather than depicting the historical Queen of Sheba, whose visit to King Solomon is chronicled in the Bible and has been the subject of many history paintings, this piece emphasizes the visual balance of related geometric forms and the subtle interplay of different shades of white.[1]

The work embodies opposite qualities. On the one hand, it is austere and elegant, planned and executed with mathematical precision. Yet *Sheba* also seems sensuous and mysterious because of its cast shadows, layered folds, and the drawn line that ties together the composition. Although she has often been termed a minimalist, Rockburne rejects this label, pointing out that, far from being nonreferential, her art refers to many things: art history, philosophy, mathematics, kinetic and emotional experiences she had as a dancer, and her memories of creating a network of lines by skiing through new snow.[2]

Sheba is an excellent example of Rockburne's quiet, introspective paintings that keep their distance from the viewer. Instead of assaulting the senses with vivid colors or dramatic brush strokes, she prefers her work to simply "sit and beckon," drawing the visitor closer to examine its surprisingly complex textures and forms.[3]

Until the age of twelve, Dorothea Rockburne was a virtual invalid because of repeated bouts of pneumonia. However, these years of listening to the radio and reading in the family home near Montreal, Quebec, laid the intellectual and emotional foundations for her later art.

As soon as she was physically able, Rockburne began swimming, skiing, and attending classes at Montreal's Ecole des Beaux-Arts. In her late teens she enrolled at Black Mountain College in North Carolina, where she earned her B.F.A. degree in 1956. North Carolina proved crucial, both personally and professionally. There, Rockburne was strongly influenced by her painting teachers Philip Guston and Jack Tworkov, fellow students Robert Rauschenberg and Cy Twombly, and the modern-dance pioneer Merce Cunningham.

At twenty-two, Rockburne was living in New York City and holding a variety of jobs to support herself and her daughter.[4] During the 1960s she took abstract black-and-white photographs, danced with the innovative Judson Theater group, and appeared in happenings, an early form of performance art. These apparently disparate experiences led Rockburne to experiment with folding and refolding paper into geometric forms, an approach she later pursued using pieces of canvas.

Rockburne's first one-woman exhibition, held in New York in 1970, launched her career as a full-time visual artist. Since then she has produced numerous series of largely monochromatic works known as painted structures, inspired by such diverse sources as the Golden Section, Italian Renaissance frescoes, and Mandelbrot's ideas about fractals. Rockburne has taught in New York, Maine, and Rome; won awards from the Guggenheim Foundation and the National Endowment for the Arts; and had important solo shows in Europe, Canada, and the United States, including a major 1989 retrospective at Brandeis University.

HOLLIS SIGLER

AMERICAN, B. 1948

Since 1975 the Chicago artist Hollis Sigler has created psychologically complex narrative paintings, drawings, and prints grounded in personal experience. Adopting a *faux naif* style, the childlike look of her art has been characterized by Sigler as a reaction against what she saw as a patriarchal culture that historically treated women as little more than children.[1] And yet, from its inception, this style was also a means of conveying difficult emotional content in a way that viewers could easily understand.

Born in Gary, Indiana, Sigler earned a B.F.A. degree from Moore College of Art. Three years later, she received an M.F.A. degree from the School of the Art Institute of Chicago and began to take her place in Chicago's art scene during a period when artists in that city, as well as in Los Angeles and San Francisco, were questioning New York's cultural hegemony. Familiar with Chicago's Hairy Who group—with its emphasis on cartoons and other low-art imagery—as well as the whimsical art of Florine Stettheimer, Sigler found sympathetic and quirky precedents for her own burgeoning, idiosyncratic approach.[2]

TO KISS THE SPIRITS: NOW THIS IS WHAT IT IS REALLY LIKE

1993, oil on canvas with painted frame
66 × 66 × 3 in. (167.6 × 167.6 × 7.6 cm.)
Promised gift of Steven Scott, Baltimore, Md.,
in honor of the artist

Extrapolating on events from her life, the artist's favored subjects became women's experience in and of the world, from love, family, and the domestic sphere to disease, coping with loss, and ultimately the inevitability of death. Using her purposely awkward style, complete with written banners and borders and decorative, painted frames, Sigler conjures up intimate interiors or suburban backyards in which household objects or a shadow figure called "the Lady" serve as stand-ins for real people. Typically, too, her set pieces register the emotional aftermath rather than the cause of a dramatic action.

From 1985 onward, she has focused on the complex issues surrounding breast cancer—its incident rates, causes, and treatments; its fears, rages, and uncertainties. A long-term survivor of the disease to which her mother and grandmother have already succumbed, Sigler creates works that are emotionally relentless for all their sweet coloring and engaging style. In what can best be described as a coda to the 1992–93 series *Breast Cancer Journal: Walking with the Ghosts of Our Grandmothers*, the painting *To Kiss the Spirits: Now This Is What It Is Really Like* presents the artist's most hopeful expressions to date.[3]

At the lower register of the painting, small, toylike brick and timber houses softly glow under their porch and street lamps, while the upper two-thirds of the canvas pays homage to Vincent Van Gogh's *Starry Night*.[4] At the center of the picture, bathed in celestial light, the silhouetted "Lady" rises effortlessly along a fluted staircase, changing color from purple through rose to white as her arms slowly lift upward to become an angel's wings. Freed from the mundane cares of this small patch of suburban ground, Sigler envisions the end of a most difficult physical, psychological, and emotional journey and the achievement of a long-awaited state of grace. —SFS

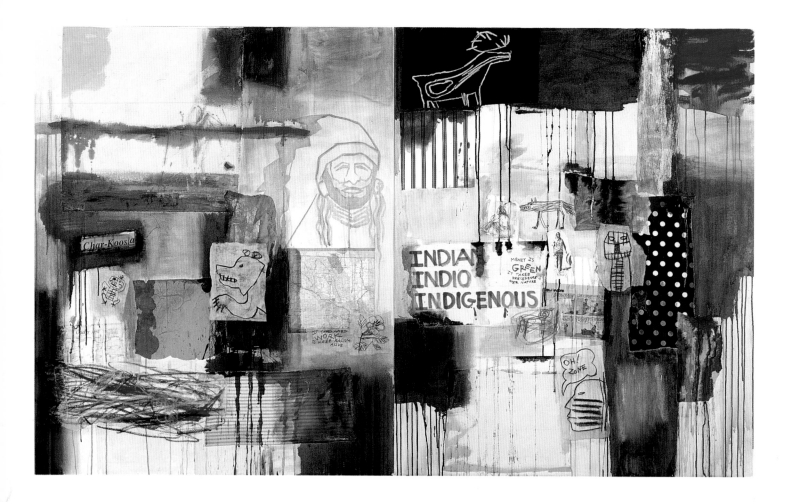

INDIAN, INDIO, INDIGENOUS

1992, oil and mixed media on canvas

60 × 100 in. (152.4 × 254 cm.)

Museum Purchase: Members' Acquisition Fund

Indian, Indio, Indigenous is an important example of what Jaune Quick-to-See Smith calls her narrative landscapes: paintings in which stories are revealed only to those who know how to see life in the arid "empty" land.[1] Set within a collage of striped and polka-dotted fabrics, which bears a resemblance to aerial photographs of cultivated lands, Smith includes the masthead of her reservation newspaper, *Char Koosta*, photocopies of George Catlin's drawings of American Indians, part of a U.S. map, pictographs of bear, deer, and a coyote, a painted bust, written declarations, and abstract blocks of paint.

In this work, Smith provides the viewer with multiple symbolic elements that require deciphering. Be-

ginning with the red painted words "Indian Indio Indigenous"—suggestive of American Indian blood that has been spilt on the soil—pictorial images are juxtaposed with such sardonic comments as "it takes hard work to keep racism alive" and "money is green: it takes precedence over nature." Representative of both the wounded earth and the unjust treatment of native peoples, this painting strongly echoes Chief Seattle's 1854 statement, "We are part of the earth and it is part of us."[2] In this context, it is possible to see the august-looking figure to the left of center in the painting as a representation of this famous Duwamish chief who was forced to sell native ancestral lands to the U.S. government under the 1855 Port Elliot Treaty.[3]

Reading these symbols, the meaning of Smith's canvas becomes clear. It is a morality tale about the historical desecration of Indian lands and culture as well as a modern-day admonition to stop the injustices native peoples experience in the United States.

JAUNE QUICK-TO-SEE SMITH

AMERICAN INDIAN, B. 1940

Jaune Quick-to-See Smith's art presents a cross-cultural dialogue between those values and experiences of the artist's inherited past and those of late-twentieth-century Euro-American culture. A painter of Salish, French-Cree, and Shoshone heritage, Smith was born in St. Ignatius, Montana, and raised on the Flathead Reservation. She became an artist while in her thirties, and was already earning a living as a painter before she completed her M.F.A. degree at the University of New Mexico. By the mid-1970s Smith had also founded artists' groups, curated exhibitions, and organized grassroots protests to express her concern for the land and its people. Over the past two decades, she has become one of the best known American Indian artists in a ground-breaking generation that includes herself, George Longfish, Hachivi Edgar Heap of Birds, and others.

Deeply connected to her heritage, Smith creates work that addresses the myths of her ancestors in the context of current issues facing American Indians. She works with paint, collage, and appropriated imagery, using a combination of representational and abstract images to confront subjects such as the destruction of the environment, governmental oppression of native cultures, and the pervasive myths of Euro-American cultural hegemony. Inspired by the formal innovations of such artists as Pablo Picasso, Paul Klee, and Robert Rauschenberg, as well as traditional American Indian art, Smith sees herself as "a harbinger, a mediator and a bridge builder. My art, my life experience, and my tribal ties are totally enmeshed. I go from one community with messages from the other, and I try to enlighten people."[4] —SFS

JOAN SNYDER

AMERICAN, B. 1940

In the 1960s, modernist abstraction, which held tremendous sway in the United States, was characterized by a concentration on the formal qualities of painting to the exclusion of any carriers of meaning that existed outside the work. This suppression of narrative was followed fewer than ten years later by a reintroduction of content so strong that its effects are still with us today. The expressionist response to the reductive aesthetic of 1960s painting was championed by numerous artists, including Joan Snyder, Jennifer Bartlett, Susan Rothenberg, and Elizabeth Murray. Engaged in and informed by feminist politics and the women's movement in the 1970s, their desire to challenge the myth of male artistic genius and to recast the traditional canon of art history helped them make their mark on American painting during the last three decades of the twentieth century.[1]

Snyder provided a model for ambitious women artists of her generation in the 1970s. She began painting as a senior at Douglass College in New Brunswick, New Jersey, and continued her studies at Rutgers University, receiving an M.F.A. degree in 1966. From the very start, Snyder saw her art as visual poetry, a language that opened up her world. "When I started to paint, it was like speaking for the first time. I mean, I felt like my whole life, I had never spoken. I had never been heard. I had never said anything that had any meaning."[2]

At the beginning of the 1970s, she received early, positive critical attention for her "stroke" paintings—loosely brushed paintings using vertical and horizontal marks that were concerned with formalist issues such as the integrity of the picture plane, the grid, and the canvas's edge. As Snyder recalls, she soon found these works "too easy" and began to search for a less formulaic approach to her art making.[3]

In the ensuing five years, Snyder consciously and openly rejected the analytic approach of many of her peers and sought a new lexicon of artistic forms that was more expressive, deeply emotional, and personal. By 1974 her iconography encompassed images of the body, childlike drawings of houses and landscapes, hearts, stick figures, and scrawled personal notes. In addition, although her painterliness took its cue from abstract expressionism, she added to the canvas surface a wealth of collage elements—fabric, wallpaper, linoleum, and papier mâché—and she even sewed, stuffed, or darned elements into the core of the work, processes the artist described as markedly female in sensibility.[4]

Beginning in the mid-1980s in her "field paintings," landscape (which had always been a part of her work) resurfaced as a principal theme.[5] Equating her artistic activity with the ability to make a fallow, unmarked canvas field bloom, in these works Snyder expressed a strong identification of the female body with the earth and fertility.

CAN WE TURN OUR RAGE TO POETRY

1985, mixed media on canvas
59½ × 144 in. (151.1 × 365.8 cm.)
Gift of Exxon Corporation

In *Can We Turn Our Rage to Poetry*, which is more powerfully abstract than most of the "field paintings," Joan Snyder literally plants thick strokes of paint in three squares laid out on an inflected gray ground.[6] Reading the painting from left to right, the first and darkest section is made up of pieces of black velvet, broken mirrors, and thin ropes of sequins as well as paint. The center section includes brilliantly colored rectangles laid out in a grid, followed by a wonderful wall or path of golden bricklike strokes. In the third and final section, elemental shapes such as circles, rectangles, and triangles float in thickly encrusted space. These shapes then reappear in papier mâché and Rhoplex acrylic reliefs that jut out from the gray matter of the surrounding field. As much about the possibilities of life as about art, the transition from chaos to order in this painting, combined with its title, represents a summation of Snyder's core beliefs and her search for transcendence.

Looking back over her career, Snyder wrote in 1992: "I believe that women artists pumped the blood back into the art movement.... At the height of the Pop and Minimal movements, we were making other art—art that was personal, autobiographical, expressionist and political—using words and photographs and as many other materials as we could get our hands on. This was ... appropriated by the most famous male artists of the decade. They called it Neo-Expressionist. It wasn't Neo to us."[7] —*SFS*

SOHO WOMEN ARTISTS

1977–78, acrylic on canvas
78 × 142 in. (198.12 × 360.68 cm.)
Museum Purchase: The Lois Pollard Price Acquisition Fund

SoHo Women Artists is a group portrait featuring a number of May Stevens's friends—well-known feminist artists and thinkers as well as several SoHo residents. Depicted in a friezelike composition are, from left to right: Signora D'Apolito, owner of a bakery; two older men from the Italian community; May Stevens herself; Harmony Hammond; Joyce Kozloff, sitting on the ground with her son Nikolas; Marty Pottenger;

Louise Bourgeois wearing one of her sculptures; Miriam Schapiro; the cultural critic Lucy Lippard; and Sarah Charlesworth with a bicycle. The large canvas is divided into three distinct groupings: residents, friends, and, in the background, deep royal blue renditions of three of Stevens's earlier works. The locals are separated from the rest of the group by a shift in color, by less clearly defined faces, and by Stevens's facing them to indicate that the locals occupy a different but equally important sphere in her life.

In contrast to Stevens's previous flat and poster-like style, *SoHo Women Artists* displays a looser brush stroke and stronger modeling. Likewise, the

MAY STEVENS

AMERICAN, B. 1924

Born in Quincy, Massachusetts, near Boston, May Stevens grew up in a working-class family. Women's poverty and lack of opportunity, which she perceived in the environment surrounding her, strongly influenced her outlook on society. Stevens studied at the Massachusetts College of Art in Boston, the Art Students League in New York, and the Académie Julian in Paris. Combining her personal experience with political engagement, Stevens's work focuses on the effects the late twentieth century has had on our lives, especially those of women. She believes that artists have the possibility to use their art not just for personal expression, but for social and political commentary and activism as well.[1] Stevens has been particularly identified with the feminist art movement of the 1970s and 1980s, and much of her work critiques women's historical, political, and social conditions. Her recent creations have become increasingly lyrical and poetic and address themes of loss and absence.

representation of the figures resembles a montage with multiple viewpoints that differ from Stevens's earlier work, which was constructed with not only a single perspective but, figuratively speaking, also a narrower political view in mind. Two examples of this are represented in the background: *Benny Andrews and Big Daddy* (1976) on the left and *Big Daddy Draped* (1971) on the right. Both draw on Stevens's perception of her father as representative of male chauvinism, American racism, and military nationalism. The central work represented is *Artemisia Gentileschi* (1976), an imaginary portrait of the seventeenth-century painter who has been celebrated by feminist art historians. Therefore, Stevens adds another autobiographical component to *SoHo Women Artists* by recording her own recent artistic production.

SoHo Women Artists belongs to a group of large paintings that Stevens has called history painting, or "parod[ies] thereof,"[2] which present an alternative history.[3] They continue the tradition of historical, mostly male, group portraits but represent a recent part of history in which Stevens, and women in general, participated. While Stevens is thus subverting history painting, she is using its authority, albeit with tongue in cheek, at the same time. —BK

ALMA W. THOMAS

AMERICAN, 1891–1978

She had her first one-woman show at the age of sixty-eight and developed her signature style seven years later. Despite her belated start, Alma Woodsey Thomas went on to have retrospectives at the Corcoran Gallery of Art and the National Museum of American Art, both in Washington, D.C.; she was the first African American woman to have a solo show at the Whitney Museum of American Art; and she exhibited her paintings at the White House on three occasions.

Thomas was born and raised in Columbus, Georgia. In 1907 she moved with her family to Washington, D.C., into the house where she spent the remaining seven decades of her life. After graduating from high school, where she excelled at art, Thomas earned a teaching certificate and, later, a master's degree in art education. Throughout her life, Thomas concentrated on her career; she painted part time while supporting herself by teaching art, notably at Shaw Junior High School, where she worked from 1924 until her retirement in 1960.

Thomas's early art was realistic. However, at Howard University, where she was the Art Department's first graduate in 1924, she became fascinated by abstraction, based on the influence of her professors Lois Mailou Jones and James V. Herring.[1] When she was invited to exhibit her art at Howard in 1966, Thomas decided to experiment with a new approach, developing the type of painting for which she is best known today: large abstract canvases filled with dense, irregular patterns made by brushes heavily laden with bright colors. Thomas's mature work has been compared with Byzantine mosaics, the pointillist technique of Georges Seurat, and the paintings of the Washington Color School, yet her work is quite distinctive.

A lifelong political activist, Thomas offered weekly art classes to children from Washington's poorest neighborhoods even when she was suffering from severe arthritis. In her eighties, neither a broken hip nor a debilitating heart ailment prevented her from continuing to paint.

ORION

1973, oil on canvas, 64 × 53¾ in. (162.6 × 136.5 cm.)
Gift of Wallace and Wilhelmina Holladay

Orion is part of Alma W. Thomas's *Space Paintings* series, inspired by her interest in the American space program, especially the dramatic photographs of the universe taken during rocket flights.[2] Although it does not depict the mythological hunter Orion or the constellation named after him, Thomas's canvas does suggest what one writer has called "a glimmering, starlike flicker."[3]

Like all of Thomas's works, this painting was created from a series of small watercolor sketches. Thomas then applied her colors freehand, using faint pencil lines as a guide. The darker of the two shades of red used in *Orion* is concentrated in two areas, both to the left of the painting's center. This adds to the dynamism in the composition. Aside from the vibrant quality of the lighter red, what makes this work exciting is the unpainted white spaces still visible between the dabs of color. This creates a pulsating, shimmering, and ever-changing visual rhythm all across the composition—comparable, as Thomas said, to the streaks of color one might see while riding in a fast-moving train or airplane.[4]

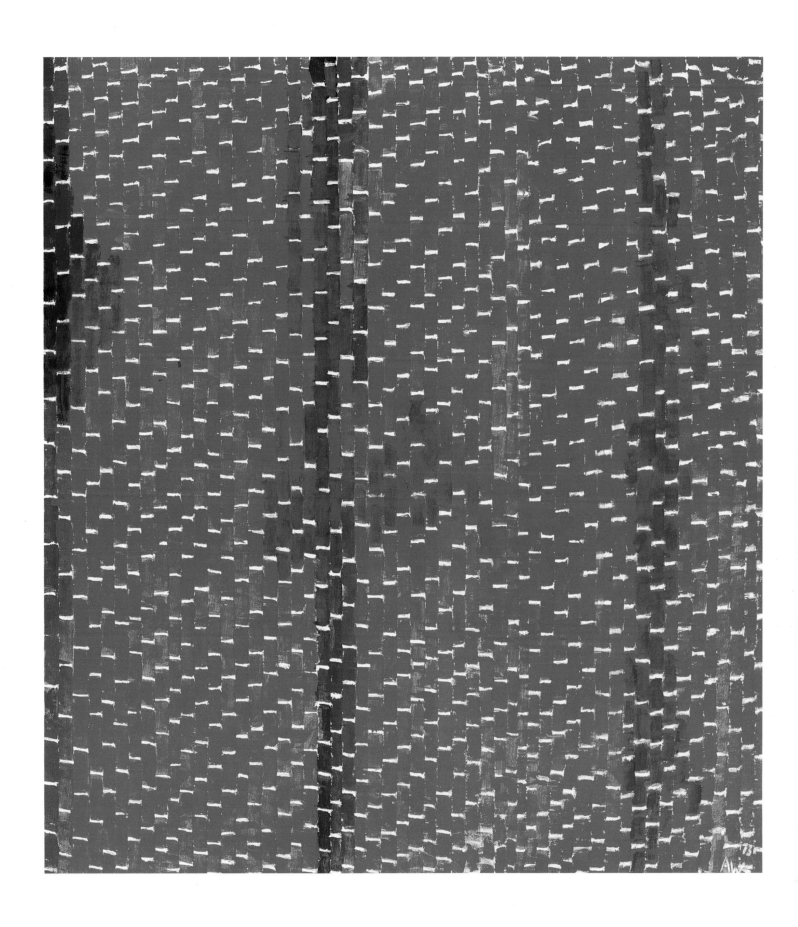

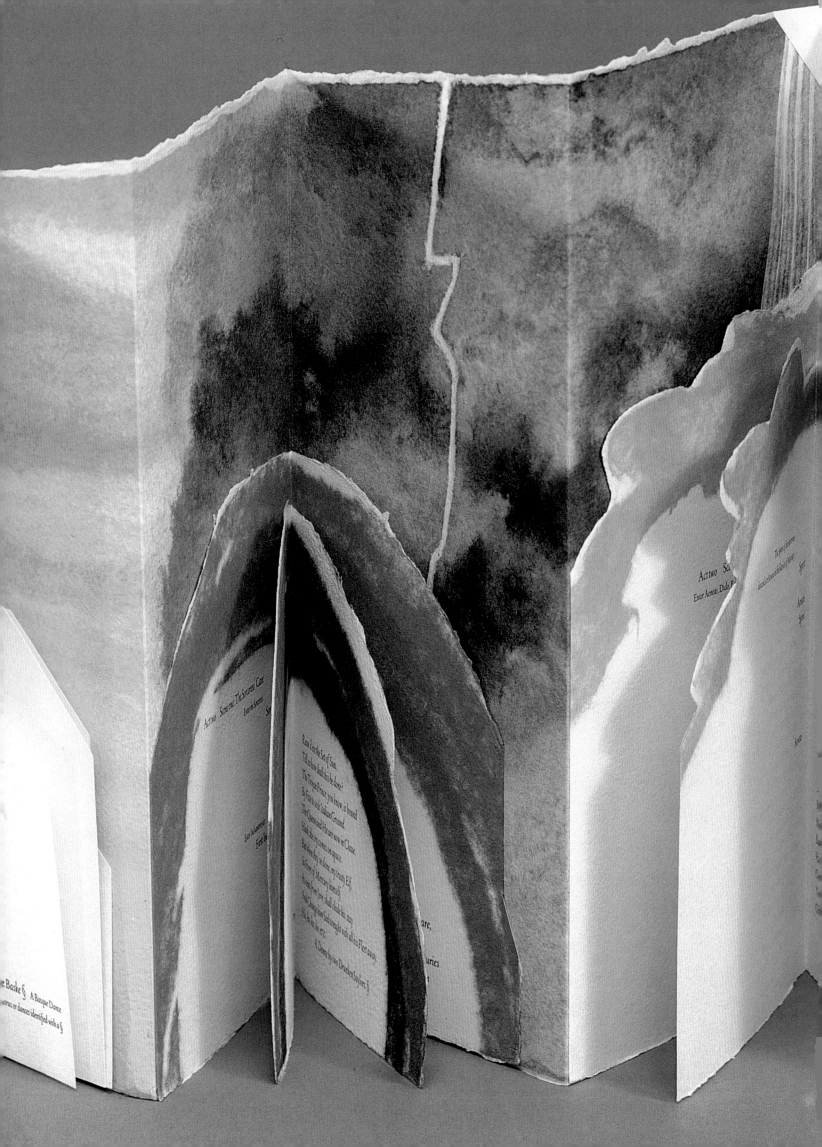

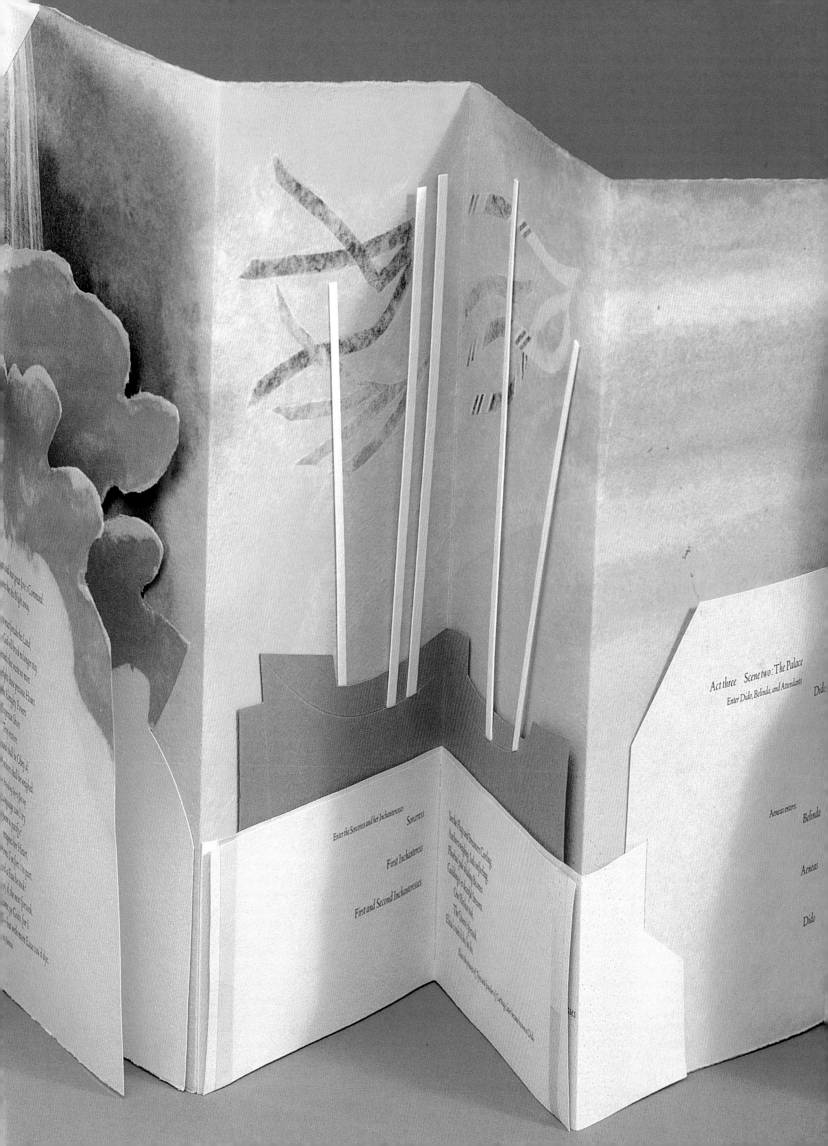

Act three Scene two: The Palace
Enter Dido, Belinda, and Attendants

ARTISTS' BOOKS

Everyone knows what a book is, but the term *artist's book* is unfamiliar to most people. Yet, since the late 1960s, artists' books have increased exponentially in number, variety, and importance, becoming—according to one writer—"the 20th-century art form par excellence."[2]

That which we call a book has changed tremendously over the centuries. Ancient clay and stone tablets and papyrus rolls were replaced in the fifth century C.E. by the codex—pages made from animal skin and stitched together. The late fifteenth century introduced movable type. Subsequent technological innovations, such as offset and digital printing processes, helped establish the modern publishing industry. However, for 1,600 years, in whatever form they took, whether hand painted or produced with a laser printer, books have been clearly recognizable as books. Artists' books often have not. Unlike commercially produced text or trade books, artists' books are not printed in mass quantities or advertised and distributed through the networks developed by major publishing houses. They cannot be found on the shelves of the local library or bookstore. Like other forms of art, artists' books are more likely to show up in gallery and museum exhibitions or in private collections.

Specialists disagree about the precise definition of artists' books.[3] In fact, the only thing they agree on is the fact that no single definition can encompass the myriad recent variations on this form. Nevertheless, most artists' books share certain characteristics. They are handmade by the artists themselves; the artists exercise a high degree of control over all aspects of the books they produce; and artists' books are conceived from the beginning as works of art. The term *artist's book* has been traced to an exhibition held at the Moore College of Art in Philadelphia in 1973,[4] although artists' books are also called *bookworks* or *book objects*. *Book arts* is another important related term, generally used to refer to the many crafts (including papermaking, typography, printing, and bookbinding) involved in creating artists' books.

Artists' books occupy their own niche—or, rather, a succession of niches, including everything from exquisite deluxe editions produced by so-called fine presses to unique objects that sometimes seem more like pieces of sculpture than books. The most important element in a traditional book is its text. Many book artists also use text written by the artist or someone else in actual or imaginary languages and transcribed in graceful calligraphy, scribbled graffiti, or formal type. However, artists' books deal with text in different ways. For example, both Debra Weier and Jenny Hunter Groat encourage us to read the texts of the poems that inspired their bookworks; Claire Van Vliet does the same with the libretto of the opera on which her piece is based. Mirella Bentivoglio incorporated only a line from the poem "To Malherbe" into her creation, while Elisabetta Gut built her artist's book around an actual "found" book—but placed it inside a cage, where it cannot be read; and Molly Van Nice teases the viewer by including beautifully formed words she creates that have no literal meaning. Some book artists also challenge the traditional Western notion that a book must be read from left to right and from top to bottom. Others reject the whole concept of sequential narration. The variations are endless.

Many artists' books include images like those in a traditional illustrated book. Such images may be literal embodiments of the text, abstract evocations of its overall mood, or totally separate creations. Other artists' books contain neither text nor image. Because the single inscribed phrase is so discreetly placed, Bentivoglio's bookwork appears more like a sculpture—a solid piece of onyx with a single, egglike form atop a rectangle. Indeed, "sculptural" books are a pop-

ular subgroup within the broad category of artists' books.

Artists' books can exist as standard rectangles or in any other format, from a folding, accordion-like structure to a scroll such as the one in Groat's piece or a Möbius strip. Some are so small they must be read with a magnifying glass; others have expanded into room-size installations. The range of materials used in artists' books is equally diverse, and the degree to which a given artist's book is interactive also varies tremendously. Some artists' books are so fragile they must be displayed inside protective cases, whereas others cannot be experienced fully unless the "reader" physically manipulates part of the bookwork.

The seven artists' books discussed in this section represent varied approaches, from the environmental message emphasized by Groat to the sheer aesthetic splendor of Spitzmueller's gleaming bookwork and Van Nice's unexpected humor.[5] The artists' biographies also demonstrate that most book artists have day jobs in related fields—often as book conservators or proprietors of small presses.

Although it has roots in earlier twentieth-century avant-garde movements (notably futurism, dada, and surrealism), the artists' book as an art form exploded during the late 1960s. Bentivoglio became intrigued with the expressive potential of the book form in the aftermath of the 1966 flooding that threatened so much Florentine art. In the same year, Walter Hamady—the person most often mentioned as a source of inspiration by American book artists, including Debra Weier—started one of the most influential book arts programs, at the University of Wisconsin, Madison. During the last thirty years many more such programs have been established at American art schools, colleges, and universities. Beginning in the 1980s, a number of these institutions began offering B.A. and M.F.A degrees or concentrations in book arts.[6] The first national conference on book arts was held in 1990; these meetings, along with periodicals such as *Umbrella* and *The Journal of Artists Books* and a number of doctoral dissertations, have helped raise the profile of artists' books.

At the start of a new millennium, the question arises: will the increasing availability of online newspapers, magazines, and books eventually wipe out their three-dimensional counterparts? Some pundits believe the opposite will happen—that, because of their scarcity, books and especially artists' books will seem all the more precious.

ARTISTS' BOOKS TAKE EVERY POSSIBLE FORM, PARTICIPATE IN EVERY POSSIBLE CONVENTION OF BOOK MAKING,... EVERY DEGREE OF EPHEMERALITY OR ARCHIVAL DURABILITY.

—JOHANNA DRUCKER[1]

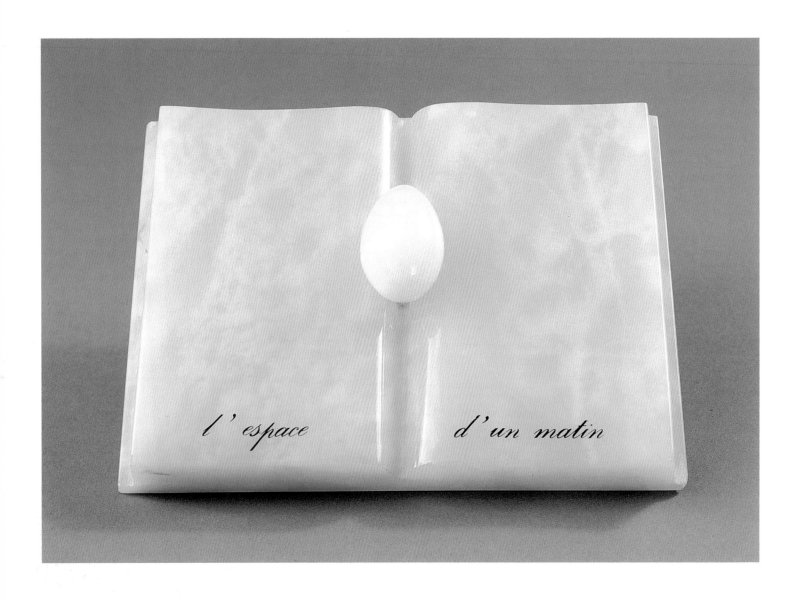

TO MALHERBE

1975, onyx, 5⅜ × 7⅛ × 2¼ in. (13.7 × 18 × 5.7 cm.)
Gift of the artist

To Malherbe was inspired by a poem of the same title written in 1599 by François de Malherbe to console M. du Perier, a barrister at the parliament in Aix-en-Provence who lost his young daughter Marguerite at an early age. The poet compares the brevity of Marguerite's life to the life of a rose. Bentivoglio carved the book in pink onyx to evoke through the color the ephemeral nature of the morning light. The line *l'espace d'un matin* (the span of a morning) from Malherbe's poem and the transparent egg suggesting a half-filled hourglass, allude to the all-too-brief life of the heroine.

MIRELLA BENTIVOGLIO

ITALIAN, B. 1922

Mirella Bentivoglio explores the relationship between language and image in her art. "Language is not only bureaucracy and power," she explains, "it belongs to history, to a domestic history, where woman had a large part. It is the woman who gives language to the human being in his first years of existence."[1]

Born in Klagenfurt, Austria, to Italian parents, Bentivoglio grew up in Milan. Having studied languages in Switzerland and London as a young woman, she used her father's extensive library as a home-based university during World War II. Her course of artistic study was determined by both parents. "My mother was always a bit jealous of my father's books," Bentivoglio recalls, "and by extension, of my relationship with him. She wanted me to paint, whereas my father encouraged my reading and writing. I hope, that through the creation of artists' books and works of visual and concrete poetry, combining image and language, I have finally made peace between them."[2]

Two symbols have dominated Bentivoglio's work since the 1970s: the egg and the tree. She sees the egg as a symbol of unity and equality between the sexes, because, she asserts, "we never know if an egg will contain a male or female life."[3] The tree represents her connection to the earth and nature, which she feels need our protection now more than ever. In honor of her commitment to the earth and to ensure the durability of her work, Bentivoglio's unique books are often made from materials that cannot be easily destroyed, such as stone, metal, and wood.

Bentivoglio is not only a book artist, she is also an art critic and curator, a researcher, a sculptor, and a performance artist. Her research has brought recognition to many women artists, and she has organized exhibitions in Europe, Australia, Japan, and North and South America. She currently resides and works in Rome. —KW

JENNY HUNTER GROAT

AMERICAN, B. 1929

Jenny Hunter Groat's interest in artists' books was stimulated by her love for beautiful handwriting and her fascination with bookbinding techniques. "In the artist's book," says Groat, "I could create an entire, small environment, very much like a stage set. It could become a whole, integrated art form in which the parts were all directed and composed to communicate a meaning."[1]

Born in California, Groat wanted to be an artist from earliest childhood. "Although there were few things in my environment to give this inner knowing any depth," reveals the artist, "I had an innate longing for poetry, classical music, visual art, and the desire to do all these for myself."[2] Groat's mother encouraged her interest in music and dance. "In modern dance I found my first, true art field in which all the arts I loved could be joined."[3]

After five years of training (1951–56) at the Halprin-Lathrop School and Studio, she began to compose and perform her own dance works. She eventually abandoned dance because of financial struggles, stress, and personal problems. Calligraphy became her new passion. In 1956 she began to study the art of beautiful writing with her teacher Lloyd J. Reynolds, who was also instrumental in spreading an interest in Asian art and Zen Buddhism, which has had a lasting influence on Groat's philosophy of life.

During the same period, Groat's exposure to the abstract expressionist painters in San Francisco and New York made a lasting impression on her and underscored her own belief in the importance of improvisation in art. She began to paint large abstract works on paper and canvas. In recent years, her works have included spontaneous calligraphic forms. —*KW*

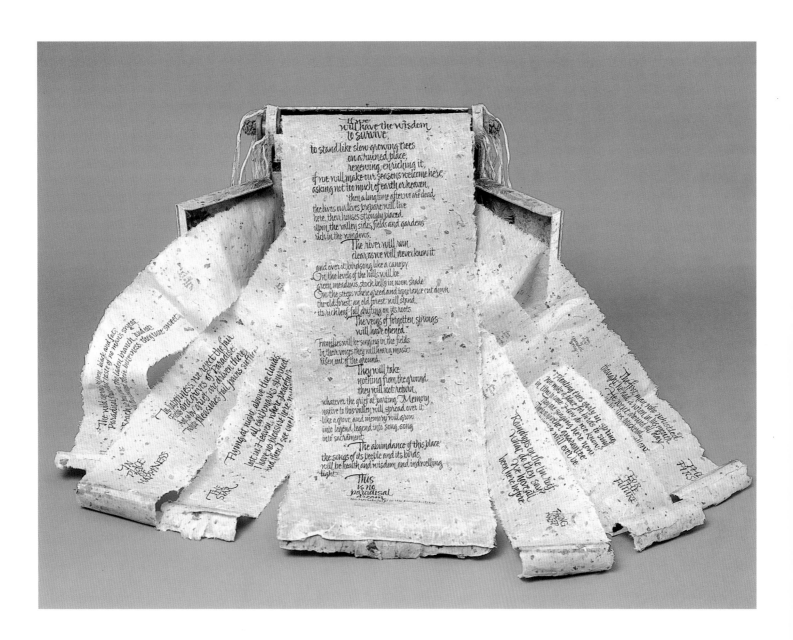

A VISION

1992, mat board, Chinese and Japanese paper,
linen threads, cones, wood, bark, and plants
9 × 12 × 3¼ in. (22.9 × 30.5 × 8.3 cm.)
Gift of the National Museum of Women in the Arts
Library Fellows

A Vision houses seven Wendell Berry poems that extol the beauty and vulnerability of nature. The book is made of bark, cones, ferns, and rare plants growing in the redwood forest. The little knobs that turn the scrolls are cones from the sequoia trees, while the hand-carved latches are made of redwood. The cabinet door's collage includes yerba buena grass and wild strawberries, both unique to the area. Integrating structure and content, Groat's book both protects and reveals the words of the poet. While most artists' books allow viewers to see only one page at a time, the design of *A Vision* permits the viewer to see the book, including all seven of its poems, concurrently. To give the structure its inner glow, Groat laminated handmade paper from Bhutan over antique gold tea-chest paper from Japan. She worked every day for four months on *A Vision*.

BOOK IN A CAGE

1981, wood, wire, and French-Italian pocket dictionary
5⅛ × 4⅝ × 4½ in. (13 × 11.7 × 11.4 cm.)
Gift of the artist

Book in a Cage demonstrates the ambiguity of language as a tool of communication. The tiny French-Italian dictionary has been trapped inside the cage. On one level it implies that words, when used indiscriminately, can lead to a cagelike isolation; on another level it suggests the limitation of language to express ideas through words alone. The captured book also symbolizes the constraints imposed on the printed word through history. The open door to the cage is a metaphor for the inherent liberty of ideas.

ELISABETTA GUT

ITALIAN, B. 1934

Endowed with an aura of originality and poetic whimsy, Elisabetta Gut's book-objects must be seen rather than read. Gut was born in Rome and has lived there ever since. She studied at the city's art institute and later at the Academy of Fine Arts. Her early work was primarily in stage and costume design and documentary film.

In 1964 Gut created her first book-object, *Diario* (Diary), and from that time on she has devoted most of her energy to the exploration of the relationship among language, music, image, and nature through book-objects and visual poetry. Buzz Spector, the conceptual and book artist, writes that book-objects are "a genre of artwork that refers to forms, relations, and configurations of the book."[1] A uniqueness and tactile physicality defines Gut's book-objects. Ideas are expressed through the symbolic meanings of found or fabricated objects, rather than through words. The artist frequently uses organic matter such as leaves, seeds, and wood in her work. For example, her *Seed-Book* is bound in a shell of a split coconut. As the title aptly suggests, the book, like a seed, is a symbol and a source of creative growth.

Gut's book-objects express her most intimate emotions, fleeting moods, and sensations. "I love silence and solitude, they stimulate my creativity and bring new and yet unknown to me ideas to the surface. The vein of a leaf, flowers following the journey of the sun, thin blades of grass blown by the wind, are for me the ancient alphabets of unknown languages."[2]

Gut often uses collage in combination with the written word. One work, *A Kafka a Kafka,* dedicated to the Czech writer Franz Kafka, visualizes the gestures, the smell, and the taste of Kafka's smoking a cigarette. Rather than an image of the novelist himself, it includes only an image of his smoke.

Gut is the recipient of many Italian and international prizes, including the Premio de Poesia Esperimental Gerardo Diego, which she received in Madrid in 1988. Her work can be found in major museums, archives, and public collections throughout Europe and the Americas. For the last ten years she has been involved in environmental art and large-scale earth art projects. —*KW*

PAMELA SPITZMUELLER

AMERICAN, B. 1950

One of the most inventive and admired book artists in the United States, Pamela Spitzmueller is also a professional book conservator. The inner structure of damaged volumes and the natural aging of book materials inspire her creative work. "My specialized interest in historic book structures, in particular sewing techniques, finds an outlet in my three-dimensional work," says the artist. "The combination of traditional book materials, paper, fabric, leather, wood, parchment, ink, paint, and metal is the basis of my work."[1]

Spitzmueller grew up in suburban Chicago, "making things" in her father's wood workshop. After graduating from the University of Illinois with a degree in art education, she went on to study bookbinding with the book conservator Gary Frost of the Newberry Library, where she worked from 1976 to 1983. There she broke traditional gender barriers by being the first woman trained in assignments requiring physical strength and artistic decision making.

Spitzmueller subsequently moved to Washington, D.C., and worked in the Library of Congress as a rare book conservator. After six years, she was invited to direct the University of Iowa Conservation Department and serve as an adjunct associate professor at the university's School of Art and Art History. In 1998 she was appointed the first James H. Needham Chief Conservator for Special Collections at Harvard University's Library Preservation Center. She also teaches classes and workshops and lectures in conservation techniques, papermaking, and the book arts.

Spitzmueller frequently dedicates her artists' books to her favorite poets and artists—Walt Whitman, Emily Dickinson, and Joseph Cornell, to name a few. In 1998 Spitzmueller was asked to create an artist's book for Hillary Rodham Clinton, who was meeting the Harvard Preservation Librarian. *For Hillary* includes the poem "Fate Conspires to Strengthen Us" by Anne Dutlinger. There are two copies of the book—one in the White House and the other kept by the artist.

BRITISH MUSEUM MEMOIR

1997, small-grid graph paper, colored pencil, ink, copper sheet and copper wire, 11 × 4 × 7 in. (27.9 × 10.2 × 17.8 cm.) Gift of the United States Department of Education

British Museum Memoir is bound in a thin sheet of copper. Pamela Spitzmueller created this fragile and intimate book after a visit to London's British Museum. The artist was inspired by the objects in the exhibition cases, which tantalize and invite the visitor but are never fully revealed. Delicate, crumpled pages of Spitzmueller's *Memoir* may fascinate and beguile the viewer, but they never fully disclose the artist's secrets. The book underscores the private nature of Spitzmueller's beautiful drawings, poetry, and confessional writings. "I am a kite caught in the tree, only revealed when the wind lifts and ruffles the leaves," she proclaims on one of the pages. This very light book derives a sense of volume and airiness from the crumpled paper, yet it is surprisingly durable. —*KW*

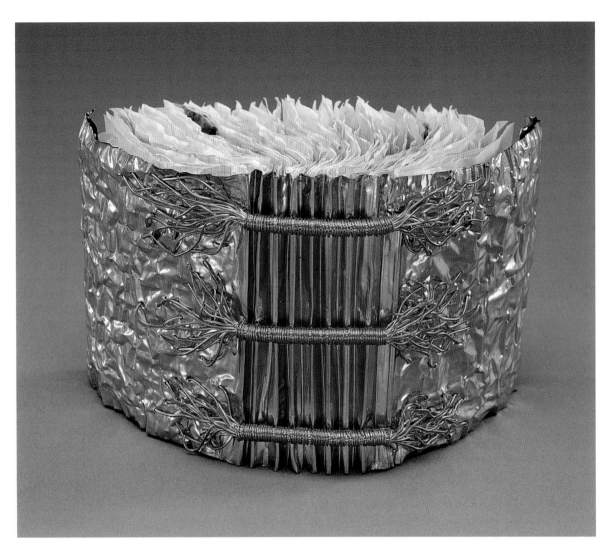

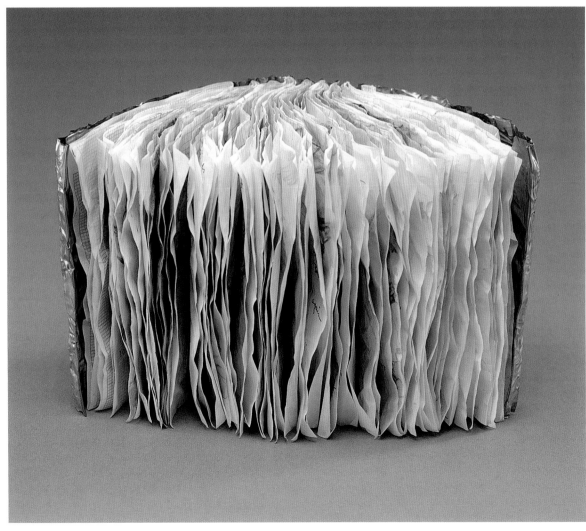

MOLLY VAN NICE

AMERICAN, B. 1945

Certain moments in the life of an artist can set life's significance in sharp focus. For the Boston-born Molly Van Nice, it was seeing El Greco's painting *The View of Toledo* at the age of fourteen. It was then, at the Metropolitan Museum of Art in New York, that she first experienced the power of art.

Van Nice went on to attend the George Washington University in Washington, D.C., graduating with a degree in philosophy. She explains her decision to study philosophy as follows: "I was a serious existentialist, interested in what is the meaning of life. I understood early on that art is a serious undertaking—it comes from philosophy and from experience."[1] From 1972 to 1976 Van Nice was a student at the Corcoran School of Art, also in Washington. She was greatly influenced by the work of Marcel Duchamp and Larry Rivers. "Rivers's *History of the Russian Revolution* at the Hirshhorn Museum made me start to think about installations and conceptual art."[2]

Like Duchamp, Van Nice transforms found objects into works of art, creating for them a new poetic and visual context. She fishes through garbage and roams around markets and garage sales in search of art material and treasures. She has discovered postal stamps from the 1940s, boxes of tiny bottles of ginseng extract, and discarded books of medical drawings. All of these objects can be found in her unique book-objects and book installations.

Van Nice can build almost anything from wood and paper, including a typewriter and a clock. She challenged history and the belligerent nature of man by presenting an installation of artifacts from never-fought wars (*Artifacts of the Anglo-Armenian Wars*) that included a handmade cannon and a painted map of military operations. Van Nice's art represents scholarship combined with a whimsical and unbound imagination.

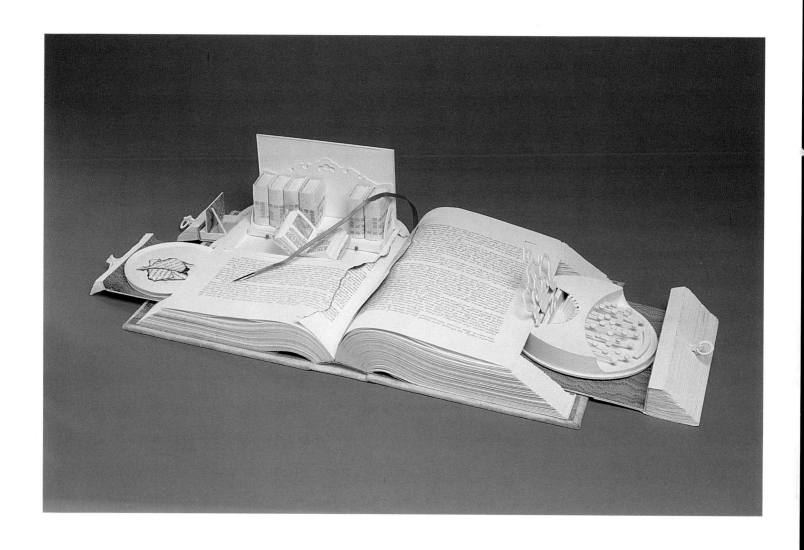

SWISS ARMY BOOK

1990, ink on paper, linen, wood, pen nib, and ribbon
1½ × 20 × 8¾ in. (3.8 × 50.8 × 22.2 cm.)
Gift of Lois Pollard Price

Swiss Army Book was inspired by the Swiss army knife, "a tool so ludicrously elaborate, as to include toothpicks, saws, bottle openers, etc.," Van Nice muses. She constructed a number of tiny folios growing out of the main body of the book to articulate the idea that knowledge derives from previously accumulated wisdom. Through the display of partly burned pages, the artist demonstrates the fragility and vulnerability of books. Van Nice believes that writing is a never-ending process. To facilitate a rewriting of *Swiss Army Book,* she provides a handcrafted typewriter and an actual pen nib.

The text in the *Swiss Army Book* is rendered in Van Nice's meticulous calligraphy of illegible signs. Van Nice calls her writing "Palmer neurotic," in defiance of the Palmer method of teaching penmanship. *Swiss Army Book* challenges the viewer on both a visceral and an intellectual level. The artist believes that the viewer likes surprises, and she generously provides them. —*KW*

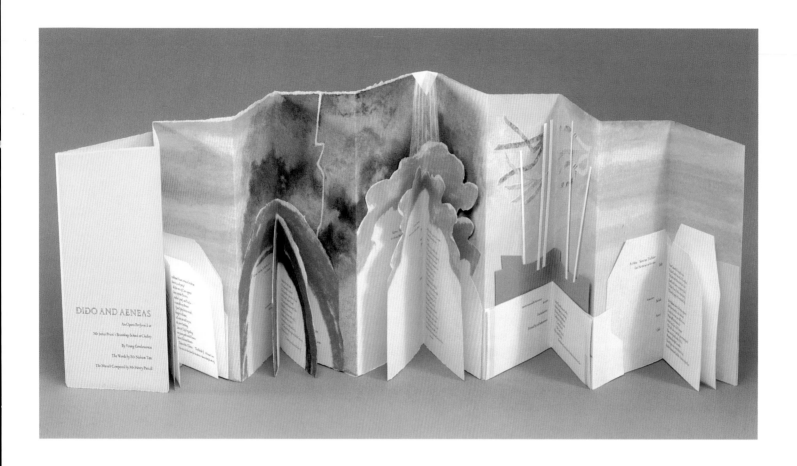

DIDO AND AENEAS

1989, monoprint on handmade paper, 100/150
14 × 7 in. (35.6 × 17.8 cm.) (closed)
The Janus Press, West Burke, Vermont,
and Theodore Press, Bangor, Maine
Gift of Lois Pollard Price

Dido and Aeneas is a celebration of the three-hundredth anniversary of Henry Purcell's baroque opera, first performed in London in 1689. Nahum Tate's libretto tells the drama of the betrayed and abandoned queen of Carthage, Dido, who throws herself on a funerary pyre as the ship of her lover, Aeneas, leaves the harbor. The book includes a compact disk of the opera performed by the Taverner Choir and Taverner Players. "It seems appropriate to encourage reading while listening to the performance," explains Van Vliet.[1] Each scene of the opera has the text of the libretto sewn into the accordion book structure. The dark sky reflects the turbulent feelings of the despairing queen. The tops of the trees are symbolic of the grove where the lovers met. The masts of the ships signal the departure of Aeneas. The last section of the book takes us back to the royal palace, where the story begins. The sky in Carthage is quiet again and looks surprisingly like the sky surrounding Van Vliet's home in northern Vermont.

CLAIRE VAN VLIET

AMERICAN, B. 1933

Born in Ottawa, Canada, Claire Van Vliet lost both parents before she reached age fourteen. She was raised by her maternal aunt in San Diego, California. An exceptional child, Van Vliet was graduated from high school at fifteen, attended San Diego State College, and in 1954 received an M.F.A. degree from Claremont Graduate School. In 1958 she moved to Philadelphia to work as an apprentice with John Anderson at his Pickering Press.

Van Vliet's first artist's book of wood engravings, *The Oxford Odyssey*, was published in 1955. That year also marks the beginning of Van Vliet's Janus Press, which, like its two-faced namesake, the Roman god Janus, looks to both the past and the future. The Janus Press embodies the age-old tradition of bookmaking, yet it also experiments with innovative book formats and structures. Van Vliet has published more than one hundred limited-edition artists' books.[2]

In addition to creating and publishing artists' books, Van Vliet has executed numerous drawings, prints, watercolors, and, more recently, large paintings and monotypes on pulp paper. One of her recent projects is *Circle of Wisdom*, a celebration of the nine-hundredth birthday of Hildegard von Bingen, a medieval composer and poet. The book will contain a recording of *Symphonia*, one of von Bingen's major works.

Van Vliet has exhibited her books, prints, and paintings all over the world, has lectured at universities and museums, and has led book-art workshops. She has been the recipient of many honors, including a MacArthur Fellowship in 1989. —KW

DEBRA WEIER

AMERICAN, B. 1954

To meet her own standards of excellence, Debra Weier usually devotes two years of intensive labor to the creation and printing of each of her artists' books. The limited editions vary from eight to sixty copies.[1]

Born in West Bend, Wisconsin, Weier was graduated from the University of Wisconsin in Madison, with an M.F.A. in 1979. Her initial focus was painting and printmaking, but in 1976 she developed an interest in the narrative quality of Japanese scrolls. "At times, I stretched canvases of my abstract paintings over the entire length of my studio. Eventually presentation problems demanded another format. A natural development was to fold these images, incorporating them into books," she explains.[2] A key influence in Weier's career was her association with Walter Hamady, a teacher of typography, papermaking, and book arts at the University of Wisconsin. "If there was anyone who could upturn my idea of what a book was, it was Walter," she recalls. "With him I developed both printed, editioned books, and unique, purely visual books. We began by making books with no words, books that challenged the traditional format. Our books had flaps, pop-outs, pages within pages—the possibilities seemed endless."[3]

Landscape has also left a strong impression on Weier's work, particularly the petroglyphs, pueblos, and kivas (American Indian places of worship) of northern New Mexico. Many of her works explore the colors and structure of the land.

A MERZ SONATA

1985, etching, rubber stamp, collage, and handmade paper
11½ × 8¼ in. (29.2 × 21 cm.), 483/500
Emanon Press, New Jersey
and Women's Studio Workshop, Rosendale, New York
Gift of Ann D. Mitchell

Debra Weier created *A Merz Sonata* in collaboration with the poet Jerome Rothenberg as a tribute to the German artist and poet Kurt Schwitters. A dada master, Schwitters created collage assemblages he called Merz. Weier's book includes Rothenberg's lengthy poem "A Merz Sonata." The combination of Weier's inventive typography, collage, and pop-ups with Rothenberg's poem results in a harmonious artistic statement, a sonata con brio, in true dada spirit. Since Schwitters was not only an artist but also a poet and a graphic designer, he was an ideal subject for a book incorporating poetry and unusual graphic design. "I used Futura type, which was Schwitters's favorite typeface," says Weier.[4]

Because Schwitters elevated collage to a true art form, collage is the major visual element in *A Merz Sonata.* Weier's design includes glued bits of paper, ticket stubs, pieces of string, and rubber-stamped images—another invention of Schwitters. These tactile elements create an element of joy and surprise to counterbalance the feeling of anxiety and unrest prevalent in the poem. —*KW*

streamers of wet merz
merz merchants
line the streets with--
commercial merzers
merzing in a ring
their products
sauce & ciders
jars
delirious as number two's
he slabs onto his roof
o coupons
tiny tickets
we trade off with burgermeisters
bits of shoe-lace
half-stapled cigarettes
a worm a fish
merz angels swing from
tangled in air
nail pairings
slice of tie
mimosa orange tulpe flora aphrodite
bottles alight with piss
& baking soda
merzed in his slots
a pot of water
--boiling--
you can drop a clock in

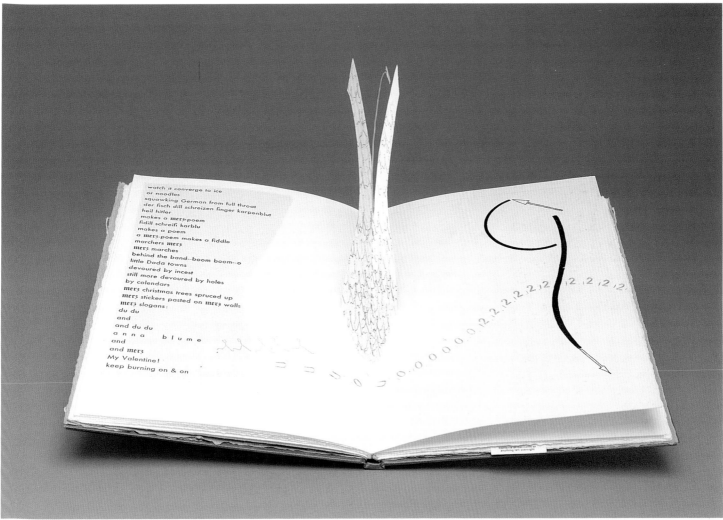

watch it converge to ice
or noodles
squawking German from full throat
der fisch dill schreizen finger karpenblut
heil hitler
makes a merz-poem
fidill schreifi karblu
makes a poem
a merz-poem makes a fiddle
marchers merz
merz marches
behind the band--boom boom--o
little Dada towns
devoured by incest
still more devoured by holes
by calendars
merz christmas trees spruced up
merz stickers pasted on merz walls
merz slogans:
du du
and
and du du
a n n a b l u m e
and
and merz
My Valentine!
keep burning on & on

NOTES

NATIONAL MUSEUM OF WOMEN IN THE ARTS

1. Sappho (ca. 610–ca. 580 B.C.E.) was an ancient Greek woman poet. Quoted in David A. Campbell, trans., *Greek Lyric*, vol. I (Loeb Classical Library. Cambridge, Mass.: Harvard University Press, 1982), 49.

16TH- AND 17TH-CENTURY EUROPE

1. Anne Baynard (1672–1697), quoted in Elaine Partnow, ed., *The Quotable Woman: From Eve to 1799* (New York: Facts on File, 1985), 208, entry no. 1.

Lavinia Fontana

1. Caroline P. Murphy, "Lavinia Fontana and Female Life Cycle Experience in Late Sixteenth-Century Bologna," in Geraldine A. Johnson and Sara F. Matthews Grieco, eds., *Picturing Women in Renaissance and Baroque Italy* (Cambridge, England: Cambridge University Press, 1997), 114–19.

Judith Leyster

1. Anne E. Johnson, a New York–based musicologist and author, generously contributed her expertise about early music. **2.** James A. Welu, "Judith Leyster," in Delia Gaze, ed., *Dictionary of Women Artists* (Chicago: Fitzroy Dearborn, 1997), vol. II, 847. Welu notes that few of Leyster's works were commissioned. Instead, most were painted for the open market—a new development on the Haarlem art scene during her lifetime. **3.** For an invaluable source on this artist's life and work, see Frima Fox Hofrichter's catalogue raisonné, *Judith Leyster: A Woman Painter in Holland's Golden Age* (Doornspijk, The Netherlands: Davaco Publishers, 1989).

Maria Sibylla Merian

1. Three plates from this book were probably engraved by Merian herself. The rest were produced, under her direct supervision, by three professional Dutch engravers (Joseph Mulder, Pieter Sluyter, and Daniel Stoopendaal), whose signatures are clearly visible on the images. See G. Evelyn Hutchinson, "The Influence of the New World on the Study of Natural History," in Clyde E. Goulden, ed., *Changing Scenes in Natural Sciences, 1776–1976* (Philadelphia: Academy of Natural Sciences, Special Publication 12, 1977), 19. **2.** On March 3, 1997, the U.S. Postal Service released two new thirty-two-cent stamps bearing images from Merian's *Metamorphosis*: a citron and this pineapple. **3.** Hutchinson, op. cit., 22. The National Museum of Women in the Arts owns a copy of the second, posthumous, edition of Merian's *Metamorphosis*, published in 1719.

Louise Moillon

1. The evolution and significance of this type of still life is discussed by Charles Sterling in his now-classic survey, *Still Life Painting from Antiquity to the Present Time* (rev. ed.), James Emmons, trans. (New York: Universe Books, 1959), 49–50. **2.** Her husband was Etienne Girardot, a Calvinist merchant with whom Moillon had at least three children. **3.** Contemporary praise for Moillon comes, for example, from Georges de Scudéry, writing in *Le Cabinet de M. de Scudéri gouverneur de Notre-Dame de la Garde*, 1646. Cited by Lesley Stevenson, "Louise Moillon," in Delia Gaze, ed., *Dictionary of Women Artists* (Chicago: Fitzroy Dearborn, 1997), vol. II, 972. The quotation comes from Christopher Wright in *The French Painters of the Seventeenth Century* (Boston: Little, Brown, 1985), 232. Wright notes that Moillon is credited with creating the first French paintings that combine important still-life elements with human figures. For an illustration, see his plate 61.

Clara Peeters

1. Noted by Julie Berger Hochstrasser, "Clara Peeters," in Delia Gaze, ed., *Dictionary of Women Artists* (Chicago: Fitzroy Dearborn, 1997), vol. II, 1,083; Sybille Ebert-Schifferer, *Still Life: A History*, Russell Stockman, trans. (New York: Harry N. Abrams, 1998), 118–20. **2.** Several scholars note that Peeters probably visited the Netherlands on several occasions and theorize that her works of this type may have influenced Dutch still-life painting. **3.** Peeters was known for her fondness for painting metal objects. She is credited with having been the first Flemish artist to introduce multiple tiny self-portrait reflections into her works—in the surfaces of goblets, salvers, and the like. **4.** Melinda Silva, "From the Collection: Clara Peeters's *Still Life of Fish and Cat*," *Women in the Arts*, Spring 1999, 4–5.

Rachel Ruysch

1. Marianne Berardi, "Science Into Art: Rachel Ruysch's Early Development as a Still-Life Painter," unpublished doctoral dissertation, University of Pittsburgh, 1998, 354. **2.** In recent curatorial correspondence Berardi explains her reasons for departing from the previously accepted date for this painting of ca. 1745, originally suggested by the late Ingvar Bergstrom. While she agrees that architectural backgrounds were more typically used by Dutch flower painters in the eighteenth century, Berardi has found evidence that a number of other artists besides Ruysch began experimenting with this motif at the end of the previous century. **3.** Mariane Berardi, "Rachel Ruysch," in Delia Gaze, ed., *Dictionary of Women Artists* (Chicago: Fitzroy Dearborn, 1997), vol. II, 1,209. **4.** In 1693 Ruysch married the portrait painter Juriaen Pool II, with whom she had ten children. Throughout her lengthy career, Ruysch continued to sign her works with her maiden name. **5.** As a woman, she was ineligible to join the Amsterdam painters' guild. **6.** See, for example, the laudatory comments about Ruysch in three widely spaced publications from the twentieth century: Cornelius Hofstede de Groot, *A Catalogue Raisonné of the Works of the Most Eminent Dutch Painters of the 17th Century* (1928; reprint, Teaneck, N.J.: Somerset House, 1976), 493–96; Colonel M. H. Grant, *Rachel Ruysch, 1664–1750* (Leigh-on-Sea, England: F. Lewis, 1956), 19; and Ann Sutherland Harris and Linda Nochlin, *Women Artists: 1550–1950* (Los Angeles County Museum of Art. New York: Alfred A. Knopf, 1976), 158. Nearly every writer also comments on the remarkably high prices that Ruysch's pictures have consistently fetched, from her own era to the present day.

Elisabetta Sirani

1. Adelina Modesti points out the Bolognese-style turban, and many other useful facts, in "Elisabetta Sirani," in Delia Gaze, ed., *Dictionary of Women Artists* (Chicago: Fitzroy Dearborn, 1997), vol. II, 1,272–75.

18TH-CENTURY EUROPE

1. Samuel Johnson (1709–1784) was a noted British critic and poet. Quoted in Walter S. Scott, *The Bluestocking Ladies* (London: John Green, 1947), 45. **2.** As one source notes, "They championed the rights of commoners, the rights of citizens, the rights of slaves, Jews, Indians and children, but not those of women." Bonnie S. Anderson and Judith P. Zinsser, *A History of Their Own: Women in Europe from Prehistory to the Present* (New York: Harper and Row, 1989), vol. II, 88–89. **3.** Whitney Chadwick notes that Rousseau justified keeping women in the home, based on "a lengthy list of feminine qualities which he considers innate, among them shame, modesty, love of embellishment, and the desire to please." See Chadwick, *Women, Art and Society* (London: Thames and Hudson, 1992), 34. **4.** For example, the Roman Academy of Saint Luke was founded in 1593, Paris's Royal Academy of Painting and Sculpture in 1648, and the Royal Academy in London in 1768. For excellent discussions of these and many other art academies, see the introductory essays by Wendy Wassyng Roworth on pp. 43–45 and 50–53 and by Mary D. Sheriff on pp. 45–48 of Delia Gaze, ed., *Dictionary of Women Artists* (Chicago: Fitzroy Dearborn, 1997), vol. I. The information in this section has been abstracted from these essays. **5.** The situation was not much better in England. Only two women were among the founding members of the British Royal Academy in 1768. After that, no other women artists were admitted until the 1920s.

Rosalba Carriera

1. This information, and much of what follows, was generously conveyed by Ronald Grim, specialist in cartographic history at the Library of Congress's Geography and Map Division. **2.** This version of *America* is closely related to another in a series of four pastels

representing the continents, in the museum at Dresden. For illustrations see Bernardina Sani, *Rosalba Carriera* (Turin: Allemandi, 1988), figs. 142–45.

Louisa Courtauld

1. In mid-eighteenth-century London, the term *goldsmith* encompassed people who made their livings by designing and manufacturing silver objects, plus masters who ran workshops that produced such objects, and retailers who sold—but often had nothing to do with making—them. Source: Philippa Glanville, "Women and Goldsmithing," in Philippa Glanville and Jennifer Faulds Goldsborough, *Women Silversmiths, 1685–1845* (Washington, D.C.: National Museum of Women in the Arts with Thames and Hudson, 1990), 14. **2.** Glanville and Goldsborough, op. cit., 53–54. Professor Goldsborough's recent research reveals that the term *caddy* may not have been used until the 1780s. Before that time, such containers were generally referred to as *tea boxes* or *tea vases*. Goldsborough generously provided expert help with the entries on Georgian silver. **3.** The National Museum of Women in the Arts owns such a set, dated 1755, by Elizabeth Godfrey.

Marguerite Gérard

1. See, for example, Mary D. Sheriff, "Marguerite Gérard," in Delia Gaze, ed., *Dictionary of Women Artists* (Chicago: Fitzroy Dearborn, 1997), vol. I, 582. **2.** Robert C. Page, a guitarist, guitar-history expert, and owner of Philadelphia's Classical Guitar Store, contributed these and other related observations.

Elizabeth Godfrey

1. Ann Eatwell, "Elizabeth Godfrey," in Delia Gaze, ed., *Dictionary of Women Artists* (Chicago: Fitzroy Dearborn, 1997), vol. I, 587. **2.** Philippa Glanville, "Women and Goldsmithing," in Philippa Glanville and Jennifer Faulds Goldsborough, *Women Silversmiths, 1685–1845* (Washington, D.C.: National Museum of Women in the Arts with Thames and Hudson, 1990), 14. **3.** Ibid., 86.

Angelica Kauffman

1. Ann Sutherland Harris and Linda Nochlin, *Women Artists: 1550–1950* (Los Angeles County Museum of Art. New York: Alfred A. Knopf, 1976), 176. **2.** For the Gower family lineage see *Burke's Peerage and Baronetage*, 105th edition (London: Burke's Peerage, 1975), 2,585–87, under "Sutherland." The art historian Bonita Billman contributed generous help with British genealogy and several other matters. **3.** The help of Wendy Wassyng Roworth, a leading expert on Kauffman, was instrumental in preparing this section. She is currently finishing a book about Kauffman's history paintings. Also see Angela Rosenthal, "Kauffman and Portraiture," in Roworth, ed., *Angelica Kauffman: A Continental Artist in Georgian England* (London: Reaktion Books, 1992).

Adélaïde Labille-Guiard

1. Two of the more recent books about Adrienne de Noailles were inspired by the discovery in 1956 of a cache of letters and other important documents that had been hidden in an unused tower of the family's chateau. See, for example, Constance Wright, *Madame de Lafayette* (New York: Henry Holt, 1959) and André Maurois, *Adrienne: The Life of the Marquise de La Fayette*, Gerard Hopkins, trans. (New York: McGraw-Hill, 1961).

Marianne Loir

1. Ann Sutherland Harris and Linda Nochlin, *Women Artists: 1550–1950* (Los Angeles County Museum of Art. New York: Alfred A. Knopf, 1976), 167–68; and Jane Shoaf Turner, ed., *The Dictionary of Art* (New York: Grove/Macmillan, 1996), vol. 19, 543. **2.** Turner, op. cit., vol. 12, 312. **3.** Isabelle Knafou of Sotheby's, Paris, contributed to the preparation of this entry by generously sharing the results of her research on other contemporary portraits of Madame Geoffrin.

Elisabeth-Louise Vigée-Lebrun

1. For additional information see Lada Nikolenko, "The Russian Portraits of Madame Vigée-Lebrun," *Gazette des Beaux-Arts* 70 (1967): 91–120. **2.** See, for example, Nikolenko, 94. **3.** The couple was divorced in 1794. **4.** She had previously been barred from this organization because of her husband's profession. By tradition and law, academicians did not engage in art-related commerce. **5.** For a discussion of Vigée-Lebrun's history paintings, see Mary D. Sheriff, *The Exceptional Woman: Elisabeth Vigée-Lebrun and the Cultural Politics of Art* (Chicago: University of Chicago Press, 1996), 120.

19TH-CENTURY EUROPE

1. Marie-Élisabeth Boulanger Cavé (1809–?) was a Parisian painter. Quoted from her book *Drawing from Memory* (New York: Putnam, 1868), 39. **2.** Whitney Chadwick, *Women, Art, and Society* (New York: Thames and Hudson, 1992), 167. **3.** For details see Chadwick, 165–90 and 213–35. **4.** No women were admitted to the British Royal Academy or the Ecole des Beaux-Arts in Paris during the nineteenth century. Similar restrictions existed in Germany and elsewhere in Europe. **5.** For example, of the seven artists discussed in this section, five (Forbes, Gardner, Gonzalès, Haudebourt-Lescot, and Morisot) married practicing artists; Bonheur and Claudel remained single. **6.** See Gabriel P. Weisberg and Jane R. Becker, eds., *Overcoming All Obstacles: The Women of the Académie Julian* (Dahesh Museum. New Brunswick, N.J.: Rutgers University Press, 1999). **7.** See Nancy Mowll Mathews in Delia Gaze, ed., *Dictionary of Women Artists* (Chicago: Fitzroy Dearborn, 1997), vol. I, 91. **8.** The exception was Elizabeth Armstrong Forbes, who worked and was known primarily in England. For

statistics regarding the participation of female artists in the Salon, international expositions, and other important venues, see Charlotte Yeldham, *Women Artists in Nineteenth-Century France and England* (New York: Garland, 1984), 2 vols.

Rosa Bonheur

1. James Saslow, "'Disagreeably Hidden': Construction and Constriction of the Lesbian Body in Rosa Bonheur's *Horse Fair*," in Norma Broude and Mary D. Garrard, eds., *The Expanding Discourse: Feminism and Art History* (New York: HarperCollins, 1992), 186–205. **2.** Theodore Stanton, ed., *Reminiscences of Rosa Bonheur* (New York: Hacker Art Books, 1976), 344. **3.** Ibid., 375.

Camille Claudel

1. Claudine Mitchell, "Camille Claudel," in Delia Gaze, ed., *Dictionary of Women Artists* (Chicago: Fitzroy Dearborn, 1997), vol. I, 401. **2.** Ibid.

Elizabeth Adela Armstrong Forbes

1. Quoted in Caroline Fox and Francis Greenacre, *Artists of the Newlyn School, 1880–1900* (Newlyn: Newlyn Art Gallery, 1979), 187. **2.** The conflicts that women of the Newlyn Art School faced are discussed in Deborah Cherry, *Painting Women* (London: Routledge, 1993), 183–86.

Elizabeth Jane Gardner (Bouguereau)

1. Quoted in Fidell-Beaufort, "Elizabeth Jane Gardner Bouguereau: A Parisian Artist from New Hampshire," *Archives of American Art Journal* 24 (2) (1984), 2–3. **2.** Elizabeth Gardner to Maria Gardner, June 8, 1879. Elizabeth Gardner Papers, Archives of American Art, Smithsonian Institution. **3.** Elizabeth Gardner to Maria Gardner, May 3, 1895. Elizabeth Gardner Papers, Archives of American Art, Smithsonian Institution.

Eva Gonzalès

1. Mary Tompkins Lewis, "Eva Gonzalès," in Delia Gaze, ed., *Dictionary of Women Artists* (Chicago: Fitzroy Dearborn, 1997), vol. I, 599.

Antoinette-Cécile-Hortense Haudebourt-Lescot

1. Ann Sutherland Harris and Linda Nochlin, *Women Artists, 1550–1950* (Los Angeles County Museum of Art. New York: Alfred A. Knopf, 1976), 46–47.

Berthe Morisot

1. Morisot quoted in *Berthe Morisot: The Correspondence with Her Family and Her Friends Manet, Puvis de Chavannes, Degas, Monet, Renoir and Mallarmé* (London: Moyer Bell, 1987), 8. **2.** Kathleen Adler and Tomar Garb, "Berthe Morisot," in Delia Gaze, ed., *Dictionary of Women Artists* (Chicago: Fitzroy Dearborn, 1997), vol. II, 978. **3.** Charles F. Stuckey and William P. Scott, *Berthe Morisot: Impressionist* (New York: Hudson Hills Press, 1987), 187, 197.

19TH-CENTURY NORTH AMERICA

1. Anna Massey Lea Merritt (1844–1930) was an American artist and writer. Quoted from her article "A Letter to Artists: Especially Women Artists," *Lippincott's Monthly Magazine* 65, March 1900, 467. **2.** Two notable eighteenth-century American women artists were Henrietta Johnston (ca. 1670–ca. 1728) and Patience Lovell Wright (1725–1786). Johnston was a Dublin-born portraitist who immigrated to South Carolina, where she supported her family by producing likenesses in pastels of prominent Charleston residents. In addition to making an excellent living by sculpting wax busts and full-length, life-size figures of important politicians and other leaders, Wright also served as a spy at the court of George III before and during the American Revolutionary War. **3.** Until the latter part of the century women were not allowed to enter the most important and rigorous art school in France, the government-run Ecole des Beaux-Arts. **4.** Women discussed here who chose to remain single are Cecilia Beaux, Jennie Augusta Brownscombe, Mary Cassatt, Ellen Day Hale, and Sarah Miriam Peale. Lilly Martin Spencer, who had both a successful career and a very large family, was an exception. **5.** The exceptions were, respectively, Mary Nimmo Moran and Eva Watson-Schütze. **6.** See Charlotte Streifer Rubinstein, *American Women Sculptors: A History of Women Working in Three Dimensions* (Boston: G. K. Hall, 1990), 24–96. **7.** See Naomi Rosenblum, *A History of Women Photographers* (New York: Abbeville Press, 1994), 55–71.

Cecilia Beaux

1. Charleen Akullian and Tara Leigh Tappert, "Cecilia Beaux and the Art of Portraiture," *American Art Review* 7 (5): 140 (1995). **2.** The retrospectives were held by the Syracuse Museum of Fine Art (1931) and the American Academy of Arts and Letters (1935). Beaux's autobiography, *Background with Figures*, was first published in Boston by Houghton Mifilin in 1930. Her papers are on deposit at the Smithsonian Institution's Archives of American Art and at the Pennsylvania Academy.

Jennie Augusta Brownscombe

1. Charlotte Streifer Rubinstein, *American Women Artists: From Early Indian Times to the Present* (New York: Avon, 1982), 114. **2.** The National Museum of Women in the Arts also owns one other oil painting by Brownscombe: *Thanksgiving at Plymouth.*

Mary Cassatt

1. Cassatt quoted in *The Graphic Art of Mary Cassatt* (New York: Museum of Graphic Art, 1967), 9.

Eulabee Dix

1. Dix also painted the last portrait from life of Mark Twain. **2.** Dix's unpublished memoirs, on deposit at the National Museum of Women in the Arts, 11–12. The museum also owns a significant collection of other miniatures and papers by Dix. **3.** Jo Ann Ridley, *Looking for Eulabee Dix: The Illustrated Biography of an American Miniaturist* (Washington, D.C.: National Museum of Women in the Arts, 1997), 43. **4.** Ibid., 16.

Ellen Day Hale

1. In her master's thesis, "American Impressionist Ellen Day Hale" (The George Washington University, Washington, D.C., unpublished, 1994, 41, n73), Tracy B. Schpero theorizes that the title of this canvas may refer to the month in which it was painted. **2.** Schpero (43) interprets the detail of the missing button as evidence that this is a working-class woman who sews to earn her living, not a lady of leisure.

Claude Raguet Hirst

1. Unsigned article in the *New York Times*, 4 June 1922, sec. 7, p. 5. She married Fitler in 1901. **2.** Martha M. Evans, who is writing a doctoral dissertation about Hirst for Columbia University, shared her research for this essay. According to Evans, Hirst typically included some underlying symbolism in her still lifes. While Evans has not yet determined the precise meaning of this painting, she believes that many of Hirst's works are actually critiques of male vices. **3.** Evans notes that by the 1890s, American women were beginning to participate in the previously all-male "smoking culture." **4.** Ron Fuchs, a curatorial assistant at the Winterthur Museum, suggested that the evening depicted by Hirst was still young, considering the amount of liquor remaining in the bottles on the right, the unopened red wax tax seals on the bottles at the left, and the fact that the lemons (possibly intended for punch, a popular drink involving fruit juice, alcohol, water, sugar, and spices) have not yet been squeezed.

Gertrude Käsebier

1. Mary Ann Tighe, "Gertrude Käsebier: Lost and Found," *Art in America*, March–April 1977, 95.

Evelyn Beatrice Longman

1. For information on Margaret French Cresson, see vol. 7, no. 1 of *Pedestal*, the publication put out by Chesterwood (Daniel Chester French's former estate in Stockbridge, Mass., now a museum). **2.** The reproduction was entitled *The Laughing Girl* (correspondence from Chesterwood, dated 10 January 1992, in the files of the National Museum of Women in the Arts). **3.** See Charlotte Streifer Rubinstein, *American Women Sculptors: A History of Women Working in Three Dimensions* (Boston: G. K. Hall, 1990), 172–76.

Anna Massey Lea Merritt

1. See Galina Gorokhoff, ed., *Love Locked Out: The Memoirs of Anna Lea Merritt with a Checklist of Her Works* (Boston: Museum of Fine Arts, 1982).

Mary Nimmo Moran

1. Phyllis Peet, *American Women of the Etching Revival* (Atlanta: High Museum of Art, 1988), 30. **2.** Sylvester Koehler, *Etching: An Outline of Its Technical Processes and Its History with Some Remarks on Collectors and Collecting . . .* (New York: Cassell, 1885).

Anna Claypoole Peale

1. This information was provided by Elizabeth Wister Aertsen, a descendent of the sitter. **2.** Lillian B. Miller, ed., *The Peale Family: Creation of a Legacy, 1770–1870* (National Portrait Gallery. New York: Abbeville Press, 1996), 228.

Sarah Miriam Peale

1. Charlotte Streifer Rubinstein, *American Women Artists: From Early Indian Times to the Present* (New York: Avon Books, 1982), 46. **2.** Lillian B. Miller, "Sarah Miriam Peale," in Delia Gaze, ed., *Dictionary of Women Artists* (Chicago: Fitzroy Dearborn, 1997), vol. II, 1,079. **3.** Lillian B. Miller (ed., Peale Family Papers, National Portrait Gallery, Smithsonian Institution, Washington, D.C.) letter dated 18 January 1996, in the files of the National Museum of Women in the Arts. **4.** Wilbur H. Hunter and John Mahey, *Miss Sarah Miriam Peale, 1800–1885: Portraits and Still Life* (Baltimore: Peale Museum, 1967), 10–11.

Lilla Cabot Perry

1. While the identity of the sitter is unknown, one writer has suggested that she is the artist's youngest daughter, Alice. See Krystyna Wasserman, untitled article, *Journal of the American Medical Association* 253 (14): 1,997, 12 April 1985. Perry often used her daughters as subjects. **2.** *Impressions from Giverny*, a film about Perry's friendship with Monet, was made in Paris by Toby Molenaar and Meredith Martindale Frapier in 1983.

Lilly Martin Spencer

1. Despite her considerable reputation, Spencer's earnings were not always sufficient to comfortably support her large family. Therefore, she sometimes supplemented her income by creating illustrations for such publications as *Godey's Lady's Book*. (See Robin Bolton-Smith and William H. Truettner, *Lilly Martin Spencer, 1822–1902: The Joys of Sentiment* (Washington, D.C.: Smithsonian Institution Press, 1973), 55, and the artist's letters, on deposit at the Archives of American Art, Smithsonian Institution, Washington, D.C.). **2.** See David M. Lubin, *Picturing a Nation: Art and Social Change in Nineteenth-Century America* (New Haven: Yale University Press, 1994), 189–93.

Bessie Potter Vonnoh

1. Janis Conner and Joel Rosenkranz, *Rediscoveries in American Sculpture: Studio Works, 1893–1939* (Austin: University of Texas Press, 1989), 161, 163, cited in Charlotte Streifer Rubinstein, *American Women Sculptors: A History of Women Working in*

Three Dimensions (Boston: G. K. Hall, 1990), 110. Conner and Rosenkranz believe that Vonnoh's lengthy illness was a case of hysterical paralysis brought on by the shock of her father's death in a railroad accident in 1874. In this connection, they also note the absence of adult male figures and the emphasis on strong, protective mothers in Vonnoh's art. **2.** At seventy-six, Vonnoh married the physician Edward Keyes. Her papers are on deposit at the Archives of American Art, Smithsonian Institution, Washington, D.C. **3.** Quoted by Julie Aronson, "Bessie Potter Vonnoh," in Delia Gaze, ed., *Dictionary of Women Artists* (Chicago: Fitzroy Dearborn, 1997), vol. II, 1,412. **4.** Her work has also been compared to *Tanagra* figures—ancient Greek terra-cotta statues, often of dancing women. However, Rubinstein notes (112) that Vonnoh began sculpting these figures before she had ever seen *Tanagra* statues. **5.** Julie Aronson in Delia Gaze, op. cit., vol. I, 412.

Eva Watson-Schütze

1. This was the title of a series of articles written about seven important women by the esteemed photographer Frances Benjamin Johnston and published in the *Ladies' Home Journal* in 1901–2. See Naomi Rosenblum, *A History of Women Photographers* (New York: Abbeville Press, 1994), 325.

20TH-CENTURY EUROPE

1. Harriet Hosmer (1830–1930) was an American sculptor. Quoted in Phebe A. Hanaford, *Daughters of America* (Augusta, Maine: True and Company, 1883), 321–22. **2.** Quoted in Peter Selz, *Art in Our Times: A Pictorial History, 1890–1980* (New York: Harcourt Brace Jovanovich and Harry N. Abrams, 1981), 59. **3.** Delaunay, Hepworth (both times), Taeuber-Arp, Valadon (the second time), and Vieira da Silva married other artists. **4.** Other women artists, including the Russians Alexandra Exter, Liubov Popova, and Natalia Goncharova, along with the Swiss-born Sophie Taeuber-Arp, made major contributions as both theatrical designers and creators of more conventional artworks. Many of the best-known male artists of the day—such as Pablo Picasso, Joan Miró, Wassily Kandinsky, Laszlo Moholy-Nagy, and Max Ernst—were occasionally commissioned to design for Diaghilev, but for them this was clearly a marginal activity.

Alice Bailly

1. For a discussion of the introduction of cubism into Switzerland (as early as 1908), and other useful information about Bailly, see Paul-André Jaggard, "Alice Bailly et l'introduction du Cubisme en Suisse," *Etudes de Lettres*, Faculté des Lettres de l'Université de Lausanne (Switzerland) 8 (3): 55–79 (1975). **2.** Chris Petteys, *Dictionary of Women Artists* (Boston: G. K. Hall, 1985), 36.

Sonia Terk Delaunay

1. Sonia Terk Delaunay's other work in this pavilion, *Distant Voyages*, was awarded a gold medal by the exhibition's judges. (Robert Delaunay's work for the same building received a less prestigious *diplôme d'honneur*.) For a discussion of how her murals came to be "lost," see Stanley Baron, *Sonia Delaunay: The Life of an Artist* (New York: Thames and Hudson, 1995), 106–07.

Alexandra Exter

1. Andrei B. Nakov, "Painting and Stage Design: A Creative Dialogue," in *Artist of the Theatre: Alexandra Exter* (New York: New York Public Library, 1974), 6. **2.** John Bowlt, "Alexandra Exter," in Delia Gaze, ed., *Dictionary of Women Artists* (Chicago: Fitzroy Dearborn, 1997), vol. I, 596. For additional information and numerous color reproductions, see M. N. Yablonskaya, *Women Artists of Russia's New Age, 1900–1935*, Anthony Parton, ed. and trans. (New York: Rizzoli, 1990), 117–40.

Barbara Hepworth

1. Hilton Kramer, "Spirit of 30s Sculpture," *New York Times*, 22 May 1975; and Alden Whitman, "Barbara Hepworth Dies in Fire at Cornwall Studio," *New York Times*, 22 May 1975, C-42.

Käthe Kollwitz

1. Silesia was a central European region shared by Germany, Poland, and Czechoslovakia. Scholars disagree about the significance of the rope held in the father's right hand; however, most commentators interpret it as a hangman's noose. The emotional force of *The Downtrodden* is especially noteworthy, as it was created fourteen years before Kollwitz's son, Peter, was killed during World War I. **2.** Remarkably, Kollwitz was largely self-taught as a printmaker. For further information on the artist's life and work, see Elizabeth Prelinger, *Käthe Kollwitz* (National Gallery of Art. New Haven: Yale University Press, 1992).

Lotte Laserstein

1. See Marsha Meskimmon, "Lotte Laserstein," in Delia Gaze, ed., *Dictionary of Women Artists* (Chicago: Fitzroy Dearborn, 1997), vol. II, 824–26. **2.** *Traute Washing* was the first painting acquired by the National Museum of Women in the Arts when it opened in 1987. **3.** Several writers have suggested the possible influence of Laserstein's figures on the painting of Lucien Freud.

Gabriele Münter

1. A related painting, *Tilmice on Snow Covered Branches* (ca. 1934, private collection), is reproduced on page 64 of Anne Mochon, *Gabriele Münter: Between Munich and Murnau* (Cambridge, Mass.: Busch-Reisinger Museum, Harvard University, 1980).

2. Many of Münter's paintings and writings are now in the Städtische Galerie im Lenbachhaus, Munich.

Sophie Taeuber-Arp

1. She designed the furniture and helped with the architectural plans for her Meudon house. Taeuber-Arp's designs for the Café de l'Aubette were removed by new owners twelve years after their completion and later destroyed by the Nazis as examples of "degenerate" art.

Suzanne Valadon

1. The other canvas, dated 1913, shows Gilberte holding her doll. **2.** Warren M. Robbins, founding director emeritus of the Smithsonian Institution's National Museum of African Art, has identified the rug on the floor in this painting as "a woven raffia cloth made by the Kuba people of what in 1921 was the Belgian Congo" (letter dated 30 August 1984 in the files of the National Museum of Women in the Arts). Robbins also notes that—like African tribal sculpture—such cloths were commonly found in early-twentieth-century Parisian homes. The influence of traditional African art on the work of early European modernists is well documented. **3.** Valadon frequently participated in three-person exhibitions with Utrillo and Utter. For more information about her art and life, see the artist's autobiography, *Suzanne Valadon par elle-même* (Paris: Prométhée, 1939) and Gill Perry, "Suzanne Valadon," in Delia Gaze, ed., *Dictionary of Women Artists* (Chicago: Fitzroy Dearborn, 1997), vol. II, 1,384–87.

Maria Elena Vieira da Silva

1. "Painter of Space" (author not identified), *Time* magazine, 22 September 1961, 105. **2.** See, for example, Vieira da Silva's obituary in the *New York Times*, 11 March 1992, B-7.

EARLY-20TH-CENTURY NORTH AMERICA

1. Anna Mary Robertson ("Grandma") Moses (1860–1961) was a self-taught American painter. Quoted in her autobiography, *My Life's History* (New York: Harper and Row, 1947), 138. **2.** For example, the National Academy of Design first admitted women to its anatomy classes in 1914. Noted in Deborah Jean Johnson's article in Delia Gaze, ed., *Dictionary of Women Artists* (Chicago: Fitzroy Dearborn, 1997), vol. I, 137. **3.** This was true both in the United States and Canada. For information on the latter, see Johnson (in Gaze), 137, and Joyce Zemans, "A Tale of Three Women: The Visual Arts in Canada—A Current Accounting" (forthcoming), in *RACAR (Revue d'art canadienne/Canadian Art Review)*, Montreal. **4.** Thirteen of the fourteen women discussed in this section got married, and more than half had children. Moreover, ten of the thirteen married women were wed to other visual artists. **5.** The dis-

tinguished American photographer and printmaker Mariana Yampolsky, who has lived in Mexico since 1945 and who worked as Alvarez Bravo's assistant, recalls that Mexico offered many more opportunities for women artists during the late 1940s than did the United States.

Berenice Abbott

1. Quoted in *Recollections: Ten Women of Photography*, ed., Margaretta K. Mitchell (New York: Viking Press, 1979), 12. **2.** Cited in Bart Barnes, "Famed Photographer Berenice Abbott Dies," *The Washington Post*, 11 December 1991, D-6.

Grace Albee

1. Gene Baro, "Grace Albee: The Art of Wood Engraving," Brooklyn Museum of Art exhibition brochure, 1976.

Lola Alvarez Bravo

1. Unsigned, undated information in files on Lola Alvarez Bravo, National Museum of Women in the Arts, Library and Research Center, Archives of Women Artists.

Elizabeth Catlett

1. See Lucinda H. Gedeon, ed., *Elizabeth Catlett: Sculpture—A Fifty-Year Retrospective* (Purchase, N.Y.: Neuberger Museum of Art, 1998).

Louise Dahl-Wolfe

1. Dahl-Wolfe obituary (unsigned), *New York Times*, 13 December 1989, D-21. **2.** It was Dahl-Wolfe's cover photo of Bacall as a Red Cross blood donor, for the March 1943 issue of *Harper's Bazaar*, that caught the eye of the director Howard Hawks and launched Bacall's Hollywood career.

Lois Mailou Jones

1. Alicia Craig Faxon, "Lois Mailou Jones," in Delia Gaze, ed., *Dictionary of Women Artists* (Chicago: Fitzroy Dearborn, 1997), vol. II, 753.

Frida Kahlo

1. The great Russian revolutionary had been expelled from the U.S.S.R. by Stalin in 1929 and sentenced to death, in absentia, by a Soviet court in 1937. After nine years of exile, in January 1937 Trotsky and his wife found asylum in Mexico, thanks to Rivera's help. They lived in Kahlo's house for two years, before Trotsky was assassinated by a Stalinist agent. **2.** Herrera suggests (op. cit., 209) that Kahlo initiated the affair in retaliation for Rivera's own affair with her younger sister, Cristina. **3.** The famous Casa Azul (Blue House), in which Kahlo was born and died, is now the Frida Kahlo Museum. **4.** The precise details in Kahlo's works were painted with the tiny, invisible brush strokes she had learned from her father, a professional photographer, who taught her to retouch hand-colored pho-

tographs. As a young girl Kahlo had also studied drawing and modeling and made watercolors; at one time, she even considered a career in scientific illustration. (See Sarah M. Lowe, "Frida Kahlo," in Delia Gaze, ed., *Dictionary of Women Artists* (Chicago: Fitzroy Dearborn, 1997), vol. II, 759–62. **5.** Kahlo and Rivera were married in 1929, divorced in 1939, and remarried in 1940. **6.** Although the bibliography on Kahlo is now enormous, one of the best sources remains the first significant monograph about her, Hayden Herrera's *Frida: A Biography of Frida Kahlo* (New York: Harper & Row, 1983).

Lucy Martin Lewis

1. See Susan Peterson, *Pottery by American Indian Women: The Legacy of Generations* (National Museum of Women in the Arts. New York: Abbeville Press, 1997), 74–83. **2.** Ibid., 75. **3.** As adults several of Lewis's daughters, including Dolores, Emma, and Carmel, also became potters.

Bertha Lum

1. Lum also developed the innovative "raised-line" technique of making color woodcuts. For a detailed description see Mary Evans O'Keefe Gravalos and Carol Pulin, *Bertha Lum* (Washington, D.C.: Smithsonian Institution Press, 1991), 25. **2.** According to Leonard Topper ("Bertha Lum and Her Japoniste Color Woodcuts," *The Washington Print Club Newsletter*, Spring 1991, 2), Lum was born in 1869.

María Montoya Martínez

1. See Susan Peterson, *Pottery by American Indian Women: The Legacy of Generations* (National Museum of Women in the Arts. New York: Abbeville Press, 1997), 62–73. **2.** The National Museum of Women in the Arts also has a pot made and decorated by Santana Martínez, María's daughter-in-law. **3.** This was not unusual, as traditional pottery making was often a collaborative process. **4.** The Tewa language, spoken in San Ildefonso Pueblo, has no word for *art*, indicating a way of looking at pottery that is very different from that employed by most of the Anglo world.

Barbara Morgan

1. Quoted in Franklin Cameron's interview "Barbara Morgan: Quintessence," in *PhotoGraphic* magazine, March 1985, 36. **2.** For an intriguing discussion of Morgan's dance photographs, see Vicki Goldberg, "Transfixing Motion," *New York Times*, 14 March 1999, AR-42. **3.** The book was Barbara Morgan, *Martha Graham: Sixteen Dances in Photographs* (1941; reprint, Dobbs Ferry, N.Y.: Morgan and Morgan, 1980). **4.** Morgan's dance photographs traveled to more than 150 colleges and other exhibition venues across the United States, from ca. 1938 through the early 1940s. They also toured South America in 1945. See Curtis L. Carter and William C. Agee, *Barbara Morgan:*

Prints, Drawings, Watercolors and Photographs (Milwaukee: Marquette University and Dobbs Ferry, N.Y.: Morgan and Morgan, 1988), 17.

Alice Neel

1. Neel also painted Negrón's wife and children. **2.** Although he developed emphysema and was briefly addicted to painkilling medications, Negrón was still alive nearly four decades after this painting was completed. **3.** Neel herself made this comparison, for example, in a letter dated 26 June 1978, in the National Museum of Women in the Arts Library and Research Center, Archives of Women Artists. **4.** Quoted in Judith Higgins, "Alice Neel and the Human Comedy," *ARTnews*, October 1984, 73.

Georgia O'Keeffe

1. The bibliography on O'Keeffe is immense, but two of the best recent sources on her life and work are Elizabeth Hutton Turner, *Georgia O'Keeffe: The Poetry of Things* (Phillips Collection. New Haven: Yale University Press, 1999) and *The Georgia O'Keeffe Museum*, Peter H. Hassrick, gen. ed. (Georgia O'Keeffe Museum. New York: Harry N. Abrams, 1997).

Beatrice Whitney Van Ness

1. Donald B. Kuspit, "Timely Space by the Timeless Sea: Modern Views of the Beach," in Russell Lynes, ed., *At the Water's Edge: 19th and 20th Century American Beach Scenes* (Tampa: Tampa Museum of Art, 1989), 46. **2.** For further information on the artist's life and work, see letter from Van Ness's elder daughter (1983) in the files of the National Museum of Women in the Arts; also see Elizabeth M. Stahl, *Beatrice Whitney Van Ness, 1888–1981: The Privilege of Learning to Paint* (Boston and New York: Childs Gallery, 1987).

LATE-20TH-CENTURY NORTH AMERICA

1. bell hooks (b. 1952) is an American art critic and essayist. Quoted in her book *Outlaw Culture: Resisting Representation* (New York: Routledge, 1994), 29. **2.** The book is Robert Hughes's *American Visions: The Epic History of Art in America* (New York: Alfred A. Knopf, 1997). **3.** See Barbara Haskell, *The American Century: Art and Culture, 1900–1950* (New York: Whitney Museum of American Art, 1999), and Lisa Phillips, *The American Century: Art and Culture, 1950–2000* (New York: Whitney Museum of American Art, 1999). It is noteworthy that both parts of this important exhibition catalogue were written by women. **4.** The most influential exhibition and accompanying catalogue were *Women Artists: 1550–1950*, curated by Ann Sutherland Harris and Linda Nochlin, which opened at the Los Angeles County Museum of Art in the winter of 1976. Although it dealt almost exclusively with European painters and stopped midway through the twentieth century, it greatly increased

people's awareness of the history of women artists throughout the Western world. **5.** See, for example, Deborah Jean Johnson's article in Delia Gaze, ed., *Dictionary of Women Artists* (Chicago: Fitzroy Dearborn, 1997), vol. I, 141–45. **6.** Interestingly, both the Black Panthers and the National Organization for Women were founded in 1966. **7.** For example, the Women's Caucus for Art, established in 1972, brought a new emphasis on women's issues into the generally conservative realm of academia. The inaugural issue of *Ms.* magazine was published 20 December 1971. **8.** See, for example, Johnson in Gaze, op. cit., vol. I, 144–45. **9.** For additional information see Whitney Chadwick, *Women, Art, and Society* (New York: Thames and Hudson, 1992), 347. **10.** Examples include the Georgia O'Keeffe Museum in Santa Fe, N.M.; Emily Carr House in Victoria, British Columbia; and Frida Kahlo Museum in Mexico City. **11.** Robert Hughes's book, cited above, is woefully dismissive of American women artists. For instance, he includes four illustrations of abstract expressionist paintings by Pollock but none at all by Lee Krasner, Joan Mitchell, Grace Hartigan, or Elaine de Kooning. The only women with any significant representation in his survey are Mary Cassatt and Georgia O'Keeffe.

Louise Bourgeois

1. Goldwater died in 1973; Bourgeois became a naturalized U.S. citizen in 1951. **2.** See, for example, Deborah Wye and Carol Smith, *The Prints of Louise Bourgeois* (New York: Museum of Modern Art, 1994), 10. **3.** Ibid. **4.** For information about Bourgeois's collaboration with the master printer Judith Solodkin, see Kathleen McManus Zurko, "Partners in Printmaking: Works from SOLO Impression," *Women in the Arts*, Holiday 1996, 10–11. **5.** Wye and Smith, op. cit., 189. The spirals have also been interpreted as "a plea for love" (Ibid., 20).

Petah Coyne

1. "Petah Coyne: Interview" with Carrie Przybilla in *PETAH COYNE: black/white/black* (Washington, D.C.: Corcoran Gallery of Art, 1996), 27–39. 29. **2.** Petah Coyne, quoted in "Sculptures That Melt Distinctions Between Life and Death," by Jo Ann Lewis, *The Washington Post,* 29 October 1996, E-1, E-6.

Dorothy Dehner

1. The "F" in the title indicates that this is the sixth in a series of related views. **2.** As a young girl in Ohio, Dehner had studied painting with three of her aunts.

Helen Frankenthaler

1. Deborah Solomon, "Artful Survivor: Helen Frankenthaler Stays Loyal to Abstract Expressionism," *New York Times Magazine,* 14 May 1989, 32. **2.** John Elderfield, *Frankenthaler* (New York: Harry N. Abrams, 1989), 214. She married the American painter Robert Motherwell in 1958; the couple divorced in 1971.

Nan Goldin

1. Nan Goldin, Introduction, *The Ballad of Sexual Dependency* (New York: Aperture Foundation, 1986), 7. **2.** Dennis Cooper, "The Ballad of Nan Goldin," *Spin,* November 1996, 80. **3.** Amy Virshup, "Brief Lives: Slide Show," *New York,* 10 February 1986, 28. **4.** Cooper, op. cit., 80. **5.** Nan Goldin, *The Other Side* (Manchester: Cornerhouse Publications, 1993); Nan Goldin and David Armstrong, *A Double Life* (New York: Scalo Publishers, 1994); Nan Goldin and Guido Costa, *Ten Years After* (New York: Scalo Publishers, 1998).

Grace Hartigan

1. Quoted in Suzanne Muchnic, "Artist's Work Is Back in Fashion," *St. Paul* (Minn.) *Sunday Pioneer Press* (reprinted from the *Los Angeles Times*), 5 August 1984, E-4 (photocopy in National Museum of Women in the Arts files). **2.** Hartigan generously shared her thoughts about this painting in a recent conversation with the author. On that occasion the artist stated that she regarded *December Second* as one of her few "completely abstract" works, adding that it was more convenient to give her works titles rather than simply numbering them consecutively. Hartigan also made it clear that she encourages others to interpret her paintings however they wish. **3.** This exhibition was entitled "New Talent."

Eva Hesse

1. Lucy R. Lippard, *Eva Hesse* (New York: New York University Press, 1976), 88. Other helpful publications on the artist are *Eva Hesse: A Retrospective* (Yale University Art Gallery. New Haven: Yale University Press, 1992) by Helen A. Cooper with essays by Maurice Berger, Anna C. Chave, Maria Kreutzer, Linda Norden, and Robert Storr, as well as Bill Barrette's *Eva Hesse: Sculpture, Catalogue Raisonné* (New York: Timken Publishers, 1989).

Lee Krasner

1. Artist's statement, quoted in Bryan Robertson and B. H. Friedman, *Lee Krasner: Paintings, Drawings, and Collages* (London: Whitechapel Gallery, 1965), n.p.

Melissa Miller

1. Richard Huntington, "The Animal Artistry of Melissa Miller," in *The Buffalo News,* 20 July 1986, E-1, 5. **2.** Katherine Gregor, "Melissa Miller's Animal Kingdom," ART*News,* December 1986, 110. **3.** Ibid. **4.** Melissa Miller, Artist Statement, in *Melissa Miller* (New York: Holly Solomon Gallery, 1995), 1.

Joan Mitchell

1. See, for example, Judith E. Bernstock, *Joan Mitchell* (New York: Hudson Hills Press, 1988), 165–68.

Louise Nevelson

1. John Russell, "Louise Nevelson, Sculptor, Is Dead at 88," *New York Times,* 19 April 1988, D-31. **2.** Nevel-son had a son in 1922. She separated from her husband in 1931; they were later divorced. **3.** Russell; her first solo show was held at the Karl Nierendorf Gallery in New York. **4.** See Russell, op. cit. **5.** Associated Press, Nevelson obituary, *New York Times,* 19 April 1988, D-6. Although she never abandoned her interest in all-black or all-white sculptures, in later years Nevelson also experimented with sculpture painted entirely in gold; in addition, she made pieces from clear Plexiglas, Cor-ten steel, and cast bronze.

Dorothea Rockburne

1. Rockburne has often said that she wants the meanings of her works to be open to diverse interpretations. See, for example, John Gruen, "Dorothea Rockburne's Unanswered Questions," *ARTnews,* March 1986, 101. **2.** Ibid., 98. **3.** Ibid., 101. **4.** This child was born in North Carolina, where Rockburne was briefly married.

Hollis Sigler

1. The term *faux naif* signifies Sigler's identification with the naive or untrained approach to art practiced by self-taught artists. Before she adopted this "false naive" style, Sigler was an accomplished photorealist painter. **2.** Members of Chicago's Hairy Who included Leon Golub, Nancy Spero, Jim Nutt, and Gladys Nillson, among others. See Irving Sandler, *The New York School* (New York: Harper and Row, 1978), for a discussion of this Chicago phenomenon. **3.** *Breast Cancer Journal: Walking with the Ghosts of Our Grandmothers* was exhibited at the National Museum of Women in the Arts in 1994. **4.** *Starry Night* is often interpreted as symbolic of Van Gogh's apotheosis. Sigler appropriated this image with this interpretation in mind.

Jaune Quick-to-See Smith

1. Lucy Lippard, *Mixed Blessings: New Art in a Multicultural America* (New York: Pantheon Books, 1990), 113. **2.** See Jonathan Binstock, "Jaune Quick-to-See Smith," in *Kaleidoscope: Themes and Perspectives in Recent Art* (Washington, D.C.: National Museum of American Art, 1996), 46. **3.** Ibid., 46. In 1990 Smith devoted an entire series of paintings to Chief Seattle. **4.** Interview with the artist in Trinkett Clark, *Parameters #9: Jaune Quick-to-See Smith* (Norfolk, Va.: Chrysler Museum of Art, 1993), n.p.

Joan Snyder

1. Judith Stein, "Making Their Mark," in Randy Rosen and Catherine C. Brawer, *Making Their Mark: Women Enter the Mainstream, 1970–1985* (New York: Abbeville Press, 1989). **2.** Carl Belz, "Joan Snyder," in Delia Gaze, ed., *Dictionary of Women Artists* (Chicago: Fitzroy Dearborn, 1997), vol. II, 1,292. **3.** Hayden Herrera, *Joan Snyder: Seven Years of Work* (Purchase, N.Y.: Neuberger Museum of Art, 1978), 2. **4.** See Gerritt Henry, "Joan Snyder: True Grit," *Art in America* (February 1986): 97–98, and

Hayden Herrera, "Joan Snyder Traffics in Art and True Grit," *New York Times,* 24 July 1994. **5.** Snyder's 1980s "field paintings" are actually based on bean fields that surrounded a small farm she owned at the time in Eastport, Long Island. This reference offers an ironic recasting of the grand, gestural "field paintings" of abstract expressionists such as Jackson Pollock, Mark Rothko, and Barnett Newman. **6.** In an e-mail of 5 November 1999, Snyder recounts that the original impetus behind this painting was the murder of San Francisco Mayor George Moscone and Councilman Harvey Milk. A number of painters had been asked to send in studies for a painting to commemorate the event. Although Snyder's work was not chosen, she returned to the study a few years later while creating the "field paintings." **7.** Joan Snyder, "It Wasn't Neo to Us," *The Journal of the Rutgers University Libraries* 14 (1): 34–35.

May Stevens

1. Folke T. Kihlstedt, "Narrowing the Gap: An Interpretation of Recent Works by May Stevens," in *Mysteries and Politics by May Stevens: Exhibition of Paintings and Color Xeroxes* (Lancaster, Pa.: Franklin and Marshall College, 1979), n.p. A recent source of information on the artist is *May Stevens: Images of Women Near and Far 1983–1997* (New York: Mary Ryan Gallery, 1999). **2.** Notes by the artist, dated 29 November 1993, a copy of which is in the possession of the National Museum of Women in the Arts Library and Research Center, Archives of Women Artists. **3.** The others are *Artist's Studio (After Courbet)* (1975) and *Mysteries and Politics* (1978).

Alma W. Thomas

1. Thomas also became familiar with modernist art during the summers she spent in New York City, where she earned her master's degree from Columbia University's Teacher's College in 1934, and while she was a part-time painting student at American University in Washington, D.C., 1950–60. **2.** This painting was executed one year after the Apollo moon launches came to an end. **3.** Merry A. Foresta, *A Life in Art: Alma Thomas, 1891–1978* (Washington, D.C.: Smithsonian Institution Press, 1981), 28. **4.** Eleanor Munro, *Originals: American Women Artists* (New York: Simon and Schuster, 1979), 194.

ARTISTS' BOOKS

1. Johanna Drucker (b. 1952) is an American book artist, author, and editor. Quoted from her article "Critical Necessities," *The Journal of Artists' Books* 4: 4 (Fall 1995). **2.** Johanna Drucker, *The Century of Artists' Books* (New York: Granary Books, 1995). Drucker's book, cited by numerous other authorities in the field, is a useful source on the history of artists' books and many other related topics. **3.** A brief survey of the recent literature reveals differences even in the use or omission of an apostrophe in the phrase *artists' books.* **4.** Noted by Stefan Klima in the introduction to *Artists Books: A Critical Survey of the Literature* (New York: Granary Books, 1998), 7. He also points out that in 1977 *Documenta 6,* the international exhibition of contemporary art held in Kassel, Germany, included a major exhibition of artists' books for the first time in the history of this prestigious exhibition series. **5.** A complete listing of the artists whose works are represented in the National Museum of Women in the Arts Library and Research Center collection of artists' books may be obtained directly from the center. **6.** See the College Art Association's Directory of M.F.A. Programs in the Fine Arts (New York: College Art Association, 1999) for further information.

Mirella Bentivoglio

1. Quoted by Frances K. Pohl in "An Art of Alternatives: The Work of Mirella Bentivoglio," in *The Visual Poetry of Mirella Bentivoglio* (Rome: Edizioni DeLuca, 1999), 14. **2** Mirella Bentivoglio, quoted in "An Interview with Mirella Bentivoglio," by Krystyna Wasserman, in *The Visual Poetry of Mirella Bentivoglio,* 38. **3.** Ibid., 40.

Jenny Hunter Groat

1. Jenny Hunter Groat to Krystyna Wasserman, posted 20 February 1999. National Museum of Women in the Arts Library and Research Center, Archives of Women Artists, Jenny Hunter Groat's file. **2.** Ibid. **3.** Ibid.

Elisabetta Gut

1. Buzz Spector, "The Fetishism of the Book Object," in *The Book Maker's Desire* (Pasadena, Calif.: Umbrella Edition, 1995), 15. **2.** Excerpt from Elisabetta Gut's 1999 letter to Krystyna Wasserman, National Museum of Women in the Arts Library and Research Center, Archives of Women Artists, Elisabetta Gut's file.

Pamela Spitzmueller

1. Excerpt from Pamela Spitzmueller's artist statement, National Museum of Women in the Arts Library and Research Center, Archives of Women Artists, Pamela Spitzmueller's file.

Molly Van Nice

1. Excerpt from Krystyna Wasserman's taped interview with Molly Van Nice, 1 June 1999, National Museum of Women in the Arts Library and Research Center, Archives of Women Artists. **2.** Ibid.

Claire Van Vliet

1. Claire Van Vliet to Krystyna Wasserman, posted 2 April 1999. National Museum of Women in the Arts Library and Research Center, Archives of Women Artists, Claire Van Vliet's file. **2.** Ruth E. Fine, in her three catalogues raisonné of the Janus Press, describes in detail all the books produced by the press in 1955–75, 1975–80, and 1981–90.

Debra Weier

1. Weier numbers her limited-edition books in an arbitrary manner, as in the case of *A Merz Sonata,* which begins with number 450 rather than number one. **2.** Debra Weier to Krystyna Wasserman, dated 5 February 1999. National Museum of Women in the Arts Library and Research Center, Archives of Women Artists, Debra Weier's file. **3.** Ibid. **4.** Ibid.

ILLUSTRATION CREDITS

Photographs of the permanent collection © by Lee Stalsworth; museum interior © by Robert Isacson; museum exterior © by Mark Gulezian/Quicksilver; and Esther Mahlangu © by Bill Fitzpatrick, courtesy of BMW (US) Holding Corp.

16TH- AND 17TH-CENTURY EUROPE

Lavinia Fontana. *Self-Portrait* (Playing a musical instrument), 1577. Uffizi, Florence, Italy. Scala/Art Resource, New York. **Judith Leyster.** *Self-Portrait,* ca. 1630. Gift of Mr. and Mrs. Robert Woods Bliss, © 1999 Board of Trustees, National Gallery of Art, Washington, D.C. **Maria Sibylla Merian.** *Maria Sibylla Merian* by Jakob Moillon. Department of Printing and Fine Arts, Houghton Library, Harvard University. **Louise Moillon.** Believed to be a self-portrait of Louise Moillon or else a work by an unknown French seventeenth-century artist. *Girl Carrying a Basket of Fruit on Her Head.* Statens Konstmuseer, Nationalmuseum, Stockholm. **Clara Peeters.** *Self-Portrait,* 1610–20. Courtesy of Philips International Auctioneers and Valuers. **Rachel Ruysch.** *Portrait of Rachel Ruysch* by Aert Schouman, 1749. Rijksprentenkabinet Rijksmuseum, Amsterdam. **Elisabetta Sirani.** *Self-Portrait,* 1660. Pinacoteca Nazionale di Bologna.

18TH-CENTURY EUROPE

Rosalba Carriera. *Self-Portrait,* 1715. Uffizi, Florence, Italy. Alinari/Art Resource, New York. **Louisa Courtauld.** *Portrait of Louisa Courtauld* by Johann Zoffany. Private Collection. Photo by © Lee Stalsworth. **Marguerite Gérard.** *Portrait of Marguerite Gérard* by François Dumont, 1793. Reproduced by permission of the Trustees of the Wallace Collection, London. **Angelica Kauffman.** *Self-Portrait,* 1762–63. Galleria di S. Luca, Roma. Alinari/Art Resource, New York. **Adélaïde Labille-Guiard.** *Self-Portrait with Two Pupils, Mademoiselle Marie Gabrielle Capet and Mademoiselle Carreaux de Rosemond.* Oil on canvas. The Metropolitan Museum of Art, Gift of Julia A. Berwind, 1953. **Elisabeth-Louise Vigée-Lebrun.** *Self-Portrait,* ca. 1781. Kimbell Art Museum, Fort Worth, Tex.

19TH-CENTURY EUROPE

Rosa Bonheur. *Rosa Bonheur* by Anna Elizabeth Klumpke, 1898. Oil on canvas. The Metropolitan Museum of Art, gift of the artist in memory of Rosa Bonheur, 1922. **Camille Claudel,** 1913. Private Collection. **Elizabeth A. Armstrong Forbes.** *Elizabeth A. Armstrong Forbes* by Stanhope Forbes. Collection of Newlyn Art Gallery on loan to Penlee House Gallery and Museum, Penzance. **Elizabeth Jane Gardner (Bouguereau).** Photo courtesy of Miriam Gardner Dunnan. **Eva Gonzalès.** *Eva Gonzalès* by Edouard Manet, 1870. © National Gallery, London.

Antoinette-Cécile-Hortense Haudebourt-Lescot. *Self-Portrait,* 1825. Museé National du Louvre, Paris. **Berthe Morisot.** Courtesy of Galerie Hopkins • Thomas • Custot, Paris.

19TH-CENTURY NORTH AMERICA

Cecilia Beaux. *Cecilia Beaux Painting the Portrait of Ethel Page,* 1884. Courtesy of The Pennsylvania Academy of the Fine Arts, Philadelphia, Archives, Henry S. Drinker Collection. **Jennie Augusta Brownscombe.** Photo courtesy of Wayne County Historical Society, Honesdale, Pa. Photo by Mike Fisher. **Mary Cassatt.** *Mary Cassatt* by Baroni and Gardelli, 1872. Albumen print. Courtesy of the Pennsylvania Academy of the Fine Arts, Philadelphia, Archives. **Eulabee Dix.** National Museum of Women in the Arts Library and Research Center, Archives of Women Artists. **Ellen Day Hale.** *Self-Portrait,* 1885. Oil on canvas. Museum of Fine Arts, Boston. Gift of Nancy Hale Bowers. **Gertrude Käsebier.** Courtesy of the Library of Congress, Washington, D.C. Photo by Lifshey. **Evelyn Beatrice Longman.** Courtesy of The Loomis Chaffee School. **Anna Massey Lea Merritt.** *Self-Portrait.* Oil on canvas. The National Museum of Women in the Arts, Gift of David and Anne Sellin. **Mary Nimmo Moran.** *Mary Nimmo Moran* by Naplean Sarony. From the collection of The Thomas Gilcrease Institute of American History and Art, Gilcrease Museum, Tulsa. **Anna Claypoole Peale.** *Anna Claypoole Peale* by James Peale. The Metropolitan Museum of Art, Fletcher Fund, 1937 (38.146.8). **Sarah Miriam Peale.** *Self-Portrait.* Maryland Historical Society, Baltimore, Md. **Lilla Cabot Perry.** Perry Family Archives. **Lilly Martin Spencer.** *Self-Portrait.* Ohio Historical Society. Archives. **Bessie Potter Vonnoh,** 1913. Berry-Hill Galleries, New York. **Eva Watson-Schütze.** *Eva Watson-Schütze* by Thomas Eakins, 1880s. Philadelphia Museum of Art, Gift of Seymour Adelman.

20TH-CENTURY EUROPE

Alice Bailly. Courtesy of the artist's estate. **Sonia Terk Delaunay.** © L& M Services B.V. Amsterdam 991005. Photo by © Lee Stalsworth. **Alexandra Exter.** Billy Rose Theatre Collection, The New York Public Library for the Performing Arts, Astor, Lenox and Tilden Foundations. **Barbara Hepworth.** © Alan Bowness, Hepworth Estate. Photo by J. S. Lewinsky. **Käthe Kollwitz.** *Self-Portrait,* 1891–92. © 1999 Artists Rights Society (ARS), New York/VG Bild-Kunst, Bonn. **Lotte Laserstein.** Belgrave Gallery, London. **Gabriele Münter.** *Portrait of Gabriele Münter* by Wassily Kandinsky, 1905. © 1999 Artists Rights Society (ARS), New York/ADAGP, Paris. **Sophie Taeuber-Arp.** Photographer unknown. **Suzanne Valadon.** *Self-Portrait,* 1915. Centre Georges Pompidou, MNAM, Paris. **Maria Elena Vieira da Silva.** Galerie Jeanne-Bucher.

EARLY-20TH-CENTURY NORTH AMERICA

Berenice Abbott. *Berenice Abbott Playing the Concertina* by Kay Simmon Blumberg, May 1940. Black-and-white gelatin silver print. Museum of the City of New York, Gift of Kay Simmon Blumberg. **Grace Albee.** Courtesy of Mrs. P. Frederick Albee. **Lola Alvarez Bravo.** Courtesy of Throckmorton Fine Art, New York. Photo by Manuel Alvarez Bravo. **Elizabeth Catlett,** 1988. Photo courtesy of Elizabeth Catlett. By Brian Lanker. **Louise Dahl-Wolfe,** 1949. Courtesy Staley-Wise Gallery, New York. **Lois Mailou Jones.** © 1987 Marvin T. Jones. **Frida Kahlo.** Photo by Imogen Cunningham, © 1970 The Imogen Cunningham Trust. **Lucy Martin Lewis.** The Octagon Center for the Arts, Ames, Iowa. **Bertha Lum,** ca. 1920. Photo by © Lee Stalsworth. **María Montoya Martínez.** Photo © Jerry Jacka. **Barbara Morgan** with 4 x 4 Graphlex. © Willard Morgan, 1942. **Alice Neel,** 1970. Photo by Sam Brody. **Georgia O'Keeffe.** Woodfin Camp & Associates, Inc. **Beatrice Whitney Van Ness.** Photo Courtesy of Childs Gallery, Boston.

LATE-20TH-CENTURY NORTH AMERICA

Louise Bourgeois. Courtesy of the artist. **Petah Coyne.** Photo by Jeanne Strongin. **Dorothy Dehner** with "Gateway 3," 1985. Courtesy of the Artist. Photo by Arthur Tress. **Helen Frankenthaler,** 1993. Photo by Marabeth Cohen-Tyler. Courtesy of Tyler Graphics, Ltd. **Nan Goldin.** *Self Portrait on the Train, Germany,* 1992. © Nan Goldin. **Grace Hartigan,** by Martin O'Neill. **Eva Hesse.** © Estate of Eva Hesse. Photo courtesy of Robert Miller Gallery, New York. **Lee Krasner.** Photo by Ann Chwatsky. **Melissa Miller.** Courtesy of the artist. **Joan Mitchell.** Photo by Rudy Burckhardt. **Louise Nevelson,** 1968. Photo courtesy of PaceWildenstein. **Dorothea Rockburne.** Photo by Duane Michals. **Hollis Sigler.** Photo courtesy of Melanie Ames Arnold. **Jaune Quick-to-See Smith.** Courtesy of Bernice Steinbaum Gallery, Miami, Fla. **Joan Snyder.** *Joan Snyder and Daughter Molly* by Ruth Makofske, 1990. **May Stevens** in her Santa Fe studio, 1999. Photo by Gay Block, courtesy of Mary Ryan Gallery, New York. **Alma W. Thomas.** National Museum of American Art, Smithsonian Institution. Photo by Michael Fischer.

ARTISTS' BOOKS

Mirella Bentivoglio. Photo by Marco Persichetti. **Jenny Hunter Groat.** Courtesy of Jenny Hunter Groat. **Elisabetta Gut** with *Io E Sigmund Freud,* 1983; photo by Oscar Savio, Rome. **Pamela Spitzmueller.** Photo by Margie Kelley. **Molly Van Nice.** Courtesy of the artist. **Claire Van Vliet.** Photo by John Somers. **Debra Weier.** Courtesy of the artist.

A

Louise Abbema (French, 1858–1927)
Berenice Abbott (American, 1898–1991)
Alice Acheson (American, b. 1895)
Linda Adato (American, b. 1942)
Eleanor Curtis Ahl (American, 1875–1953)
Ida Alamuddin (Lebanese, b. 1947)
Benny Alba (American, b. 1949)
Grace Albee (American, 1890–1985)
Anni Albers (American, 1899–1994)
Carmen Aldunate (Chilean, b. 1940)
Suad Allatar (Iraqi)
Altina (Miranda) (American, b. 1907)
Blanche Ames Ames (American, 1878–1969)
Betsy Anderson (American, b. 1936)
Christine Anderson (American, b. 1970)
Elaine Anderson
Judith Oak Andraka (American, b. 1938)
Francoise Andre (Canadian, b. 1926)
Sharron Antholt (American, b. 1944)
Marie Apel (English, 1880–1970)
Ida Applebroog (American, b. 1929)
Birgitta Ara (Finnish, b. 1934)
Pilar de Arstegui (Spanish, b. 1945)
Mada Artha (Balinese)
Lila Oliver Asher (American, b. 1921)
Dotty Attie (American, b. 1938)
Sally Michel Avery (American, b. 1902)
Alice Aycock (American, b. 1946)

B

Alice Baber (American, 1928–1982)
Frances Bagley (American, b. 1946)
Alice Bailly (Swiss, 1872–1938)
Carolyn Balcom (American, b. 1935)
Laurie Balmuth (American, b. 1945)
Jan C. Baltzell (American, b. 1948)
Frida Baranek (Brazilian, b. 1961)
Candace Barbot (American)
Susanna Barker (English, d. 1793)
Jennifer Bartlett (American, b. 1941)
Loren Roberta Barton (American, 1893–1975)
Ann Bateman (English, 1749–1815)
Hester Bateman (English, 1709–1794)
Wanita Bates (Canadian, b. 1960)
Wanda Baucus (American, b. 1947)
Mary Beale (English, 1632–1697)
Carolina Van Hook Bean (American, 1879–1980)
Lady Diana Beauclerk (English, 1734–1808)
Cecilia Beaux (American, 1855–1942)
Friedy Becker-Wegeli (American, 1900–1984)
Annie Beckett
Enella Benedict (American, 1858–1942)
Lynda Benglis (American, b. 1941)
Millie Bennett (American, b. 1923)
Philomene Bennett (American, b. 1935)
Mirella Bentivoglio (Italian, b. 1922)
Ruth Bernhard (American/German?, b. 1905)
Ileane Bernstein (American, b. 1956)

Sylvia Bernstein (American, b. 1914)
Theresa Bernstein (American, b. 1898)
Virginia Berresford (American, b. 1902)
Betsy Best-Spadero (American, b. 1957)
Catharina Biddle (American, b. 1918)
Electra Waggoner Biggs
 (American, active 20th century)
Margaret Binley (English)
Ruth Walhberg Birch (American, b. 1924)
Isabel Bishop (American, 1902–1988)
Elizabeth Blackadder (Scottish, b. 1931)
Joan Ross Blaedel (American, b. 1942)
Nell Blaine (American, b. 1922)
Sarah Blake (English)
Tina Blau (Austrian, 1845–1916)
Rosina Cox Boardman (American, 1878–1970)
Dusti Bongé (American, 1909–1993)
Rosa Bonheur (French, 1822–1899)
Suzanne Bonin (American, b. 1955)
Lee Bontecou (American, b. 1931)
Karen Borchers (American)
Kathy Borchers (American)
Dorr Bothwell (American, b. 1902)
Sue Ann Bottomley (American, b. 1946)
Louise Bourgeois (American [b. France, 1911])
Antoinette Bouzonnet-Stella (French, 1638–1691)
Jessica Boyatt (American, b. 1964)
Sarah Yocum McFadden Boyle (American)
Lisa Bradley (American, b. 1951)
Carolyn Brady (American, b. 1937)
Lola Alvarez Bravo (Mexican, 1907–1993)
Gisela Breitling (German, b. 1939)
Anne Breivik (Norwegian, b. 1932)
Jamie Brooks (American, b. 1926)
Judith Brown (American, b. 1931)
Pamela Wedd Brown (American, b. 1928)
Colleen Browning (Irish, b. 1929)
Jennie Augusta Brownscombe
 (American, 1850–1936)
Barbara Bruch (American, b. 1940)
Anita Bucherer (German)
Alice Standish Buell (American, 1892–1964)
Linda Burgess (American, b. 1954)
Alice Burrows (English)
Margaret Lesley Bush-Brown
 (American, 1857–1944)
Marjorie Conant Bush-Brown
 (American, 1885–1978)
Sarah Buttall (English)
Mimi Quilici Buzzacchi (Italian, 1903–1990)
Anne Frances Byrne (English, 1775–1837)
Judy Byron (American)

C

Nicole Callebaut-Saey (Belgian)
Jo Ann Callis (American, b. 1941)
Mary-Helen Carlisle (American [b. South Africa],
 19th century–1925)
Cynthia Carlson (American, b. 1942)

Jewel Carrera (American, b. 1942)
Rosalba Carriera (Italian, 1675–1757)
Leonora Carrington (English, b. 1917)
Mary Cassatt (American, 1844–1926)
Elizabeth Catlett (American, b. 1915)
Lydia Chamberlin (American, b. 1923)
Minerva Chapman (American, 1858–1947)
Linda Charleston (American, b. 1942)
Louisa Chase (American [b. Panama, 1951])
Mary Lloyd Chase (American, b. 1942)
Roz Chast (American, b. 1955)
Mary Chawner (English)
Ann Chernow (American, b. 1936)
Judy Chicago (American, b. 1939)
Marie Z. Chino (American Indian, 1907–1984)
Young-ja Cho (Korean)
Kyung-yeun Chung (Korean, b. 1955)
Alberta Cifolelli (American, b. 1931)
Minna Citron (American, 1896–1991)
Charlotte C. Clark (American, b. 1917)
Camille Claudel (French, 1864–1943)
Manon Cleary (American, b. 1942)
Gabrielle de Veaux Clements
 (American, 1858–1948)
Gaines Reynolds Clore (American, b. 1946)
Sue Coe (English, b. 1951)
Phoebe Cole (American, b. 1959)
Clyde Connell (American, b. 1901)
Micheline Roquebrune Connery
 (English [b. France, 1929])
Marjorie Content (American, 1895–1984)
Elizabeth Cooke (English)
Janet Cook-Rutnik (American, b. 1946)
Pilar Cocero de Corvera (Spanish, b. 1949)
Lottaria Corva (Italian, 1934–1991)
Louisa Courtauld (English, 1729–1807)
Fleur Cowles (American)
Petah Coyne (American, b. 1953)
Ann Craig (English, b. 1720)
Deb Cram (American)
Vicki Cronis (American, b. 1966)
Susan Crowder (American, b. 1943)
Ann E. Crumbley (American, b. 1934)
Janet Culbertson (American, b. 1932)
Imogen Cunningham (American, 1883–1976)
Richenda Cunningham (English)
Nancy Cusick (American)
Peggy Cyphers (American, b. 1954)
Ruth Cyril (American, active 1960s)
Oszi Czinner

D

Louise Dahl-Wolfe (American, 1895–1989)
Virginia Daley (American, b. 1950)
Betsy Damon (American, b. 1940)
Joan Danzinger (American, b. 1934)
Rebecca Davenport (American, b. 1943)
Roselle Davenport (American, b. 1948)
Carol Kreeger Davidson (American, b. 1932)

COLLECTION

Ingrid Davis (American, b. 1935)

Worden Day (American, 1916–1986)

Dale De Armond (American, b. 1914)

Margarita Lozano De Cavelier (Colombian, b. 1936)

Dorothy Dehner (American, 1901–1994)

Aude de Kerros (French, b. 1947)

Elaine Fried de Kooning (American, 1920–1989)

Sonia Terk Delaunay (Russian, 1885–1979)

Kate Delos (American)

Maria Noppen de Mattheis (Belgian, b. 1921)

Donna Dennis (American, b. 1942)

Susana de Quadros (American, b. 1945)

Dianna Diatz (American, b. 1951)

Eleanor Dickinson (American, b. 1931)

Jane Dickson (American, b. 1952)

Lesley Dill (American, b. 1950)

Robin Dintiman (American, b. 1951)

Barbara Dix (American, b. 1931)

Eulabee Dix (American, 1878–1961)

Wendy Fay Dixon (American, b. 1931)

Blanche Dolmatch (American, b. 1925)

Anne Doran

Mary Ellen Doyle (American, b. 1938)

Nancy Proskauer Dryfoos (American, b. 1918)

Valentina Du Basky (American, b. 1951)

Alice Dubiel (American, b. 1951)

Marjorie Cline Dunn (American, 1894–1989)

Elizabeth Lyman Boott Duveneck
 (American, 1846–1888)

Mable Dwight (American, 1876–1955)

Natalie Dymnickie (American, b. 1924)

E

Elizabeth Eaton (English)

Abastenia St. Leger Eberle (American, 1878–1942)

Jane Eddy (American, b. 1922)

Mary Beth Edelson (American, b. 1934)

Sylvia Edwards (American, b. 1937)

Sally Ehrlich-Hoffman (American, b. 1949)

Rowena Caldwell Elkin (American, b. 1917)

Deborah Ellis (American, b. 1939)

Rebecca Emes (English, b. 1830)

Jane Erin Emmet (American, 1841–1907)

Lydia Field Emmet (American, 1866–1952)

Simona Ertan (Argentinian [b. Romania, 1923])

Jessie Benton Evans (American, b. 1938)

Alexandra Exter (Russian, 1882–1949)

Sara Eyestone (American, b. 1943)

F

Claire Falkenstein (American, 1908–1999)

Maysaloon Faraj (Iraqui)

Abab Farhan (Kuwaiti, b. 1938)

Susan Farley (American, b. 1957)

Harriet Feigenbaum (American, b. 1939)

Marsha Feigin (American, b. 1946)

Aline Feldman (American, b. 1928)

Magdalene Feline (English, d. 1796)

Mary Lou Ferbert (American, b. 1942)

Anne Ferguson (Australian, b. 1939)

Jackie Ferrara (American, b. 1929)

Marie Ferrian (American, b. 1927)

Susan Firestone (American, b. 1946)

Anya Fisher (American [b. Russia, 1905])

Susan Fishgold (American, b. 1949)

Harriet Fitzgerald (American, b. 1904)

Audrey Flack (American, b. 1931)

Lavinia Fontana (Italian, 1552–1614)

Elizabeth Adela Armstrong Forbes
 (Canadian, 1859–1912)

Helen Forbes (American, 1891–1945)

Patricia Tobacco Forrester (American, b. 1940)

Cornelia Foss (American, b. 1933)

Connie Fox (American, b. 1920)

Mary Frances (American, b. 1962)

Mary Frank (American [b. London, 1933])

Helen Frankenthaler (American, b. 1928)

Theresa Frare (American, b. 1958)

Sondra Freckelton (American, b. 1936)

Yolande Frederikse (American, b. 1927)

Jenny Freestone (American, b. 1950)

Christina Freitag (American)

Magda Soliz French (American, b. 1933)

Inga Frick (American)

Steffani Frideres (Canadian, b. 1965)

Elizabeth Friedman (American, b. 1918)

Elisabeth Frink (English, 1930–1993)

Harriet Whitney Frishmuth (American, 1880–1979)

Maggie Furman (American, b. 1941)

Zsuzsa Fuzesi (Hungarian, b. 1953)

G

Aniko Gaal (Hungarian, b. 1944)

Ada V. Gabriel (American, b. 1898)

Cynthia Gallagher (American)

Carolyn Gallois (French, b. 1954)

Dinah Gamon (English)

Freda G. Gandy (American, b. 1935)

Agnes Garabuczy (Hungarian, b. 1936)

Jeanne Garant (American, b. 1939)

Dolores Lewis Garcia (American Indian, b. 1938)

Elizabeth Jane Gardner (Bouguereau)
 (American, 1837–1922)

Maud Gatewood (American, b. 1934)

Grace Gaupe-Pillard

Sonia Gechtoff (American, b. 1926)

Marguerite Gérard (French, 1761–1837)

Helen Gerardia (American, d. 1988)

Eugenia Gershoy
 (American, [b. Russia] 1902–1986)

Gianacles (American, b. 1961)

Joanne M. Gigliotti (American, b. 1945)

Dorothy Gillespie (American, b. 1920)

Ruth Gikow (American, [b. Ukraine] 1913)

Francoise Gilot (French, b. 1921)

Terry Gips (American, b. 1945)

Elizabeth Godfrey (English, active ca. 1720–1758)

Judith Godwin (American, b. 1930)

Abby Goell (American, active 1960s)

Carol Goldberg (American, b. 1940)

Nan Goldin (American, b. 1953)

Anne Wilson Goldthwaite (American, 1869–1944)

Natalia Sergeevna Goncharova
 (Russian, 1881–1962)

Eva Gonzalès (French, 1849–1883)

Glenna Goodacre (American, b. 1939)

Sarah Stout Gooding (American, b. 1935)

Shirley Gorelick (American, b. 1924)

April Gornik (American, b. 1953)

Mary Gould (English)

Lorrie Goulet (American, b. 1925)

Constance R. Grace (American, b. 1929)

Margaret Gradwell (South African, b. 1956)

Nancy Graves (American, b. 1940)

Eliza Greatorex (American, 1820–1897)

Adele Greeff (American, b. 1911)

Pat Greenhouse (American)

Marion Greenwood (American, 1909–1970)

Martha Griffin (American, b. 1951)

Mary Grigoriades (American, b. 1942)

Jenny Hunter Groat (American, b. 1929)

Nancy Grossman (American, b. 1940)

Elisabetta Gut (Italian, b. 1934)

H

Bonnie Hagstrum, (American, b. 1918)

Samia Halaby (American [b. Palestine, 1936])

Nancy Halbrooks (American, b. 1953)

Ellen Day Hale (American, 1855–1940)

Jean Hale (American, b. 1930)

Lee Hall (American, b. 1934)

Susan Hall (American, b. 1943)

Beverly Hallam (American, b. 1923)

Juliette Hamélécourt (American, b. 1912)

Harmony Hammond (American, b. 1944)

Anna Marie Hancke
 (Norwegian [b. Yugoslavia, 1939])

Renata von Hanffstengel
 (Mexican, [b. Germany] 1934)

Ann Hanson (American, b. 1959)

Dionne Haroutunian (Swiss, b. 1960)

Carole Harrison (American, b. 1933)

Grace Hartigan (American, b. 1922)

Cleo Hartwig (American, b. 1911)

Noriko Hasegawa (American, b. 1933)

Elizabeth Haselwood (English)

Mansoora Hassan (Pakistani, b. 1953)

Antoinette-Cécile-Hortense Haudebourt-Lescot
 (French, 1784–1845)

Linda Hawkin-Israel (American, b. 1942)

Annie Hayes (American)

Edith Hayllar (English, 1860–1948)

Eleanor Heller (American, b. 1918)

Jill S. Henriod (American [b. New Zealand, 1941])

Myra Henry (American, 1921–1985)

Barbara Hepworth (British, 1903–1975)

Eva Hesse (American [b. Germany], 1936–1970)

Jackie L. Heupel (American, b. 1946)
Louise Douglas Hibben (American, 1895–1974)
Eleanor Himmelfarb (American, b. 1910)
Carolyn Hine (American)
Claude Raguet Hirst (American, 1855–1942)
Hannah Höch (German, 1889–1978)
Malvina Hoffman (American, 1887–1966)
Helen Hoie (American, b. 1911)
Judy Hokanson (American, b. 1951)
Sarah Holaday (English)
Janice Holkup (American, b. 1946)
Eva Bull Holte (Norwegian)
Harriet Hosmer (American, 1830–1908)
Marion Howard (American, b. 1923)
Laura Weaver Huff (American, b. 1930)
Bernice B. Hunter (American)
Clementine Hunter (American, 1886–1988)
Susan Hunt-Wulkowicz
Anna Vaughn Hyatt Huntington
 (American, 1876–1973)
Mary Huntoon (American, b. 1896)
Frances Hynes (American, b. 1945)

I

Dorothy Iannone (American, b. 1933)
Connie Imboden (American, b. 1953)
Judith Ingram (American, b. 1926)
Sheila Isham (American, b. 1927)
Yoshiko Ishikawa (Japanese, b. 1929)
Wako Ito (Japanese, b. 1945)
Reika Iwami (Japanese, b. 1927)

J

Yvonne Jacquette (American, b. 1934)
Agnes Jacobs (American, b. 1943)
Pauline Jakobsberg (American, b. 1937)
Virginia Jaramillo (American, b. 1939)
Valerie Jaudon (American, b. 1945)
Huldah Jeffe (American)
Georgia Mills Jessup (American, b. 1926)
Inger Jirby (American [b. Swedish, 1942])
Patricia Johanson (American, b. 1940)
Grace Spaulding John (American, 1890–1972)
Gwen John (Welsh, 1876–1939)
Harriet Johns (American)
Eleanora Madsen Johnson (American, b. 1900)
Inez Johnston (American, b. 1920)
Elizabeth Jones (American, b. 1935)
Jo Jones (English, 1913–1989)
Lois Mailou Jones (American, 1905–1998)
Megan Hart Jones (American, 1966–1987)

K

Frida Kahlo (Mexican, 1907–1954)
Robin Kahn (American, b. 1961)
Mary K. Karasick
 (American [b. Russia], 1888–1985)
Nanette Kardaszeski (American, b. 1963)
Gertrude Käsebier (American, 1852–1934)

Stefanija Katkeviciene (Lithuanian)
Angelica Kauffman (Swiss, 1741–1807)
Pam Keeley (American, b. 1950)
Elizabeth Keith (American, 1887–1956)
Maurie Kerrigan (American, b. 1951)
Niki Ketchman (American, b. 1942)
Dora Khayatt (Egyptian, 1910–1986)
Soo Ja Kim (Korean, b. 1957)
Junghi Kim (Korean-American, b. 1962)
Rosemary Kimball (American, b. 1922)
Jessie Marion King (Scottish, 1876–1949)
Marcia Gygli King (American, b. 1931)
Minnie Klavans (American, b. 1915)
Carla Klevan (American, b. 1939)
Georgina Klitgaard (American, 1893–1976)
Jennie Lea Knight (American, b. 1933)
Guitou Knoop (Russian, 1902–1985)
Kiki Kogelnik (American)
Ida Kohlmeyer (American, 1912–1997)
Käthe Kollwitz (German, 1867–1945)
Joyce Kozloff (American, b. 1942)
Lee Krasner (American, 1908–1984)
Jill Krementz (American, b. 1940)
Margo Kren (American, b. 1939)
Kathleen Rogers Krikorian (American)
Elizabeth Kronseder (German, b. 1940)
Ziva Kronzon (Israeli, b. 1939)
Amy Kunhardt (American)
Leslie Kuter (American, b. 1947)

L

Adélaïde Labille-Guiard (French, 1749–1803)
Valeria Gibson Ladd (American, 1890–1984)
Hortensia Nunez Ladeveze (Spanish)
Ingrid Lahti (American, b. 1943)
Aimee Lamb (American, 1893–1989)
Dorothy Langlands (English)
Ellen Lanyon (American, b. 1926)
Constance Stuart Larrabee (South African, b. 1914)
Pat Lasch (American, b. 1944)
Lotte Laserstein (German, 1898–1993)
Alice Lauffer (American, b. 1919)
Marie Laurencin (French, 1885–1956)
Pamela Harris Lawton (American, b. 1959)
Elizabeth Layton (American, 1909–1993)
Doris Lee (American, 1905–1983)
Claire Leighton (American, 1901–1989)
Ora Lerman (American, b. 1938)
Jeanette LeRoy (French, b. 1928)
A. Lesley (American, b. 1948)
Lucy M. Lewis (American Indian, 1890–1992)
Beatrice McComb Ley (American, 1890–1980)
Judith Leyster (Dutch, 1609–1670)
Marjorie Liebman (American, b. 1912)
Sharon Ligorner (American, b. 1964)
Maya Lin (American, b. 1960)
Joan M. Linsley (American, b. 1922)
Grazia Lodeserto (Italian, b. 1944)
Rebecca Pollard Logan (American, b. 1903)

Elfriede Lohse-Wächtler (German, 1899–1940)
Marianne Loir (French, active ca. 1737–1779)
Edith London, (German, b. 1904)
Evelyn Beatrice Longman (American, 1874–1954)
Jessie Dorr Luca (American, 1877–1978)
Nancy Youngblood Lugo
 (Santa Clara Pueblo, b. 1955)
Bertha Lum (American, 1879–1954)
Elenore Lust (American)
Ruth Ava Lyons (American, b. 1956)

M

Anne MacAdam (American)
Betty Ann MacDonald (American, b. 1936)
Ellen MacDonald (American, b. 1955)
Mary Oliveira Maciel (American, 1906–1990)
Loren MacIver (American, b. 1909)
Mary Lizzie Macomber (American, 1861–1916)
Arika Madeyska (Polish, b. 1935)
Phyllis Maher (American, b. 1945)
Sigrid Mahncke (German, b. 1927)
Maia (Portuguese, b. 1941)
Mary Maison (American, 1886–1954)
Lea Majaro-Mintz (Israeli, b. 1926)
Lindsay Harper Makepeace (American, b. 1926)
Elaine Malco (American, b. 1916)
Marcia Marcus (American, b. 1928)
Susan B. Markisz (American)
Agnes Martin (American, b. 1912)
Marilyn Martin-Kiel (American, b. 1932)
Alice Trumbull Mason (American, 1904–1971)
María Montoya Martínez (American, 1880–1980)
Norma Mascellani (Italian, b. 1909)
Louisa Mattiasdottir (Icelandic American, b. 1917)
Joanne Matuschka (American, b. 1954)
Eveline V. Maydek
Elizabeth McBride (American, b. 1920)
Edith McCartney (American, 1897–1981)
Joan Y. McClure (American, b. 1934)
Mary Beth Mckenzie (American, b. 1946)
Hazel McKinley (American, 1903–1995)
Charlotte Mercier (French, 1738–1762)
Maria Sibylla Merian (German, 1647–1717)
Anna Massey Lea Merritt (American, 1844–1930)
Karen Metcalf
Anna Meyer-Zachurski (American, b. 1945)
Julie Mihes (Prussian)
Dorothy Mill (English)
Cheryl Miller (American)
Kay Miller (American, b. 1946)
Melissa Miller (American, b. 1951)
Pamela Mills (American, b. 1948)
Mary Miss (American, b. 1944)
Corinne Howard Mitchell (American, 1914–1993)
Emma Lewis Mitchell (American Indian, b. 1931)
Joan Mitchell (American, 1926–1992)
Ayako Miyawaki (Japanese, b. 1905)
Mkonokono Workshop (Kenya)
Paula Modersohn-Becker (German, 1876–1907)

Louise Moillon (French, 1610–1696)

Dorothy Kerper Monnelly (American, b. 1937)

Mary Nimmo Moran (American, 1842–1889)

Barbara Morgan (American, 1900–1992)

Gertrude Morgan (American, 1900–1980)

Berthe Morisot (French, 1841–1895)

Elizabeth Morley (English)

Christine Morrison (American, b. 1951)

Anna Mary Robertson Moses
 (American, 1860–1961)

Alice Mostoff (American, b. 1934)

Laura Mott (American)

Lydia Mott (American)

Maxine Mott (American)

Roxie Munro (American, b. 1945)

Ruth Munson (American, b. 1931)

Gabriele Münter (German, 1877–1962)

Elizabeth Murray (American, b. 1940)

Jo Owens Murray (American)

Theresa Musoke (Ugandan, b. 1945)

Nina Muys (American, b. 1945)

Frances Myers (American, b. 1936)

Virginia Myers (American, b. 1927)

N

Sahomi Naka (Japanese, b. 1946)

Annette Nancarro (American, b. 1907)

Diane Rutter Nargiz (American, b. 1930)

Marie-Genevieve Navarre (French, 1737–1795)

Allina Ndebele (South African, b. 1939)

Alice Neel (American, 1900–1984)

Joan Nelson (American, b. 1958)

Lydia Nelson (American, b. 1956)

Annette Nancarrow (American, b. 1907)

Louise Nevelson
 (American, [b. Russia], 1900–1988)

Natalie Niblack (American, b. 1957)

Iris Nichols (American, b. 1938)

Nelleke Langhout Nix (American)

Evelyn Hunter Nordhoff (American)

Hannah Northcote (English)

Elizabeth Norton (American, 1888–1985)

Elizabeth Nourse (American, 1859–1938)

Judith Nulty (American, b. 1944)

Marina Nunez del Prado (Bolivian, b. 1912)

O

Ellen Oakford (American, active 1880–1890s)

Elizabeth Gaither Ochs (American, b. 1928)

Tomie Ohtake (Japanese Brazilian, b. 1913)

Georgia O'Keeffe (American, 1887–1986)

Nancy O'Malley (American, b. 1920)

Yoko Ono (Japanese, b. 1933)

Deborah Oropallo (American, b. 1954)

Marian Osher (American, b. 1945)

Susan Osterberg (American, b. 1939)

Beatrice Ost-Kuttner (German, b. 1940)

Helen Ottoway (American, b. 1938)

Katja Oxman (American, b. 1942)

P

Terry Parmelee (American, b. 1929)

Betty Parsons (American, 1900–1982)

Gertrude Partington (American, 1883–1959)

M. Marvin Breckinridge Patterson
 (American, b. 1905)

Bo Peabody (American, 1924–1990)

Anna Claypoole Peale (American, 1791–1878)

Mary Jane Peale (American, 1827–1902)

Sarah Miriam Peale (American, 1800–1885)

Susan Due Pearcy (American, b. 1945)

Clara Peeters (Flemish, active ca. 1594–1657)

Edith Penman (American, 1860–1929)

Lora Pennington (American, b. 1933)

Beverly Pepper (American, b. 1924)

Lilla Cabot Perry (American, 1848–1933)

Jane Peterson (American, 1876–1965)

Kristin Peterson (American, b. 1952)

Judy Pfaff (American, b. 1945)

Constance Pierce (American, b. 1946)

Howardena Pindell (American, b. 1943)

Jody Pinto (American, b. 1942)

Adrian Piper (American, b. 1948)

Jane Piper (American, 1916–1991)

Linda Plotkin (American, b. 1938)

Carolyn Pomponio (American, b. 1934)

Katherine Porter (American, b. 1941)

Elizabeth Morris Poucher (American, 1896–1988)

Valentine Henriette Prax (Algerian, b. 1899)

Audrey Preissler (American)

Elena Presser (American [b. Argentina, 1940])

Mary Catherine Prestel (German, 1744–1794)

Elizabeth Primas (American, b. 1948)

Yvonne Prins-de Sarria (Dutch [b. France, 1941])

Lisa Pumphrey (American, b. 1937)

Ann Purcell (American, b. 1941)

Florence Putterman (American, b. 1927)

R

Barbara Rae (Scottish, b. 1943)

Felicity Rainnie (Canadian, b. 1945)

Christina Ramberg (American, b. 1946)

Lynn Randolph (American, b. 1938)

Joanne Rathe

Cathy Raymond (American, b. 1949)

Anne Redpath (Scottish, 1895–1965)

Jane Reece (American, 1869–1961)

Carol Reed (American)

Pascal Regan (American, b. 1914)

Maria Regnier (American [b. Romania, 1901])

Edna Reindel (American, 1894–1990)

Edda Renouf (American, b. 1943)

Nancy duPont Reynolds (American)

Beatrice Riese (American, b. 1917)

Judy Rifka (American, b. 1945)

Bridget Riley (English, b. 1931)

Sallie Ritter (American, b. 1947)

Ellen Robbins (American, 1828–1905)

Pamela Roberson (American, b. 1947)

Genevieve Roberts (American, b. 1920)

Ines E. Roberts (American, b. 1929)

Priscilla Roberts (American, b. 1916)

Charlotte Robinson (American, b. 1924)

Ione Robinson (American, b. 1910)

Dorothea Rockburne (Canadian, b. 1934)

Lourdes Rodriguez

Oliver Verna Rogers (American, 1902–1989)

Susan Rogers (American, b. 1939)

Clare Romano (American, b. 1922)

Mary Rood (English)

Sadie Rosenblum (American)

Doris Rosenthal (American, 1890–1971)

Kathy Ross (Canadian, b. 1948)

Maxine Ross (American, b. 1925)

Shirley Rothenberg (American, b. 1920)

Blanche Rothschild (American, 1893–1988)

Isabelle Rouault (French, b. 1910)

Marjorie J. Rubin (American, 1955)

Barbara Russell (American, b. 1911)

Rachel Ruysch (Dutch, 1664–1750)

S

Alison Saar (American, b. 1956)

Kay Sage (American, 1898–1965)

Joanna Salska (Polish, b. 1951)

Fanny Sanín (Colombian, b. 1938)

Maria da Conceicao Sao (Portuguese, b. 1946)

Geneve Rixford Sargeant (American, 1868–1957)

Marjatta Sarasolo (Finnish, b. 1930)

Dudum Sardjaya

Sahomi Sargent (Japanese)

Lolo Sarnoff (Swiss, b. 1916)

Mona Saudi (Jordanian, b. 1945)

Mizue Sawano (Japanese, b. 1941)

Miriam Schapiro (American, b. 1923)

Laura Schechter (American)

Deborah Schindler (American, b. 1950)

Ellouise Schoettler (American, b. 1936)

Ann Didusch Schuler (American, b. 1917)

Barbara Schwartz (American, b. 1948)

Janet Sears

Sarah Sears (American, 1858–1935)

Helen Sebidi (South African, b. 1943)

Joan Semmel (American, b. 1932)

Susan Shatter (American, b. 1943)

Laila Shawa (Palestinian, b. 1940)

Stella Shawzin (South African)

Lisa Sheets (American, b. 1963)

Mary Michael Shelley (American, b. 1950)

Fawn Shillinglaw (American, b. 1944)

Anne Shreve (American, b. 1926)

Hollis Sigler (American, b. 1948)

Tammra Sigler (American, b. 1943)

Margy Silvey (American, b. 1940)

Renee Sintenis (German, 1888–1965)

Nell Sinton (American, b. 1910)

Elisabetta Sirani (Italian, 1638–1665)

Gazbia Sirry (Egyptian)

Beverly Sloan

Helen Farr Sloan (American, b. 1911)

Jennifer Sloan (American, b. 1958)

Anne Smith (English)

Jaune Quick-to-See Smith
 (American Indian, b. 1940)

Jean Ranney Smith (American, b. 1929)

Mimi Smith (American, b. 1942)

Patricia Smith (American)

Zoe Smith

Joan Snyder (American, b. 1940)

Maria M. Somogyi (German, b. 1936)

Lily Spandorf (Austrian)

Louise Kidder Sparrow (American, 1884–1979)

Lilly Martin Spencer (American, 1822–1902)

Nancy Spero (American, b. 1926)

Pamela Spitzmueller (American, b. 1950)

Elizabeth Cady Stanton (American, 1894–1981)

Ellen Stavitsky (American, b. 1951)

Beatrice Stein (American, 1879–1961)

Hedda Sterne (American [b. Romania, 1916])

May Stevens (American, b. 1924)

Maggie Stewart (American, 1937)

Marguerite de Limburg Stirum (Belgian, b. 1932)

Immi Storrs (American, b. 1945)

Jane Stuart (American, 1810–1886)

Kiel Stuart (American, b. 1951)

Dorothy Sturm (American, 1910–1988)

Marie Sugar (American, b. 1951)

Kathleen Sullivan (American)

Nola de Jong Sullivan (American, b. 1924)

Altoon Sultan (American, b. 1948)

Mary and Eliza Sumner (English)

Nita Sunderland (American, b. 1927)

Carol Ann Sutherland (Scottish, b. 1952)

Terry Svat (American, b. 1938)

Jadwiga Szmidt (Polish, b. 1938)

T

Celine M. Tabary (French, 1908–1993)

Mitsuko Tabe (Japanese)

Shirley M. Tabler (American, 1936)

Martha Tabor (American, b. 1939)

Athena Tacha (American, b. 1936)

Sophie Taeuber-Arp (Swiss, 1889–1943)

Lu Ann Tafoya (American Indian, b. 1938)

Margaret Tafoya (American Indian, b. 1904)

Teresa Tamura (Japanese-American, b. 1960)

Anne Tanqueray (English, 1691–1733)

Bertha Tarnay (English, 1891–1973)

Barbara Tebbetts (American)

Madge Tennent (American, 1889–1972)

Joyce Tenneson (American, b. 1945)

Lyndia Terre (American, b. 1946)

Linda Thern-Smith (American, b. 1946)

Alma W. Thomas (American, 1891–1978)

Helga Thomson (Argentinian, b. 1938)

Caroline Thorington (American, b. 1943)

Joan Thorne (American, b. 1943)

Maureen Jordan Tierney (American)

Heloise Helena Tigre (American, b. 1939)

Izumi Tokuno (Japanese)

Elizabeth Tookey (English)

Nuong Van Dinh Tran (American, b. 1928)

Honor Tranum (American, b. 1910)

Mary Troby (English)

Anne Truitt (American, b. 1921)

Deborah Turbeville (American, b. 1938)

Bracha Turner (American [b. Israel, 1925])

Janet E. Turner (American, b. 1935)

Li Turner (American, b. 1951)

Karen Tweedy Holmes (American, b. 1942)

U

Agnese Udinotti (American, b. 1940)

V

Suzanne Valadon (French, 1865–1938)

Katrine Van Houten

Beatrice Whitney Van Ness (American, 1888–1981)

Molly Van Nice (American, b. 1945)

Laura van Papplendam (American, 1883–1974)

Anna Maria Van Schurman (German, 1607–1678)

Claire Van Vliet (American, b. 1933)

Gemma Vercelli (Italian, b. 1912)

Maria Vicentini (Italian, b. 1912)

Assia Busiri Vici (Italian, 1906–1989)

Princess Adelaide Mary Louise Victoria
 (English, 1840–1901)

Elena Bonafonte Vidotto (American, b. 1934)

Maria Elena Vieira da Silva (Portugese, 1908–1992)

Elisabeth-Louise Vigée-Lebrun (French, 1755–1842)

Elizabeth Voelker (American, b. 1931)

Bessie Potter Vonnoh (American, 1872–1955)

Charmion Von Wiegand (American, 1900–1983)

W

Selma Waldman (American, b. 1931)

Anna Walinska (American, 1906–1997)

Diana Walker (American, b. 1942)

Martha Walter (American, 1875–1976)

Ruth V. Ward (American, b. 1932)

Sandra Wasko-Flood (American, b. 1943)

Lady Louisa Ann Waterford (English, 1818–1891)

Caroline Watson (English, 1761–1814)

Eva Watson-Schütze (American, 1867–1935)

June Wayne (American, b. 1918)

Katharine Ward Lane Weems
 (American, 1899–1989)

Debra Weier (American, b. 1954)

Joyce Ellen Weinstein (American, b. 1931)

Ruth Weisberg (American, b. 1942)

Lee Weiss (American, b. 1928)

Annie Wells (American)

Eudora Welty (American, b. 1909)

Moose Karen Wesler (American, b. 1961)

Gertrude Wetmore (American, b. 1919)

Barbara Whipple (American, 1921–1989)

Anne Whitney (American, 1821–1915)

Wijdan [HRH Princess Wijdan Ali, Ph.D]
 (Jordanian, b. 1939)

Irena Wiley (American [b. Poland], d. 1972)

Ann Williams (American, b. 1934)

Jane Williams (English, d. 1845)

Joan Witek (American, b. 1943)

Marbet Maize Wolfson (American, b. 1952)

Marcy Shear Wolpe (American, b. 1949)

Ethelyn Hurd Woodlock (American, b. 1907)

Betty Woodman (American, b. 1930)

Janet Worne (American)

Nancy Worthington (American, b. 1947)

Henriette Wyeth (American, 1907–1997)

Y

Yuriko Yamaguchi (Japanese, b. 1948)

Loretta Yang

Z

Michele Zackheim (American, b. 1941)

Ann Zahn (American, b. 1931)

Hanna Zawa-Cywinska (American, b. 1939)

Malcah Zeldis (American, b. 1931)

Anna Katrina Zinkeisen (English, 1902–1976)

Marguerite Thompson Zorach
 (American, 1887–1968)

Zuka (American, b. 1924)